A HANDBOOK FOR THE S █████████████████████ DE

A HANDBOOK FOR THE STUDY OF
SUICIDE

Edited by

SEYMOUR PERLIN, M.D.

Senior Research Scholar, Center for Bioethics
Kennedy Institute, Washington D.C.
Clinical Professor of Psychiatry
George Washington University
School of Medicine

New York
OXFORD UNIVERSITY PRESS
London 1975 Toronto

0 9 8 7 6 5 4

To my sons, Jeremy Francis, Steven Michael, Jonathan Brian
To my wife, Ruth
To my teacher, Viola W. Bernard

CONTRIBUTORS

A. Alvarez, Author and Critic, London, England.

Richard Brandt, Ph.D., Professor and Chairman, Department of Philosophy, University of Michigan, Ann Arbor, Michigan.

Kurt Gorwitz, Sc.D., Assistant Director for Research and Analysis, Office of Health and Medical Affairs, State of Michigan, Lansing, Michigan; formerly Director, Maryland Psychiatric Registry, Maryland State Department of Mental Hygiene.

Dr. Jean La Fontaine, Reader in Social Anthropology, The London School of Economics and Political Science, London, England.

Ronald William Maris, Ph.D., Professor and Chairman, Department of Anthropology and Sociology, University of South Carolina, Columbia, South Carolina.

Mary A. Monk, Ph.D., Professor of Community and Preventive Medicine, New York Medical College, New York, New York.

Seymour Perlin, M.D., Clinical Professor of Psychiatry, George Washington University School of Medicine, and Senior Research Scholar, Center for Bioethics, The Joseph and Rose Kennedy Institute, Washington, D.C.; formerly Professor of Psychiatry, Director, Suicidology Program, School of Medicine, The Johns Hopkins University.

George Rosen, M.D., Ph.D., M.P.H., Professor of the History of Medicine, and Epidemiology and Public Health, School of Medicine, Yale University, New Haven, Connecticut.

Peter Sainsbury, M.D., Director of Research, Medical Research Council, Clinical Psychiatry Unit, Graylingwell Hospital, Chichester, England.

Chester W. Schmidt, Jr., M.D., Chief, Department of Psychiatry, Baltimore City Hospital, Baltimore, Maryland.

Solomon H. Snyder, M.D., Professor of Pharmacology and Psychiatry, School of Medicine, The Johns Hopkins University, Balitimore, Maryland.

George J. Vlasak, Ph.D., Assistant Professor, Department of Behavioral Sciences, School of Hygiene and Public Health, The Johns Hopkins University, Baltimore, Maryland.

CONTENTS

PREFACE

In 1967, funded by a grant from the Center for Studies of Suicide Prevention, National Institute of Mental Health, the first formal postgraduate Fellowship Program in Suicidology was offered by the Department of Psychiatry and Behavioral Sciences at The Johns Hopkins University School of Medicine. The program emphasized three teaching areas: the "data" of suicide; crisis theory and intervention; community psychiatry and related mental health sciences. However, the faculty felt the lack of a suitable background source for the understanding of suicidal behavior and it was this feeling that led, after some delay, to the present *Handbook*. Our plan was to survey certain disciplines relevant to the study of suicide and present their contributions in succinct form, recognizing the complementarity of works from other disciplines which can provide still broader combinations of understanding.

The *Handbook* emphasizes our fundamental concerns in the historical context. George Rosen captures this approach in his introductory chapter:

History provides perspective. . . . An historical approach makes it possible to see suicide in different temporal contexts, and to try to understand the meaning it has for people of varying backgrounds and experiences. . . . The relation of changing social conditions, value systems and ideologies to the occurrence of suicide . . . may possibly establish the circumstances under which social groups accept or reject human self-destruction.

The disciplines represented in this volume are history, literature, philosophy, anthropology, sociology, biology, epidemiology, and psychiatry. A complete review of the literature in each field has not been attempted; rather, critical notions are examined and case examples are provided which demonstrate the limitations as well as the potential of any single avenue of study.

ACKNOWLEDGMENTS

Preparation for a Fellowship Program in Suicidology from which this *Handbook* evolved, was actively inspired by Dr. Edwin Shneidman, former Chief of the Center for studies of Suicide Prevention at the National Institute Of Mental Health. His personal and professional support to myself and other students of suicidal behavior is noteworthy. The grant awarded by his Center was effectively coadministered by Dr. Chester W. Schmidt, Jr. whose early collaboration in the preparation for this volume was essential to its fruition. My thanks too are extended to the Fellows who encouraged this work and to the participating Faculty at The Johns Hopkins University Schools of Medicine and Public Health and Hygiene. Dr. Paul Lemkau was especially generous in providing advice and resources.

I am grateful to the contributors whose kind permission for revision of cherished products made possible a more cohesive approach. My hope is that much of the deleted data plus those chapters which had to give way to space limitations will find their way into the literature of suicide.

I am especially thankful to my wife Ruth who aided significantly in the assembly of this book.

Jeffrey W. House, the Oxford University Press Editor, was unstinting in his advice, corrections, and support. The completion of this *Handbook* reflects his persistence.

Two respites from everyday surroundings permitted major progress. My thanks are extended to Dr. Willard Dalrymple who provided accommodations at Princeton University during a Visiting Fellowship in the Fall of 1973, and to Dr. Michael Gelder, Chairman, Department of Psychiatry, University of Oxford, who offered me the special quietude of Ivory Tower-4 at Warneford Hospital in the summer of 1974. Finally, award of the Joseph P. Kennedy Jr. Fellowship in Medicine, Law and Ethics contributed substantively to the conditions necessary for the completion of this book.

A HANDBOOK FOR THE STUDY OF SUICIDE

GEORGE ROSEN

1 HISTORY

Introduction

As a form of human behavior, suicide is probably as ancient as man himself. Suicide has been practiced for thousands of years in primitive and historic societies, but the ubiquity of the phenomenon has been associated with a wide diversity of attitude and feeling in the judgment of suicidal behavior. Societal responses to the act of self-destruction can be viewed as a spectrum ranging from outright condemnation on the one hand through mild disapproval to acceptance and incorporation into the sociocultural system on the other. But, just as societies vary in their reactions to suicide, so attitudes within a society have changed in the course of time.

History provides perspective for present views of suicide. An historical approach makes it possible to see suicide in different temporal contexts, and to try to understand the meaning it has for people of varying backgrounds and experiences. Moreover, by examining suicide not simply as a medical or psychological phenomenon, but rather as an element in a process of social change over time, it is possible to study it in relation to various facets of a population or a society. Why suicide has become a problem, or altered its nature as a problem at different periods and in various societies, will be examined. At the same time the relation of changing social conditions, value systems, institutions, and ideologies to the occurrence of suicide may suggest ways of looking at our present

This essay first appeared as "History in the Study of Suicide," copyright © 1971 by Oxford University Press, Inc., in *Psychological Medicine: A Journal for Research in Psychiatry and the Allied Sciences,* Vol. 1, No. 4, Aug. 1971.

problem and possibly may establish the circumstances under which social groups accept or reject human self-destruction.

Since it is manifestly impossible to offer an exhaustive study along those lines within the limits of this presentation, I have chosen to deal more or less chronologically with selected societies and periods. On this basis, it will be possible to delineate various views of suicide and to show under what circumstances mental disorder and suicidal behavior have been linked.

Suicide among the Jews of antiquity

Biblical suicides are rare. There are only five instances reported in the Hebrew Bible and one in the New Testament. The suicide of Saul, first king of Israel, occurred in battle. When the Philistines and the Israelites clashed on Mount Gilboa, Saul fought bravely as long as he could and killed himself by falling on his sword only after three of his sons had been killed and he had been severely wounded. When Saul's armor bearer saw that the king was dead, he too fell upon his sword and died with him. Saul took his life so as not to fall into the hands of his foes, who would mock and torture him. His armor bearer died out of loyalty to his sovereign and leader.

Self-destruction to escape the consequences of political or military defeat is likewise exemplified by Ahitophel, who supported Absalom in his revolt against David, and by Zimri who usurped the throne of Israel in 876 B.C. When Ahitophel realized that Absalom would be defeated "he saddled his ass, and went off home to his own city. And he set his house in order and hanged himself." Zimri's awareness of the hopelessness of his situation, following the capture of the city of Tirzah in which he was beseiged, led him to seek death. "He went into the citadel of the king's house and burned the king's house over him with fire, and died."[1]

Samson's destruction of the Philistines in the temple of Dagon was an act of vengeance, but it was also suicidal. Recognizing that his desire for revenge could be achieved only at the cost of his life, Samson prayed, "Let me die with the Philistines," and his wish was granted.[2]

Neither the Hebrew Bible nor the New Testament prohibits suicide, nor is suicidal behavior condemned. Indeed, there is no specific word for suicide. Each instance is reported factually and generally briefly. Even of Judas Iscariot we are told simply that "he went and hanged himself."[3]

However, Josephus writing in the first century of the Christian era seems to indicate two currents of thought about suicide. Finding the situation hopeless after the defeat of his army by the Romans, Josephus decided to surrender to Vespasian, but the Jews who were with him insisted that it would be more honorable for all of them to die in a mass suicide. Arguing against this demand, Josephus reminded them that "for those who have laid mad hands upon themselves, the darker regions of the netherworld receive their souls, and God, their father, visits upon their posterity the outrageous acts of the parents. That is why this crime, so hateful to God, is punished also by the sagest of legislators. With us it is ordained that the body of a suicide should be exposed unburied until sunset. . . ."[4] Nevertheless, Josephus agreed with his compatriots on the obligation to uphold and to defend the Torah, "to sanctify the Holy Name," under all circumstances, and in this cause even suicide was justified.[5] This profound religious conviction combined with an equally strong sense of freedom led the 960 surviving defenders of Masada, after three years of siege, to kill themselves rather than surrender to the Romans. That such behavior could be carried to excess and might even endanger the community led Jewish religious leaders after the fall of Jerusalem in 70 A.D. to define more closely when self-destruction was a necessity. Their object was to discourage fanatical voluntary martyrdom, but religious suicide as such was accepted.

Suicide among Greeks, Romans, and neighboring peoples

Attitudes toward suicide among the Greeks and Romans also varied widely in the course of time. Suicide to maintain one's honor was approved. Charondas, the legendary law-giver of Catana, a Greek colony in Sicily, had made a law that no armed man should enter the town assembly upon pain of death. When he inadvertently entered without removing his dagger, his enemies accused him of annulling the law. Thereupon, to vindicate his position, he drew the dagger and slew himself.

Honor suicides to avoid capture, humiliation, and death are frequent in the conflicts among the Greeks, the Romans, and their neighbors. With the capture of Athens by Antipater in 322 B.C., Demosthenes, the opponent of the Macedonians, fled to Calauria, where he took poison in the temple of Poseidon to avoid falling into Macedonian hands. Hannibal the Carthaginian committed suicide by poison, probably in 183 B.C., when

Prusias, King of Bithynia, with whom he had taken refuge, was about to surrender him to his sworn enemies, the Romans. Lucan describes how in the civil war between Caesar and Pompey, the tribune Vulteius and his cohort in their attempt to cross the Adriatic were surrounded by Pompeian troops. Defending themselves with great courage, the Caesarian troops repulsed attack after attack, but finally recognized that escape was impossible. Thereupon, Vulteius called on his soldiers to die by their own hands rather than to fall alive into the enemy's hands. None survived to become prisoners of the Pompeians. As Lucan emphasized, "how simple a feat it is to escape slavery by suicide."[6]

In his account of Otho's death, Tacitus mentions that "Some soldiers slew themselves near his pyre, not because of any fault or from fear, but prompted by a desire to imitate his glorious example and moved by affection for their emperor. Afterwards many of every rank chose this form of death at Bedriacum, Placentia, and in other camps as well."[7] Such suicides out of loyalty are quite close to institutionalized and ritual suicide. Instances of this kind are described among different peoples in various historical periods. As reported by Nicolas of Damascus, a historian of the time of Augustus, the chieftain of the Sotiani, a Celtic tribe, had a body-guard of 600 picked men who were bound by a vow to live and to die with him, no matter whether the chief died in battle or of disease or in any other manner.

Another form of institutional suicide is the practice whereby a widow or a concubine offers her life when the husband or master dies. Herodotus describes this custom among the Thracians, who practiced polygamy. When a man died, his wives vied for the honor of being judged the one he had loved most. The wife who was accorded this honor was slain over the grave and buried with her husband. Similar is the account of a Rus funeral by Ibn Fadlan, an Arab, who during 921-22 served as secretary of an embassy from the Caliph of Bagdad to the Bulgars of the middle Volga. The Rus were Scandinavian, chiefly Swedish, traders and soldiers in Russia. When one of their chiefs died, his women slaves were asked who would die with him. The one who answered "I" went through a series of rituals and after ten days was killed and cremated together with her master. Analogous to these two cases is the Hindu custom of *suttee* in which the widow immolated herself with the corpse of her husband. Indeed, according to Strabo, *suttee* was already being practiced when Alexander the Great came to India.

Greco-Roman antiquity also knew of suicides by immolation. Theatricality is evident in the fiery death of Peregrinus Proteus, a Cynic philosopher, at the Olympic Festival in 165 A.D. The Greek satirist Lucian witnessed this happening and wrote an essay "The Death of Peregrinus," which provides most of our information about him. Born of wealthy parents at Parium on the Hellespont, Peregrinus got into trouble as a young man because of disreputable love affairs. Having fallen out with his father, he left home under suspicion of having strangled him in order to get his hands on the family fortune. Whatever the truth of the matter, Peregrinus spent the remainder of his life in restless wandering, endeavoring to assauge his guilt feelings through various religious and philosophical faiths. In Palestine he became a Christian, and when jailed refused to renounce his faith, but the governor of the province decided not to make a martyr of Peregrinus and released him. Thereafter he returned to Parium where he met the accusation of patricide by donating his property to the town for charitable purposes. But he was soon at loggerheads with the authorities and, failing to obtain a return of his estates, went to Egypt where he adopted the Cynic philosophy and way of life. Mortification of the flesh through flagellation, poverty, and other practices did not satisfy Peregrinus, and he then appeared in Rome, from where he was expelled for publicly criticizing and insulting the Emperor Antoninus Pius. Moving on to Greece, Peregrinus repeated the pattern. In Athens he baited and insulted the philanthropist Herodes Athicus, and incited anti-Roman riots in several cities. Finally, in 165 A.D. he ended his life before a large crowd by cremating himself ritually on a pyre in the Indian manner. Having instructed his disciples to establish a cult in his honor after his death, this was done at Parium, his native town. A statue set up in his honor worked miracles and attracted pilgrims.

Lucian depicts Peregrinus as an exhibitionist, a man with an insatiable craving for notoriety. There is some truth in this view, just as the behavior of Peregrinus is in accord with that of other exponents of Cynicism. Rudeness, indifference to conventional standards, voluntary poverty, ascetic practices are all traditional Cynic traits. Nevertheless, these elements do not fully explain this bizarre life. Aulus Gellius, who met Peregrinus in Athens, described him as a man of dignity and fortitude who said many helpful and noble things.[8] Indeed, some two hundred years after his death, Ammianus Marcellinus still referred to him as a celebrated philosopher. Perhaps his last words provide a clue to his per-

sonality and behavior. Just before jumping into the fire, he exclaimed: "Gods of my mother, gods of my father, receive me with favor."[9] Suggestive also is the theme of a sermon preached by Peregrinus at Athens. The burden of his discourse was that those who sin in the hope of remaining undetected labor under self-deception, since wrongdoing cannot be permanently concealed. Therefore, one should always remember the lines of Sophocles, "See to it lest you try aught to conceal;/ Time sees and hears all, and will all reveal."[10] This evidence, though fragmentary, suggests that Peregrinus was "a sick soul" of the type described by William James. An intense hostility to authority as well as an equally strong tendency to punish himself suggest that Peregrinus bore within him an emotional wound that never healed, an unresolved conflict which was finally resolved by suicide, by an act of self-destruction which ensured his justification through cult apotheosis.

Psychopathology, philosophy, and suicide

The time of Peregrinus was a period of sick souls, when many were filled with contempt for the human condition, felt themselves to be aliens in this world, and asked the question, "What are we here for?" In numerous individuals this resentment against the world was intimately associated with hostility toward the self, what Seneca called *displicentia sui,* self-dissatisfaction. This hostility might take various forms, even self-mutilation or suicide, especially among individuals with mental and emotional disorders in certain sociocultural contexts. Seneca (*c.* 5 B.C.-65 A.D.) in his *Epistles* refers to a desire which possessed many, a longing for death (*affectus qui multos occupavit, libido moriendi*).[11] Epictetus (*c.* 50-120 A.D.) noted such a death wish among young men and felt obliged to restrain it, urging them not to commit suicide.[12]

Fascination with voluntary death can also be seen in the apologia for Christianity of Tertullian (*c.* 160-224 A.D.). Indeed, voluntary martyrdom was frequent among the early Christians. As a youth, Origen of Alexandria (*c.* 185-253/54 A.D.) exterienced the martyrdom of his father in 202 and was possessed by a passionate desire to suffer the same fate. Although his mother prevented him from achieving this aim, his fundamental attitude did not change. Perhaps his self-castration to become a eunuch for the kingdom of heaven may be interpreted as a symbolic surrogate for voluntary death. A similar attitude is revealed in the

passion of Vibia Perpetua, a young married woman, twenty-two years of age, who was executed in the reign of Septimius Severus. Despite the appeals of her father, who was not a Christian, and the fact that she had an infant at the breast, she preferred to die in the arena and to experience bliss in the next world. Eusebius (c. 260-339/40 A.D.), bishop of Caesarea, tells of Christians about to be tortured who committed suicide, "regarding death as a prize snatched from the wickedness of evil men."[13] The pathological element in the craving for martyrdom appears most evident in the wild language and the state of exaltation bordering on mania displayed by Ignatius of Antioch in his letters, particularly in that to the Christian community of Rome. "I beseech you . . . ," he wrote, "Suffer me to be eaten by the beasts that I may be found pure bread of Christ. Rather entice the wild beasts that they may become my tomb, and leave no trace of my body, than when I fall asleep I be not burdensome to any. Then shall I be truly a disciple of Jesus Christ, when the world shall not even see my body. Beseech Christ on my behalf, that I may be found a sacrifice through these instruments."[14]

Apparently for some persons Christianity was attractive because among other benefits it offered a chance of martyrdom and a possible opportunity to die as a blood-witness to Christ. Small wonder that with such a prospect there should have been an excessive eagerness to attain this aim by a premature voluntary death. Generally, Christians despised the tendency toward suicide among pagans, but was martyrdom suicide? Yet this type of sensibility and its associated emotional climate characterized large groups in the Roman Empire between the reigns of Nero and Julian (i.e., 54-363 A.D.).[15]

What many troubled people looked for was a meaning in life, a raison d'être for a disciplined life. A religion such as Christianity, or that of Asclepius, was the solution for some; for others there were moral philosophies that offered a life with a scheme. There was the Cynic doctrine espousing a life of detachment and freedom, teaching men that conventional standards were worthless and urging them to cut themselves loose from the bonds of social life. The wandering Cynic philosopher garbed in his ragged cloak, begging his bread, haranguing and lecturing those who would listen to him in the street or the marketplace, behaving rudely and even obscenely in defiance of social convention was a familiar figure in the later Empire. Epicureanism imbued its ideal of the calm life with a strong driving quality of joy because its adherents felt themselves de-

livered from supernatural terrors and fears of capricious divine action. Stoicism with its doctrine of natural law and man's conformity to it, the value of actively doing good and taming the passions, and more generally of the need to recognize and to accept a world order, provided a way of life for others.

Indeed, the philosopher was considered a man able to relieve humanity of numerous failings by teaching, exhorting, and reproaching. Thus Epictetus compares the philosopher's lecture hall to a physician's office or a hospital.[16] Though Epictetus did not propose self-destruction as a mode of therapy, indeed he opposed it, some of these philosophies, particularly Stoicism, accepted and even recommended suicide, but only under certain conditions, as an escape from evil. According to Diogenes Laertius, writing of Zeno, the founder of Stoicism, "the wise man will for reasonable cause make his own exit (*exagōgē*) from life on his country's behalf, or for the sake of his friends, or if he suffer intolerable pain, mutilation, or incurable disease."[17] Similarly, Marcus Aurelius approved of suicide if carried out on a rational basis, but not to put on a show or to simply express irrational ideas. As he expressed his position: "How admirable is the soul which is ready and resolved, if it must this moment be released from the body, to be either extinguished or scattered or to persist. This resolve too must arise from a specific decision, not out of sheer opposition like the Christians, but after reflection and with dignity, and so as to convince others, without histrionic display."[18]

Nevertheless, the Stoics did have what amounted to a cult of suicide, based in part no doubt on a tradition apparently set by their founder and his first disciples. Zeno (331-261 B.C.) is reported to have tripped, fallen, and broken his toe. Thereupon he struck the ground with his fist, feeling that he was being called home, and died on the spot by holding his breath. Cleanthes (331-232 B.C.) is said to have committed suicide by starving himself to death. To a lesser degree this was also true of the Cynics, for the latter also had a tradition going back to Diogenes. His pupil Menippus accumulated a large fortune, but when he was robbed of his wealth, hanged himself in despair.

Epicurus and the Epicureans opposed suicide, as did the Neoplatonists of the late Empire. In general, however, suicide was tolerated, even extolled, in the Imperial period until it became almost a social disease. This situation did not change until Christian views began to influence social and legal attitudes.

The earliest measures against suicide among the Greeks and the Romans were based on religious or on political-ethical grounds. At Athens, for example, it was customary to chop off the hand of a suicide; if possible that with which he had taken his life. In Rome a suicide by hanging was refused an honorable burial according to pontifical law by the Pontifex Maximus. This practice was continued into the Imperial period, and was a vestige of earlier religious views. Suicide per se was never a penal offense in Rome, and eventually there were, practically speaking, no penalties. Suicide was punishable in Italy only for three classes of persons: criminals, soldiers, and slaves. In these cases it is clear that deterrent sanctions were motivated by practical and economic causes.

Cases of suicide by mentally disordered persons were well known in antiquity. The self-destruction of Cleomenes, king of Sparta (end of the sixth century B.C.), is described at length by Herodotus. One may also note the comments in the fragmentary Hippocratic work *Peri parthenion* (On the diseases of maidens) regarding the mental symptoms including suicidal tendencies to which young girls are prone if they have menstrual troubles. These symptoms, particularly the suicidal behavior, have been interpreted as an example of psychopathic collective behavior. In this connection one may note the story of the maidens of Miletus who suddenly, without any apparent reason, conceived a desire to die and thereupon many hanged themselves. To deal with the situation, the Milesians passed a law that all maidens who hanged themselves should be carried to the grave naked along with the rope with which they had destroyed themselves. Deterred by the shame of a disgraceful burial, the young women stopped seeking a voluntary death and the epidemic ceased.

Caelius Aurelianus observes that victims of madness have often killed themselves by jumping out of windows. Aretaeus observed that violent madmen injure or kill themselves, and sometimes their keepers. Finally, one may note the statement by Paul of Aegina that insane patients who are violent should be secured so that they may not injure themselves or those who approach them. By and large physicians in the Roman Empire dealt with psychopathology by limiting themselves to what were defined as medical problems. As Caelius Aurelianus put it, they were concerned with madness characterized by "an impairment of reason resulting from bodily disease or indisposition."[19] It is likely that some suicides or attempted suicides were the result of pathological depressions, for example, the cases of Parmeniscus in the Hippocratic *Epidemics,* VII, 89, or that

of Hadrian after the death of Aelius Verus, but prevalent social attitudes and the emotional climate led to the definition and consideration of such cases as moral rather than medical problems.

Suicide and society in the Middle Ages

Antagonism to suicide and its eventual condemnation in the Roman Empire had several sources. One was economic. The Christian Church continued Roman legislation against suicide by slaves. At the Council of Arles in 452 A.D. measures were passed directed against suicides by servants (*famuli*). Furthermore, as Christianity spread, it found itself opposing other religions and philosophies that tolerated and even recommended suicide. Among these were Manichaeism whose adherents freely resorted to voluntary death. As a result the Church declared suicide tantamount to murder. This position was strengthened by the increasingly important position of Christianity, first as a tolerated faith and then as the state religion. Under these circumstances, voluntary martyrdom was discouraged by Church leaders, and opposition to suicide hardened. However, it was not actually until the Council of Braga in 563 that suicide as an act was condemned by the Church. This position was confirmed by the Councils of Auxerre (578) and Antisidor (590) and remained the canon law until 1284 when the Synod of Nîmes refused burial in consecrated ground to suicides.

An exception seems to have been made of the insane, if one is to judge from the *Penitentials* of Egbert, archibishop of York, which appeared in the middle of the eighth century.[20] Indeed, throughout the medieval period there is a continuing recognition that mental and emotional disorder may lead to suicide. Such states and their consequences are frequently related to the concepts of melancholy or *acedia,* spiritual sloth. David of Augsburg, a Franciscan, who lived about the middle of the thirteenth century, distinguished three types of *acedia,* of which the first is relevant here.

The first [he said] is a certain bitterness of the mind which cannot be pleased by anything cheerful or wholesome. It feeds upon disgust and loathes human intercourse. This is what the Apostle calls the sorrow of the world that worketh death. It inclines to despair, diffidence, and suspicions, and sometimes drives its victim to suicide when he is oppressed by unreasonable grief. Such sorrow arises sometimes from previous impatience, sometimes from the fact that

one's desire for some object has been delayed or frustrated, and sometimes from the abundance of melancholic humors, in which case it behooves the physician rather than the priest to prescribe a remedy.[21]

Caesarius of Heisterbach (c. 1180-1240/50?) provides a number of stories that illustrate the temptation to end one's life as a result of melancholy and *acedia*.[22] In one case a nun was "so driven mad by the magic arts of a miserable brother" that she threw herself into a well. Another instance involved a nun of advanced years who was so troubled by melancholy leading to religious doubts that she despaired and jumped into the Moselle River. However, she was saved and taken back to the cloister where she was closely guarded to prevent any further attempts. Still other accounts involve a young girl who had borne an illegitimate child, and being abandoned by her lover, despaired and hanged herself, and a young man who, having gambled away his clothes, fell into melancholy and despair, went home, and hanged himself.

The two views of melancholy as a vice leading to the sin of suicide, frequently at the promptings of the devil, or as a mental and emotional disorder due to a humoral excess and imbalance explain in large part the varying social attitudes and practices with respect to suicide during the Middle Ages. Custom based on folk beliefs, ecclesiastical views, and medical theories preceded legal authority in dealing with suicide as a crime. Henry de Bracton, the legal authority of his time in England, writing in the middle of the thirteenth century, did not consider suicide a felony, which it became by the middle of the following century. Indeed, discussing suicide by the insane, he exempted such acts from any criminal considerations.[23]

On the other hand, according to Bracton an ordinary suicide forfeited his goods, while one who killed himself to avoid a felony conviction forfeited both goods and land. This law of fortfeiture remained in force in England into the nineteenth century but was not infrequently circumvented through the claim of insanity. On the continent, the *Sachsenspiegel* dating from the beginning of the thirteenth century, the *Schwabenspiegel* from the end of the thirteenth century, and the Freising municipal law code did not punish suicide. The *Carolina,* the Criminal Constitution of Charles V, in 1551 confiscated the property of those who committed suicide while under accusation of a felony.

More severe was the punishment visited on the corpse of the suicide. The cadaver was subjected to various indignities and degradations. A

common practice in England was to bury the suicide at a crossroad by night with a stake driven through the heart. Indeed, as late as 1811 a suicide was buried in this manner at the corner of Commercial Road and Cannon Street Road in East London, and the practice was not actually stopped until 1823. This custom had a religious and magical background of great antiquity. As reported by Tacitus and confirmed by numerous bog burials, the practice of pinning down the body antedates Christianity among the Germanic peoples of Europe. It was intended to make certain that the spirit of the dead would not return to haunt or harm the living.[24]

Official, legal, and ecclesiastical attitudes toward suicide remained conservative until well into the eighteenth century; suicide was equated with murder in various parts of Europe, and the corpse was treated accordingly. In France and England the body was dragged through the streets, head downward on a hurdle, and then hanged on a gallows. The French Criminal Ordinance of August 1670 still required that the body of a suicide be dragged through the streets and then thrown into a sewer or onto the town dump. Despite the law, however, cases were often overlooked and penalties were not applied. In Toulouse, for example, the punishment of dragging the corpse was imposed in 1742 and again in 1768, but it is worth noting that the suicides occurred in jail and that the victims were either convicted of or indicted for a criminal offense. Indeed, because of spectator reaction against the practice the penalty was not imposed after 1768. Burial in consecrated ground was frequently denied the suicide, and in Prussia the law stipulated in the early eighteenth century that a suicide be buried under the gallows.

The three penalties—confiscation of property, degradation of the corpse, and refusal of burial in consecrated ground—reflect prevailing attitudes toward suicide from the Middle Ages through the eighteenth century. The degree to which these penalties were applied varied from time to time and place to place. In general the penalties against the body of a suicide tended to lapse by the latter part of the seventeenth century, and even the sanction of confiscation was handled more leniently. Important factors in such cases were the social rank of the suicide and his family, as well as the circumstances of the suicidal act.

Some causes of suicide were considered more justified than others. Self-destruction because of protracted physical illness, mental and emotional disorder, melancholy or similar conditions did not subject the suicide to any penalties in Prussia in the early eighteenth century. On the

other hand, impoverishment, indebtedness, dishonor, despair, or vexation were not regarded as a sufficient justification of suicide. This differentiation is also evident in the case of Kate Joyce, a cousin of Samuel Pepys, whose husband in January 1668 attempted suicide by drowning, was rescued, but died soon thereafter, probably of exposure and pneumonia. Even though the coroner's jury permitted a regular burial, having arrived at a verdict of death from a fever, the widow was for a while threatened with confiscation of the estate, because it was suspected that her husband's action was occasioned by financial difficulties.

This differentiation tends to reflect new attitudes toward suicide which began to emerge tentatively during the Renaissance and finally came out into the open in the eighteenth century. Opinion in the upper, educated strata of society diverged increasingly from the medieval position of absolute condemnation. But before turning to these aspects, it is important to note that older attitudes still persisted outside the framework of Christendom. Forms of secular and religious suicide also occurred in the Middle Ages.

Although the Jewish position was basically opposed to suicide, there were extenuating and justifiable motivations for suicidal behavior, among them the prospect of torture, refusal to submit to forced apostasy, preservation of one's chastity, good of country, honor, and atonement.

New views on suicide

Orthodox medieval Christianity consigned the souls of those who wantonly destroyed their lives to an eternity of Hell whose terrors were expected to deter potential suicides. Dante found the souls of suicides encased in thorny, withered trees on which the Harpies fed, inflicting wounds from which issued cries of lamentation and pain. Nor does there seem to be a recognition of extenuating circumstances. The one suicide to whom Dante refers specifically and to whom he talked was Pier delle Vigne (1190-1249), for a long time chief counselor of Emperor Friedrich II Hohenstaufen. In 1247 he was accused of treachery by conspiring against his lord, imprisoned and blinded. In despair and to avoid further torture delle Vigne took his own life. How different is the attitude of Madame de Sévigné writing in 1671 of Vatel, the *maître d'hôtel* of the Prince de Condé, who killed himself for shame when a dinner and entertainment prepared for Louis XIV seemed to have turned out a fiasco.[25]

Vatel's story is told without horror or theological odium. Indeed, Condé comments that Vatel acted out of a sense of honor, and Mme. de Sévigné adds that he was highly praised for his courage and resolution, even though the praise was mingled somewhat with reproaches.

Clearly, from the thirteenth to the seventeenth century social attitudes to suicide had been changing. Whether or not periods of social crisis and disorganization lead to an increase in suicide may be debated. However, a belief in the increased prevalence of suicide appears to have been widespread in the sixteenth and seventeenth centuries and is reflected both in a renewed discussion of suicide and in the appearance of more favorable or at least less hostile views on suicidal behavior.

Eramus in his colloquy *Funus* (The Funeral, 1526), explaining why God meant death to be an agony, remarks that he did this "lest men far and wide commit suicide. And since, even today, we see so many do violence to themselves, what do you suppose would happen if death weren't horrible? Whenever a servant or even a young son got a thrashing, whenever a wife fell out with her husband, whenever a man lost his money, or something else occurred that upset him, off they'd rush to noose, sword, river, cliff, poison."[26] Yet, in his *In Praise of Folly* Eramus commends those who voluntarily killed themselves to get rid of a miserable and troublesome world, considering them wiser than those who are unwilling to die and want to live longer.[27]

The question of suicide also crops up in the *Essais* of Montaigne. To this subject he devoted a long chapter in which with apparent approval he presents the views of the ancients extolling voluntary death. Thus, Montaigne remarked that death is "not a remedy for one malady only, but for all ills. It is a very secure haven, never to be feared and often to be sought. It is all one whether man ends his life or endures it; whether he ends it before it has run its course or whether he waits for it to end; no matter whence the end comes it is always his own; no matter where the thread snaps, it's the end of the road." Nonetheless, despite his evident sympathy for the views of the ancients, such as Seneca, Montaigne comes to a more moderate practical position. "The opinion which disdains our life," he says, "is ridiculous. After all, this life is ours, it is all we have. . . . To hate and to despise oneself is a sickness peculiar to man and is not observed in any other creature. . . . What situations then can truly justify the act of killing oneself? . . . After all, since there are so many sudden changes in human affairs, it is difficult to judge

at what point we are really without hope. . . . I have seen a hundred
hares save themselves, even in the greyhounds' jaws. *Aliquis carnifici suo
superstes fuit.'* [Some man has outlived his executioner.]" Finally, Mon-
taigne concludes that only unsupportable pain or a worse death are ac-
ceptable justifications for suicide.[28]

The attitudes of Eramus and Montaigne are essentially those of Chris-
tian humanism, a compromise between Christianity and the tenets of clas-
sical philosophy, particularly Roman Stoicism. Furthermore, in view of
the religious and moral attitudes that clustered around the judgment of
suicide, it is not surprising that a number of those who addressed them-
selves to this problem were clergymen. John Donne, poet and later Dean
of St. Paul's, wrote *Biathanatos,* the first defense of suicide in English.
Written in 1608, it was first circulated in manuscript, and was only pub-
lished posthumously in 1644. Donne proposed to demonstrate that sui-
cide is not incompatible with the laws of God, reason, and nature. More-
over, inherent in the condition and dignity of being a man is the right to
end one's life. As Donne expressed it, "methinks I have the keys of my
prison in mine own hand, and no remedy presents itself so soone to my
heart, as mine own sword."[29]

Robert Burton's encyclopedic *Anatomy of Melancholy* (1621) is rele-
vant because the author, a minister, emphasized the relation between
melancholy and suicide and in this connection offered his views of self-
destruction. According to Burton the prognosis of melancholy is bleak,
for "after many tedious dayes at last, either by drowning, hanging or
some such fearfull end, they precipitate, or make away with them-
selves. . . ."[30]

But, if such men are in essence doomed to die by their own hands,
how is their behavior to be judged? On this point, Burton's position is
similar to that of Montaigne. First, citing a host of ancient authorities
and examples, he clearly indicates that suicide has been approved and
even recommended by many wise and eminent persons. However, in
order not to go too far out on a limb, Burton suddenly makes a volte-face
and proclaims that "these are false and Pagan positions, prophane Stoical
Paradoxes, wicked examples, it boots not what Heathen Philosophers
determine in this kind, they are impious, abominable, and upon a wrong
ground." Despite this condemnation, however, Burton was not a dog-
matic adherent of the orthodox Christian position on suicide. Eternal
damnation is not necessarily the punishment for every suicide, for there

may be mitigating circumstances, such as madness in which a person is deprived of reason and judgment.

The same problem had been discussed several years earlier by Johannes Neser, a Protestant minister at Rothenburg ob der Tauber. Having been aroused by a rash of suicides in the area, he discovered that there were a large number of persons, troubled by melancholy, doubts, and despair, who harbored thoughts of suicide and were inclined to put them into effect. To reassure and to console such individuals, Neser preached three sermons which were published in 1613.[31] Based on the 77th and 88th psalms, the first two sermons dealt with melancholy, depression, serious inner conflicts, and temptations; the third considered the problem of despair and the state of salvation of those who killed themselves as a consequence. Neser considered the publication of his sermons as a preventive measure. In the sermons, based on the teachings of Luther and other theologians, he says that those who commit suicide when sane and with premeditation are damned. On the other hand, it often happens that people lose their reason because of intense vexations, severe affections of the head, or other painful chronic sicknesses. In such a state of madness they may be driven to utter blasphemy and even to kill themselves. Such individuals are not damned, because they are mentally deranged and do not know what they do. Finally, he refers to suicides where it is not possible to establish the occurrence of mental disorder, as in cases of gout, bladder stone, and gravel, where severe, acute pain may cause temporary mental derangement. In such cases, Neser concludes, the issue of salvation must be left to God since the circumstances are unclear.[32]

Motives similar to those of Neser also impelled John Sym (1581?-1637), an English country clergyman, to combat suicide. Worried by an apparent increase in suicide, Sym decided to counteract this trend by making available his experience in counseling potential suicides. His treatise published in 1637 expresses this purpose in its title: *Lifes Preservative against Self-Killing.*[33] Discussing suicide in relation to mental and emotional disorder, he concluded that many suicides were sick in mind and could not be held responsible for their behavior. Consequently, not all suicides were in a state of damnation. However, he divides suicide into direct and indirect forms, condemning various types involving intemperance, gluttony, dueling, and foolhardiness. Of the last, Sym remarks that it is suicidal "when self-conceited wilfull fool-hardy men will fight against their enemies, upon desperate disadvantages; and imminent peril of

death." His real interest, however, is in the prevention of suicide, and he describes premonitory and diagnostic signs: unusual solitariness; neglect of the necessary duties of a man's calling; change in manifest behavior, including "gastly lookes, wilde frights and flaights, nestling and restlesse behaviour, a mindelessness and close dumpishnesse, both in company and in good imployments; a distracted countenance and carriage; speaking and talking to, and with themselves, in their solitary places and dumps; reasoning and resolving with themselves about that fact, and their motives to it, in a perplexed disturbed manner, with the like"; and speeches and actions threatening or predicting some action referable to suicide.[34] These signs indicated the need for preventive action, and Sym prescribes specific practical measures to be taken by those who are melancholy, depressed, and the like. Such individuals should avoid solitude, darkness, going over bridges or near the edge of steep places, and should be careful in using weapons such as knives.

Views of suicide as arising from mental disorder were reinforced by the publication of case histories. Hugh Ryder (fl. 1664-93), surgeon to James II, tells of "A Young Woman who had been at a Meetinghouse . . . in a great discontent went home, and fell into such despair, that being melancholy by herself in her chamber, with a Knife cut her Throat. . . ." The wound was not mortal and under Ryder's care she recovered. Another case is that of George Trosse (1631-1713), a clergyman, who had a psychotic breakdown in the mid seventeenth century. His autobiography published after his death contains a vivid account of his experiences. Among his symptoms were suicidal impulses.[35]

From sin to environment

The notion which became widespread in the eighteenth century that England was a land of melancholy and suicide had its roots in the preceding century.[36] Natives and foreigners generally accepted the allegation that gloominess was a characteristic of the inhabitants of the British Isles, particularly the English. This melancholy was more than just a mood; it was a disease, a malady of mind and body which directly affected the imagination and was liable to end in self-destruction. This condition, also known as the spleen or the English malady, was linked etiologically with the physical and social environment.

Notions of environmental influence can be traced back to antiquity

with roots in medicine and geography, both evident in the Hippocratic corpus, specifically in *Airs, Waters, Places*.[37] Transmitted through the Middle Ages in various ways, such ideas began to assume an increasing significance in many fields of thought and practice during the sixteenth and seventeenth centuries. Focusing on questions of national character and cultural differences within this context, a number of writers discussed the causal role of environmental factors, such as air, diet, temperature, in social and medical problems. These discussions became increasingly frequent in the eighteenth century.

The utility of such ideas in opposing sanctions against suicide and in urging a less prejudiced, more tolerant view of such acts is nowhere better expressed than in the writings of Montesquieu. One of his *Lettres Persanes* (1721), written by Usbek from Paris to his friend Ibben in Smyrna, ridicules the barbarous and unjust European laws on suicide and defends its practice. "Life has been given to me as a gift," he says. "I can therefore return it when this is no longer the case. . . ." "When I am overwhelmed by pain, poverty and scorn, why does one want to prevent me from putting an end to my troubles, and to deprive me cruelly of a remedy which is in my hands?"[38]

Moreover, influenced by earlier and contemporary authors, among them Hippocrates, Bodin, and Arbuthnot, Montesquieu used the theory of climatic influence in combination with cultural factors to explain the occurrence of suicide among different peoples. Contrasting suicide among the English and the Romans, Montesquieu in the *Esprit des lois* (1748) asserted that the former kill themselves without any ostensible reason, seemingly in the very midst of happiness, while for the latter suicide was a consequence of education, closely related to their customs and way of thinking. In fact, suicide among the English is the result of a malady arising ultimately from the effects of the local climate on the body and mind, and therefore should not be punishable, just as the consequences of madness are not punished.[39] Montesquieu's views reflect the trends of opinion about suicide that had been developing up to his time, and presage the directions that societal concern with suicide would take in the eighteenth and nineteenth centuries, indeed up to the present.

First was the opposition to the traditional Christian attitude to suicide as sinful and morally obnoxious. The leaders of the Enlightenment—Voltaire, d'Holbach, Rousseau, Hume, Beccaria—and their allies condemned the conventional harsh treatment of suicides and assaulted the Christian

interpretation through the exercise of empirical observation and critical reason, thus laying the foundation for a secular approach to the problem of suicide.[40]

Second was the preoccupation of writers on suicide with national character in relation to self-destruction, especially the alleged English propensity for such acts, and the claim that suicide was on the increase. Those who pursued this line of interest tended to focus on environmental factors. Illustrative are the comments of George Cheyne, the English physician, on the circumstances that led to the appearance of his work *The English Malady* in 1733. He would have had this work published posthumously had he not been urged by his friends because of "the late frequency and daily encrease of wanton and uncommon self-murderers, produced mostly by this distemper . . . to try what a little more just and solid philosophy, join'd to a method of cure, and proper medicines could do, to put a stop to so universal a lunacy and madness."[41]

Related to this trend and overlapping with it was the view of suicide as a consequence of mental and emotional disorder. This *third* tendency to consider self-destruction as a medical problem is already evident in Cheyne's book and becomes increasingly prominent in the nineteenth century. As part of this approach, efforts were made to differentiate conditions leading to suicide from other disorders, to give more attention to the problems of the individual patient, and to collect and use statistics for research on suicide. Indicative of such attitudes are the comments of William Battie in *A Treatise on Madness* (1758):

Whatever may be the cause of Anxiety, it chiefly discovers itself by that agonising impatience observable in some men of black November days, of easterly winds, of heat, cold, damps, etc. Which real misery of theirs is sometimes derided by duller mortals as a whimsical affectation. And of the same nature are the perpetual tempests of love, hatred, and other turbulent passions provoked by nothing or at most by very trifles. In which state of habitual diseases many drag on their wretched lives; whilst others, unequal to evils of which they see no remedy but death, rashly resolve to end them at any rate. Which very frequent cases of suicide though generally ascribed to lunacy by the verdict of a good-natured jury, except where the deceased hath not left assets, are no more entitled to the benefit of passing for pardonable acts of madness than he who deliberately has killed the man he hated deserves to be acquitted as not knowing what he did.[42]

Suicide was regarded as so widely prevalent in England by the middle of the eighteenth century that many *believed* the problem constituted a

national emergency. Whatever the case may have been, there is no doubt that by the early nineteenth century suicide was being considered less in moral and theological terms and increasingly as a social and medical problem. Indeed, by the beginning of the twentieth century, even though disapproving of suicide, popular opinion had generally come to view such acts as deviations from normality. This attitude is well presented by an episode in Joyce's *Ulysses*. On the way to a funeral, four men talk about attempted suicide and death.

> "But the worst of all," Mr. Power said, "is the man who takes his own life."
> Martin Cunningham drew out his watch briskly, coughed and put it back.
> "The greatest disgrace to have in the family," Mr. Power added.
> "Temporary insanity, of course," Martin Cunningham said decisively.
> "We must take a charitable view of it."
> "They say a man who does it is a coward," Mr. Dedalus said.
> "It is not for us to judge," Martin Cunningham said.[43]

By the twentieth century, in the conventional wisdom of the middle class, suicide was more significant socially as a disgrace rather than as a sin, and could conventionally be glossed over by attributing it to mental aberration. As Byron indicates, this had originally been an upper-class position and prerogative. In the preface to Cantos VI–VIII of *Don Juan,* commenting on the suicide of Viscount Castlereagh, he says: "Of the manner of his death little need be said, except that if a poor radical, such as Waddington or Watson, had cut his throat, he would have been buried in a cross-road, with the usual appurtenances of the stake and mallet. But the minister was an elegant lunatic—a sentimental suicide—he merely cut the 'carotid artery,' (blessing on their learning!) and lo! the pageant, and the Abbey! and 'the syllables of dolour yelled forth' by the newspapers. . . ." Thus, in the course of the nineteenth century, the label of madness became a socially acceptable means of avoiding the implications and consequences of suicide, even though insanity itself had unpleasant associations.

Reinforcing this view was the circumstance that during this period suicide emerged as a subject for medical and social investigation. The question "Is suicide on the increase?" which had already been raised in the eighteenth century became even more prominent as reliable data on suicide began to be collected in the nineteenth century. This question was considered important because this was also the period of the early In-

dustrial Revolution with its attendant evidences of social maladjust-
ment. The alleged increase in the incidence of suicide was viewed as
another aspect of this situation. Moreover, by linking suicide with mental
disorder, the problem was brought into the larger discussion of the rela-
tion between civilization and madness, and the role of social stresses in
the causation of such conditions. Physicians, social reformers, statisti-
cians endeavored to uncover the causes of the alleged rising tide of self-
destruction. The majority of the more important studies appeared in
France. This is not surprising in view of French leadership in public
health and social theory during the first half of the nineteenth century.[44]

Suicide was investigated as a social problem together with poverty,
crime, alcoholism, illegitimacy, and disease, within the context chiefly of
the urban community. Based on available mortality tables, Lachaise in
1822 studied the question of suicide in Paris.[45] Concerning the statistical
data, he pointed out that the reported cases probably understated the ac-
tual dimensions of the problem: first, because relatives in some cases try
to avoid a family disgrace by having the death attributed to some other
cause such as insanity; second, because reported suicides take no account
of a large number of attempted suicides that fail for one or another rea-
son. Furthermore, Lachaise claimed that suicide was more frequent in
the laboring class (*la classe des prolétaires*) for the most part because of
poverty.

The claims that suicide was an urban phenomenon, occurring in large
cities, especially Paris, and that suicide was related to poverty and for
this reason occurred more frequently among the laboring poor, were re-
peated by numerous writers on the subject particularly in the 1840's and
50's. These investigations cannot be examined in detail, but certain as-
pects must be mentioned. On the whole they are characterized by an in-
creasing use of statistical information, an endeavor to study suicide as a
social phenomenon, and a trend to link these aspects wherever possible
with data derived from pathological anatomy and clinical observation.
Although these developments were most prominent in France in the first
half of the nineteenth century, a more or less similar pattern can be dis-
cerned in Great Britain, the German language area of central Europe,
and the United States.

Within this general framework, two major approaches to an under-
standing of suicide developed, which may be designated as statistical-
sociological and medico-psychiatric. The former was rooted in the en-

vironmental ideas of the eighteenth century. However, as numerical data and statistical analysis became more readily available from the 1820's onward, those concerned with suicide began to employ them vigorously. Efforts were made to relate the kinds, occurrence, and distribution of suicide to such factors as climate, urban-rural residence, age, sex, marital status, socioeconomic class, occupation, intemperance, and disease. Certain defects were common to all these investigations; the population samples with which they dealt were too small or not representative, and often the populations at risk were not known or not indicated. Investigators were not unaware of these problems. J. L. Casper (1796-1864), a Prussian physician, who in 1825 was the first to use statistics as the principal means for research on suicide, was aware of the inadequacies of the data available to him. Emphasizing the need to use a variety of sources (police records, mortality tabulations, public announcements), he also pointed out his inclusion in the study of attempted suicides to the extent that they could be determined.[46]

As such studies accumulated, it became apparent that certain factors were of minor significance, if not completely irrelevant. Indeed, it was realized that the suicidal act resulted from the interaction of a number of causal factors, operating directly or indirectly on an individual. J. P. Falret, who in 1822 published the first study of suicide to make use of statistical data, though only on a small scale, classified causal factors leading to suicide under four headings: (1) predisposing-heredity, temperament, climate (the last of little significance); (2) accidental direct-passions, domestic troubles and the like; (3) accidental indirect-bodily pain, illness; (4) general-civilization, civil disorders, religious fanaticism.[47]

Essentially, the problem for nineteenth-century investigators of suicide was the relevant significance to be assigned to such factors in the causation of suicide, and the ways in which they were related in their action on the individual. Some considered suicide to be a form of insanity. This view was by no means new. In 1783, Leopold Auenbrugger, known to posterity as the discoverer of percussion, published a slim volume on suicide as a disease in its own right.[48] In it he defined suicide as the consequence of an emotional disorder that brings on melancholy and eventually leads to self-destruction. He described the emotional disorder as a "quiet rage," but his views on the nature of this state were rooted in the older ideas of the passions. Somewhat over a decade later, E. G. Elvert

published the results of his autopsies on suicides in the course of which he had attempted to discover changes in the body that might have affected the mind.[49]

By the early 1800's however, the view was emerging ever more clearly that there was a definite connection between findings obtained through clinical observation and anatomical lesions observed in autopsy. The fusion of the clinical and anatomical approaches to the investigation of disease and their systematic application was the major contribution of the Paris school of clinical pathologists from 1800 to 1850. In these terms, if suicide was regarded as a form of insanity, it seemed reasonable to seek the cause in the nervous system. In 1818 the phrenologist-physician J. C. Spurzheim characterized suicide as a form of insanity produced by disease of the body, which revealed itself in chronic cases by thickening of the skull.[50] Falret (see above) considered suicide to be a special form of insanity which he called "la mélancolie—suicide," a disease in which the brain is almost always originally affected. This type of research continued into the present century.

Not all investigators of suicide, however, held such views. Esquirol (1838) maintained that suicide was almost always a symptom of insanity but that it was not a disease per se. In his opinion climate was of no significance in endeavoring to understand the pathogenesis of suicide. Nor was he at all sanguine about the possibilities of pathological anatomy shedding light on suicidal behavior. He specifically denied Spurzheim's claim. Esquirol did emphasize hereditary factors and the need to consider the individual disposition. This emphasis was strengthened by talks with individuals who had attempted suicide.[51]

More extensive studies along this line were carried out by Brierre de Boismont, probably the most important contributor to the problem of suicide in the 1850's. In his treatise *Du Suicide et de la folie suicide* . . . published in 1856, he made extensive use of statistics, but he also used information obtained by questioning 265 individuals who either had planned or attempted to commit suicide. On the basis of a detailed analysis, Brierre de Boismont denied that all suicides are due to insanity, even though a large number are caused by mental illness. Among the more important causes that he lists are insanity, alcoholism, illness, family troubles, love problems, and poverty. Other findings bring him close to a sociological explanation of suicide. Among the suicides studied, he found a higher proportion of unmarried persons, of old people, and of

men. More generally, he saw suicide as a consequence of changes in society leading to social disorganization and to alienation for many people.[52] Similar views were expressed by E. Lisle in a work also published in 1856.[53]

Brierre de Boismont, Lisle, and other investigators were pointing to the conclusion that Durkheim was to state in 1897: suicide will not be widely prevalent in a society that is well integrated politically, economically, and socially.[54]

Notes and references*

1. II Samuel 17.23; I Kings 16.18.
2. Judges 16.23-31.
3. Matthew 27.5.
4. Josephus, trans. H. St. J. Thackeray, 8 vols., Loeb Classical Library, London: William Heinemann; New York: G. P. Putnam's Sons (1926), 2: 681-83. For the possible origin of this practice, see Deuteronomy 21. 22f. for the burial at sunset of a hanged criminal.
5. Josephus, 1:383; Philo, *Legatio and Caium,* ed. and trans. E. M. Smallwood, Leiden (1961), pp. 162, 192, 215, 233, 249, 266, 329.
6. Lucan, *The Civil War,* trans. J. D. Duff, Loeb Classical Library, Cambridge, Mass.: Harvard University Press; London: William Heinemann (1951), pp. 205-17.
7. Tacitus, *Histories,* trans. C. H. Moore, Loeb Classical Library, Cambridge, Mass.: Harvard University Press; London: William Heinemann, (1952), 1:242-43.
8. Aulus Gellius, *Attic Nights,* trans. John C. Rolfe, 3 vols., Loeb Classical Library, London: William Heinemann (1927), 2:393.
9. *Ammianus Marcellinus,* trans. John C. Rolfe, 3 vols., Loeb Classical Library, Cambridge, Mass.: Harvard University Press (1935-39), 3:211.
10. *The Works of Lucian of Samosata,* trans. H. W. Fowler and F. G. Fowler, 4 vols., Oxford: Clarendon Press (1905), 4:79-95.
11. Seneca, *Epistles,* 24:25.
12. Epictetus, *The Discourses as reported by Arrian, The Manual and Fragments,* trans. W. A. Oldfather, 2 vols., Loeb Classical Library, Cambridge, Mass.: Harvard University Press (1956-59), 1:66-69.
13. Eusebius, *The Ecclesiastical History,* trans. J. E. L. Oulton, 2 vols., Loeb Classical Library, Cambridge, Mass.: Harvard University Press (1959-64), 2:10-11, 28-29, 288-89; Herbert A. Musurillo, *The Fathers of the Primitive Church,* New York: New American Library (1966), pp. 161-72.

* For more extensive bibliography, see George Rosen, "History in the Study of Suicide," *Psychological Medicine* 4:267-85 (August 1971).

14. *The Apostolic Fathers*, trans. Kirsopp Lake, 2 vols., Loeb Classical Library, Cambridge, Mass.: Harvard University Press (1965), 1:230-31; W. H. C. Frend, *Martyrdom and Persecution in the Early Church*, Garden City, New York: Anchor Books-Doubleday and Company (1967), pp. 151-53.

15. For the concepts of sensibility and emotional climate see George Rosen, "Emotion and Sensibility in Ages of Anxiety: A Comparative Historical Review," *Am. J. Psychiatry*, 124:771-84 (1967). Sensibility refers to modes of perceiving and feeling shared in varying degree by those living at a particular time. An emotional climate is a prevalent psychological orientation or pattern of emotional attitudes deriving from numerous individual sensibilities, which characterizes a society or a group within it in a given historical period.

16. Epictetus, *The Discourses*, 2:129, 181.

17. Diogenes Laertius, *Lives of Eminent Philosophers*, trans. R. R. Hicks, 2 vols., Loeb Classical Library, London: William Heinemann (1930), 2: 235; see also Pliny, *Natural History* XXV, VII: 23.

18. *Meditations of the Emperor Marcus Aurelius*, ed. and trans. A. S. L. Farquarson, 2 vols., Oxford: Clarendon Press (1944), 1:217.

19. George Rosen, *Madness in Society, Chapters in the Historical Sociology of Mental Illness*, Chicago: The University of Chicago Press (1968), pp. 99-100.

20. H. R. Fedden, *Suicide: A Social and Historical Study*, London: Peter Davies (1938), pp. 115, 133-35.

21. Siegfried Wenzel, *The Sin of Sloth. Acedia in Medieval Thought and Literature*, Chapel Hill: University of North Carolina (1967), p. 160.

22. Caesarius of Heisterbach, *The Dialogue on Miracles*, trans. H. von E. Scott and C. C. Swinton Bland, 2 vols., London: George Routledge & Sons (1929), 1:237-41.

23. Henry de Bracton, *De legibus et consuetudinibus Angliae*, ed. George E. Woodbine, 2 vols., New Haven: Yale University Press (1915), 2:424; Nigel Walker and Sarah McCabe, *Crime and Insanity in England*. Vol. I. *The Historical Perspective*, Edinburgh University Press (1968), pp. 27-34.

24. P. V. Glob, *The Bog People. Iron-Age Man Preserved*, London: Faber and Faber (1969), pp. 66, 74, 77, 80, 87, 91, 104-105, 112, 149, 153.

25. Madame de Sévigné, *Lettres*, ed. Gérard-Gailly, 3 vols., Bibliothèque de la Pléiade, Paris: Gallimard (1953-57), 1:273-75.

26. *The Colloquies of Erasmus*, trans. Craig R. Thompson, Chicago: University of Chicago Press (1965), p. 360.

27. Desiderius Erasmus, *In Praise of Folly*, London: George Allen and Unwin (1937), p. 60.

28. Michel Eyquem de Montaigne, *Essais*, ed. Albert Thibaudet, Bibliothèque de la Pléiade, Paris: Gallimard (1958), pp. 385-99. The Latin quotation is from Seneca, *Epistles* XIII.

29. John Donne, *Biathanatos,* New York: Facsimile Text Society (1930), p. 18.
30. Robert Burton, *The Anatomy of Melancholy,* Oxford: Cripps (1621). I have used the edition published by the Nonesuch Press, London (1925), p. 223.
31. Johannes Neser, *Drey Christliche Predigten; Die zwei Ersten/Auss dem sieben und siebentzigsten Psalmen/Von Melancholia, Schwermutigkeit/ hohen innerlichen Anfechtungen/& Die Dritte Predigt: Auss dem acht und achtzigsten Psalmen. Von den schrecklichen Anfechtungen der Verzweiffelung: Und was von derer Seligkeit zu halten/die sich selbsten entleiben* . . . , Wittenberg: Wolffgang Meissner (1613).
32. Ibid., pp. 69-72.
33. John Sym, *Lifes Preservative against Self-Killing,* London: Dawlman and Fawne (1637). For appropriate selections see Richard Hunter and Ida Macalpine, *Three Hundred Years of Psychiatry 1535-1860,* London: Oxford University Press (1963), pp. 113-15.
34. Hunter and Macalpine, *Three Hundred Years,* p. 114.
35. Ibid., pp. 226, 155.
36. Oswald Doughty, "The English Malady of the Eighteenth Century," *Review of English Studies,* 2:257-69 (1926); Roland Bartel, "Suicide in Eighteenth-Century England: The Myth of a Reputation," *Huntington Library Quarterly,* 23:145-58 (1959-60).
37. For a comprehensive review of the subject of environmental influences see Clarence J. Glacken, *Traces on the Rhodian Shore: Nature and Culture in Western Thought from Ancient Times to the End of the Eighteenth Century,* Berkeley and Los Angeles: University of California Press (1967).
38. Charles de Secondat, baron de Montesqieu, *Oeuvres complètes,* 2 vols., Bibliothèque de la Pléiade, Paris: Gallimard (1949-51), 1:246.
39. Ibid., 2:485-86.
40. Lester G. Crocker, "The Discussion of Suicide in the Eighteenth Century," *Journal of the History of Ideas,* 13:47-52 (1952).
41. George Cheyne, *The English Malady: or A Treatise of Nervous Diseases of all Kinds, as Spleen, Vapours, Lowness of Spirits, Hypochondriacal, and Hysterical Distempers, etc.,* London: G. Strahan and J. Leake (1733), pp. I-III; see also pp. 48-60.
42. William Battie, *A Treatise on Madness,* London: J. Whiston and B. White (1758), pp. 36-37.
43. James Joyce, *Ulysses,* 2 vols., Hamburg: Odyssey Press (1932), 1:99-100.
44. An invaluable source for these studies is the *Annales d'hygiène publique* which began to appear in 1829. For the context of these investigations see George Rosen, "The Evolution of Social Medicine," in *Handbook of Medical Sociology,* ed. Howard E. Freeman, Sol Levine, Leo G. Reeder, Englewood Cliffs, N.J.: Prentice-Hall (1963), pp. 17-61, & pp. 29-35.

45. C. Lachaise, *Topographie médicale de Paris,* Paris: J. B. Baillière (1822), pp. 225-29.
46. J. L. Casper, *Beiträge zur medicinischen Statistik und Staatsarzneikunde,* 2 vols., Berlin (1825-35), 1:4-6.
47. J. P. Falret, *De l'hypochondrie et du suicide,* Paris (1822); see also Krügelstein, "Zur Statistik des Selbstmordes," *Zeitschrift für Staatsarzneykunde* (1854), pp. 182-99 (see p. 193); John R. Miner, "Suicide in its Relations to Climate and other Factors," *Am. J. Hygiene,* Monograph Series, No. 2 (July 1922), p. 111.
48. Leopold Auenbrugger, *Von der stillen Wuth oder dem Triebe zum Selbstmorde als einer wirklichen Krankheit mit Original-Beobachtungen und Anmerkungen,* Dessau (1783).
49. E. G. Elvert, *Über den Selbstmord in Bezug auf die gerichtliche Arzneykunde,* Tübingen (1794), cited in K. G. Dahlgren, *On Suicide and Attempted Suicide,* Lund: Håkan Ohlssons Boktryckeri (1945), p. 3.
50. J. C. Spurzheim, *Observations sur la folie, ou sur les derangements des fonctions morales et intellectuelles de l'homme,* Paris: Treuttel and Würtz (1818), pp. 207-20 (particularly pp. 208, 214, 219).
51. Jean Etienne Esquirol, *Des Maladies mentales, considérées sous les rapports médicaux, hygiéniques et médico-légaux,* 2 vols., Paris: J. B. Baillière (1838), pp. 526-676.
52. A. Brierre de Boismont, *Du Suicide et de la folie suicide considérés dans leurs rapports avec la statistique, la médecine et la philosophie,* Paris: Germer Baillière (1856).
53. E. Lisle, *Du Suicide, statistique, médecine, histoire et legislation,* Paris: J. B. Baillière (1856).
54. Émile Durkheim, *Suicide* (1897), trans. J. A. Spaulding and G. Simpson, Glencoe, Ill.: The Free Press (1951).

A. ALVAREZ

2 LITERATURE
IN THE NINETEENTH AND TWENTIETH CENTURIES

Introduction

With the Romantics, toward the end of the eighteenth century, suicide—which before had been more or less marginal to art—emerged for the first time as a major theme and preoccupation. In the Middle Ages, for example, the influence of the Church was so powerful and pervasive that suicide was simply not a possible subject. Thus, Dante put the suicides in the seventh circle of Hell, below the heretics and the murderers. It was only during the Renaissance and Reformation that the savage churchly taboos began gradually to lose their power and the topic re-emerged from the shadows. Sir Thomas More justified it as a form of euthanasia in his *Utopia*. Montaigne, later, freer, more skeptical, and more radical, defended the act strenuously. And since the Renaissance rediscovery of classical literature meant also the rediscovery of the Senecan solution to an unbearable or dishonored life, many of Shakespeare's characters kill themselves, as history and practical dramatic necessity demand, without apparent obloquy. John Donne, obsessed with death in his poems, prose, and sermons and—to judge from certain letters and poems—prone to periods of suicidal depression, wrote the first book in English on the subject, *Biathanatos*. It was, significantly, a defense; equally significantly, it was not published in his lifetime. This was the model for the next century and

This essay is adapted and abridged from *The Savage God: A Study of Suicide,* New York: Random House, 1972, by kind permission of the publishers.

a half: however suicidal a writer may in fact have been, it never quite emerges in his work, since that peculiarly desperate quality of emotion was not yet usable in poetry.

But during this period the Rationalists, such as Voltaire and Hume, steadily attacked the suicide taboos and superstitions and the primitive punishments still meted out. As a result, the laws slowly changed, along with a corresponding shift in emotional attitudes. The stage was set for the Romantic drama.

The romantic agony

In 1770, at the age of seventeen, Thomas Chatterton committed suicide by poison. His reasons were harshly realistic: he had failed in his brief attempt to make a living as a writer and was, literally, starving to death. Arsenic merely forestalled by a few days an ending that was already inevitable. To that eminently eighteenth-century figure, Dr. Johnson, Chatterton was the object of a grudging, amiably condescending admiration: "This is the most extraordinary young man that has encountered my knowledge. It is wonderful how the whelp has written such things." The signs are that had Chatterton lived he would have developed into the kind of writer whom the Doctor found easy to praise and the nineteenth-century Romantics detested; before he died his tastes had turned toward satire, politics, and the stage.

Yet, within a generation, Chatterton had become the supreme symbol of the Romantic poet. Even Wordsworth, whose absorption in the "egotistical sublime" would presumably have made him chronically antipathetic to Chatterton's whole style of life, interests, and talent, called him "the marvellous Boy,/ The sleepless Soul that perished in his pride." Coleridge wrote a "Monody" on his death, Keats composed a lame sonnet on him, Alfred de Vigny, a vastly successful and influential play, and Shelley invoked him beautifully in *Adonais,* his elegy on Keats:

> The Inheritors of unfulfilled renown
> Rose from their thrones, built beyond mortal thought,
> Far in the Unapparent. Chatterton
> Rose pale,—his solemn agony had not
> Yet faded from him. . . .

But of all the Romantics, only Keats seems to have used and understood Chatterton's poetry in itself. For the others, Chatterton's verse seems to

have been largely inconsequential. What mattered was his way of life: the brilliant, untutored, creative gift appearing out of nowhere, and his stirring combination of pride and precocity. More important still was his way of death. Although the exact circumstances and grinding financial reasons were not quite the Romantics' style, the broad outline was their ideal: the untimeliness, waste, pathos, the lack of recognition, the rejection and prematurity. For the Romantics Chatterton became the first example of death by alienation.

The traditional combination of genius and melancholy, which had so preoccupied the Renaissance, was transformed by the Romantics into the the Siamese twins of genius and premature death. "Cover his face: mine eyes dazzle: he died young." Given the ideal of lyric spontaneity and a unity with nature so exquisite and complete that the poet flourishes and fades like, in Shelley's words, a "sensitive plant," it could scarcely have been otherwise.[1] Youth and poetry and death became synonymous: Keats died in 1821 at the age of twenty-five, Shelley the next year at twenty-nine, and when Byron died two years later at thirty-six, his brain and heart, according to the postmortem, already showed symptoms of old age: ". . . the intense atom glows/ A moment, then is quenched in a most cold repose." This is from *Adonais,* the fullest and most emphatic statement of the Romantic belief that for the poet, life itself is the real corruption, and only "the white radiance of eternity" is pure enough for his fine sensibilities:

> Peace, peace! he is not dead, he doth not sleep—
> He hath awakened from the dream of life—
> 'Tis we, who lost in stormy visions, keep
> With phantoms an unprofitable strife,
> And in mad trance, strike with our spirit's knife
> Invulnerable nothings.—*We* decay
> Like corpses in a charnel; fear and grief
> Convulse us and consume us day by day,
> And cold hopes swarm like worms within our living clay.

What Keats—with his appetites, vigor, nerve, relish of life, and canny, restless intelligence—would have thought of all this is beside the point. Like Chatterton, he had become part of the myth. His savage treatment at the hands of the reviewers, the heartbreak with Fanny Brawne may, like his early death, have been as irrelevant to his gifts as his friend Joseph Severn's sickly posthumous portraits were to his vitality. But they

were essential to the Romantic image. Keats famous, honored, married, and middle-aged would have been for the nineteenth century an altogether unsatisfactory figure, even if he had fulfilled every last hint of his creative genius:

> From the contagion of the world's slow stain
> He is secure, and now can never mourn
> A heart grown cold, a head grown gray in vain;
> Nor, when the spirit's self has ceased to burn,
> With sparkless ashes load an unlamented urn.

It was a Romantic dogma that the intense, true life of feeling does not and cannot survive into middle age. Balzac defined the alternatives in *La Peau de chagrin:* "To kill the emotions and so live on to old age, or to accept the martyrdom of our passions and die young, is our fate." Even Coleridge, who lived on into his prosaic sixties, seems to have subscribed to this. But where the other Romantics believed that "the visionary powers" vanished inexorably, like youth and with youth, Coleridge alone recognized the death of his creativity as a kind of suicide. That, in fact, is the theme of his masterpiece, "Dejection: An Ode":

> But now afflictions bow me down to earth:
> Nor care I that they rob me of my mirth:
> But oh! each visitation
> Suspends what nature gave me at my birth,
> My shaping spirit of Imagination.
> For not to think of what I needs must feel,
> But to be still and patient, all I can;
> And haply by abstruse research to steal
> From my own nature all the natural man—
> This was my sole resource, my only plan:
> Till that which suits a part infects the whole,
> And now is almost grown the habit of my soul.

> Hence, viper thoughts. . .

Part of the genius of the poem is in the curious, plangent realism with which Coleridge faces the complexities of his situation, the responsibilities of dejection. If afflictions bow him down now as they could not before, it is not simply because they are more powerful and he is older, but because he himself has cooperated in his own betrayal.

That he recognized this as a form of suicide is, I think, certain, if for no other reason than that the passage reworks a theme from his "Monody

on the Death of Chatterton," a poem that was apparently on his mind for years. He had written the first, utterly undistinguished version while he was still a sixteen-year-old schoolboy at Christ's Hospital. At that stage the only hint of his own commitment to Chatterton's final solution was in the ambiguous last few lines, which no one would ever have suspected of being suicidal without an embarrassed footnote added later by someone other than Coleridge. Over the years he continued to tinker with the poem, rewriting and adding to it until it was almost twice its original length. Only in the last additions to the final version did he admit his own temptation to commit suicide, though still with more rhetoric than conviction:

> . . . [I] dare no longer on the sad theme muse,
> Lest kindred woes persuade a kindred doom:
> For oh! big gall-drops, shook from Folly's wing,
> Have blacken'd the fair promise of my spring;
> And the stern Fate transpierc'd with viewless dart
> The last pale Hope that shiver'd at my heart!
>
> Hence, gloomy thoughts. . .

Six years later, in 1802, when he wrote his great ode "Dejection," the same theme and echoes of the same language reappeared. Thus, by the beginning of the nineteenth century the example of Chatterton haunted the imagination of the poets in their moments of crisis; he was the standard by which they measured their despair. Just as he had swallowed arsenic, so Coleridge deliberately poisoned his creative gifts by an overdose of Kant and Fichte, because to survive as a poet demanded an effort, sensitivity, and continual exposure to feeling which were too painful for him. Subsequently, opium finished what metaphysics had begun. Although he went on writing verse until his death in 1834, it was, as he himself called it, "Work Without Hope." Poetically speaking, the last thirty-odd years of his life were a posthumous existence.

Coleridge's symbolic suicide—creative death by opium—was to become one of the Romantic alternatives for those fated not to die prematurely: Baudelaire also had the opium habit and systematically immersed himself in *les bas fonds;* Rimbaud, who called himself a *"littératuricide,"* had abandoned poetry by the age of twenty and finished his life as a trader in Ethiopia. And so on through a host of lesser figures. The Romantics changed the image of the poet radically: he became a doomed figure; his public expected it of him.

The ground had already been prepared, within four years of the death of Chatterton, by Goethe's novel *The Sorrows of Young Werther*. That martyr of unrequited love and excessive sensibility created a new international style of suffering:

There was a *Werther* epidemic: *Werther* fever, a *Werther* fashion—young men dressed in blue tail coats and yellow waistcoats—*Werther* caricatures, *Werther* suicides. His memory was solemnly commemorated at the grave of the young Jerusalem, his original, while the clergy preached sermons against the shameful book. And all this continued, not for a year, but for decades; and not only in Germany but in England, France, Holland and Scandinavia as well. Goethe himself noted with pride that even the Chinese had painted Lotte and Werther on porcelain; his greatest personal triumph was when Napoleon told him at their meeting, that he had read the book seven times. . . .

. . . When the epidemic was at its height some officer said: "A fellow who shoots himself for the sake of a girl he cannot sleep with is a fool, and one fool, more or less, in the world is of no consequence." There were many such fools. One "new Werther" shot himself with particular *éclat:* having carefully shaved, plaited his pigtail, put on fresh clothes, opened *Werther* at page 218 and laid it on the table, he opened the door, revolver in hand, to attract an audience and, having looked round to make sure they were paying sufficient attention, raised the weapon to his right eye and pulled the trigger.[2]

Before the craze for *Werther,* suicide for reasons more high-minded than money was thought to be a lapse of taste; now it was more than exonerated, it was fashionable. The great burst of spontaneous high feeling, which erupted like a genie from a bottle at the close of the eighteenth century, was vindicated by its very excesses. It was precisely these that demonstrated the new freedom from the rational, gossipy, powdered restrictions of the classical period. Two suicides—Werther and, in a slightly different way, Chatterton—were models of the new style of genius: "The word genius in those days was used frequently and indiscriminately, and it had a derisive secondary meaning: a "genius" was a rather bizarre, haughty young man who made great claims for himself without having proved whether or not such claims were mere arrogance." It follows that real geniuses, who produced as well as posed, had to live at a certain dramatic pitch—at least in the imagination of their adoring public. At the height of the Romantic fever, this personal intensity became almost more important than the work itself. Certainly the life and work began to seem inseparable. However strenuously the poets insisted on the impersonality

of art, the audience was reluctant to read them in any way except that by which Keats's tuberculosis, Coleridge's opium, and Byron's incest became an intrinsic part of their work—almost an art in themselves, equal and not at all separate.

Again, *Werther* is the first and best paradigm:

In those days the public had a very personal attitude towards an author, and towards the characters of a novel too. . . . The originals of famous fictional characters were tracked down with the utmost zeal, and, once found, their private lives were subjected to the most unrestrained and shameless intrusions. As Lotte, Frau Hofrat Kestner was the first victim of this treatment, to her sorrow and satisfaction; next came her husband, who entered into the game and complained in all sincerity that, as "Albert," Goethe had not given him sufficient integrity and dignity. The grave of the unhappy Jerusalem became a place of pilgrimage. The pilgrims cursed the parson who had denied him an honest burial, put flowers on the grave, sang sentimental songs and wrote home about their moving experience.

An essential part of the Romantic revolution was to make literature not so much an accessory of life—a pleasure and recreation for gentlemen of means and leisure, as Walpole had primly told the struggling Chatterton —but a way of life in itself. Thus, for the reading public Werther was no longer a character in a novel, he was a model for living, an individual who set a whole style of high feeling and despair. The Rationalists of the previous generations had vindicated the act of suicide, they had helped change the laws and moderate the primitive churchly taboos, but it was Werther who made the act seem positively desirable to the young Romantics all over Europe. Chatterton did much the same for the British poets; his considerable reputation depended not on his writing but on his death.

The Romantic stance, then, was suicidal. Byron, the most self-consciously doomed and dramatic of them all, remarked that "no man ever took a razor into his hand who did not at the same time think how easily he might sever the silver cord of life." Goethe, on the other hand, despite the vast success of Young Werther's tragedy, remained skeptical about the whole enterprise. He recounts how, in his youth, he had so admired the Emperor Otto, who had stabbed himself, that he finally decided that if he were not brave enough to die in the same manner, he was not brave enough to die at all:

By this conviction, I saved myself from the purpose, or indeed, more properly speaking, from the whim of suicide. Among a considerable collection of

arms, I possessed a costly well-ground dagger. This I laid down nightly by my side, and, before extinguishing the light, I tried whether I could succeed in sending the sharp point an inch or two deep into my heart. But as I truly never could succeed, I at last took to laughing at myself, threw away these hypochondriacal crotchets, and determined to live.[3]

However laughable the whim may have seemed to Goethe in his maturity, the fact remains that the Romantics thought of suicide when they went to bed at night, and thought of it again in the morning when they shaved.

William Empson once remarked that the first line of Keats's "Ode to Melancholy"—"No, no, go not to Lethe; neither twist . . ."—tells you that somebody, or some force in the poet's mind, must have wanted to go to Lethe very much, if it took four negatives in the first line to stop them."[4] In varying degrees, this was true of all the Romantics. Death was, literally, their fatal Cleopatra. But they conceived of death and suicide childishly: not as an end of everything, but as the supreme, dramatic gesture of contempt toward a dull, bourgeois world. *Werther's* progress was like that of the Indian Juggernaut; its triumph was measured by the number of suicides in its wake. It was the same with de Vigny's *Chatterton,* which was credited with doubling the annual suicide rate in France between 1830 and 1840. But these epidemics of suicide à la mode had one element in common: the belief that the suicide himself would be present to witness the drama created by his death. "Our unconscious," said Freud, ". . . does not believe in its own death; it behaves as if it were immortal." Thus suicide as a gesture enhances a personality which magically survives. It is as much a literary affectation as was the fashion for Werther's blue tail coat and yellow waistcoat. Freud again:

It is an inevitable result of [our complex denial of death] that we should seek in the world of fiction, in literature and in the theatre compensation for what has been lost in life. There we still find people who know how to die—who, indeed, even manage to kill someone else. There alone too the condition can be fulfilled which makes it possible for us to reconcile ourselves with death; namely, that behind all the vicissitudes of life we should still be able to preserve a life intact. For it is really too sad that in life it should be as it is in chess, where one false move may force us to resign the game, but with the difference that we can start no second game, no return-match. In the realm of fiction we find the plurality of lives which we need. We die with the hero with whom we have identified ourselves; yet we survive him, and are ready to die again just as safely with another hero.[5]

At the high point of Romanticism, life itself had lived as though it were
fiction, and suicide became a literary act, a hysterical gesture of solidarity
with whichever imaginative hero was, at that moment, the rage. "The one
desire," said Sainte-Beuve, ". . . of all the Renés and all the Chattertons
of our time is to be a great poet and to die." When Alfred de Musset,
aged twenty, was shown a particularly lovely view he cried with pleasure,
"Ah! It would be a beautiful place to kill oneself in!" Gérard de Nerval
said much the same thing on an evening walk by the Danube. Years later
Nerval hanged himself—with an apron string which, in his madness, he
thought was "the girdle Mme. de Maintenon wore when she acted at Saint
Cyr in *Esther*."[6] But he was one of the very few writers who finally acted
out the Romantic agony to its logical end. The rest contented themselves
with writing about it. Even Flaubert, who graduated swiftly to far cooler
things, confessed in his letters that as a youth "I dreamed of suicide." He
and his group of young provincial friends, he wrote nostalgically, "lived
in a strange world, I assure you; we swung between madness and suicide;
some of them killed themselves . . . another strangled himself with his
tie, several died of debauchery in order to escape boredom; it was beau-
tiful!"[7]

For the young Romantics who had the attitudes but not the gifts of
their heroes, death was "the great inspirer" and "great consoler." It was
they who made suicide fashionable, and during the epidemic in France
in the 1830's, "practised it as one of the most elegant of sports."[8] One
man, when charged with pushing his pregnant mistress into the Seine,
defended himself by saying, "We live in an age of suicide; this woman
gave herself to death." For the young would-be poets, novelists, drama-
tists, painters, great lovers, and members of countless suicide clubs, to
die by one's own hand was a short and sure way to fame. In the words
of the hero of a contemporary satirical novel, *Jérôme Paturot à la
recherche d'une position sociale* (1844), "A suicide establishes a man.
Alive one is nothing; dead one becomes a hero. . . . All suicides are
successful; the papers take them up; people feel for them. I must decid-
edly make my preparations." Jérôme may have been an object of deri-
sion, but dozens of young people had already done as he said. From
1833 to 1836, says Maigron, the papers were full of their deaths by sui-
cide; every morning, over coffee, "le lecteur peut s'en donner, avec un
petit frisson, l'émotion délicieuse."

In England the epidemic never properly took hold. The suicide rate

mounted, but the causes were thought to be characteristically sturdier and more practical than literary excess. Writing in 1840, a surgeon, Forbes Winslow, blamed the rising figures on socialism; there was, he said, a sudden increase after the publication of Tom Paine's *Age of Reason.* He also attributed it to "atmospherical moisture" and, of course, masturbation—"a certain secret vice which, we are afraid, is practised to an enormous extent in our public schools."[9] As a cure for the French fever of suicide he recommended cold showers and laxatives, the public school answer to the ultimate question.

As the nineteenth century wore on and Romanticism degenerated, the ideal of death degenerated also. In *The Romantic Agony,* Mario Praz has shown how fatalism gradually came to mean fatal sex; the femme fatale replaced death as the supreme inspiration. "Le satanisme a gagné," said Baudelaire, "Satan s'est fait ingénu." Homosexuality, incest, and sadomasochism took over where suicide left off, if only because they seemed at the time far more shocking. As the social, religious, and legal taboos against suicide lost their power, the sexual taboos intensified. Fatal sex also had the added advantage of being safer and slower than suicide, an enhancement rather than the contradiction of a life dedicated to art.

The savage god: suicide in the twentieth century

Suicide did not disappear from the arts; instead it became part of their fabric. In their heyday the Romantics established in the popular mind the idea that suicide was one of the many prices to be paid for genius. Although that idea faded, nothing has been the same since. Suicide has permeated Western culture like a dye that cannot be washed out. It is as though the Romantic epidemics in Germany and France created throughout Europe a general tolerance for the act. "Tolerance" in both the ordinary and medical senses of the word: the public attitude became more forbearing—the suicide was no longer thought of as a criminal, whatever the outdated laws decreed—and at the same time, the cultural system acquired a tolerance for suicide, as for a drug or a poison. It survived not merely despite the high level of suicides, it flourished because of them, rather in the way Poe and Berlioz swallowed near-lethal doses of opium during the course of unhappy love affairs and, instead of dying, were inspired.

Once suicide was accepted as a common fact of society—not as a noble Roman alternative, nor as the mortal sin it had been in the Middle Ages, nor as a special cause to be pleaded or warned against, but simply as something people did, often and without much hesitation, like committing adultery—then it automatically became a common property of art. And because it threw a sharp, narrow, intensely dramatic light on life at its extreme moments, suicide became the preoccupation of a certain kind of post-Romantic writer, like Dostoevski, who was the forerunner of twentieth-century art.

At the core of the Romantic revolution was the acceptance of a new responsibility. When, for example, the Augustans spoke of "the World," they meant their audience, polite society; the World flourished in certain salons in London and Paris, Bath and Versailles. For the Romantics, on the other hand, the world usually meant Nature—probably mountainous, certainly untamed—through which the poet moved in isolation, justified by the intensity of his unpremediated responses—to the nightingale and lark, the primrose and the rainbow. At first it was enough that these responses should be pure, fresh, and his own, that the artist should be free from the iron conventions of classicism that had fettered him for more than a hundred years. But as the initial enthusiasm wore off, it became clear that the revolution was more profound than it had first appeared. A radical reorientation had taken place: the artist was no longer responsible to polite society—on the contrary, he was often at open war with it. Instead, his prime responsibility was toward his own consciousness.

The arts of the twentieth century have inherited this responsibility and gone on from it, just as we have inherited political responsibilities—principles of democracy and self-government—laid down in the French and American revolutions. But since the discovery, or rediscovery, of the self as the arena of the arts was also concurrent with the collapse of the whole framework of values by which experience was traditionally ordered and judged—religion, politics, national cultural tradition and, finally, reason itself[10]—it follows that the new, permanent condition of the arts was depression. Kierkegaard put this first and clearest in his *Journals:*

The whole age can be divided into those who write and those who do not write. Those who write represent despair, and those who read disapprove of it and believe that they have a superior wisdom—and yet, if they were able to write, they would write the same thing. Basically they are all equally de-

spairing, but when one does not have the opportunity to become important with his despair, then it is hardly worth the trouble to despair and show it. Is this what it is to have conquered despair?"[11]

Despair was for Kierkegaard what grace was for the Puritans: a sign, if not of election, at least of spiritual potentiality. For Dostoevski, and for most of the important artists since him, it is the one common quality that defines their whole creative effort. Although it seemed limiting, it became finally a way through to new areas, new norms, and new ways of looking from which the traditional concepts of art—as a social grace and ornament, as an instrument of religion or even of Romantic humanitarian optimism—themselves appeared narrow and bounded. If the new concern of art was the self, then the ultimate concern of art was, inevitably, the end of self—that is, death.

In 1896 W. B. Yeats attended the first performance of Jarry's *Ubu Roi* in Paris. Of course there was a riot, and of course Yeats fought on the side of the play. But afterwards in his room he had second thoughts: "After Stéphane Mallarmé, after Paul Verlaine, after Gustave Moreau, after Puvis de Chavannes, after my own verse, after all our subtle colour and nervous rhythm, after the faint mixed tints of Conder, what more is possible? After us the Savage God." I think Yeats prophesied correctly. In a sense, the whole of twentieth-century art has been dedicated to the service of this earthbound Savage God who, like the rest of his kind, has thrived on blood-sacrifice. As with modern warfare, enormous sophistication of theory and technique has gone into producing an art which is more extreme, more violent, and, finally, more self-destructive than ever before.

To put it most simply: one of the most remarkable features of the arts in this century has been the sudden, sharp rise in the casualty rate among the artists. Of the great premodernists, Rimbaud abandoned poetry at the age of twenty, Van Gogh killed himself, Strindberg went mad. Since then the toll has mounted steadily. In the first great flowering of modernism, Kafka wanted to turn his premature natural death from tuberculosis into artistic suicide by having all his writings destroyed. Virginia Woolfe drowned herself, a victim of her own excessive sensitivity. Hart Crane devoted prodigious energy to aestheticizing his chaotic life—a desperate compound of homosexuality and alcoholism—and finally, thinking himself a failure, jumped overboard from a steamer in the Caribbean. Dylan Thomas and Brendan Behan drank themselves to death. Antonin Artaud

spent years in lunatic asylums. Delmore Schwartz was found dead in a run-down Manhattan hotel. Malcolm Lowry and John Berryman both rounded off a lifetime's alcoholism with suicide. Cesare Pavese and Paul Celan, Randall Jarrell and Sylvia Plath, Mayakovsky, Yesenin, and Tsvetayeva killed themselves. Among the painters, the suicides include Modigliani, Arshile Gorki, Mark Gertler, Jackson Pollock, and Mark Rothko. Spanning the generations was Hemingway, whose prose was modeled on a kind of physical ethic of courage and the control necessary at the limits of endurance. He stripped his style to the bone in order to achieve the aesthetic corollary of physical grace—a matter of great economy, great precision, great tension under the appearance of ease. In such a perspective, the natural erosions of age—weakness, uncertainty, clumsiness, imprecision, an overall slackening of what had once been a highly tuned machine—would have seemed as unbearable as losing the ability to write. In the end, he followed the example of his father and shot himself.

Each of these deaths has its own inner logic and unrepeatable despair, and to do them justice would require a degree of detail beyond my purposes here. But a simple point emerges: before the twentieth century it is possible to discuss cases individually, since the gifted artists who killed themselves or were even seriously suicidal were rare exceptions. In the twentieth century the balance suddenly shifts: the better the artist, the more vulnerable he seems to be. Obviously, this is in no way a firm rule. The Grand Old Men of literature have been both numerous and very grand: Eliot, Joyce, Valéry, Pound, Mann, Forster, Frost, Stevens, Ungaretti, Montale, Marianne Moore. Even so, the casualty rate among the gifted seems out of all proportion, as though the nature of the artistic undertaking itself and the demands it makes have altered radically.

There are, I think, a number of reasons. The first is the continuous, restless urge to experiment, the constant need to change, to innovate, to destroy the accepted styles. "If it works," says Marshall McLuhan, "it's obsolete." But experiment has a logic of its own, which leads it unceasingly away from questions of formal technique into a realm where the role of the artist himself alters. Since art changes when the forms available are no longer adequate to what has to be expressed, it follows that every genuine technical revolution is parallel to a profound internal shift. For the Romantic poets, a major gesture of their new emotional freedom was to abandon the straitjacket of the classical rhymed couplet. Similarly, the first modernists jettisoned traditional rhymes and meters in favor of a

free verse which would allow them to follow precisely and without deflection the movement of their sensibilities. Technical exploration, in short, implies a degree of psychic exploration; the more radical the experiments, the deeper the responses tapped. That, presumably, is why the urge to experiment faded in the 1930's, when it seemed that left-wing politics would provide all the answers, and again in England in the 1950's, when the Movement poets were busy immortalizing the securities and complacencies of life in the suburbs. Not that an experimental, avantgarde appearance guarantees anything; it can be as easily assumed as any other fancy dress, and more easily than most becomes an embarrassment to the timid and conventional, since its see-through design effortlessly reveals the user's lack of originality: witness the drab followers of Ezra Pound and William Carlos Williams, on both sides of the Atlantic.

But for the more serious artist, experiment has not been a matter of merely tinkering with the machinery. Instead, it has provided a context in which he explores the perennial question "What am I?" without benefit of moral, cultural, or even technical securities. Since part of his gift is also a weird knack of sensing and expressing the strains of his time in advance of other people, the movement of the modern arts has been, with continual minor diversions, toward a progressively more inward response to a progressively more intolerable sense of disaster. It is as though, by taking to its limits Conrad's dictum "In the destructive element immerse," his whole role in society had changed; instead of being a Romantic hero and liberator, he has become a victim, a scapegoat.

One of the most beautiful, and certainly the saddest statement of this new fate is by Wilfred Owen, who was dead before the great modernist change had properly begun. On New Year's Eve, 1917, he wrote to his mother:

I am not dissatisfied with my years. Everything has been done in bouts:
Bouts of awful labour at Shrewsbury and Bordeaux; bouts of amazing pleasure in the Pyrenees, and play at Craiglockhart; bouts of religion at Dunsden; bouts of horrible danger on the Somme, bouts of poetry always; of your affection always; of sympathy for the oppressed always.
I go out of this year a Poet, my dear Mother, as which I did not enter it. I am held peer by the Georgians; I am a poet's poet.
I am started. The tugs have left me; I feel the great swelling of the open sea taking my galleon.
Last year at this time (it is just midnight, and now is the intolerable instant of the Change) last year I lay awake in a windy tent in the middle of a vast,

dreadful encampment. It seemed neither France nor England, but a kind of paddock where the beasts are kept a few days before the shambles. I heard the revelling of the Scotch troops, who are now dead, and who knew they would be dead. I thought of this present night, and whether I should indeed —whether we should indeed—whether you would indeed—but I thought neither long nor deeply, for I am a master of elision.

But chiefly I thought of the very strange look on all the faces in that camp; an incomprehensible look, which a man will never see in England, though wars should be in England; nor can it be seen in any battle. But only in Étaples.

It was not despair, or terror, it was more terrible than terror, for it was a blindfold look, and without expression, like a dead rabbit's.

It will never be painted, and no actor will ever seize it. And to describe it, I think I must go back and be with them.[12]

Nine months later Owen was back in France. Two months after that he was killed in action, exactly one week before the war ended.

There are two forces at work in this letter, each pulling in the opposite direction: nurture and nature, training and instinct, or, in Eliot's phrase, "tradition and the individual talent." Both are personal, yet both also correspond to vital elements in his poetry. The first is traditional, which is inevitable, since Owen was in many ways still at one with the comfortable Georgians, who had no truck with the poetic changes already beginning around them. As such, he was responding in the heroic tradition of Sir Philip Sidney and, say, Captain Oates, as "a brave man and an English gentleman." He was going back to France because he had to do his duty as a soldier; since duty invariably means sacrifice, even the chance of the ultimate sacrifice must be accepted without fuss.

But even more strongly, there is an antiheroic force at work which corresponds to all those elements in his writing that went to make him one of the British forerunners of modernism; it corresponds, that is, to his poems' harsh, disabused vision of the war and, technically, to their subtle, decisive use of half-rhymes which helped effectively to dispose of the chiming sweetness of much Georgian verse. It was this second force that impelled him to return to France not as "an officer and a gentleman" but as a writer. The letter is, after all, about his coming of age as a poet, and it was in the context of this newly matured power that he made his decision to return to the front. It seems, literally, to have been a decision: he had already seen a great deal of active service, and as a result had been hospitalized with shell shock. Moreover, his poetry had brought him

powerful friends, one of whom, Proust's translator Scott-Moncrieff, worked in the War Office and had been using his influence to get Owen a safe posting in England. It may, then, have taken as much effort and organization to return to the fighting as to stay away. What drew him back, I think, had nothing to do with heroism and everything to do with poetry. The new powers he felt in himself seem to have been inextricably linked with the strange, unprecedented vision he had had in France:

> But chiefly I thought of the very strange look on all the faces in that camp; an incomprehensible look, which a man will never see in England, though wars should be in England; nor can it be seen in any battle. But only in Étaples.
>
> It was not despair, or terror, it was more terrible than terror, for it was a blindfold look, and without expression, like a dead rabbit's.
>
> It will never be painted, and no actor will ever seize it. And to describe it, I think I must go back and be with them.

That numbness—beyond hope, despair, terror and, certainly, beyond heroics—is, I think, the final quantum to which all the modish forms of twentieth-century alienation are reduced. Under the energy, appetite, and constant diversity of the modern arts is this obdurate core of blankness and insentience which no amount of creative optimism and effort can wholly break down or remove. It is like, for a believer, the final, un-budgeable illumination that God is not good. A psychiatrist, Robert Jay Lifton, has defined it, in more contemporary terms, as that "psychic numbing" that occurs in an overwhelming encounter with death. That is, when death is everywhere and on such a vast scale that it becomes in-different, impersonal, inevitable and, finally, without meaning, the only way to survive, however briefly, is by shutting oneself off utterly from every feeling, so that one becomes invulnerable, not like an armored ani-mal but like a stone. Robert Jay Lifton has described this process:

> . . . psychic closing-off can serve a highly adaptive function. It does so partly through a process of denial ("If I feel nothing, then death is not taking place"). . . . Further, it protects the survivor from a sense of complete helplessness, from feeling himself totally inactivated by the force invading his environment. By closing himself off, he resists being "acted upon" or altered. . . . We may thus say that the survivor initially undergoes a radical but tem-porary diminution of his sense of actuality in order to avoid losing this sense completely and permanently; he undergoes a reversible form of symbolic death in order to avoid a permanent physical or psychic death.[13]

Dr. Lifton is, as it happens, describing the defense mechanisms brought into play by the survivors of the Hiroshima atom bomb and the Nazi concentration camps. But that awareness of a ubiquitous, arbitrary death—which descends like a medieval plague on the just and unjust alike, without warning or reason—is, I think, central to our experience of the twentieth century. It began with the pointless slaughters of World War I, continued through Nazi and Stalinist extermination camps, through a Second World War, which culminated in two atomic explosions, and has survived with genocide in Tibet, Biafra, and Bangladesh, a senseless war in Vietnam, atomic testing which poisons the atmosphere, and the development of biological weapons which kill haphazardly and more or less without control; it ends with the possibility of the globe itself shadowed by nuclear weapons orbiting in outer space.

It is important not to exaggerate; after all, this sense of disaster is, for the moment, mercifully peripheral to the lives most of us lead. To harp on it like Cassandra is as foolish, and ultimately as boring, as to ignore it completely. Yet the fact remains that the context in which our arts, morals, and securities are created has changed radically. "After Hiroshima," says Dr. Lifton, "we can envisage no war-linked chivalry, certainly no glory. Indeed, we can see no relationship—not even a distinction —between victimizer and victim—only the sharing in species annihilation. . . . In every age man faces a pervasive theme which defies his engagement and yet must be engaged. In Freud's day it was sexuality and moralism. Now it is unlimited technological violence and absurd death."

In other words, that sense of chaos which, I suggested, is the driving force behind the restless experimentalism of the twentieth-century arts has two sources: one developing directly from the period before 1914, the other emerging for the first time during World War I and growing increasingly stronger and more unavoidable as the century has gone on. Both, perhaps, are consequences of industrialism: the first is connected with the destruction of the old social relationships and the related structures of belief during the Industrial Revolution; the second is produced by the technology itself, which, in the process of creating the wherewithal to make life easier than ever before, has perfected, as a kind of lunatic spin-off, instruments to destroy life completely. More simply, just as the decay of religious authority in the nineteenth century made life seem absurd by depriving it of any ultimate coherence, so the growth of modern technology has made death itself absurd by reducing it to a random

happening totally unconnected with the inner rhythms and logic of the lives destroyed.

This, then, is the Savage God whom Yeats foresaw and whose intolerable, demanding presence Wilfred Owen sensed at the front. To be true to his vocation as a poet, Owen felt he must describe that "blindfold look, and without expression, like a dead rabbit's"; which meant he had to return to France and risk his life. This double duty—to forge a language that will somehow absolve or validate absurd death, and to accept the existential risks involved in doing so—is, I think, the model for everything that was to follow. "There exist no words, in any human language," wrote a Hiroshima survivor, "which can comfort guinea pigs who do not know the cause of their death."[14] It is precisely the pressure to discover a language adequate for this apparently impossible task that is behind the curious sense of strain characteristic of nearly all the best and most ambitious work of this century.

There are, of course, other, more obvious pressures, some of which I have already touched on: the collapse of traditional values, impatience with worn-out conventions, the minor pleasures of iconoclasm and experiment for their own sakes. There is also the impact of what Marshall McLuhan calls the "electronic culture," which has so effortlessly usurped both the audience and many of the functions of the "formal" highbrow arts. But beyond all these, and becoming continually more insistent as the atrocities have grown in size and frequency, has been the absolute need to find an artistic language with which to grasp in the imagination the historical facts of this century; a language, that is, for "the destructive element," the dimension of unnatural, premature death.

Inevitably, it is the language of mourning. Or rather, the arts take on the function of mourning, breaking down that "psychic numbness" that follows any massive immersion in death. "The books we need," wrote Kafka in a letter to his friend Oscar Pollack, "are the kind that act upon us like a misfortune, that make us suffer like the death of someone we love more than ourselves, that make us feel as though we were on the verge of suicide, or lost in a forest remote from all human habitation—a book should serve as the axe for the frozen sea within us."[15]

Clearly, books of this order will not be written simply by invoking the atrocities—a gesture which usually guarantees nothing but rhetoric and the cheapening of all those millions of deaths. What is required is something a good deal more difficult and individual: the creative act itself,

which gives shape, coherence, and some kind of gratuitous beauty to all those vague depressions and paranoias which art is heir to. Freud responded to World War I by positing a death instinct beyond the pleasure principle; for the artist, the problem is to create a language that is both beyond the pleasure principle and at the same time pleasurable.

This ultimately is the pressure forcing the artist into the role of scapegoat. In order to evolve a language of mourning that will release all those backed-up guilts and obscure hostilities he shares with his audience, he puts himself at risk and explores his own vulnerability. It is as though he were testing out his own death in his imagination—symbolically, tentatively and with every escape hatch open. "Suicide," said Camus, "is prepared within the silence of the heart, as is a great work of art." Increasingly, the corollary also seems to be true: under certain conditions of stress, a great work of art *is* a kind of suicide.

There are two opposite ways into this dimension of death. The first is through what might be called "Totalitarian art"—which is, incidentally, different in kind from traditional art in a totalitarian society. It tackles the historical situation frontally, more or less brutally, in order to create a human perspective for a dehumanizing process. The second is what I have called elsewhere "Extremist art": the destruction is all turned inward and the artist deliberately explores in himself that narrow, violent area between the viable and the impossible, the tolerable and the intolerable. Both approaches involve certain radical changes in the relationship of the artist to his material.

For Totalitarian art, the changes are both inevitable and unwished for. The simple reason is that a police state and its politics of terror produce conditions in which the intense individualism on which art is traditionally based—its absolute trust in the validity of the unique personal insight—is no longer possible. When the artist is valued like an engineer or factory worker or bureaucrat, only to the extent to which he serves the policies of the state, then his art is reduced to propaganda, sometimes sophisticated, more often not. The artist who refuses that role refuses everything; he becomes superfluous. In these circumstances, the price of art in the traditional sense and with its traditional values is suicide—or silence, which amounts to the same thing.

Perhaps this explains the phenomenal casualty rate among the generation of Russian poets who had begun to work before the convulsions of 1917 and refused the Joycean alternative of "silence, exile and cunning."

In 1926, after Sergei Yesenin hanged himself, first cutting his wrists and then, as a last aesthetic gesture, writing a farewell poem in his own blood, Mayakovsky wrote, condemning him: "In this life it is not difficult to die/ It is more difficult to live." Yet less than five years later Mayakovsky himself, poetic hero of the Revolution and inveterate gambler who had twice already played Russian roulette with a loaded revolver, came to the conclusion that his political principles were poisoning his poetry at its source. He played Russian roulette for the last time and lost. In his suicide note he wrote laconically, "I don't recommend it for others." Yet several others did, in fact, follow him, apart from all those who, like Osip Mandelstam and Isaak Babel, disappeared in the purges. Boris Pasternak wrote an epitaph on them all:

> To start with what is most important: we have no conception of the inner torture which precedes suicide. People who are physically tortured on the rack keep losing consciousness, their suffering is so great that its unendurable intensity shortens the end. But a man who is thus at the mercy of the executioner is not annihilated when he faints from pain, for he is present at his own end, his past belongs to him, his memories are his and if he chooses, he can make use of them, they can help him before his death.
>
> But a man who decides to commit suicide puts a full stop to his being, he turns his back on his past, he declares himself a bankrupt and his memories to be unreal. They can no longer help or save him, he has put himself beyond their reach. The continuity of his inner life is broken, his personality is at an end. And perhaps what finally makes him kill himself is not the firmness of his resolve but the unbearable quality of this anguish which belongs to no one, of this suffering in the absence of the sufferer, of this waiting which is empty because life has stopped and can no longer fill it.
>
> It seems to me that Mayakovsky shot himself out of pride, because he condemned something in himself, or close to him, to which his self-respect could not submit. That Yesenin hanged himself without having properly thought out the consequences of his act, still saying in his inmost heart: "Who knows? Perhaps this isn't yet the end. Nothing is yet decided." That Maria Tsvetayeva had always held her work between herself and the reality of daily life; and when she found this luxury beyond her means, when she felt that for her son's sake she must, for a time, give up her passionate absorption in poetry and look round her soberly, she saw chaos, no longer screened by art, fixed, unfamiliar, motionless, and, not knowing where to run for terror, she hid in death, putting her head into the noose as she might have hidden her head under her pillow. It seems to me that Paolo Yashvili was utterly confused, spellbound by the Shigalyovshchina of 1937 as by witchcraft; and that he watched his daughter as she slept at night and, imagining himself unworthy to look at her, went out in the morning to his friends' house and blasted his

head with grapeshot from his double-barrelled gun. And it seems to me that Fadeyev, still with the apologetic smile which had somehow stayed with him through all the crafty ins and outs of politics, told himself just before he pulled the trigger: "Well, now it's over. Good-bye, Sasha."

What is certain is that they all suffered beyond description, to the point where suffering has become a mental sickness. And, as we bow in homage to their gifts and to their bright memory, we should bow compassionately before their suffering.[16]

Pasternak writes, I think, with the poignancy of a man who has been there himself. This is not in any way to imply that he had considered taking his own life—a question which is none of our business—but simply that he had endured those conditions in which suicide becomes an unavoidable fact of society. As he describes them, they are precisely the same as those which obtain, according to Hannah Arendt, when a totalitarian system achieves full power: like the victim of the totalitarian state, the suicide assists passively at the cancellation of his own history, his work, his memories, his whole inner life—in short, of everything that defines him as an individual:

The concentration camps, by making death itself anonymous (making it impossible to find out whether a prisoner is dead or alive) robbed death of its meaning as the end of a fulfilled life. In a sense they took away the individual's own death, proving that henceforth nothing belonged to him and he belonged to no one. His death merely set a seal on the fact that he had never existed.[17]

Both for the exterminated million Miss Arendt writes about and for Pasternak's suicides, the conditions of terror were the same: "chaos, no longer screened by art, fixed, unfamiliar, motionless." But the suicides retained at least one last shred of freedom: they took their own lives. In part this is a political act, both a gesture of defiance and a condemnation of the system—like the self-immolation of the student, Jan Palach, in Prague in 1969. It is also an act of affirmation; the artist values life and his own truths too much to be able to tolerate their utter perversion. Thus the totalitarian state presents its artists with suicide as though with a gift, a final work of art validating all his others.

It was part of Pasternak's own genius and uniqueness that he refused to be canceled in this way and continued, by some political miracle, to write his poems and his novel as though all those improbable personal values still survived. No doubt he paid for his understanding in isolation and depression, but few others got out so cleanly. Yet neither those who

survived contaminated nor those who went under ever managed to hold up the mirror to that complete corruption of nature which is the totalitarian system in action. Not necessarily for lack of trying. But despite the hundreds of attempts, police terror and the concentration camps have proved to be more or less impossible subjects for the artist; since what happened in them was beyond the imagination, it was therefore also beyond art and all those human values on which art is traditionally based.

The most powerful exception is the Pole Tadeusz Borowski. Where the Russian poets to whom Pasternak paid homage continued to write to the point where they felt their whole life and work had been canceled by history, Borowski was unique in beginning with that cancellation. In one of his Auschwitz stories, "Nazis," he remarks sardonically: "True, I could also lie, employing the age-old methods which literature has accustomed itself to using in pretending to express the truth—but I lack the imagination." Lacking the imagination, he avoided all the tricks of melodrama, self-pity, and propaganda which elsewhere are the conventional literary means of avoiding the intolerable facts of life in the camps. Instead, he perfected a curt, icy style, as stripped of feeling as of ornament, in which the monstrous lunacies of life in Auschwitz were allowed to speak for themselves, without comment and therefore without disguise: "Between two throw-ins in a soccer game, right behind my back, three thousand people had been put to death."[18] Following an almost idyllic, almost pastoral description of a lazy game of football in a setting for the moment as peaceful as an English village cricket green, the sentence explodes like a bomb.

Borowski's art was one of reduction; his prose and his stories are as bare and deprived as the lives described in them. A Polish critic has pointed out that his notion of tragedy "has nothing to do with the classical conception based on the necessity of choice between two systems of value. The hero of Borowski's stories is a hero *deprived of all choice*. He finds himself in a situation without choice because every choice is base." Because death in the ovens came to all, regardless of their innocence or their crimes, "the de-individualization of the hero was accompanied by a *de-individualization of the situation*."[19] Borowski himself called his stories "a journey to the utmost limit of a certain kind of morality." It is a morality created out of the absence of all morality, a skillful, minimal, yet eloquent language for the most extreme form of what Lifton called "psychic numbing." By reducing his prose to the facts

and images of camp life and refusing to intrude his own comments, Borowski also contrived to define, as though by his omissions and silences, precisely that state of mind in which the prisoners lived: brutal, depersonalized, rapacious, deadly. Morally speaking, it is a posthumous existence, like that of the suicide, as Pasternak described him, who "puts a full stop to his being . . . turns his back on his past . . . declares himself a bankrupt and his memories to be unreal."

This, then, is Totalitarian art: it is as much an art of successful suicide as Extremist art is that of the attempt. And in order to achieve it, Borowski himself underwent a progressive, triple suicide. Although he had behaved with great courage in Auschwitz, voluntarily giving up the relatively easy post of a hospital orderly in order to share the lot of the common prisoners, his first-person narrator is callous, corrupt, well placed in the camp hierarchy, a survival artist who hates his fellow victims more than the guards because their weakness illuminates his, and each new death means a further effort of denial and a sharper guilt. Thus his first self-destruction was moral: he assuaged his guilt for surviving when so many others had gone under by identifying with the evil he described. The second suicide came after his concentration camp stories were written: he abandoned literature altogether and sank himself into Stalinist politics. Finally, having escaped the Zyklon B of Auschwitz for so long, he gassed himself at home in 1951, when he was twenty-seven years old.

The politicians and economists of disaster may talk glibly of "thinking about the unthinkable," but for the writers the problem is sharper, closer, and considerably more difficult. Like the Hiroshima survivor I mentioned earlier, Borowski seems to have despaired of ever communicating adequately what he knew: "I wished to describe what I have experienced, but who in the world will believe a writer using an unknown language? It's like trying to persuade trees or stones." The key to the language turned out to be deprivation, a Totalitarian art of facts and images, without frills or comments, as depersonalized and deprived as the lives of the victims themselves. In the same way, when Peter Weiss created his documentary tragedy, *The Investigation,* he invented nothing and added nothing; he simply used a blank stage, unnamed and anonymously dressed actors, and skillfully chosen fragments of the Auschwitz trials in Frankfurt. The result was a great deal more shocking than any "imaginative" re-creation of the camps could ever have been.

Similarly, Samuel Beckett began at the other end of the spectrum with an Irish genius for words, words, words, and finished by creating a world of what Coleridge called "Life-in-Death." His people lead posthumous, immobile lives, stripped of all personal qualities, appetites, possessions, and hope. All that remains to them is language; they palliate their present sterility by dim, ritual invocations of a time when things still happened and their emotions still stirred. The fact that Beckett's detachment and impeccable timing produce comedy out of this universal impotence only serves, in the end, to make the desolation more complete. By refusing even the temptation to tragedy, and by stylizing his language to the point of minimal survival, he makes his world impregnable. He is creating a world that God has abandoned, as life might abandon some burnt-out star. To express this terminal morality he uses a minimal art, stripped of all artifact. It is the complement of Borowski's concentration camp stories, and equally deprived: the totalitarianism of the inner world.

It is here that Totalitarian and Extremist art meet. When Norman Mailer calls the modern, statistical democracies of the West "totalitarian," he is not implying that the artist is bound and muzzled and circumscribed as he would be in a dictatorship—a vision not even the most strenuous paranoia could justify. But he is implying that mass democracy, mass morality, and the mass media thrive independently of the individual, who joins them only at the cost of at least a partial perversion of his instincts and insights. He pays for his social ease with what used to be called his soul—his discriminations, his uniqueness, his psychic energy, his self. Add to that the ubiquitous sense of violence erupting continually at the edges of perception: local wars, riots, demonstrations, and political assassinations, each seen, as it were, out of the corner of the eye as just another news feature on the television screen. Add, finally, the submerged but never quite avoidable knowledge of the possibility of ultimate violence, known hopefully as the balance of terror. The result is totalitarianism not as a political phenomenon but as a state of mind.

The artistic revolution of the last decade and a half has occurred, I think, as a response to totalitarianism in Mailer's sense of the word: not as so many isolated facts out there in another country and another political system for which somebody else is responsible, but as part of the insidious atmosphere we breathe. The nihilism and destructiveness of the self—of which psychoanalysis has made us sharply and progressively more aware—turns out to be an accurate reflection of the nihilism of our

own violent societies. Since we apparently cannot control it on the outside, politically, we can at least try to control it in ourselves, artistically.

The operative word is "control." The Extremist poets are committed to psychic exploration out along that friable edge that divides the tolerable from the intolerable: but they are equally committed to lucidity, precision, and a certain viligant directness of expression. In this they have more in common with the taxingly high standards set by Eliot and the other grand-masters of the 1920's than with the Surrealists, who were concerned with the wit, or whimsicality, of the unconscious. Out of the haphazard, baroque connections of the mind running without restraints, the Surrealists created what is essentially a landscape art. In comparison, the Extremist artists are committed to the stage below this, a stage before what Freud called "the dream-work" begins. That is, they are committed to the raw materials of dreams; all the griefs and guilts and hostility which dreams express only elliptically, by displacement and disguise, they seek to express directly, poignantly, skillfully, and in full consciousness. Extremism, in short, has more in common with psychoanalysis than with Surrealism.

In poetry the four leading English-language exponents of the style are Robert Lowell, John Berryman, Ted Hughes, and Sylvia Plath, all of whom are highly disciplined and highly aware of formal demands and possibilities. All begin with a thickly textured, wary, tensely intelligent style they inherited ultimately from Eliot, and progress, in their different ways, toward a poetry in which the means, though no less demanding, are subordinate to a certain inner urgency which makes them push continually at the limits of what poetry can be made to bear. Inevitably so, since each of them is knowingly salvaging his verse from the edge of some kind of personal abyss. The crucial work was Lowell's *Life Studies,* in which he turned away from the highly wrought Roman Catholic symbolism of his earlier poetry in order to face—without benefit of clergy, and in a translucent, seemingly more casual style—his own private chaos as a man subject to periodic breakdowns. And by some odd creative logic, the more simply and personally he wrote, the more authentic and authoritative his work became. He transformed the seemingly private into a poetry central to all our anxieties.

In much the same way, John Berryman turned from the public, literary world of *Homage to Mistress Bradstreet* to the still-stylized but far more intimate cycle of *Dream Songs.* These began as a quirky poetic journal of

misdemeanors, gripes, hangovers, and morning-after despair, then gradually clarified and deepened into an extended act of poetic mourning for the suicide of a father, the premature deaths of friends, and for his own suicidal despair. Berryman had always been a poet of bristling nervous energy; now his sense of grief and loss added an extra, urgent dimension to his work, impelling it through the whole process of mourning—guilt, hostility, expiation—which ended with the beautifully lucid acceptance of his own mortality. He ended, that is, by writing his own epitaph before he committed suicide.

Ted Hughes and Sylvia Plath, belonging to a younger generation, began further along the road and explored further into the hinterland of nihilism. Thus Hughes starts with a series of extraordinary animal poems, full of sharp details and unexpected shifts of focus, in which he elegantly projects onto a whole zooful of creatures whatever unpredictable violence he senses in himself. Then, gradually, as in a case of demonic possession, the animals begin to take over; the portraits turn into soliloquies in which murder is no longer disguised or excused; the poet himself becomes both predator and prey of his own inner violence. Following the example of the Yugoslav poet Vasco Popa, Hughes exercises strict control over his private monsters by making them subject to arbitrary rules, as in some psychotic child's game, but he also carries the hunt on into the darkness with exceptional single-mindedness. The result so far has been the creation of Crow, antihero of an antiepic, whose one distinction is survival. Jaunty and murderous, he bobs up irrepressibly from every disaster, as unkillable as hope. But he is unkillable precisely because he is without hope. He has a beady eye only for destructiveness, and his pessimism is unwavering. Hughes's other animals were all redeemed, in their different ways, by a certain instinctive grace. In comparison, Crow is irredeemable: pure death instinct.

But it is with Sylvia Plath that the Extremist impulse becomes total and, literally, final. In the briefest terms, her dissatisfaction with the elegant, rather arty styles of her early poems more or less coincided with the appearance of *Life Studies*. Lowell proved that it was possible to write about these things without sinking into the witless morass of "confessional" verse. And this was the excuse she had been waiting for, the key to unlock the reserves of pain which had built up steadily since her father's premature death when she was a child and her own suicide attempt at the age of twenty. In the mass of brilliant poems which poured

out in the last few months of her life she took Lowell's example to its logical conclusion, systematically exploring the nexus of anger, guilt, rejection, love, and destructiveness, which made her finally take her own life. It is as though she had decided that for her poetry to be valid, it must tackle head-on nothing less serious than her own death, bringing to it a greater wealth of invention and sardonic energy than most poets manage in a lifetime of so-called affirmation.

If the road had seemed impassable, she proved that it was not. It was, however, one-way, and she went too far along it to be able, in the end, to turn back. Yet her actual suicide, like Berryman's or like Lowell's breakdowns, is incidental; it adds nothing to her work and proves nothing about it. It was simply a risk she took in handling such volatile material. Indeed, what the Extremists have in common is not a style, but a belief in the value, even the necessity, of risk. They do not deny it like our latter-day aesthetes, nor drown it in the benign, warm but profoundly muddied ocean of hippie love and inarticulateness. This determination to confront the intimations not of immortality but of mortality itself, using every imaginative resource and technical skill to bring it close, understand it, accept it, control it, is finally what distinguishes genuinely advanced art from the fashionable crowd of pseudo-avant-gardes. On these terms, an artist could live to be as old as Robert Frost or Ezra Pound and yet, in his work, still be a suicide of the imagination.

I am suggesting, in short, that the best modern artists have in fact done what the Hiroshima survivor thought impossible: out of their private tribulations they have invented a public "language which can comfort guinea pigs who do not know the cause of their death." That, I think, is the ultimate justification of the highbrow arts in an era in which they themselves seem less and less convinced of their claims to attention and even to existence. They survive morally by becoming, in one way or another, an imitation of death in which their audience can share; to achieve this the artist, in his role of scapegoat, finds himself testing out his own death and vulnerability for and on himself.

It may be objected that the arts are also about many other things, often belligerently so; for example, that they are preoccupied as never before with sex. But I wonder if sexual explicitness is not a diversion, almost a form of conservatism. After all, that particular battle was fought and won by Freud and Lawrence in the first quarter of this century. The real resistance now is to an art which forces its audience to recognize and

accept imaginatively, in their nerve ends, not the facts of life, but the facts of death and violence: absurd, random, gratuitous, unjustified, and inescapably part of the society we have created. "There is only one liberty," wrote Camus in his *Notebooks,* "to come to terms with death. After which, everything is possible."

Summary

As I see it, once suicide is admitted wholly into the arts it begins to dominate them. The movement is from a flamboyant but relatively superficial gesture, enhancing the figure of the artist, to something integral to the nature of art itself. For the Romantics suicide was important and also inevitable, given the ideal of the poet as young and doomed, and their theories of the interconnection between life and art. But in the twentieth century the collapse of all traditional values, including religion, is taken for granted as the basis for art. Suicide thus becomes progressively more central as the neoreligious defenses—aesthetics and politics—fall away. For example, the Dadaists' rejection of everything, including their own art, landed them with a cult of suicide as the ultimately desirable psychopathic gesture, replacing and improving upon the work of art. For more serious and creative figures suicide becomes an integral element of their work as the reality mirrored in their work has become increasingly more volatile and violent. In order to create a language adequate to the destructive element, they find themselves committed to forms of psychic exploration that make the creative act steadily riskier and more demanding, forcing them to live beyond their existential means, and changing their role from that of hero to victim and scapegoat. I suggest that there are two solutions to the present artistic predicament. The first is a Totalitarian art which recreates in different ways a life in death or, in other words, those conditions of total deprivation—physical, moral, spiritual—which a totalitarian society produces in its victims. The second is Extremist art in which the artist internalizes the ubiquitous violence of his time and salvages his art from the edge of breakdown, from his own intimations of mortality. For both it is a question of holding a mirror up not to life, nor to death, but to life in a deadly context.

It may be that this goes against the grain of Dr. Perlin's anthology. After all, "the study of suicide" is validated, I suppose, by the idea that suicide is a disease to be cured. In contrast, the artists seem concerned

in a more immediately personal, less obviously therapeutic way. They view suicide not from the perspective of prevention but as a problem to be felt in the nerves and the senses, and powerfully expressed. What they offer, in short, is not solutions but understanding. And this seems to me at least as important as any more rigorously scientific approach to a desperately sensitive and confused subject.

Notes and references

1. See one of the earliest documents of English Romanticism, Edward Young's, *Conjectures on Original Composition* (1749): "An Original may be said to be a *vegetable* nature; it rises spontaneously from the vital root of genius; it *grows,* it is not *made* . . ." Raymond Williams, *Culture and Society 1780-1950,* New York: Columbia University Press (1958), p. 37.
2. This quotation and the two following are from Richard Friedenthal, *Goethe: His Life and Times,* New York: World Publishing Company (1965), pp. 128-30.
3. Quoted by Forbes Winslow, *The Anatomy of Suicide,* London (1840), p. 118.
4. William Empson, *Seven Types of Ambiguity,* New York (1931), p. 205.
5. Sigmund Freud, "Thoughts for the Times on War and Death (1915)" in *The Standard Edition of the Complete Psychological Works of Sigmund Freud,* trans. and ed. John Stachey with Anna Freud, London: Hogarth (1957), 14:291.
6. Maxime Du Camp, *Literary Recollections,* London (1893) 1:112; 2:122.
7. Gustave Flaubert, *Correspondance,* Paris (1887-93), 2:191, 58.
8. All the quotations in this paragraph are from Louis Maigron, *Romantisme et les moeurs,* Paris (1910). He has a particularly fascinating and informative chapter called "Romanticism and Suicide."
9. Winslow, *Anatomy of Suicide,* pp. 83-87, 136.
10. This is a large statement to stand unsupported. I have discussed this theme in detail in the title essay of *Beyond All This Fiddle,* New York: Random House (1969), pp. 7-11.
11. *Søren Kierkegaard's Journals and Papers,* ed. and trans. H. V. Kong and E. H. Kong, Bloomington, Ind.: Indiana University Press (1967), p. 345.
12. Wilfred Owen, *Collected Letters,* eds. Harold Owen and John Bell, New York: Oxford University Press (1967), p. 521.
13. Robert Jay Lifton, *Death in Life: Survivors of Hiroshima,* New York: Random House (1968), p. 500. And see "The Survivor," pp. 479-541.
14. Ibid., p. 528, quoting Keisuke Harada.
15. Used by Anne Sexton as epitaph to her *Selected Poems,* London: Oxford University Press (1964), p. ix.

16. Boris Pasternak, *An Essay in Autobiography*, trans. Manya Harari, New York: Fernhill (1959), pp. 91-93. *Shigalyovshchina* means, according to Mrs. Harari's notes, " 'Shigalyov methods.' Shigalyov is a conspirator in Dostoievski's *The Possessed* who 'sets outs from boundless freedom and arrives at boundless despotism.' According to another member of the conspiracy he says, 'everyone must spy and inform on everyone else . . . All are slaves and equal in their slavery . . .' "

17. Hannah Arendt, *The Origins of Totalitarianism*, New York: Harcourt, Brace (1951), pp. 423-24. See also the whole section "Totalitarianism in Power," pp. 376-428.

18. Tadeusz Borowski, *This Way for the Gas, Ladies and Gentlemen*, London: Jonathan Cape (1967), p. 64. I have discussed Borowski and the general problem of writing about the concentration camps in *Beyond All This Fiddle:* "The Literature of the Holocaust," pp. 22-23.

19. Andrzej Wirth, "A Discovery of Tragedy," *The Polish Review*, 12:43-52 (1967).

3 THE MORALITY AND RATIONALITY OF
SUICIDE

From the point of view of contemporary philosophy, suicide raises the following distinct questions: whether a person who commits suicide (assuming that there is suicide if and only if there is intentional termination of one's own life) is morally blameworthy, reprehensible, sinful in all circumstances; whether suicide is objectively right or wrong, and in what circumstances it is right or wrong, from a moral point of view; and whether, or in which circumstances, suicide is the best or the rational thing to do from the point of view of the agent's personal welfare.

The moral blameworthiness of suicide

In former times the question of whether suicide is sinful was of great interest because the answer to it was considered relevant to how the agent would spend eternity. At present the practical issue is not as great, although a normal funeral service may be denied a person judged to have committed suicide sinfully. The chief practical issue now seems to be that persons may disapprove of a decedent for having committed suicide, and his friends or relatives may wish to defend his memory against moral charges.

The question of whether an act of suicide was sinful or morally blameworthy is not apt to arise unless it is already believed that the agent

morally ought not to have done it: for instance, if he really had very poor reason for doing so, and his act foreseeably had catastrophic consequences for his wife and children. But, even if a given suicide is morally wrong, it does not follow that it is morally reprehensible. For, while asserting that a given act of suicide was wrong, we may still think that the act was hardly morally blameworthy or sinful if, say, the agent was in a state of great emotional turmoil at the time. We might then say that, although what he did was wrong, his action is *excusable,* just as in the criminal law it may be decided that, although a person broke the law, he should not be punished because he was *not responsible,* that is, was temporarily insane, did what he did inadvertently, and so on.

The foregoing remarks assume that to be morally blameworthy (or sinful) on account of an act is one thing, and for the act to be wrong is another. But, if we say this, what after all does it *mean* to say that a person is morally blameworthy on account of an action? We cannot say there is agreement among philosophers on this matter, but I suggest the following account as being safe from serious objection: *"X is morally blameworthy on account of an action A"* may be taken to mean *"X did A,* and *X* would not have done *A* had not his character been in some respect below standard; and in view of this it is fitting or justified for *X* to have some disapproving attitudes including remorse toward himself, and for some other persons *Y* to have some disapproving attitudes toward *X* and to express them in behavior."* Traditional thought would include God as one of the "other persons" who might have and express disapproving attitudes.

In case the foregoing definition does not seem obviously correct, it is worthwhile pointing out that it is usually thought that an agent is not blameworthy or sinful for an action unless it is a *reflection on him;* the definition brings this fact out and makes clear why.

If someone charges that a suicide was sinful, we may now properly ask, "What defect of character did it show?" Some writers have claimed that suicide is blameworthy because it is *cowardly,* and since being cowardly is generally conceded to be a defect of character, if an act of suicide is admitted to be both objectively wrong and also cowardly, the claim to blameworthiness might be warranted in terms of the above definition. Of course, many people would hesitate to call taking one's own life a cowardly act, and there will certainly be controversy about which

acts are cowardly and which are not. But at least we can see part of what has to be done to make a charge of blameworthiness valid.

The most interesting question is the general one: which types of suicide in general are ones that, even if objectively wrong (in a sense to be explained below), are not sinful or blameworthy? Or, in other words, when is a suicide *morally excused* even if it is objectively wrong? We can at least identify some types that are morally excusable.

1. Suppose I *think* I am morally bound to commit suicide because I have a terminal illness and continued medical care will ruin my family financially. Suppose, however, that I am mistaken in this belief, and that suicide in such circumstances is not right. But surely I am not morally blameworthy; for I may be doing, out of a sense of duty to my family, what I would personally prefer not to do and is hard for me to do. What defect of character might my action show? Suicide from a genuine sense of duty is not blameworthy, even when the moral conviction in question is mistaken.

2. Suppose that I commit suicide when I am temporarily of unsound mind, either in the sense of the M'Naghten rule that I do not know that what I am doing is wrong, or of the Durham rule that, owing to a mental defect, I am substantially unable to do what is right. Surely, any suicide in an unsound state of mind is morally excused.

3. Suppose I commit suicide when I could not be said to be temporarily of unsound mind, but simply because I am not myself. For instance, I may be in an extremely depressed mood. Now a person may be in a very depressed mood, and commit suicide on account of being in that mood, when there is nothing the matter with his character—or, in other words, his character is not in any relevant way below standard. What are other examples of being "not myself," of emotional states that might be responsible for a person's committing suicide, and that might render the suicide excusable even if wrong? Being frightened; being distraught; being in almost any highly emotional frame of mind (anger, frustration, disappointment in love); perhaps just being terribly fatigued.

So there are at least three types of suicide which can be morally excused even if they are objectively wrong. The main point is this: Mr. X may commit suicide and it may be conceded that he ought not to have done so, but it is another step to show that he is sinful, or morally blameworthy, for having done so. To make out that further point, it must be

shown that his act is attributable to some substandard trait of character. So, Mrs. X after the suicide can concede that her husband ought not to have done what he did, but she can also point out that it is no reflection on his character. The distinction, unfortunately, is often overlooked. St. Thomas Aquinas, who recognizes the distinction in other places, seems blind to it in his discussion of suicide.

The moral reasons for and against suicide

Persons who say suicide is morally wrong must be asked which of two positions they are affirming: Are they saying that *every* act of suicide is wrong, *everything considered;* or are they merely saying that there is always *some* moral obligation—doubtless of serious weight—not to commit suicide, so that very often suicide is wrong, although it is possible that there are *countervailing considerations* which in particular situations make it right or even a moral duty? It is quite evident that the first position is absurd; only the second has a chance of being defensible.

In order to make clear what is wrong with the first view, we may begin with an example. Suppose an army pilot's single-seater plane goes out of control over a heavily populated area; he has the choice of staying in the plane and bringing it down where it will do little damage but at the cost of certain death for himself, and of bailing out and letting the plane fall where it will, very possibly killing a good many civilians. Suppose he chooses to do the former, and so, by our definition, commits suicide. Does anyone want to say that his action is morally wrong? Even Immanuel Kant, who opposed suicide in all circumstances, apparently would not wish to say that it is; he would, in fact, judge that this act is not one of suicide, for he says, "It is no suicide to risk one's life against one's enemies, and even to sacrifice it, in order to preserve one's duties toward oneself."[1] St. Thomas Aquinas, in his discussion of suicide, may seem to take the position that such an act would be wrong, for he says, "It is altogether unlawful to kill oneself," admitting as an exception only the case of being under special command of God. But I believe St. Thomas would, in fact, have concluded that the act is right because the basic intention of the pilot was to save the lives of civilians, and whether an act is right or wrong is a matter of basic intention.[2]

In general, we have to admit that there are things with some moral obligation to avoid which, on account of other morally relevant consid-

erations, it is sometimes right or even morally obligatory to do. There may be some obligation to tell the truth on every occasion, but surely in many cases the consequences of telling the truth would be so dire that one is obligated to lie. The same goes for promises. There is some moral obligation to do what one has promised (with a few exceptions); but, if one can keep a trivial promise only at serious cost to another person (i.e., keep an appointment only by failing to give aid to someone injured in an accident), it is surely obligatory to break the promise.

The most that the moral critic of suicide could hold, then, is that there is *some* moral obligation not to do what one knows will cause one's death; but he surely cannot deny that circumstances exist in which there are obligations to do things which, in fact, will result in one's death. If so, then in principle it would be possible to argue, for instance, that in order to meet my obligation to my family, it might be right for me to take my own life as the only way to avoid catastrophic hospital expenses in a terminal illness. Possibly the main point that critics of suicide on moral grounds would wish to make is that it is never right to take one's own life *for reasons of one's own personal welfare,* of any kind whatsoever. Some of the arguments used to support the immorality of suicide, however, are so framed that if they were supportable at all, they would prove that suicide is *never* moral.

One well-known type of argument against suicide may be classified as *theological.* St. Augustine and others urged that the Sixth Commandment ("Thou shalt not kill") prohibits suicide, and that we are bound to obey a divine commandment. To this reasoning one might first reply that it is arbitrary exegesis of the Sixth Commandment to assert that it was intended to prohibit suicide. The second reply is that if there is not some consideration which shows on the merits of the case that suicide is morally wrong, God had no business prohibiting it. It is true that some will object to this point, and I must refer them elsewhere for my detailed comments on the divine-will theory of morality.[3]

Another theological argument with wide support was accepted by John Locke, who wrote: ". . . Men being all the workmanship of one omnipotent and infinitely wise Maker; all the servants of one sovereign Master, sent into the world by His order and about His business; they are His property, whose workmanship they are made to last during His, not one another's pleasure. . . . Every one . . . is bound to preserve himself, and not to quit his station wilfully. . . ."[4] And Kant: "We have

been placed in this world under certain conditions and for specific purposes. But a suicide opposes the purpose of his Creator; he arrives in the other world as one who has deserted his post; he must be looked upon as a rebel against God. So long as we remember the truth that it is God's intention to preserve life, we are bound to regulate our activities in conformity with it. This duty is upon us until the time comes when God expressly commands us to leave this life. Human beings are sentinels on earth and may not leave their posts until relieved by another beneficent hand."[5] Unfortunately, however, even if we grant that it is the duty of human beings to do what God commands or intends them to do, more argument is required to show that God does *not* permit human beings to quit this life when their own personal welfare would be maximized by so doing. How does one draw the requisite inference about the intentions of God? The difficulties and contradictions in arguments to reach such a conclusion are discussed at length and perspicaciously by David Hume in his essay "On Suicide," and in view of the unlikelihood that readers will need to be persuaded about these, I shall merely refer those interested to that essay.[6]

A second group of arguments may be classed as arguments *from natural law*. St. Thomas says: "It is altogether unlawful to kill oneself, for three reasons. First, because everything naturally loves itself, the result being that everything naturally keeps itself in being, and resists corruptions so far as it can. Wherefore suicide is contrary to the inclination of nature, and to charity whereby every man should love himself. Hence suicide is always a mortal sin, as being contrary to the natural law and to charity."[7] Here St. Thomas ignores two obvious points. First, it is not obvious why a human being is morally bound to do what he or she has some inclination to do. (St. Thomas did not criticize chastity.) Second, while it is true that most human beings do feel a strong urge to live, the human being who commits suicide obviously feels a stronger inclination to do something else. It is as natural for a human being to dislike, and to take steps to avoid, say, great pain, as it is to cling to life.

A somewhat similar argument by Immanuel Kant may seem better. In a famous passage Kant writes that the maxim of a person who commits suicide is "From self-love I make it my principle to shorten my life if its continuance threatens more evil than it promises pleasure. The only further question to ask is whether this principle of self-love can become a universal law of nature. It is then seen at once that a system of nature by

whose law the very same feeling whose function is to stimulate the furtherance of life should actually destroy life would contradict itself and consequently could not subsist as a system of nature. Hence this maxim cannot possibly hold as a universal law of nature and is therefore entirely opposed to the supreme principle of all duty."[8] What Kant finds contradictory is that the motive of self-love (interest in one's own long-range welfare) should sometimes lead one to struggle to preserve one's life, but at other times to end it. But where is the contradiction? One's circumstances change, and, if the argument of the following section in this chapter is correct, one sometimes maximizes one's own long-range welfare by trying to stay alive, but at other times by bringing about one's demise.

A third group of arguments, a form of which goes back at least to Aristotle, has a more modern and convincing ring. These are arguments to show that, in one way or another, a suicide necessarily does harm to other persons, or to society at large. Aristotle says that the suicide treats the *state* unjustly.[9] Partly following Aristotle, St. Thomas says: "Every man is part of the community, and so, as such, he belongs to the community. Hence by killing himself he injures the community."[10] Blackstone held that a suicide is an offense against the king "who hath an interest in the preservation of all his subjects," perhaps following Judge Brown in 1563, who argued that suicide cost the king a subject—"he being the head has lost one of his mystical members."[11] The premise of such arguments is, as Hume pointed out, obviously mistaken in many instances. It is true that Freud would perhaps have injured society had he, instead of finishing his last book, committed suicide to escape the pain of throat cancer. But surely there have been many suicides whose demise was not a noticeable loss to society; an honest man could only say that in some instances society was better off without them.

It need not be denied that suicide is often injurious to other persons, especially the family of a suicide. Clearly it sometimes is. But, we should notice what this fact establishes. Suppose we admit, as generally would be done, that there is some obligation not to perform any action which will probably or certainly be injurious to other people, the strength of the obligation being dependent on various factors, notably the seriousness of the expected injury. Then there is *some* obligation not to commit suicide, when that act would probably or certainly be injurious to other people. But, as we have already seen, many cases of *some* obligation to do something nevertheless are *not* cases of a duty to do that thing, *every-*

thing considered. So it could sometimes be morally justified to commit suicide, even if the act will harm someone. Must a man with a terminal illness undergo excruciating pain because his death will cause his wife sorrow—when she will be caused sorrow a month later anyway, when he is dead of natural causes? Moreover, to repeat, the fact that an individual has some obligation not to commit suicide when that act will probably injure other persons does not imply that, everything considered, it is wrong for him to do it, namely, that in all circumstances suicide *as such* is something there is some obligation to avoid.

Is there any sound argument, convincing to the modern mind, to establish that there is (or is not) *some moral obligation* to avoid suicide *as such,* an obligation, of course, which might be overridden by other obligations in some or many cases? (Captain Oates may have had a moral obligation not to commit suicide as such, but his obligation not to stand in the way of his comrades getting to safety might have been so strong that, everything considered, he was justified in leaving the polar camp and allowing himself to freeze to death.)

To present all the arguments necessary to answer this question convincingly would take a great deal of space. I shall, therefore, simply state one answer to it which seems plausible to some contemporary philosophers. Suppose it could be shown that it would maximize the long-run welfare of everybody affected if people were taught that there is a moral obligation to avoid suicide—so that people would be motivated to avoid suicide just because they thought it wrong (would have anticipatory guilt feelings at the very idea), and so that other people would be inclined to disapprove of persons who commit suicide unless there were some excuse (such as those mentioned in the first section). One might ask: how could it maximize utility to mold the conceptual and motivational structure of persons in this way? To which the answer might be: feeling in this way might make persons who are impulsively inclined to commit suicide in a bad mood, or a fit of anger or jealousy, take more time to deliberate; hence, some suicides that have bad effects generally might be prevented. In other words, it might be a good thing in its effects for people to feel about suicide in the way they feel about breach of promise or injuring others, just as it might be a good thing for people to feel a moral obligation not to smoke, or to wear seat belts. However, it might be that negative moral feelings about suicide as such would stand in the way of ac-

tion by those persons whose welfare really is best served by suicide and whose suicide is the best thing for everybody concerned.

When a decision to commit suicide is rational
from the person's point of view

The person who is contemplating suicide is obviously making a choice between future world-courses; the world-course that includes his demise, say, an hour from now, and several possible ones that contain his demise at a later point. One cannot have precise knowledge about many features of the latter group of world-courses, but it is certain that they will all end with death some (possibly short) finite time from now.

Why do I say the choice is between *world*-courses and not just a choice between future life-courses of the prospective suicide, the one shorter than the other? The reason is that one's suicide has some impact on the world (and one's continued life has some impact on the world), and that conditions in the rest of the world will often make a difference in one's evaluation of the possibilities. One *is* interested in things in the world other than just oneself and one's own happiness.

The basic question a person must answer, in order to determine which world-course is best or rational for him to choose, is which he *would* choose under conditions of optimal use of information, when *all* of his desires are taken into account. It is not just a question of what we prefer *now,* with some clarification of all the possibilities being considered. Our preferences change, and the preferences of tomorrow (assuming we can know something about them) are just as legitimately taken into account in deciding what to do now as the preferences of today. Since any reason that can be given today for weighting heavily today's preference can be given tomorrow for weighting heavily tomorrow's preference, the preferences of any time-stretch have a rational claim to an equal vote. Now the importance of that fact is this: we often know quite well that our desires, aversions, and preferences may change after a short while. When a person is in a state of despair—perhaps brought about by a rejection in love or discharge from a long-held position—nothing but the thing he cannot have seems desirable; everything else is turned to ashes. Yet we know quite well that the passage of time is likely to reverse all this; replacements may be found or other types of things that are available to us may

begin to look attractive. So, if we were to act on the preferences of today alone, when the emotion of despair seems more than we can stand, we might find death preferable to life; but, if we allow for the preferences of the weeks and years ahead, when many goals will be enjoyable and attractive, we might find life much preferable to death. So, if a choice of what is best is to be determined by what we want not only now but later (and later desires on an equal basis with the present ones)—as it should be—then what is the best or preferable world-course will often be quite different from what it would be if the choice, or what is best for one, were fixed by one's desires and preferences now.

Of course, if one commits suicide there are no future desires or aversions that may be compared with present ones and that should be allowed an equal vote in deciding what is best. In that respect the course of action that results in death is different from any other course of action we may undertake. I do not wish to suggest the rosy possibility that it is often or always reasonable to believe that next week "I shall be more interested in living than I am today, if today I take a dim view of continued existence." On the contrary, when a person is seriously ill, for instance, he may have no reason to think that the preference-order will be reversed—it may be that tomorrow he will prefer death to life more strongly.

The argument is often used that one can never be *certain* what is going to happen, and hence one is never rationally justified in doing anything as drastic as committing suicide. But we always have to live by probabilities and make our estimates as best we can. As soon as it is clear beyond reasonable doubt not only that death is now preferable to life, but also that it will be every day from now until the end, the rational thing is to act promptly.

Let us not pursue the question of whether it is rational for a person with a painful terminal illness to commit suicide; it is. However, the issue seldom arises, and few terminally ill patients do commit suicide. With such patients matters usually get worse slowly so that no particular time seems to call for action. They are often so heavily sedated that it is impossible for the mental processes of decision leading to action to occur; or else they are incapacitated in a hospital and the very physical possibility of ending their lives is not available. Let us leave this grim topic and turn to a practically more important problem: whether it is rational for persons to commit suicide for some reason other than painful termi-

nal physical illness. Most persons who commit suicide do so, apparently, because they face a nonphysical problem that depresses them beyond their ability to bear.

Among the problems that have been regarded as good and sufficient reasons for ending life, we find (in addition to serious illness) the following: some event that has made a person feel ashamed or lose his prestige and status; reduction from affluence to poverty; the loss of a limb or of physical beauty; the loss of sexual capacity; some event that makes it seem impossible to achieve things by which one sets store; loss of a loved one; disappointment in love; the infirmities of increasing age. It is not to be denied that such things can be serious blows to a person's prospects of happiness.

Whatever the nature of an individual's problem, there are various plain errors to be avoided—errors to which a person is especially prone when he is depressed—in deciding whether, everything considered, he prefers a world-course containing his early demise to one in which his life continues to its natural terminus. Let us forget for a moment the relevance to the decision of preferences that he may have tomorrow, and concentrate on some errors that may infect his preference as of today, and for which correction or allowance must be made.

In the first place, depression, like any severe emotional experience, tends to primitivize one's intellectual processes. It restricts the range of one's survey of the possibilities. One thing that a rational person would do is compare the world-course containing his suicide with his *best* alternative. But his best alternative is precisely a possibility he may overlook if, in a depressed mood, he thinks only of how badly off he is and cannot imagine any way of improving his situation. If a person is disappointed in love, it is possible to adopt a vigorous plan of action that carries a good chance of acquainting him with someone he likes at least as well; and if old age prevents a person from continuing the tennis game with his favorite partner, it is possible to learn some other game that provides the joys of competition without the physical demands.

Depression has another insidious influence on one's planning; it seriously affects one's judgment about probabilities. A person disappointed in love is very likely to take a dim view of himself, his prospects, and his attractiveness; he thinks that because he has been rejected by one person he will probably be rejected by anyone who looks desirable to him. In a less gloomy frame of mind he would make different estimates. Part of the

reason for such gloomy probability estimates is that depression tends to repress one's memory of evidence that supports a nongloomy prediction. Thus, a rejected lover tends to forget any cases in which he has elicited enthusiastic response from ladies in relation to whom he has been the one who has done the rejecting. Thus his pessimistic self-image is based upon a highly selected, and pessimistically selected, set of data. Even when he is reminded of the data, moreover, he is apt to resist an optimistic inference.

Another kind of distortion of the look of future prospects is not a result of depression, but is quite normal. Events distant in the future feel small, just as objects distant in space look small. Their prospect does not have the effect on motivational processes that it would have if it were of an event in the immediate future. Psychologists call this the "goal-gradient" phenomenon; a rat, for instance, will run faster toward a perceived food box than a distant unseen one. In the case of a person who has suffered some misfortune, and whose situation now is an unpleasant one, this reduction of the motivational influence of events distant in time has the effect that present unpleasant states weigh far more heavily than probable future pleasant ones in any choice of world-courses.

If we are trying to determine whether we now prefer, or shall later prefer, the outcome of one world-course to that of another (and this is leaving aside the questions of the weight of the votes of preferences at a later date), we must take into account these and other infirmities of our "sensing" machinery. Since knowing that the machinery is out of order will not tell us what results it would give if it were working, the best recourse might be to refrain from making any decision in a stressful frame of mind. If decisions have to be made, one must recall past reactions, in a normal frame of mind, to outcomes like those under assessment. But many suicides seem to occur in moments of despair. What should be clear from the above is that a moment of despair, if one is seriously contemplating suicide, ought to be a moment of reassessment of one's goals and values, a reassessment which the individual must realize is very difficult to make objectively, because of the very quality of his depressed frame of mind.

A decision to commit suicide may in certain circumstances be a rational one. But a person who wants to act rationally must take into account the various possible "errors" and make appropriate rectification of his initial evaluations.

The role of other persons

What is the moral obligation of other persons toward those who are contemplating suicide? The question of their moral blameworthiness may be ignored and what is rational for them to do from the point of view of personal welfare may be considered as being of secondary concern. Laws make it dangerous to aid or encourage a suicide. The risk of running afoul of the law may partly determine moral obligation, since moral obligation to do something may be reduced by the fact that it is personally dangerous.

The moral obligation of other persons toward one who is contemplating suicide is an instance of a general obligation to render aid to those in serious distress, at least when this can be done at no great cost to one's self. I do not think this general principle is seriously questioned by anyone, whatever his moral theory; so I feel free to assume it as a premise. Obviously the person contemplating suicide is in great distress of some sort; if he were not, he would not be seriously considering terminating his life.

How great a person's obligation is to one in distress depends on a number of factors. Obviously family and friends have special obligations to devote time to helping the prospective suicide—which others do not have. But anyone in this kind of distress has a moral claim on the time of any person who knows the situation (unless there are others more responsible who are already doing what should be done).

What is the obligation? It depends, of course, on the situation, and how much the second person knows about the situation. If the individual has decided to terminate his life if he can, and it is clear that he is right in this decision, then, if he needs help in executing the decision, there is a moral obligation to give him help. On this matter a patient's physician has a special obligation, from which any talk about the Hippocratic oath does not absolve him. It is true that there are some damages one cannot be expected to absorb, and some risks which one cannot be expected to take, on account of the obligation to render aid.

On the other hand, if it is clear that the individual should not commit suicide, from the point of view of his own welfare, or if there is a presumption that he should not (when the only evidence is that a person is discovered unconscious, with the gas turned on), it would seem to be the

individual's obligation to intervene, prevent the successful execution of the decision, and see to the availability of competent psychiatric advice and temporary hospitalization, if necessary. Whether one has a right to take such steps when a clearly sane person, after careful reflection over a period of time, comes to the conclusion that an end to his life is what is best for him and what he wants, is very doubtful, even when one thinks his conclusion a mistaken one; it would seem that a man's own considered decision about whether he wants to live must command respect, although one must concede that this could be debated.

The more interesting role in which a person may be cast, however, is that of adviser. It is often important to one who is contemplating suicide to go over his thinking with another, and to feel that a conclusion, one way or the other, has the support of a respected mind. One thing one can obviously do, in rendering the service of advice, is to discuss with the person the various types of issues discussed above, made more specific by the concrete circumstances of his case, and help him find whether, in view, say, of the damage his suicide would do to others, he has a moral obligation to refrain, and whether it is rational or best for him, from the point of view of his own welfare, to take this step or adopt some other plan instead.

To get a person to see what is the rational thing to do is no small job. Even to get a person, in a frame of mind when he is seriously contemplating (or perhaps has already unsuccessfully attempted) suicide, to recognize a plain truth of fact may be a major operation. If a man insists, "I am a complete failure," when it is obvious that by any reasonable standard he is far from that, it may be tremendously difficult to get him to see the fact. But there is another job beyond that of getting a person to see what is the rational thing to do; that is to help him *act* rationally, or *be* rational, when he has conceded what would be the rational thing.

How either of these tasks may be accomplished effectively may be discussed more competently by an experienced psychiatrist than by a philosopher. Loneliness and the absence of human affection are states which exacerbate any other problems; disappointment, reduction to poverty, and so forth, seem less impossible to bear in the presence of the affection of another. Hence simply to be a friend, or to find someone a friend, may be the largest contribution one can make either to helping a person be rational or see clearly what is rational for him to do; this service may

make one who was contemplating suicide feel that there is a future for him which it is possible to face.

Notes and references

1. Immanuel Kant, *Lectures on Ethics,* New York: Harper Torchbook (1963), p. 150.
2. See St. Thomas Aquinas, *Summa Theologica,* Second Part of the Second Part, Q. 64, Art. 5. In Article 7, he says: "Nothing hinders one act from having two effects, only one of which is intended, while the other is beside the intention. Now moral acts take their species according to what is intended, and not according to what is beside the intention, since this is accidental as explained above" (Q. 43, Art. 3: I-II, Q. 1, Art. 3, as 3). Mr. Norman St. John-Stevas, the most articulate contemporary defender of the Catholic view, writes as follows: "Christian thought allows certain exceptions to its general condemnation of suicide. That covered by a particular divine inspiration has already been noted. Another exception arises where suicide is the method imposed by the State for the execution of a just death penalty. A third exception is *altruistic* suicide, of which the best known example is Captain Oates. Such suicides are justified by invoking the principles of double effect. The act from which death results must be good or at least morally indifferent; some other good effect must result: The death must not be directly intended or the real means to the good effect: and a grave reason must exist for adopting the course of action" [*Life, Death and the Law,* Bloomington, Ind.: Indiana University Press (1961), pp. 250-51]. Presumably the Catholic doctrine is intended to allow suicide when this is required for meeting strong moral obligations; whether it can do so consistently depends partly on the interpretation given to "real means to the good effect." Readers interested in pursuing further the Catholic doctrine of double effect and its implications for our problem should read Philippa Foot, "The Problem of Abortion and the Doctrine of Double Effect," *The Oxford Review,* 5:5-15 (Trinity 1967).
3. R. B. Brandt, *Ethical Theory,* Englewood Cliffs, N.J.: Prentice-Hall (1959), pp. 61-82.
4. John Locke, *Two Treatise of Government,* Ch. 2.
5. Kant, *Lectures on Ethics,* p. 154.
6. This essay appears in collections of Hume's works.
7. For an argument similar to Kant's, see also St. Thomas Aquinas, *Summa Theologica,* II, II, Q. 64, Art. 5.
8. Immanuel Kant, *The Fundamental Principles of the Metaphysic or Morals,* trans H. J. Paton, London: The Hutchinson Group (1948), Ch. 2.

9. Aristotle, *Nicomachaean Ethics*, Bk. 5, Ch. 10, p. 1138a.
10. St. Thomas Aquinas, *Summa Theologica*, II, II, Q. 64, Art. 5.
11. Sir William Blackstone, *Commentaries*, 4:189; Brown in Hales v. Petit, I Plow. 253, 75 E.R. 387 (C.B. 1563). Both cited by Norman St. John-Stevas, *Life, Death and the Law*, p. 235.

JEAN LA FONTAINE

4 ANTHROPOLOGY

Durkheim demonstrated that the most private act of an individual, the taking of his own life, also has a social dimension. For Durkheim and the sociologists who have followed him, suicide can be seen as a product of society. He showed that rates of suicide can be studied in the same way as other social facts and like these social facts can be said to be characteristic of different societies. Changes in the forces acting on society can be seen to affect suicide rates and the rates can be shown to vary for different, socially-defined categories of people. Primitive societies are no different from the so-called industrialized societies in this respect, so they can be included in the overall theory.

Durkheim held that society molds the individual both by the educative process through which the child becomes a member of a particular society and by the pressures to act in certain ways that society brings to bear upon its members. The acts of individuals are thus influenced by the values of the society of which they are a part. An important part of the investigation of any social fact thus lies in the analysis of what Durkheim called the collective repesentations, the cultural values, associated with it. These values may differ quite markedly from one society to another.

I am indebted to Professor Lucy Mair, whose comments on the first draft of this paper have improved it considerably.

The main focus of Durkheim's study was on suicide as an index of social integration; his hypothesis was that, except for the category of altruistic suicide, suicide was the result of social disorganization. This could occur in either of two ways: either society was unable, through inherent weaknesses or contradictions in its organization to integrate some individual members firmly into its structure, so that certain categories of persons represented weak points at which social strain might show (as suicides) and therefore could be said to be "at risk," or a society might be so organized that a number of individuals might be only weakly linked with one another and thus be subject to personal isolation which would induce them to take their own lives. The first case is an instance of social pathology, particularly under the influence of externally induced changes; in the second is a *type* of social organization in which the level of social integration is low. It is worth pointing out that in neither case can the social scientist predict which individuals may commit suicide but only which *categories* of persons are most susceptible.

In the third, distinctive category of altruistic suicide Durkheim was dealing with the converse:[1] a society in which individuals are so highly integrated into society that they destroy themselves in situations in which society holds that this is the proper thing to do. What distinguishes this category of suicide most clearly from the others is that a different cultural tradition is involved. Later anthropologists have followed out two main implications of this. Firstly, the case of Japan makes clear that a society may view suicide as an honorable act rather than a sin and hence to consider suicide as a universal indication of social pathology is mistaken. Secondly, whereas it is not necessary for the student of society to seek an adequate appreciation of the motives of individual suicides in order to understand the social significance of suicide in general, it is both legitimate and necessary to analyze the ideas connected with self-destruction that are subscribed to by the group and its subdivisions, and that therefore have an influence on the behavior of individuals.

The study of suicide in preindustrial societies was for some time inhibited by the comparisons with Western society implicit in the Durkheimian view, which was not seriously questioned for many years. It was assumed that these societies, being organized in small-scale communities, with a multiplicity of ties linking individuals to one another, were less likely to be subject to the social disorganization of which Durkheim wrote. The development of the functional school of anthropology favored

the conception of these societies as tightly knit units in which all institutions contributed to the maintenance of social integration, which was identified with social health. Hence, interest, if any, in suicide in these communities was confined to general statements on the incidence of suicide, usually characterized as low[2] and unaccompanied by calculation of actual rates or the analysis of cases.

It was left to Malinowski to provide a line of approach which, however, did not prove fruitful until other theoretical developments created a new overall view of society. I refer, of course, to what has been called "the best-known case in the history of anthropological theory": the case of Trobriand suicide, discussed by Malinowski in his *Crime and Custom in Savage Society*.[3] Malinowski's use of this material was designed to show the way in which public disapproval of a man who had committed a major sin, in this case incest, acted as a legal mechanism by inducing the offender to take his own life. His argument was concerned with the field of law but the case ultimately led anthropologists to reconsider the nature of suicide in primitive societies. The case fitted only uncomfortably into the category of altruistic suicide, for although one could argue that it was the force of society which induced the act, the cultural values in the Japanese and Trobriand cases are markedly different. In the first, the act is an honorable one; in the second, it is forced on the individual as the only escape from an intolerable situation and could not be said to earn the suicide posthumous social approval.

It was not, however, until 1952 that an anthropologist published evidence that forced a reassessment of the position. This was M. D. W. Jeffrey's account[4] of suicides found in Africa, and also in other parts of the world, which were directly connected with socially held beliefs in the possibility of ghostly vengeance upon the living. The suicide, by his death was believed to release a powerful force to take vengeance upon those who had injured him or thwarted his aims. This belief must not be confused with the private "neurotic" ideas of vengeance held by individuals who commit suicide; rather it is accepted in some societies as a means of social coercion available to individuals. Clearly, this type fitted badly into the typology derived from Durkheimian theory, for while an individual avenging himself might with difficulty be described as anomic or egoistic, yet suicide as a possible, not necessarily approved, course of action could not be classed within a category of altruistic suicide.

At this time anthropological theory in general was being reformulated

under the impact of the ideas of Weber and later theoreticians[5] influenced by him. As the means to a better understanding of the nature of society, the new approaches emphasized the analysis of social action and the interaction of individuals as they strove for socially evaluated goals, rather than the description of the structural rules governing the formation of groups and the relations between social roles. Attention was thus focused on the alternative actions possible for an individual member of any society and the constraints and incentives that determined choices. The behavior that anthropologists observe, which forms the data from which they draw conclusions about the society under observation, is thus the product of social forces that can be deduced from their overt manifestations in the acts of individuals. Social norms and values, inculcated in the individual as he matures, form a major influence on him.

The anthropological study of suicide benefited from these general developments in theory; in 1960 *African Homicide and Suicide*[6] was published. This book embodied the results of planned comparative research into homicide and suicide in several African societies. In theoretical outlook it reflects modern anthropological premises which can be briefly summarized as follows: society, whether industrialized or not, normally involves conflict and the inability of all individuals to conform completely to social norms. Integration and conformity are ideal formulations to which real societies only approximate; their absence is not necessarily an indication of social pathology. Different institutional complexes may uphold different ideals of conduct and make different and sometimes contradictory claims on individuals. A notable example is the conflict that occurs in many societies between the norms of impartiality in office to which public officials must subscribe and the duty also sanctioned by society in a number of ways to help and support kinsmen, friends, and affines. Each individual plays a number of different social roles and must allocate the resources available to him in order to fulfill a variety of claims on him. In the course of his life he may be forced to choose between conflicting claims and suffer the consequence of failure to fulfill some claims in order to satisfy others. His aims may conflict with the aims of others so that he is forced into rivalry with them. In some cases certain roles in different areas of social life may be mutually incompatible, so that particular individuals who must assume them will be subject to stress, for example, traditional rulers in many African societies who were forced to act as agents of colonial administrations. In his

choice of action the actor is influenced by the values, the collective representations, of his society and by the behavior of others with whom he has socially defined and sanctioned relationships. Suicide, like homicide, may be precipitated by a combination of these forces acting on the individual. Other forces such as economic fluctuations and the psychological makeup of individuals must generally be taken as given for anthropological purposes.

Cultural values serve as a starting point for an anthropological analysis of suicide. Anthropologists are interested in comparing societies with different cultures but the internal comparison of the values held by subgroups of a society, particularly a large and heterogeneous one, is quite as important. The concern for social values and their relationship to the structure of social forces that affect the incidence of suicide is characteristic of anthropological analysis.

A problem which has much concerned sociologists but which has not been central to the anthropological analysis of suicide is that of defining what shall be termed suicide. The societies that anthropologists study are usually characterized by small communities, in which the individual is well known personally to others with whom he comes in contact; the lack of privacy typical of these communities further militates against situations in which the cause of anyone's death is unknown. Furthermore, the means by which suicide is accomplished is stereotyped and distinctive in many societies, so that accidental deaths or homicide are unlikely to be confused with death by suicide. In many societies it is rare to find suicide by poison or drugs. Some methods such as hanging[7] require a steadfastness of purpose that makes the labeling of death by suicide unequivocal.

Yet, among the Yuit Eskimo as described by Leighton and Hughes[8] the situation is exceedingly complex. Here an individual may decide to die so that his spirit may save the life of a close kinsman or to acquire the prestige that this society affords the person who makes an honorable end of his life while at the height of his powers. But his death is a public ceremonial and the central act is performed by his closest kinsman, who is ritually purified afterwards. In this society the decision to die and its implementation are separate acts, but the man who deals the death blow is an agent of his victim, which makes a public performance essential to demonstrate this. In simple societies death is commonly considered the responsibility of some living person, although culpability may be considered mystical, for example, as due to witchcraft or sorcery. Responsi-

bility for a suicide rests with the dead man himself. In societies where suicide is considered sinful (as among the Joluo[9]) the corpse may be punished. Among the Eskimo, those kin who would have the duty to avenge the death were it homicide perform their act publicly and are later ritually cleansed. The Eskimo case thus comes under the definition of suicide that is usually implicitly recognized by anthropologists: a death for which responsibility is socially attributed to the dead person.

Since anthropologists consider that suicides are the results of forces acting on individuals, they must also consider courses of action in such situations that might offer alternatives to suicide. Firth[10] writes of the Tikopia method of committing suicide by setting out to sea in a canoe, a voyage likely to result in death. If, as occasionally happens, the man survives and returns he would not lose prestige, unlike a Japanese who attempted suicide and failed. Suicide thus appears as a means of escaping the community and its pressures. In some societies there are other means of escape, such as voluntary exile, which are socially acceptable. However, voluntary exile was likely to result in death at the hands of strange communities unless the exile had a means of establishing social relations with them.

Self-imposed exile is not the only alternative to suicide; the role of madman, ritual expert, or saint may provide an escape from the pressure to conform or the conflicts of social relationships. This may not be recognized as such by the people concerned, but the anthropologist can compare the case-histories and social characteristics of such individuals with those of suicides and determine whether there are similarities which would justify calling exile, madness, or other forms of withdrawal alternatives to suicide in a given society. Socially *recognized* alternatives are also of great importance. Suicide can be studied as one of a number of socially defined courses of action open to an individual in certain situations. Among the Gisu of Uganda it seemed that suicides of the elderly sick usually took place after a variety of other means of alleviating their condition had been tried and proved ineffective. In some societies suicide may be seen as a last resort.

The basis of the anthropological study of suicide is a thorough familiarity with the society or societies concerned. This involves study of the constituent social groups, and the pressures they bring to bear on individuals as well as the rewards they offer to members. Equally important is the study of interpersonal relationships and the nature of the various

roles assumed by individuals in different institutions during the course of their lives, the assessment of the means whereby society ensures conformity to rules of conduct, the socially approved goals and the means by which individuals may attain them. Most anthropologists writing on suicide sum up this material briefly as an introduction but it is essential to their interpretation.

Methodological issues

It has been established that an important focus of anthropological research is the set of ideas that evaluate suicide in any one community.[11] The words in the local language that are used to designate acts of self-destruction are of themselves of interest in this respect, and the distinctions drawn between various forms of death can indicate much of importance to the investigator. The ideas and the words that embody them must be seen not in isolation but as part of a society's overall view of the nature of death, of the human personality, and the existence of belief in nonhuman powers. Among the Gisu suicide is not the act of a person of "unsound mind"; for them it is a rational act, a deliberate choice between life and death, although subsidiary theories account for the fact that in the same situations some people may choose death and others will not. The ancestors are thought on occasion to destroy their descendants by influencing them to commit suicide; the malice of living people, which manifests itself in witchcraft and sorcery may cause misfortune but cannot, the Gisu hold, make a man commit suicide. It is the possibility of ancestral wrath being manifest that largely accounts for the postsuicide ritual of cleansing from contamination the people associated with the dead man and the place where the act was performed.[12]

In many, if not all, societies there are two types of "explanation" of social phenomena, which are not always mutually consistent. Firstly, there is usually a generally held, philosophical view and secondly, the set of explanations offered for particular instances. Gisu, like Americans or Englishmen, will often talk differently when they are discussing suicide generally and when they are discussing particular cases, and will argue different points of view. A man's interpretation of events may vary according to his social status; women may have distinctive ideas characteristic of their sex. It is thus vital to record a variety of informants' views, both on general theories and on particular cases. The Gisu do not cite

the sufferings of old age and sickness as motives for suicide when discussing it generally; they did attribute a number of particular instances of suicide to this cause.

Ideas are often only implicit in behavior. Members of a society are also unaware of the interpersonal conflicts and inconsistencies in roles that are the product of their social organization. Ritual symbolism may express strongly-held attitudes to life and death that are never verbalized. The means of disposing of a suicide's body may be explained to the observer as "customary" but it also reveals underlying social values. Participant observation is a means of collecting nonverbal data and of relating what people say they do to their actual behavior.

The essays in *African Homicide and Suicide* show a variety of ways in which case histories can be used: to illustrate "typical" social situations that lead to suicide (Fallers on the Soga), to illustrate socially held values or their breach (Wilson on the Luo), to determine whether cases of suicide are explicable in terms of the society's own assessment of motive or not (La Fontaine on the Gisu). In all these pieces of research, case histories supplement the information that can be acquired by other means.

The peoples which anthropologists have traditionally studied are those that have recently emerged or are emerging from a small-scale type of organization into world society, based on an industrialized economy. For this reason it is rare for an anthropologist to find ready at hand the records and statistics on which sociologists base their work. The anthropologist must usually search through a variety of sources in order to find records of suicides, and much of the data is uneven or lacking in sufficient information to be useful. For the research on which *African Homicide and Suicide* is based, anthropologists went through records of inquests, police files, and the memories of their informants in order to obtain their cases. Much of the data was incomplete and even where the records were full as far as the recording authorities were concerned, they lacked anthropological detail of a vital nature. Often the authorities were concerned merely to establish that the case was not one of murder. Sophisticated statistical analysis is not therefore usually possible and tables of rates and frequencies have to be viewed with caution. However, this relates to deficiencies in the data, and in societies where better records are kept, such as the Navajo, a greater use can be made of statistics.

Discussions of the reliability of statistics even where careful records

are kept show, however, that there are difficulties that derive essentially from the attitude of the community to suicide as an event. There may be a premium on hushing-up suicide and presenting it as natural death or accident. Two articles in *African Homicide and Suicide* demonstrate the different effects of cultural values of this sort: The Gisu of Uganda feel that ritual cleansing after a suicide is necessary to protect the suicide's close kin from danger and to prevent the contagion of suicide, causing the suicide of anyone passing the spot where the suicide occurred. To conceal a suicide is thus both dangerous and culpable; moreover, it is not possible to perform the necessary ritual in secret. On the other hand, the Joluo of Kenya who hold similar attitudes, manage, according to Wilson, to keep knowledge of cases of suicide within the clan, lest its prestige in the community suffer. Before attempting to collect data on suicides that have occurred, the anthropologist must investigate the possibility of attitudes of this sort biasing his sample. Certain means of suicide such as poison may lend themselves more readily to his deception, so that a relatively common method of suicide may appear rare. Qualitative material is useful as a check against this, and indeed in most non-Western societies such concealment seems rare and difficult.

It is established that in most small-scale societies suicide rates are relatively low. A low suicide rate in a small community means a very small number of cases; anthropologists, therefore, must face the problem of attempting a quantitative analysis of a very small number of cases. They have usually solved this by collecting cases over a number of years in order to obtain a sufficiently large sample to warrant statistical treatment. But this method has its own difficulties. First, care must be taken to assess the effect of the passage of time on the society in question in order to ensure that changes in social relations or in external factors have not made the time factor a source of differentiation within the sample. In societies such as those in Africa that are undergoing rapid change, this may be a serious problem. In addition, the problem of cross-cultural comparison may be complicated by the fact that rates for one society have been assessed over a period of time which may be considerably longer than that of another with which it is to be compared. Where yearly rates are to be compared these difficulties can be overcome, but where what is to be compared is the relative numbers of different categories of persons committing suicide, then the time factor may be of relevance. The migration of Alur men south to find work was found by Southall to be a signifi-

Table 1

Tribe	Time	No. of Cases
Soga	4 years	100
Gisu	10 years	100
Nyoro	10 years	61
Wanga (N. Kavirondo)	Unspecified	15
Joluo	Unspecified	220
Alur	20 (records missing for some years)	7

cant factor in considering homicide in Alur society and it seems likely, although his data were inadequate to test the hypothesis, that the increasing number of young men who are absent for long periods in this way must make earlier data on suicide not strictly comparable with the most recent cases. Table 1 above shows the number of cases and time depth which they represent for six essays in *African Homicide and Suicide*. It is clear that there are considerable doubts as to the strict comparability of this material.

Such quantitative material as is available for anthropologists can indicate problems for further research. Cross-cultural comparisons of this sort of data can show some interesting social differences. Table 2 compares Gisu and Soga suicides categorized by age and sex.

We see differing patterns between the sexes and between the two communities; for example, the number of suicides of Gisu men halves after age thirty-five, while that of Soga men continues at the same rate until age fifty. In the same way differences in the pattern of attributed motives in different societies may result in new insights. Taking the same two

Table 2

Age	Soga suicides		Gisu suicides	
	Men	Women	Men	Women
Under 21	3	6	7	0
21-35	23	35	11	6
36-50	25	31	6	3
51-65	6	12	3	3
Over 65	4	6	5	0
"Adult"	8	10	x	x

Table 3

	Soga suicides		Gisu suicides	
	Men	Women	Men	Women
Physical distress (illness)	28	11	16	8
Mental disorder	6	2	2	5
Quarrels with kin	14	9	0	3
Following own misdeed	5	0	10	3
Unknown and other	11	4	12	9
Grief	3	3	0	0
Old and unwanted	2	2		

societies we can compare (Table 3) lists of motives and relative frequency with which they are attributed to suicides, male and female.

The categories of "grief" and "old and unwanted" were meaningful for the Soga but not applicable for the Gisu, although some Gisu did attribute these motives to particular cases of suicide. (Some compression of categories has also been necessary to exploit potential differences.) The Soga and Gisu have different ideas about motives for suicide which can be related to major differences in the structure of the two societies.

Different explanations may be necessary to explain rates for different categories; the suicide of men and women in the African cases discussed relate to different areas of social organization. In this respect Durkheim's concept of integration is still useful: certain categories of men and women are prone to commit suicide because they are more likely to become isolated or find that their chances of achieving a satisfactory status within the community is low. In small-scale societies those without close kin, particularly children, are both lacking in the normal support of loyalty and help that kinsmen provide and have low status in the community. Some suicides are the result of community disapproval, as Malinowski first pointed out.

Nevertheless, Durkheim's theory is too crude to explain adequately all the anthropological data gathered; as Bohannan commented: ["When we come] to discuss suicide, role situations seem to offer a better framework than relationships." For example, Levy[13] has considered the different behavior required of Navajo in various roles and concludes that traditional modes are inadequate to maintain the relationships that are important in modern Navajo society. In this respect Navajo men are more affected than women, since it is they who must undertake new roles. Changes of

fortune that affect the suicide rate are not a direct cause, but affect individuals' ability to grasp what is required in the changed roles and to play them satisfactorily.[14]

We must now return to a problem that was touched on earlier though in a different context, the problem of assessing the effects of change on the suicide rate of a community. Implicit in Durkheim's discussion of anomie is the assumption that the breakdown of social institutions causes anomie and hence an increase in the suicide rate. The impact of modern economic and social institutions on small-scale societies usually has the effect of lessening the hold of traditional controls on individuals and weakening traditional groupings. Rapid changes in economic conditions, and the introduction of new means of subsistence and new individual goals also change the pattern of social relations. Where records permit, the accompanying changes in the suicide rate can be studied, but frequently the rapidly changing communities are just those for which records are inadequate and become more faulty the further back in time the researcher goes.

Other techniques have been developed, to study change and variations produced by social change, which are essentially synchronic and thus have the advantage of using comparable data. In particular, anthropologists compare different subdivisions of the society, usually different communities for comparison. In *African Homicide and Suicide* both Southall and Fallers use this method. Considering Alur homicide, Southall compares the rates for different sections of the Alur homeland with the rate for migrant Alur in other parts of Uganda and concludes that the heterogeneous, highly mobile community in which migrants live is conducive to higher rates of homicide than in the homeland where traditional controls on violent behavior still operate.[15] The method used by Fallers for suicide uses three divisions within Busoga, each characterized by different degrees of demographic and social change, in order to assess the effects of change of both homicide and suicide rates. His conclusion contradicts the assumption that social change necessarily causes anomie and higher suicide, for he finds that a lower homicide and suicide rate are characteristic of the area of greatest change. He explains this in terms of the lessening of conflicts where individuals may now escape traditional obligations and the interpersonal hostilities that derive from certain aspects of traditional organization. Hence, we must conclude that the effects of change may vary according to the community. In particular this

research demonstrates, what anthropologists now accept in considering other social facts, that whereas tightly structured relationships may bind people together, this very closeness may of itself produce conflicts. We do not yet know enough about social change to predict its effects, still less to control them.

Anthropology and the prevention of suicide

The anthropological view of society poses some fundamental questions to those who seek to change it in any way. The most important of these would seem to me to be the assumption implicit in the way social scientists regard suicide as a social phenomenon: that some suicide is "normal" in a community. The Tiv of Nigeria described by Bohannan seem to have the lowest incidence of suicide yet recorded; so few, indeed, that Bohannan was unable to document cases of Tiv suicide. Yet even they regard it as something which does happen and can discuss the stereotyped means by which it is accomplished. In discussing the honorable suicide, ritualized into a ceremonial occasion, of elderly Eskimo, Leighton and Hughes[16] conclude that the institution can be said to have a positive function for the society in that it rids the group of members who have outlived their usefulness and may become a social burden and provides for the transmission of their powers to others. An anthropologist might also argue that the enforced suicide of the Trobriand sinner eliminates the individual who is unable to conform to the basic rules of society and thus strengthens the community's norms. Whether one accepts this argument or not, suicide cannot be considered a social disease comparable to diseases of the body and equally susceptible to treatment.

A further assumption which anthropology questions is that the suicide is a pathological individual. In our own society suicide is associated with mental illness; indeed it is often considered proof of such derangement where none else exists. Other societies have divergent views. In some societies madness would preclude suicide, for only the sane individual is believed capable of a rational choice between life and death. The assessment of individual suicides as victims of mental disease depends largely on the fact that our society holds and teaches certain views about it. There is then no universal abhorrence of suicide; in societies where it is honorable, can one say without clear evidence that individuals who commit suicide are, *in terms of their own society,* pathological? They may be,

as among the Yuit Eskimo, respected men seeking an honorable end to a life which has already earned them prestige.

Contrary to popular belief, similar attitudes to suicide may not prevail in all sections of our society. In Britain the growth of a movement to permit voluntary euthanasia for the aged and incurably sick, and the legalization of abortion both indicate changing attitudes to the value of life and the right of an individual to take the responsibility for a decision of this sort. Self-immolation as a political act may bring veneration in some sectors. The collective representations through which individuals view suicide seem to have changed. There is a need for research to establish what sort of changes have taken place.

Anthropology is interested in the phenomenon of suicide as a source of information on the way in which a society's organization affects categories of persons within it. The anthropological study of suicide rates can reveal the categories of persons who, in a particular society or subsection of a society (for communities differ in this respect as in others), are most prone to commit suicide. Anthropology is concerned with the social elements common to the acts of self-destruction that occur in a community and how these relate to roles, structures, and related development, and resolution of conflicts in that community. Yet these studies do not reveal which particular individuals are potential suicides; those of other disciplines are more appropriate where this is the aim. An important conclusion of the studies of suicide so far is the indication that the social factors involved are highly complex and involve basic cultural values: the goals held out by society as desirable and the means by which they are to be attained. Moreover, the social evaluation of success or failure and the degree to which responsibility for this is believed to rest with the individual are also elements in the complex. How deeply society holds the individual responsible for his own failure, either to achieve the ends expected of him or to conform to social norms, and whether there are alternative outlets and explanations available to the unconforming individual: these enter into the social situation of suicide with which the anthropologist is concerned.

Notes and references

1. Subsequent criticism of Durkheim has concentrated on the nature of this category, for it makes clear that Durkheim is not clear on the relation-

ship between individual motives (which he rejects as data) and social values.

2. An earlier view, expressed by Briffault and Stienmetz, held that suicide was common in primitive societies, where people killed themselves at the slightest provocation. This was convincingly opposed by Westermark, who in 1908 pointed out that variation in the suicide rate was characteristic of primitive as well as more sophisticated societies. For a discussion of these theories see *African Homicide and Suicide,* ed. P. J. Bohannan, Princeton, N.J.: Princeton University Press (1960), Ch. 1, pp. 22-23.

3. Bronislaw Malinowski, *Crime and Custom in Savage Society,* London: Kegan Paul (1926), pp. 77-79.

4. M. D. W. Jeffreys, "Samsonic Suicide or Suicide of Revenge among Africans," *African Studies,* 2, no. 3:118-22 (1952).

5. To name only a few: Parsons and Homans among sociologists, Firth and Leach among anthropologists.

6. Bonhannan, *African Homicide.*

7. See L. A. Fallers and M. C. Fallers, "Homicide and Suicide in Busoga," in Bohannan, *African Homicide,* Ch. 3.

8. A. H. Leighton and C. C. Hughes, "Notes on Eskimo Patterns of Suicide," *South West. J. Anthrop.* 11:327-38 (Winter 1955).

9. G. M. Wilson, "Homicide and Suicide Among the Joluo of Kenya," in Bohannan, *African Homicide,* Ch. 7, p. 210.

10. Raymond W. Firth, *Tikopia Ritual and Belief,* Boston: Beacon Press (1967), Ch. 5.

11. See J. Levy, "Navajo Suicide," *Human Organization,* no. 24, 1965; See also Bohannan, *African Homicide;* Malinowski, *Crime and Custom.*

12. It should be pointed out that the contamination is magical and should not be interpreted as implying either guilt or shame.

13. Levy, "Navajo Suicide."

14. Durkheim himself maintained that social or economic change would affect the suicide rate.

15. His data did not permit a similar analysis for suicide.

16. Leighton and Hughes, "Notes on Eskimo Patterns," pp. 327-38.

RONALD MARIS
5 SOCIOLOGY

"Sociology" means the logic of human association. The unique contribution of sociology to the study of suicide has been the insight that collective behavior, such as that reflected in a group's suicide rate, requires a different level of explanation than individual behavior.[1]

I

The most cogent exponent of the sociological perspective as it relates to suicide has been the French social philosopher Émile Durkheim. It was Durkheim who first argued that society is *qualitatively* different from individuals. By interacting or associating with one another, social facts result which transcend any single individual contribution. Thus, the suicide rate as a collective representation cannot be explained by the motivations of any single suicide. The whole (the suicide rate) is greater or different in kind from its parts (individual suicides) *or* their sum.

If one can say that to a certain extent collective representations are exterior to individual minds, it means that they do not derive from them as such but from the association of minds, which is a very different thing. No doubt in the making of the whole each contributes his part, but private sentiments do not become social except by combination under the action of the sui generis forces developed in association. In such a combination, with the mutual alterations involved, they become something else. A chemical syn-

thesis results which concentrates and unifies the synthesized elements and by that transforms them. Since this synthesis is the work of the whole, its sphere is the whole. The resultant surpasses the individual as the whole the part. It is in the whole as it is by the whole. In this sense it is exterior to the individuals. No doubt each individual contains a part, but the whole is found in no one. In order to understand it as it is one must take the aggregate in its totality into consideration. It is that which thinks, feels, wishes, even though it can neither wish, feel, nor act except for individual minds. We see here also how it is that society does not depend upon the nature of the individual personality.[2]

Accordingly, analysis of case histories cannot constitute an adequate explanation of the suicide rate. Furthermore, Durkheim claimed that his data showed no significant association between suicide rates and alcoholism, insanity, race, or genetic factors.

Sometimes men who kill themselves have had family sorrow or disappointments to their pride, sometimes they have had some moral fault with which they reproach themselves, etc. But we have seen that these individual's peculiarities could not explain the social suicide rate; for the latter varies in considerable proportions, whereas the different combinations of circumstances which constitute the immediate antecedents of individual cases of suicide retain approximately the same frequency. They are therefore not the determining causes of the act which they precede.[3]

Since the suicide rate is a social product, its explanation must be social. Let us explore what this meant to Durkheim. To begin with, social facts, like the moral code of a group, are external and constraining. Social phenomena may assume such external and concrete embodiments as codes of law, monuments, architectural forms, books, rules of etiquette, or statistical regularities—such as the suicide rate.[4] Talcott Parsons calls our attention to another sense of externality—its "epistemological" sense.[5] To illustrate, suicide statistics are only manifestations of social reality—not social reality itself. Social reality is an analytical abstraction and is external to individuals.

Constrainte in Durkheim's works is best translated as regulation. Thus, social life is *nomic* life; it is governed by rules. The antithesis of social life is lawlessness or anomie, the unbridled state of nature characterized by Hobbes as the *bellum omnium contra omnes*.

Durkheim felt that the collective conscience of a group was a major source of control. Each social group has a set of beliefs and sentiments, a totality of social likeness. This *constrainte* is manifested in the law,

codified prescriptions and proscriptions of major importance. When the collective conscience of a group is functioning properly, solidarity or cohesion results. *Solidarité* refers to a type of relationship between the whole and its parts. Durkheim conceived of society as an integer, that is, as a whole. An "integrated" social situation is one in which individuals are strongly attached to society's governing rules by a sense of moral obligation or structural interdependence, or both, and is characterized by strict sanctions for disobedience of the rules. A state of morality (*nomia*) prevails when individual interests are subordinated to the common interest. Durkheim was clearly influenced in his conception of morality by Immanuel Kant's notion of a "categorical imperative," viz., that it is the duty of each individual to act so that his private will could become a universal law.

For Durkheim the suicide rate depends upon forces external to and constraining of individuals. To the degree that the societal groups are harmonious, integrated, and regulated and the individual is an active, central member of those societal groups, then the individual's suicide potential will be low and a population of such individuals will have a low suicide rate. Durkheim, therefore, concluded that "the suicide rate varies inversely with the integration of social groups of which the individual forms a part."[6]

This theoretical proposition was arrived at by determining the common denominator of thirty or more specific empirical propositions. Indeed, Durkheim was among the first sociologists to collect data on suicide and to present the rates in tabular form. Among his well-known findings are that older adults have higher suicide rates than children and young adults; that the male suicide rate is almost three times the female rate at all ages; that Protestants have higher suicide rates than Catholics, who in turn have higher rates than Jews; that the suicide rates of the unmarried, especially the divorced, exceed the rates of the married; that upper social classes and the rich have relatively high suicide rates; that soldiers have higher suicide rates than civilians; and that the suicide rate of the sane is greater than that of the insane.[7] All of these particular research results are explained (some better than others) by the postulate on social integration.

However, it does not necessarily follow that there is only one type or cause of suicide. Durkheim argued that the two primary determinants of suicide were "egoism" and "anomie." Egoism connotes a lack of mean-

ingful social interaction; while anomie refers to the lack of normative restraints on behavior. Groups with high suicide rates tend to be made up of individuals who are socially isolated from significant others and who, since they do not participate in society, do not benefit from social sanctions or normative restraints on their behavior. Thus, we can refine Durkheim's general explanation of the suicide rate to read that the suicide rate varies inversely with external constraint *and* that external constraint has two dimensions, viz., integration (egoism) and regulation (anomie). That is, when social integration and regulation are high, egoism and anomie—and the suicide rate—are low. Durkheim does mention two other minor causes of suicide, "altruistic" (the polar type of egoistic) and "fatalistic" (the polar type of anomic). Altruistic suicide results from excessive integration as in hari-kiri and fatalistic suicide occurs under conditions of excessive regulation such as black suicides in jail in repressive communities. Durkheim, Halbwachs, and recently Johnson, claim that empirical studies of suicide reveal altruistic and fatalistic suicide to be so infrequent that they need not be included in a general explanation of suicide.[8] However, there is controversy about this conclusion.

Subsequent testing of Durkheim's hypotheses in different settings have largely supported his conclusions. Critical reactions to Durkheim's *Suicide* will be examined in an effort to convey major developments in the sociological study of suicide since Durkheim's work at the turn of the century.

II

One of the cornerstones of the evolution of sociological research has been the increasing insistence upon operational definitions; that is, the meaning conveyed in the measurement of the concept being defined. Jack Gibbs has insisted that Durkheim's theory of suicide cannot be tested (i.e., confirmed or proved false) because "social integration" is not operationally defined.[9] With Walter Martin, Gibbs uses modern theory construction techniques and statistical methods to test Durkheim's proposition on status integration and the suicide rate.[10]

Searching for a proposition with empirical referents, Gibbs and Martin posit a theory with five postulates and a major theorem. The initial postulate is that suicide rate is inversely related to the stability and dura-

bility of social relationships. This proposition is intended as a translation of Durkheim's social integration proposition. Unfortunately, it seems as difficult to test as Durkheim's. Thus, Gibbs and Martin are forced to make a series of logical inferences which I have paraphrased as follows:

P1. The lower the suicide rate, the more stable and durable social relationships.

P2. The more stable and durable social relationships, the more conformity to social expectations.

P3. The more conformity to social expectations, the less role conflict.

P4. The less role conflict, the less individuals occupy incompatible statuses.

P5. The less individuals occupy incompatible statuses, the more status integration.

T1. The lower the suicide rate, the more status integration (by P1-P5 and the hypothetical syllogism).

Gibbs and Martin's status-integration theory predicts an inverse relationship (here a negative product-moment correlation) between the suicide rate and "status integration." "Status integration" means the frequency with which a particular status configuration is occupied. The greater the frequency of "occupation," the higher the status integration and the lower the suicide rate.

Having operationalized their major theorem, Gibbs and Martin test it with varying status configurations. A high percentage of correlations between status integration and suicide rates are in the direction predicted by the theorem. A major contribution of Gibbs and Martin is their formal attempt to test Durkheim's generalization about the suicide rate and social integration. However, the theory of status integration has been criticized. For example, Chambliss and Steele[11] argue that Gibbs and Martin add "auxiliary hypotheses": e.g., the claim that some infrequently occupied statuses are *not* associated with high suicide rates because they are in the process of becoming integrated; or that one of the statuses in a particular status configuration must be ascribed, and so forth—which make their theory as difficult to test as Durkheim's vaguely defined statement about social integration and the suicide rate.

Chambliss and Steele also object that since professionals make up less of the work force than do laborers, they ought to have higher suicide rates. (Data by Breed from New Orleans and Maris from Chicago show

just the opposite.[12]) However, the theory of status integration is responsive to such arguments by its assumption of status *sets,* not single statuses like occupation. Labovitz and Hagedorn state that the status integration theory implies "the less role conflict, the more status integration." But there are status configurations where actual occupance and role conflict can be *both* low or high. For example, cannot the high proportion of males engaged in semiskilled labor be accompanied by a high amount of role conflict? Furthermore, between 1940 and 1950 in the United States occupational integration of females decreased, *but* their suicide rates also decreased. To this criticism Gibbs and Martin repeat that the suicide rate is not determined by a single status and add that "a few" negative examples do not repudiate their theory. At this time many of the issues raised are still unresolved.

III

If we are indebted to Durkheim for the concepts of social integration, collective conscience, social facts, anomie, and egoism, then to Max Weber[13] sociology owes the notions of *Verstehen,* motivation, intention, social class, formal organization, bureaucracy, power, authority, values, rationality, and many more.

Weber distinguishes between empirical or observational understanding of social behavior and motivational or subjective understanding. The former he called *Begreifen* and the latter, *Verstehen.* For example, *Begreifen* could be achieved by discovering frequency of participation of Protestants, Catholics, and Jews in business. However, *Verstehen* of these rates of participation could only be arrived at by an analysis of the values and sentiments of religious groups, such as Weber undertook in his book, *The Protestant Ethic and the Spirit of Capitalism. Verstehen* gives rise to "meaningfully adequate" understanding.

Social behavior exists only when an individual's conduct is meaningfully oriented toward that of others. The subjective intention of action is an indispensable criterion for determining social situations. Consider the conversation of two students of elementary German. If they are both just imitating a printed and memorized conversation at proper times, then the situation is nonsocial, that is, they are not interacting.

From the work of George Herbert Mead[14] sociologists realized that there can be no self without social experience, because the ability to com-

municate with oneself—taking yourself as an object—is dependent upon having communicated with others. The individual gets outside himself by seeing himself as others do (what C. H. Cooley called the "looking-glass self") and by taking the attitudes of other individuals toward him. Often we literally do not know whether we are intelligent or beautiful until a set of individuals pass judgment upon us. Nevertheless, the self has two aspects which Mead calls the "I" and the "Me." The "Me" is the organized set of internalized attitudes of others toward you. The "I" is the individual's *response* to this set: it is, thus, the source of novelty, creativity, and uncertainty.

These concepts of Weber and Mead are brought to bear on the sociological study of suicide by Douglas in his *The Social Meanings of Suicide*.[15] Douglas believes that Durkheim's explanation of the suicide rate is neither operationally defined, nor based on data with a common social meaning. Three points are at issue: first, suicide has many meanings; second, suicide cannot be explained until we ascertain what it is we are trying to explain; and third, the way one arrives at the meanings of "suicide" is by observing the statements and behavior of individuals who engage in suicidal behavior. Douglas claims that "the meanings of suicidal actions are problematic." Indeed, there are cognitive, moral, and affective meanings of suicide. The usual procedure in sociology is to assume that the definitions of "suicide" are nonproblematic and to analyze the official statistics, for example, death certificates or coroners' or medical examiners' records—as Durkheim and Gibbs and Martin did. Unfortunately, contends Douglas, there are about as many "official" statistics as there are officials. It follows that official statistics are inadequate data for the study of suicide. According to Douglas, the best way to proceed is by "trying to determine the meanings [of suicide] to the people actually involved, i.e., the meanings to the labeled rather than the labelers, rather than taking as the definitions the unknown but assumed definitions of unseen officials." Many of the labelers of suicide do not agree among themselves on what suicide means. The story is told of one medical examiner who would only certify "suicide" if a suicide note were left. Contrary to Durkheim, Douglas argues that there is a need to consider the *internal meanings* of the external associations of suicide and abstract social characteristics like anomie and egoism. That is, a plea is being made for what Weber called *Verstehen*.

What "suicide" really is, is not so much the problem as is whether a

particular death fits the common definition. There are not that many meanings of suicide. Generally, one might say that suicide occurs when an individual engages in a life-style that he knows might kill him (other than living another day)—and it does. This is an omnibus definition of suicide, which includes various forms of self-destruction, such as risk-taking and many so-called "accidents." Note that most medical examiners mean suicide to be non-natural, nonhomicidal, or nonaccidental death. One implication of this official stance is that only the most dramatic cases of self-destruction are certified as suicide—that is, the shootings, hangings, jumpings, and so forth. Thus the official statistics are not so much wrong as they are incomplete. If police and medical examiners cover up suicides as accidents, this does not mean that suicide has many meanings; it means that a case can be misclassified. Since Douglas asserts that suicidal individuals *themselves* often do not understand the what or why of their acts, the "meanings" assigned to suicide take on a hit-or-miss quality.

Again in opposition to the Durkheimian perspective, Douglas claims that it is not possible to predict or explain specific types of social events, such as suicide, in abstract social terms like anomie or egoism. Since there is no common meaning used by the labelers of suicide, "official statistics cannot be expected to have any significant value in constructing or testing sociological theories of suicide." For example, one could easily argue against Durkheim that the more socially integrated an individual is, the more he and his significant others will try to avoid having his death categorized as a suicide, assuming that suicide is judged negatively. On the other hand, whether or not official suicide statistics are reliable and valid is an empirical question. Douglas does not demonstrate that all official statistics are unreliable or invalid; Jack Gibbs and Warren Breed argue that official statistics are reliable and valid enough for many propositions.[16] The usefulness of official statistics of suicide is still very much an open question. As Gibbs points out, one uses official statistics because there is no satisfactory alternative. Certainly particular motivations to suicide can be as misleading in explaining the suicide rate as abstract social characteristics like anomie and egoism. The practical exigencies of suicide research demand utilization of partial explanations, hunches, even intuition.

Finally, Douglas emphasizes the need to get at the "situated meanings" of suicide rather than their abstract meanings; he advocates "a basic reorientation of sociological work in suicide in the direction of intensive

observation, description, and analysis of individual cases of suicide."[17] At this point, Douglas seems to be returning to the medical model of intensive examination of particular cases. The most important sources of information on suicidal phenomena, according to Douglas, are the transcriptions and reconstructions of what individuals who made suicidal statements or committed suicidal actions said and did, and in what sequence. Clearly, Douglas's methodology shows affinity for what Harold Garfinkel[18] has dubbed "ethnomethodology," viz., uncovering the unstated, implicit, common-sense perceptions held and acted upon by participants in a situation.

The following questions remain: how does the researcher identify his subjects (i.e., suicides) for study, if he does not know what "suicide" means; how does one locate "suicidal statements" or a "suicidal action?" There seems to be the assumption that the individual understands himself better than any observer. This is not necessarily true. In defining the situation wholly in terms of the definitions offered by the patient, error can occur by accepting that definition as the *only* one. In doing so, the researcher may have become so personally involved in the relationship that he could no longer stand outside it.[19]

In conclusion, we should recognize that sometimes sociologists are prone to forget that social institutions have their origin in individual human exchange; on the other hand, we should recognize the many questions that are raised by reliance on ethnomethodology alone.

IV

No sociological study of suicide would be complete without mention of social psychology—a kind of merger of Durkheimian and Weberian methods. The focus is on the interplay between social facts, for example, institutions, status roles, values, and individual characteristics, that is, actual behavior in small groups. If institutions—societally prescribed systems of more or less differentiated behavior by means of which recurrent problems, like education, medical care, death, are resolved—can be thought of as social facts par excellence, then social psychology may be seen to focus on "subinstitutional" behavior, that is, how small groups of people actually interact and why. Homans is primarily concerned with explaining variations from prescribed rules by investigating face-to-face relationships among individuals.[20] His explanatory model is a combination of

Skinnerian psychology and classical economics and is generally designated "exchange theory." One of his fundamental assumptions is that reward equals profit less cost. Other principles spin off from this fundamental assumption. For example, interaction will tend to cease between any two individuals if costs continually exceed profits; liking increases with interaction, provided costs (and other things) are not too high; if interaction results in undeserved loss of profit, then anger will ensue; and so forth.

Homans argues that institutions as explicit roles governing the behavior of many people are obeyed because rewards—like money or social approval—other than primary ones are achieved by obeying them. But, sooner or later primary rewards, like food or esteem, must be provided. An institution is functional for society only because it is functional for men. Suicide rates cannot be explained only by variables like social integration; on the other hand, neither can suicide rates be explained by subinstitutional variables like situated meanings. An explanatory model is called for which incorporates interaction effects between institutional *and* subinstitutional levels of analysis.

Although the fit with Homans's approach is imperfect, the social-psychological study of suicide can be illustrated by Andrew Henry and James Short's *Suicide and Homicide*.[21] Henry and Short do relate the suicide rate to economic cycles. Although they agree with Durkheim that high social status and low external restraint are associated with high suicide rates, Henry and Short go further by adding the subinstitutional variables of "internal restraint" and frustration-aggression. Their basic position is that suicidal behavior is determined by both external and internal forces operating conjointly. (See Figure 1.)

Henry and Short assume that aggression is often, but not always, a consequence of frustration, that business cycles produce variation in the hierarchical ranking of persons and groups, and that frustrations are generated by interference with the "goal response" of maintaining a constant or rising position in a status hierarchy relative to the status position of others in the same system.

"External restraint" includes the notions of vertical restraint ("restraint deriving from one's subordinate position in a status hierarchy") and horizontal restraint ("restraint deriving from the degree of relational involvement with others"). For example, it is argued that blacks are more vertically restrained than whites and that the married are more horizon-

Figure 1. Reactions to restraint

External restraint

	High	Low
High	Anxiety	Suicide
Low	Homicide	Undetermined

Internal Restraint (High / Low)

Source: Andrew F. Henry and James F. Short, Jr., *Suicide and Homicide,* New York: Macmillan, The Free Press of Glencoe (1954), p. 121.

tally restrained than the divorced. Strong "internal restraint" is associated with self-oriented aggression. The stricter the superego restraint, the greater the internal restraint. Henry and Short argue that "the psychological legitimatization of other-diverted aggression consequent to frustration varies inversely with the degree to which other-oriented aggression threatens or has threatened the flow of nurturance and love." For example, if children are subjected to high parental severity, then rather than jeopardize the nurturance provided by their parents, the children will tend to vent their frustration upon themselves, both during childhood and later, when frustrated as adults.

Henry and Short claim that the reactions of both the suicide and homicide rates to the business cycle can be interpreted as aggressive reactions to frustration generated by the flow of economic forces and that frustration varies in its intensity and consequences depending upon sets of institutional and subinstitutional pressures. For example, they suggest that when people are subjected to strong external restraint and weak internal restraint, by virtue of either subordinate social status or intense involvement in social relationships, then it is easier to blame others when frustration occurs (i.e., circumstances favor externally directed aggressions like homicide or assault). But when external restraints are weak and in-

ternal restraints strong, the self must bear primary responsibility for frustration (i.e., circumstances favor internally directed aggression, like suicide and related forms of self-destructive activity).

Subsequent research on social status and suicide rates has raised serious questions about Henry and Short's, Durkheim's, and Gibbs and Martin's claim of a direct relationship between status and the suicide rate. Breed, Maris, Yap, Sainsbury, Lalli, and Turner have all found an *inverse* relationship between status and suicide.[22] If the lowest social classes do have the higher suicide rates, then, since they are highly restrained vertically, the possibility exists that strong external restraint causes high suicide potential in conjunction with certain subinstitutional variables. For example, research in the Johns Hopkins Suicidology program[23] provided data which indicates interaction is negative and that having many significant others *increases* suicide potential. Even if Henry and Short are correct in assuming a direct relationship between status and suicide, their explanation may be insufficient. Gold has argued that lower social classes are socialized to express frustration externally and that this conditioning, not the presence or absence of external restraint, accounts for their preference of homicide over suicide.[24] Furthermore, Gold feels that it is not proven that upper social status occupants have less external restraints than lower-status occupants.

At times Henry and Short assume that an increase in frustration will inevitably cause an increase in aggression. This is not always so. Some aggression is not the result of frustration. For example, there is the "instrumental" aggression of the United States airmen in World War II, who are reported to have felt little anger toward the German or Japanese civilian. Bombing was simply a job to be done. In other cases fear, not anger, may result from frustration. Survivors of the bombing of Hiroshima and Nagasaki felt as the predominant emotion fear of the United States immediately after the bombing, not anger. Finally, one has to distinguish among types of frustration. Maslow claims that the more basic or primary the frustration, the more likely anger will be felt.[25] Minor deprivations usually lead the nonhostile reactions, not aggression.

One of the most significant contributions of Henry and Short to the sociological study of suicide has been to refine Durkheim's treatment of anomic suicides, especially as it relates to economic change. Durkheim predicted that social changes would lead to a higher suicide rate because the normative (or institutional) order of society would be disturbed.

Thus, regardless of the direction of economic change (depression or prosperity), according to Durkheim, suicide rates should rise. Henry and Short's data confirm only half of Durkheim's prediction. That is, they found the suicide rate to be negatively correlated with business fluctuations. Contra Durkheim, during a rapid rise in the business index, suicide tends to fall. With very slight increases in the business index, during the final phases of increase, the suicide rate does increase—but primarily among females, namely, those least involved in the order and restraints provided by the economy. Generally business cycles are more highly correlated with the suicide of males than with the suicide of females. But the suicide of black females is more highly associated with business fluctuations than is the suicide of black males. Lastly, Durkheim argued that poverty protects against suicide, but the negative reaction of suicide to depression is stronger than the negative reaction of suicide to prosperity. Henry and Short explain the above findings by postulating that people in high-status categories experience greater frustration during downswings in business and less frustration during upswings in business than do low-status categories (women and blacks are both considered low-status categories). On the other hand, Albert Pierce correlated the index of common stock prices and the male suicide rate from 1919 to 1939 and discovered that the suicide rate does, as Durkheim claimed, vary directly with business anomie, regardless of the direction of economic change.[26] Pierce suggests that Henry and Short got different results because they used different and less appropriate indices of economic change.

In summary, Henry and Short's contributions to the sociological study of suicide are, first, that the interaction of institutional and subinstitutional forces with each other and with the suicide rate is introduced, especially in such concepts as "internal restraint." Second, that Durkheim's concept of anomic suicide is developed; and third, that like Gibbs and Martin, Henry and Short use modern statistical techniques and operational approaches in their analyses. Although the net result is a clear increment in the sociological understanding of suicide, the relationship between social mobility and the suicide rate seems to have been insufficiently considered in the aforementioned investigations.

V

In this concluding section it behooves us to shift the analysis to social change. That is, our primary concern will not be with either institutional

or subinstitutional variables but rather with some principles of dynamics of both types of variables. The analysis of social change is inherently more complex than that of social structure because the characteristics of the object of investigation are by definition in flux. Let us begin by looking at a few salient features of social mobility in industrial society and their explanations without specifically attending to suicide. Much of the important work in this area has been done by S. M. Lipset and R. Bendix.[27] They present a table of intergenerational mobility in the United States (1947) by gross socioeconomic status categories:

Table 1. Intergenerational mobility in the United States by occupational type of son vis-à-vis father, 1947.

		Son			
		Nonmanual	Manual	Farm	
	Nonmanual	71%	25%	4%	100%
Father	Manual	35%	61%	4%	100%
	Farm	23%	39%	38%	100%

Source: Seymour Martin Lipset and Reinhard Bendix, *Social Mobility in Industrial Society,* Berkeley: University of California Press (1963), p. 21.

Observe the diagonal running from top left to bottom right (71 per cent, 61 per cent, and 38 per cent). It indicates that most recruits for an occupational category come from within that category. That is, the society depicted in Table 1 is "stratified," and patterned inequalities of wealth, power, and prestige are observable. Especially in the upper socioeconomic categories there tends to be little social mobility. Kingsley Davis and Wilbert Moore have argued that social stratification is both functional and inevitable:[28] first, certain social positions are functionally more important than others and require special skills for their performance, e.g. medicine and law; second, only a limited number of individuals in any society have the talents which can be developed into the skills appropriate to these important positions; third, the conversion of talents into skills involves a training period during which sacrifices are made by those undertaking the training, e.g., college, medical school, internship, and residency; fourth, in order to induce the talented persons in a society to undergo these sacrifices, their future positions must carry differential inducement values; i.e., disproportionate access to the scarce rewards society has to offer, e.g., money and power; fifth, differential ac-

cess to wealth and power leads to differential prestige, i.e., to social stratification. Thus social inequality is both functional and inevitable. Having a nonmanual father enhances one's chances for a nonmanual position, because of differential educational opportunities and caste exclusiveness.

Still, Table 1 shows more upward mobility than downward mobility (compare the lower left of the table with the upper right). How is that possible? Basically, it is because industrialization of a society creates new nonmanual jobs—more than the sons of nonmanual workers can fill. Semiskilled and farm jobs are disappearing. Furthermore, fertility is inversely related to income. However, the important feature of Table 1 for the study of suicide is that upward mobility is the rule in industrial society. American social suicidologists are beginning to emphasize the importance of status loss, especially loss of occupational status, in male suicides. Sociologists like Warren Breed argue that white male suicides are distinguished from the normal population by their excessive downward mobility or "skidding."[29] Sociology is learning a lesson from psychiatry by beginning to pay more attention to the social dynamics of suicide; what might be called "suicidal careers."

For example, Breed has studied 103 suicidal careers of white males in New Orleans. Compared with 206 men who lived in the same block as the suicide, matched on sex, age, and race, suicides were disproportionately lower class. Only 50 per cent of the suicides were working full-time before dying. More important, for our present purposes, suicides showed a significantly different amount of downward mobility when compared with controls (see Table 2). Decreasing income characterized more than half of the suicides but just over 10 per cent of the controls. Mobility

Table 2. Intergenerational mobility among white male suicides and controls, New Orleans; sample from 1954-59 suicides.

Occupational level	Suicides	Controls
Subject's father higher	53%	31%
Subject's father lower	25%	38%
Subject's father same	22%	31%
	100%	100%
	(N=75)	(N=169)

Source: Warren Breed, "Occupational Mobility and Suicide Among White Males," *American Sociological Review*, 28, no. 2:183 (April 1963).

among suicides varied by occupational group. Generally, the less skilled the occupation, the greater the downward mobility before suicide. Breed offers a "structural-interaction" explanation of the feelings among subjects in these situations:

Measuring up to the standard gives the individual a feeling of achievement and self-satisfaction; falling below it produces a painful sense of failure, or self-devaluation, of shame. Using this criterion, many of our suicides were shown to lack competence on the job. And because in American society the work role is central for man, work failure is not inadequacy in just one role among many, but spreads through other roles and the self-image to threaten a general collapse of life organization.[30]

Breed's data on the importance of work failure and downward mobility have been supported by other social scientists. Powell argued that the greatest strain for males is not working.[31] Sainsbury found that increased social mobility or isolation is conducive to suicide.[32] Porterfield and Gibbs discovered that both upward and downward mobility were associated with a high suicide rate.[33] Maris's work in New Hampshire supports Breed's hypotheses on both work mobility and income loss.[34] (It may be noted that suicides were more successful at work than patients hospitalized for suicide attempts.)

These data raise several important questions. If the work-failure takes the population at large as his occupational reference group, then his vocational situation could be particularly stressful. But what if his group reference is other work failures, as perhaps in skid row "communities?" Perhaps some third factor is causing both work failure and suicide. It is not clear whether work problems are the cause or the result of the suicidal problem. Furthermore, it is probable that work problems are associated with so many outcomes—alcoholism, drug addiction, depression, or even resignation to and acceptance of failure—that it does not predict suicide. This raises the question of the various necessary sets of conditions for suicide. Several case studies of suicide compiled at Johns Hopkins suggest that depression, early object loss, isolation and rejection by significant others, alcoholism, possession of a gun, and poor physical health are some of the important contingents that greatly increase the suicide potential of old white males with work problems. It should be noted that in some suicides nothing seems to trigger the suicide. The Los Angeles Suicide Prevention Center staff wisely distinguishes between cases with a triggering factor ("acute suicides") and those where suicide

just seems to happen—if not today, then some other day ("chronic suicides"). I would hypothesize that the lower the suicide potential of any individual or risk-group, the greater the importance of a contingency factor, or factors, in causing suicide.

VI

Mention should be made of current needs in the sociology of suicide.[35] The official statistics of death must be made more reliable and valid. "Psychological autopsies" should be carried out on equivocal deaths over a period of years. Unless such a procedure (of a team of behavioral scientists investigating deaths, when the mode is uncertain) is followed by more medical examiners, many deaths will be misclassified. Of course, investigations are not the only answer. Attempts need to be made to standardize the criteria for "pronouncing" suicide as well. Once death records can provide a more representative population of suicides, a sample can be drawn and interview schedules administered to the survivors and controls.[36] Even more accurate and complete death certificates do not provide enough, nor the right kind of data; they do not help us to assess the development of suicide. After the national vital statistics are improved, a national sample of informants on suicide should be interviewed. Such a project would provide invaluable parameters for more specialized investigations of suicide. Along these lines, efforts should be made to calculate national suicide rates for more than just age, sex, race, and occupation.

Although Gibbs and Martin, and Henry and Short, have made a beginning in the application of modern multivariate and causal analysis techniques to the study of suicide, by far the majority of the work has utilized descriptive statistics. As suicidology matures, along the lines outlined above, analytical statistics should come into prominence.[37]

It is difficult and unwise to choose between the sociological perspectives presented. It is hoped that, when the objectives noted have been realized, it will be possible to develop a systematic, formal theory of suicide that integrates assumptions, definitions, rules of inference, and theorems into a meaningful whole. Nevertheless, insisting on the independent contribution of social forces to the suicide rate does not mean that social forces alone can predict or explain the individual suicide; that is the formidable task of the disciplines represented in part in this overall text.

Notes and references

1. For a comprehensive introduction to the sociological aspects of suicide, see Anthony Giddens, *The Sociology of Suicide,* London: Frank Cass & Company (1971).
2. Émile Durkheim, *Suicide,* trans. J. A. Spaulding and G. Simpson, Glencoe, Ill.: The Free Press (1951), pp. 145-276.
3. Ibid., pp. 213-14.
4. Ernest Wallwork, *Durkheim: Morality and Milieu,* Cambridge, Mass.: Harvard University Press (1972).
5. Talcott Parsons, *The Structure of Social Action,* New York: Macmillan, The Free Press of Glencoe (1949), pp. 385, 388.
6. Durkheim, *Suicide,* p. 209.; cf. David P. Phillips and Kenneth A. Feldman, "A Dip in Deaths Before Ceremonial Occasions," *Am. Sociological Rev.,* 38:678-96 (December 1973); James D. Miley and Michael Micklin, "Structural Change and the Durkheimian Legacy," *Am. J. Sociology,* 78:657-73 (November 1972).
7. See Walter R. Gore, "Sex, Marital Status, and Mortality," *Am. J. Sociology,* 79:45-67 (July 1973).
8. Durkheim, *Suicide;* Maurice Halbwachs, *Les Causes du suicide,* Paris: Alcan (1930); Barclay D. Johnson, "Durkheim's One Cause of Suicide," *Am. Sociological Rev.,* 30:875-86 (December 1965).
9. David Lester, *Why People Kill Themselves,* Springfield, Ill.: Charles C. Thomas (1972), pp. 5-12.
10. Jack Gibbs and Walter T. Martin, *Status Integration and Suicide,* Eugene, Ore.: The University of Oregon Press (1964).
11. Jack Gibbs and Walter T. Martin, "On Assessing the Theory of Status Integration and Suicide," *Am. Sociological Rev.,* 31:533-41 (August 1966); William J. Chambliss and Marion F. Steele, "Status Integration and Suicide: An Assessment," *Am. Sociological Rev.,* 31:524-32 (August 1966); Robert Hagedorn and Sanford Labovitz, "A Note on Status Integration," *Social Problems,* 14:79-94 (Summer 1966).
12. Warren Breed, "Occupational Mobility and Suicide among White Males," *Am. Sociological Rev.,* 28:179-88 (April 1963); Ronald Maris, "Suicide, Status and Mobility in Chicago," *Social Forces,* 46:246-56 (December 1967).
13. Max Weber, *The Theory of Social and Economic Organization,* New York: Macmillan, The Free Press of Glencoe (1947).
14. George H. Mead, *Mind, Self, and Society,* Chicago: The University of Chicago Press (1934).
15. Jack D. Douglas, *The Social Meanings of Suicide,* Princeton, N.J.: Princeton University Press (1967).
16. Jack Gibbs, "Review of *The Social Meanings of Suicide* by J. Douglas,"

Am. J. Sociology, 74:210-14 (September 1968); Breed, "Occupational Mobility," pp. 179-88.

17. Cf. Donald W. Light, Jr., "Psychiatry and Suicide: The Management of a Mistake," *Am. J. Sociology,* 77:821-38 (March 1972).
18. Harold Garfinkel, *Studies in Ethnomethodology,* Englewood Cliffs, N.J.: Prentice-Hall (1967).
19. James Coleman, "Review of *Studies in Ethonomethodology* by H. Garfinkel," *Am. Sociological Rev.,* 33:126-30 (February 1968).
20. George Homans, *Social Behavior: Its Elementary Forms,* New York: Harcourt, Brace, & World (1973).
21. Andrew F. Henry and James F. Short, Jr., *Suicide and Homicide,* New York: Macmillan, The Free Press of Glencoe (1954).
22. Breed, "Occuptional Mobility," pp. 179-88; Pow Meng Yap, *Suicide in Hong Kong,* Hong Kong: University Press (1958); Peter Sainsbury, *Suicide in London,* London: Chapman and Hall (1955); Michael Lalli and Stanley H. Turner, "Suicide and Homicide: A Comparative Analysis by Race and Occupational Levels," *J. Criminal Law, Criminology and Police Science,* 59:191-200 (1968).
23. Seymour Perlin and Chester W. Schmidt, Jr., "Fellowship Program in Suicidology," in J. Zusman and D. L. Davidson, eds., *Organizing the Community to Prevent Suicide,* Springfield, Ill.: Charles C. Thomas (1971); and personal conversations.
24. H. Gold, "Suicide, Homicide, and the Socialization of Aggression," *Am. J. Sociology,* 63:651-61 (1958).
25. A. H. Maslow, "Deprivation, Threat, and Frustration," *Psychological Rev.,* 48:364-66 (1941).
26. Albert Pierce, "The Economic Cycle and the Social Suicide Rate," *Am. Sociological Rev.,* 32:457-62 (June 1967).
27. Seymour M. Lipset and Reinhard Bendix, *Social Mobility in Industrial Society,* Berkeley: University of California Press (1959).
28. Kingsley Davis and Wilbert E. Moore, "Some Principles of Stratification," *Am. Sociological Rev.,* 10:242-49 (1945).
29. Breed, "Occupational Mobility," pp. 179-88.
30. Ibid., p. 188.
31. Elwin Powell, "Occupations, Status, and Suicide," *Am. Sociological Rev.,* 23:131-39 (April 1958).
32. Sainsbury, *Suicide in London.*
33. Austin L. Porterfield and Jack Gibbs, "Occupational Prestige and Social Mobility in Suicides in New Zealand," *Am. J. Sociology,* 66:147-152 (September 1960).
34. Ronald Maris, "The Sociology of Suicide Prevention: Policy Implications of Differences between Suicidal Patients and Completed Suicides," *Social Problems,* 17, no. 1:132-49 (Summer 1969).
35. Ronald Maris, "Current Problems in Suicide Research," *Crisis Interven-*

tion 4:84-89 (1972); Ronald Maris and Huell E. Connor, Jr., "Do Crisis Services Work?," *Journal of Health and Social Behavior,* 14:311-22 (December 1973).

36. Huell E. Connor, Jr., et al. "Comparative Psychopathology of Suicide Attempts and Assaults," *J. Life-Threatening Behavior,* 3:33-50 (Spring 1973).

37. See H. L. P. Resnik and Berkeley C. Hathorne, eds., *Suicide Prevention in the Seventies,* Washington, D.C.: U.S. Government Printing Office (1973), especially pp. 45-80.

6 BIOLOGY

Introduction

When a biological psychiatrist is called upon to aid in elucidating a psychological "illness," the call is often frantic and attended with magical expectations that a specific, hopefully diagnostic alteration in disease "X" will be uncovered with a "cure" soon forthcoming. Sadly, it is all too tempting for the biological psychiatrist to succumb, and since the days of phrenology or earlier, an abundance of "causes" for every conceivable manifestation of psychiatric illness have been discovered. Needless to say, the patience of clinicians and the public has been sorely tried, as false hope after false hope has been raised only to be dashed. In earlier years, the breakthroughs usually involved neuropathological changes; nowadays, they are "molecular," preferably in the urine. It would be exceedingly disheartening to chronicle all the false starts in the biological study of mental illness, whether schizophrenia, depression, or other diagnostic entities. Suffice it to say that, except for the well-known microbiological underpinnings of general paresis and the deficiency of nicotinic acid in pellagra, no findings of etiological biological abnormalities in mental illness have been substantiated.

Besides finding "causes," it is possible to seek biological abnormalities correlated with intensity of symptoms, but presumably reflecting sec-

Supported by NIMH Research Scientist Development Award K3-MH-3318 to the author.

113

ondary albeit important concomitants of disease. Such findings include the elevations of urinary 17-hydroxysteroids in depressed patients,[1] changes in normetanephrine excretion during recovery from depression,[2] and elevations in serum phosphofructosekinase and aldolase activities in the serum of acute psychotics.[3] Some of these findings and their relative significance will be discussed at a later stage in this review.

In the light of discouraging results obtained when searching almost at random for biological abnormalities in mental illness, one wonders if biological studies may be relevant in any way to mental illness. It seems to this author that the confluence of breakthroughs in neuroanatomy, neurophysiology, neurochemistry, and neuropharmacology in recent years has reached the stage where meaningful light can be shed upon the biological substrata of psychological processes. For this type of research to be effective, the investigator must define as rigorously as possible the psychological mechanisms operative in a given human psychopathological condition, endeavor to relate these to specific behavioral patterns in animals, and sort out the biological correlates of the latter. The "pay off" comes when one can "cure" the animal model of illness and translate the results back to humans. While this procedure in toto may seem long and tedious, it is the approach most likely to be productive of real advances. Let us apply this paradigm to the study of suicide.

Assessing specific psychological determinants of suicide with anything resembling rigor is difficult and not the task of this chapter. A major stumbling block lies in the wide variety of psychiatric conditions and emotional disturbances associated with suicidal behavior. One could judge futile the task of finding a neuropsychological correlate of a condition that can occur in individuals of such widely different personalities and diagnostic classifications. There are several approaches available to the student. If "suicide" is an heterogeneous bag of unrelated psychobiological categories, it might be wise to focus on a single subtype of suicidal patient, for example, the suicidal depressive. On the other hand, perhaps conventional psychiatric diagnoses fail to identify fundamental disease entities so that the classification "suicidal" is just as valid as a diagnosis of depression or schizophrenia. For instance, recent findings[4] suggest that what is called schizophrenia in the United States is composed of at least two distinct entities, one with a heavy genetic loading and poor prognosis and another with good prognosis and little genetic involvement. To simplify matters, let us assume that the second alternative is valid, con-

sider psychological factors that appear to be common to suicidal individuals, and attempt to ascertain biological determinants of such behavior.

A commonly postulated psychological mechanism in suicide holds that people who kill themselves have lost a zest for living, can no longer experience pleasure, are anhedonic. As for diagnostic categories, anhedonia is presumably most common in depressives, but is also a significant factor in chronic alcoholics and other characterological abnormalities as well as in schizophrenics. This model, although certainly a great oversimplification, has considerable neurobiological appeal, since it may be related conveniently to much contemporary understanding of brain anatomy, physiology, and chemistry, a task that will be the subject of the remainder of this chapter.

It is difficult to translate feelings in humans into observable behavior in animals. The best attempts to look at emotions such as pleasure and anhedonia by neurophysiologists, physiological psychologists, and neuropharmacologists in recent years have consistently concluded that, insofar as these emotions can be ascribed to specific "centers" in the brain, such centers involve structures collectively designated the limbic system. Neuropharmacological studies have indicated specific neurochemical correlates in limbic areas of the brain of apparent emotional behavior in animals, particularly related to "pleasure" or its absence. By drawing analogies between depression induced in humans by certain drugs, sedation produced in animals by the same drugs, and the effects of these drugs on brain (limbic) catecholamines, there has eventuated a "catecholamine hypothesis of depression."[5] While it is unclear whether or not the catecholamine hypothesis reflects something primary or secondary to the pathophysiology of depression in man, a few correlates are certain. There is fairly strong evidence that antidepressant drugs exert their clinical effects via interactions with brain catecholamines and that an abnormality in brain catecholamines may be responsible for drug-induced depression. The pleasure-aversion correlates in animals may well be models for the polarity of sense-of-well-being and anhedonia feelings in man of potential importance for suicidal behavior whether in depressed, schizophrenic, or characterologically deviant subjects. To aid in understanding the relationships of brain-pleasure centers, catecholamines, and drugs actions, we will first discuss the localization of brain tracts using catecholamines and serotonin, a putative neurotransmitter that may also be related to emotional behavior.

Mapping neurotransmitter specific tracts in the brain

The concept that when a nerve is stimulated it releases a chemical which mediates its activity on particular organs or on other neurons constitutes the essence of the "chemical" concept of neurotransmission. There has been ample evidence in the peripheral nervous system that chemicals function as neurotransmitters. Specifically, it is well accepted that acetylcholine is a neurotransmitter at the neuromuscular junction and in autonomic ganglia, and comparable evidence has accumulated that norepinephrine (Figure 1) is a neurotransmitter at sympathetic postganglionic synapses in the periphery. Such evidence included detection of norepinephrine being released when sympathetic nerves were stimulated and the demonstration that norepinephrine could mimic the effects of sympathetic nerve stimulation. It is difficult to satisfy such criteria, hence to prove that a given chemical is a neurotransmitter, in the brain since there are no readily demonstrated effects of nerve stimulation as there are in the periphery, such as glandular secretion or increase in blood pressure.

Figure 1. Structures of biogenic amines.

Norepinephrine
(noradrenaline)

Dopamine

Serotonin
(5-hydroxytryptamine)

Histamine

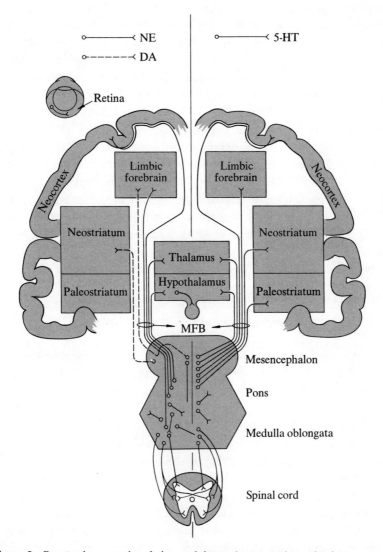

Figure 2. Serotonin, norepinephrine and dopamine tracts in rat brain.
Source: N. E. Anden, A. Dahlstrom, F. Fuxe, K. Larsson, L. Olson, and
U. Ungerstedt, "Ascending Monamine Neurons to the Telencephalon and
Diencephalon," *Acta. Physiol. Scand.*, 67:313-26 (1966).

Suspicion that catecholamines in the brain may be important to emotional functions preceded evidence that they were located in specific nerve tracts in the brain. In the mid-1950's chemical methods were developed for estimating tissue concentrations, which showed that norepinephrine, dopamine, serotonin, and histamine were localized in brain areas concerned with emotional behavior (Figure 1). These four compounds are the best candidates for neurotransmitters related to emotional behavior. Acetylcholine and gamma-aminobutyric acid (Figure 2) are also probably neurotransmitters in the brain, but with other functions.

Recently a group of Swedish investigators found that if catecholamines or serotonin in brain tissue were exposed to formaldehyde vapor they produced intensely fluorescent products, green for the catecholamines and yellow for serotonin.[6] Accordingly, it was possible to trace out brain tracts containing these compounds. These techniques have revealed that there are nerve terminals scattered throughout the brain which contain high concentrations of norepinephrine, dopamine, and serotonin (Figure 2). Cell bodies containing these amines, however, are almost exclusively localized in the brain stem. The fluorescence in these cell bodies is always in the cytoplasm, in higher concentrations in the zone around the nucleus but never within the nucleus. The cell bodies for catecholamine and serotonin containing neurons are most highly concentrated in the midbrain, located in separate areas with very little overlap.

Serotonin tracts: Serotonin-containing cell bodies are largely confined to the raphe nuclei in the lower midbrain near the midline. These raphe nuclei have shown little differentiation during evolution, suggesting that they represent neuron systems with primitive but fundamental functions. The serotonergic brain tracts are probably related to the control of sleep and wakefulness.[7] Destruction of the cell bodies of the serotonergic neurons in the raphe nuclei resulting in serotonin depletion throughout the brain produces insomnia in several animal species. There is a close correlation between the destruction of the raphe nuclei, serotonin depletion, and the extent of insomnia. Moreover, restoring normal serotonin levels by treatment with its amino acid precursor 5-hydroxytryptophan produces sleep immediately. Inhibition of serotonin synthesis also results in insomnia which can be reversed by depleting brain serotonin. Furthermore, stimulation of the serotonin tracts at low physiological frequencies produces somnolent behavior in animals. Recent findings suggest that

Figure 3. Pathway of catecholamine biosynthesis.

serotonin neurons mediate the actions of psychedelic drugs.[8] LSD, mescaline, or psilocybin appear to mimic serotonin at postsynaptic receptors causing a hyperstimulation blockade, so that instead of sleep, hyperawareness ensues. Vigorous, supraphysiological electrical stimulation of serotonin cell bodies to release excess amounts of serotonin produces behavioral effects in animals almost indistinguishable from those of LSD.[9] Presently it is difficult to adduce direct relevance of serotonin functions to suicidal behavior. Still, an understanding of biological substrata of the disorganized mental state during LSD-induced "suicides" may well benefit from consideration of drug interactions with serotonergic neurons.

There are two major catecholamines in the brain, dopamine and norepinephrine (Figures 1, 3). In most parts of the brain dopamine serves as a metabolic precursor of norepinephrine. However, in some brain regions, dopamine is the only catecholamine and presumably functions there as a neurotransmitter in its own right. In the Swedish histochemical technique both dopamine and norepinephrine give a bright green fluorescence. However, by appropriate drug treatment it is possible to distinguish between them.

Norepinephrine tracts: In contrast to the serotonin neurons, where the cell bodies are localized in a single group of nuclei, the assemblage of norepinephrine cell bodies does not follow any simple neuroanatomical scheme. All norepinephrine cell bodies occur in the brain stem, but they are spread out throughout the medulla oblongata, pons, and midbrain (Figure 2). A few nuclei, such as the *locus coeruleus* have especially high concentrations of norepinephrine in a clearly circumscribed region. Some norepinephrine tracts send axons from their cell bodies in the medulla oblongata down the spinal cord in the sympathetic columns with nerve endings at various levels of the spinal cord. There is some evidence that these tracts may play a role in facilitating simple reflexes such as the extensor reflex, but their exact function is unclear. Most norepinephrine tracts send axons ascending in the medial forebrain bundle with terminals spread throughout all other areas of the brain. The highest concentration of norepinephrine nerve endings, however, is in the hypothalamus, where endogenous concentrations of norepinephrine are highest. The concentration of norepinephrine axons in the medial forebrain bundle has major behavioral implications which will be described below.

Dopamine tracts: Unlike the diffuse system of norepinephrine tracts, there are only a few discrete dopamine tracts (Figure 2). The major one has cell bodies in the substantia nigra of the midbrain with terminals in the caudate nucleus and putamen of the corpus striatum. The corpus striatum is well known to modulate motor coordination; its function is deranged in Parkinson's disease. The corpus striatum in patients dying of Parkinson's disease is depleted of its dopamine content, indicating that the nigrostriatal dopamine tract had degenerated in these patients.[10] This finding is supported by the well-known degenerative changes observed in the substantia nigra of Parkinsonian patients. A causal relationship of this dopamine deficiency to the symptoms of Parkinson's disease has been revealed recently by the dramatic ability of L-DOPA treatment to ameliorate the symptoms of this illness.[11] L-DOPA (3,4-dihydroxy-phenylalanine), the amino acid precursor of dopamine, is converted in the brain to dopamine and presumably counteracts the dopamine deficiency in this condition.

Other dopamine tracts include ones having their cell bodies in the midbrain with endings in the nucleus accumbens and olfactory tubercle.

An interesting dopamine tract originates in the arcuate nucleus of the hypothalamus with terminals in the median eminence. There is some evidence that this tract regulates secretion of factors from the hypothalamus which influence release by the pituitary gland of its various trophic hormones.

Reward centers

Knowing the schematization of amine-containing neurons in the brain we can now observe behavioral correlates which may be relevant to the psychological status of suicidal individuals. One such behavioral model in animals is the phenomenon of brain self-stimulation. In the late 1950's, James Olds at the University of Michigan implanted electrodes into various areas of rats' brains connected to levels so that the rat could, by pressing the lever, electrically stimulate his own brain. With electrodes in certain areas rats would press levers at very rapid rates in order to stimulate themselves.[12] It was presumed that the brain regions providing high self-stimulation must be "reward centers" and that rats would stimulate themselves in these regions because "it feels good." Although we have no evidence that rats feel in the same way that humans do, the phenomenon of self-stimulation has been demonstrated in several species including monkeys, who presumably experience emotion more like man than do rats. Whether or not such stimulation is pleasurable, it certainly is reinforcing, for, with electrodes appropriately placed, rats will press levers at rates of 1,000 times per hour and do this in preference to food reward, even if they have been deprived of food for 24 hours.

Olds found that the medial forebrain bundle in the lateral hypothalamus was the area most effective in evoking self-stimulation behavior. The septal nucleus also was a major rewarding area. Certain areas of the brain were "aversive" in that rats would press levels at high rates to avoid stimulation in these brain regions. The relationship of the reward centers to brain norepinephrine tracts and pharmacological evidence implicating norepinephrine in the brain production of self-stimulation behavior will be discussed below.

Maps of the "reward centers" in the brain closely parallel the maps of the distribution of the norepinephrine tracts, especially the coincidence that the major bulk of norepinephrine tracts pass through the medial forebrain bundle (Figure 2) in the hypothalamus, the area for maximal self-

stimulation. By itself, these findings do not implicate norepinephrine selectively, since most ascending serotonin fibers also pass through the medial forebrain bundle. More direct evidence for the involvement of norepinephrine in self-stimulation was obtained recently in that direct injection into the ventricles of rat brain of small amounts of norepinephrine markedly facilitated self-stimulation in the medial forebrain bundle, while injections of serotonin were without effect.[13] Additional evidence[14] centers on the ability of amphetamine, which is well known to produce its pharmacological actions by interactions with brain norepinephrine, to markedly facilitate self-stimulation. Thus, the most convincing animal model for "pleasure" appears to involve norepinephrine tracts. Further, it is the stimulation of the norepinephrine tracts which is associated with pleasurable sensations, so that one might infer that synaptic release of norepinephrine is associated with feelings such as well-being, elation, or euphoria.

As suggested by the amphetamine effects above, a good deal of evidence relating depression to brain norepinephrine derives from drug models of depression. To understand the actions of these drug actions we must first discuss catecholamine metabolism and specific events at catecholaminergic synapses.

Norepinephrine metabolism and drug action

The dietary amino acid tyrosine is the initial precursor of norepinephrine (Figure 3). Tyrosine is hydroxylated to dihydroxyphenylalanine (DOPA) which has been discussed already as a precursor of dopamine and a "miracle drug" for Parkinson's disease. DOPA is decarboxylated to dopamine which, in norepinephrine neurons, is then hydroxylated to form norepinephrine.

Norepinephrine degradation can take place initially by the actions of one of two enzymes (Figure 4). Monoamine oxidase removes the amine group of norepinephrine resulting in the formation of an inactive catechol acid. Catechol-0-methyltransferase places a methyl group on norepinephrine to form normetanephrine, which is also pharmacologically inactive. Since both of these enzymes are relatively nonspecific, normetanephrine may then be deaminated by monoamine oxidase and the catecho acids may be 0-methylated by catechol-0-methyltransferase. Accordingly, an 0-methylated, deaminated compound, 3-methoxy-4-hydroxy-

Figure 4. Pathways of norepinephrine degradation.

mandelic acid (VMA), is the final end product of either metabolic pathway. Measurement of urinary VMA is now a common clinical laboratory technique used to diagnose conditions involving hypersecretion of catecholamines, such as the pheochromacytoma, a tumor of the adrenal gland. The location of these two enzymes in norepinephrine synapses has important bearing on drug effects.

The synapse is the junction between the nerve ending or terminal of one neuron and the cell body or dendrites of another. Neurotransmitters are released from nerve terminals into a gap called the "synaptic cleft" so that they may act on the "receptors" located on the cell bodies' dendrites of other neurons (Figure 5). Norepinephrine is stored within vesicles in nerve terminals and, on electron microscopy, causes the appearance of dense cores due to an affinity for osmium used in electron microscopic staining. These "dense core vesicles" are almost diagnostic of norepinephrine nerve terminals. The moiety of monoamine oxidase which acts on norepinephrine is located in mitochondria within norepinephrine nerve terminals. Accordingly, monoamine oxidase normally functions to destroy excess norepinephrine which leaks out of the vesicles within which

it is stored. Norepinephrine, which has been metabolized initially by mo-
noamine oxidase, therefore never reaches the synaptic cleft in a pharma-
cologically active form. The moiety of catechol-0-methyltransferase which
acts on norepinephrine is located outside the nerve terminal so that any
norepinephrine initially acted on by catechol-0-methyltransferase must
have been liberated into the synaptic cleft and, presumably, had access to
the receptors.

At synapses there are a number of ways in which drugs can effect neu-
rotransmitter action. They might enhance or prevent its release from the
nerve terminal; they might interfere with its action on receptor sites; or
they may alter its inactivation at the synapse. Many drugs exert their
clinical effects by interacting with inactivation mechanisms for neuro-
transmitters. Although we have described two enzymes that can destroy
norepinephrine, neither appears to account for norepinephrine inactiva-
tion at synapses. Instead, norepinephrine appears to have its synaptic ac-
tivity terminated by reuptake into the nerve ending that had released it

Figure 5. Drug actions at norepinephrine synapses.

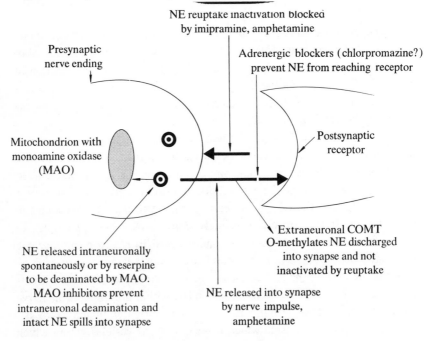

(Figure 5). Drugs that inhibit the reuptake process potentiate the synaptic activities of norepinephrine. Since norepinephrine release in the brain presumably is associated with positive affective states, its potentiation should be associated with states resembling euphoria.[15] Bearing these features in mind, let us examine the actions of a number of drugs.

1. Reserpine: This drug is commonly used for the treatment of hypertension. After extensive clinical use it became apparent that a significant number of patients receiving reserpine, as many as 15 per cent in some series, became depressed in a fashion indistinguishable from endogenous depression. Interestingly, reserpine depression was discovered by a cardiovascular researcher who noted an astoundingly high incidence of *suicide* in patients receiving this drug. In animals reserpine produces sedation without causing sleep. Besides its capacity to produce depression in humans, reserpine has been linked to depression because of its interactions with antidepressant drugs. In animals, every clinically efficacious antidepressant drug converts the sedation produced by reserpine into an excitatory state. The ability to reverse reserpine sedation is now a standard screening procedure used by all major drug manufacturers to examine for possible antidepressant activity of chemicals.

How does reserpine produce sedation in animals, depression in man? Reserpine is well known to deplete brain norepinephrine. It is not only the lowering of norepinephrine, but the manner in which it is lowered by reserpine that explains its sedating effect. Reserpine weakens the binding of norepinephrine in its storage vesicles so that norepinephrine leaks out and is degraded by monoamine oxidase in the mitochondria of the nerve ending. Accordingly, norepinephrine released by reserpine never reaches the synaptic cleft in an active form. The metabolic consequences are that reserpine causes a marked enhancement of initial deamination followed by 0-methylation when the deaminated norepinephrine leaves the nerve ending. From this formulation one would predict that if monoamine oxidase were inhibited, the sedating effect of reserpine would be converted into excitation, since massive amounts of norepinephrine leaking out of the storage vesicles would then reach the synaptic cleft in an intact form. Indeed, monoamine oxidase inhibitors do reverse reserpine sedation.

2. Monoamine oxidase inhibitors: These compounds were the first clinically employed antidepressant drugs. They act by preventing the oxida-

tive deamination of norepinephrine that leaks out of its storage vesicles. When levels of unmetabolized norepinephrine build up in the nerve terminal after inhibition of monoamine oxidase, some leak out and reach the synaptic cleft intact.

3. Amphetamine: This drug produces euphoria, but is not effective in the treatment of depression. Monoamine oxidase inhibitors have euphoriant effects and are effective antidepressants. There is no simple neuropharmacological explanation for this apparent paradox. Amphetamine lowers brain norepinephrine, although to a lesser degree than reserpine. Why, then, does it produce opposite pharmacological actions? The secret lies in the manner in which norepinephrine is released. Amphetamine causes a direct release of norepinephrine from nerve-ending vesicles into the synaptic cleft in an intact pharmacologically active form. Metabolically, one observes that after amphetamine treatment norepinephrine is initially 0-methylated, outside the nerve ending.

4. Tricyclic Antidepressants: These drugs were first introduced as phenothiazine analogues, and subsequently were found to be useful in the treatment of depression. Surprisingly, they are not euphoriant in normal human subjects, having instead only a mild sedating action. Since these drugs were discovered after the monoamine oxidase inhibitors, neuropharmacologists were greatly disappointed to find that they did not inhibit monoamine oxidase; and grave doubt was then cast upon the role of catecholamines in depression. However, when the norepinephrine uptake system was elucidated, it was found that the tricyclic antidepressants are potent inhibitors of norepinephrine reuptake. By inhibiting the inactivation of norepinephrine released, they potentiate its central stimulant actions. In series of structural analogs, antidepressant activity is closely related to the ability to inhibit norepinephrine reuptake. In fact, recent evidence suggests that some monoamine oxidase inhibitors may owe their antidepressant efficacy more to inhibition of norepinephrine reuptake than to interference with monoamine oxidase activity.

Conclusions

Many biological factors may be construed as "relevant" to the study of suicide. We have focused upon a narrow range, the "reward" centers in

the brain, the role of norepinephrine as a neurotransmitter in these centers, and the interaction with brain catecholamines of drugs that affect mood. If there is a unique biological substratum of that state of mind that eventuates in a person taking his own life, our present knowledge of brain function might elect a possible alteration in catecholamine disposition as the major candidate. The items of evidence are: (1) A major role of brain norepinephrine has to do with the enhancement of positive effect. Since there are a large number of norepinephrine tracts with presumably different functions, the association of norepinephrine with positive affect is an oversimplification, one which may be justified because of its heuristic value. (2) Drugs that alter mood appear to exert their clinical effects in a predictable way via effects on brain catecholamines. (3) At least one drug, reserpine, which depletes brain norepinephrine, can produce a syndrome in man closely resembling endogenous depression in man, and is associated with a high incidence of suicide. Alpha-methyl-DOPA (Aldomet) is another antihypertensive agent which produces a significant incidence of depression and which may also decrease central norepinephrine activity. In this case α-methyl-DOPA is converted into α-methyl-norepinephrine which is released in place of norepinephrine at brain synapses as a false transmitter, and which has weaker activity at receptors than norepinephrine itself.[16]

All of these factors taken together add up to the "catecholamine hypothesis of depression."[17] Since most of the evidence derives from animal studies, one should be cautious in inferring that the psychological state associated with a dearth of brain norepinephrine is synomous with human depression. An even more important reservation has to do with leaping to the speculation that human depressive states are "caused" by, or are even associated with, a deficiency of norepinephrine in the brain. Such a conclusion is not warranted by the available evidence which only tells us that pharmacological lessening of central noradrenergic function can result in depression while its facilitation can ameliorate symptoms. A defect in unrelated neural systems could produce the depressive condition, with antidepressant drugs counteracting the symptoms via norepinephrine neurons much as aspirin acts on central temperature regulating centers to relieve fever produced by pneumococcal and leucocytic interactions. Even if one were to demonstrate a relative depletion of norepinephrine in the brains of depressed patients, it would still be unjustified to conclude that this condition "caused" the depression. The cause could

still reside in other neuronal complexes, and the catecholamine abnormality might just be a secondary effect, just as fever reflects many disease processes.

A good example of the distinction between primary and secondary biological factors in depression is found in recent studies of the urinary excretion of 17-hydroxysteroids and normetanephrine by depressed and suicidal patients. 17-Hydroxysteroid excretion parallels the intensity of depressive symptoms and rises to a sharp peak just prior to the time of suicide in some patients.[18] It has even been proposed that a marked elevation in 17-hydroxysteroids excretion may be diagnostic of suicide potential. Even if 17-hydroxysteroid excretion consistently predicts suicidal behavior, it is more likely an endocrine reflection of the intense stress experienced by a severely depressed patient than a "cause" of suicide. Similarly, urinary excretion of the norepinephrine metabolite normetanephrine increases as depressive symptomology abates.[19] Does this finding confirm the catecholamine hypothesis of affected disorders? Probably not, since only about 15 per cent of urinary normetanephrine derives from the brain, so that the levels measured largely reflect peripheral sympathetic nervous activity. Thus, while it is interesting that urinary normetanephrine increases as the mood of the depressed patients improves and they become more physically active, one might suspect that urinary indicators of attending the theater and playing golf would also increase.

Despite these reservations, investigation of the catecholamines as well as serotonin, histamine, and as yet unidentified neurotransmitters in emotional areas of the brain are likely to bear fruit in the quest to elucidate brain mechanisms whose alterations underlie suicidal and other aberrant behavior. As understanding in this field advances, the unique dividend that neuropharmacological investigation can provide will hopefully emerge, namely new chemical agents of value in the treatment of mental illness.

Notes and references

1. W. G. Bunney, Jr. and J. A. Fawcett, "Biochemical Research in Depression and Suicide," in *Suicidal Behaviors: Diagnosis and Management,* ed. H. L. P. Resnik, Boston: Little, Brown and Company (1968), pp. 144-59.
2. J. J. Schildkraut, E. K. Gordon, and J. Durell, "Catechalomine Metabolism in Affective Disorders: Normetanephrine and VMA Excretion in

Depressed Patients Treated with Imipramine," *J. Psychiat. Res.*, 3:213-88 (1965).

3. H. Meltzer, "Muscle Enzyme Release in the Acute Psychoses," *Arch. Gen. Psychiatry*, 21:102-11 (1969).

4. L. L. Heston, "The Genetics of Schizophrenic and Schizoid Disease," *Science*, 167:249-55 (1970).

5. J. J. Schildkraut, "The Catecholamine Hypothesis of Affective Disorders: A Review of Supporting Evidence," *Am. J. Psychiatry*, 122:509-22 (1965).

6. N. A. Hillarp, K. Fuxe, and A. Dahlstrom, "Demonstration and Mapping of Central Neurons Containing Dopamine, Noradrenaline and 5-Hydroxy-tryptamine and Their Reactions to Psychopharmaca," *Pharmacol. Rev.*, 18:727-42 (1966).

7. M. Jouvet, "Biogenic Amines and the States of Sleep," *Science*, 163:32-41 (1969).

8. G. K. Aghajanian, W. E. Foote, and M. H. Sheard, "Lysergic Acid Diethylamide: Sensitive Neuronal Units in the Midbrain Raphe," *Science*, 161:706-8 (1968).

9. G. K. Aghajanian and M. H. Sheard, "Behavioral Effects of Midbrain Raphe Stimulation—Dependence on Serotonin," *Comm. Behav. Biol.*, 1:37-41 (1968).

10. O. Hornykiewicz, "Dopamine (3-Hydroxytryptamine) and Brain Function," *Pharmacol. Rev.*, 15:925-64 (1966).

11. A. Barbeau, "L-DOPA Therapy in Parkinson's Disease," *Canad. Med. Assoc. J.*, 101:791-800 (1969).

12. J. Olds, "Hypothalamic Substrates of Reward," *Physiol. Rev.*, 42:554-604 (1962).

13. C. D. Wise and L. Stein, "Facilitation of Brain Self-Stimulation by Central Administration of Norepinephrine," *Science*, 163:229-301 (1969).

14. L. Stein, "Self-Stimulation of the Brain and the Central Stimulant Action of Amphetamine," *Fed. Proc.*, 23:836-50 (1964).

15. S. H. Snyder, "New Developments in Brain Chemistry: Catecholamine Metabolism and the Action of Psychotropic Drugs." *Am. J. Orthopsychiatry*, 37:864-79 (1967); J. J. Schildkraut and S. S. Kety, "Bionemic Amines and Emotion," *Science*, 156:21-30 (1967).

16. Synder, "New Developments," pp. 864-79.

17. Schildkraut, "Catecholamine Hypothesis," pp. 509-22.

18. Bunney and Fawcett, "Biochemical Research," pp. 144-59.

19. Schildkraut, et al., "Catecholamine Metabolism," pp. 213-88.

GEORGE J. VLASAK

7 MEDICAL SOCIOLOGY

The medico-sociological study of suicide examines the interaction of the phenomenon of suicide with that complex segment of social organization referred to as the "health system." Medico-sociological inquiries, then, will typically treat suicide as an *organizationally* significant event rather than in any other context. They will seek to describe and analyze what may be the specific, differential impact of suicidal cases upon the structure and functions of health service institutions and, vice versa, what may be the impact of various organizational characteristics of health institutions on those suicide-connected events that come within their service domain.

Systematic descriptions and analyses of what actually happens—in terms of social interaction—at these various points of contact are rare. Of late, medical sociology has begun to show interest in the sociomedical phenomena surrounding death[1] and the specific case of suicide death. The methods used by medical sociologists are those of sociology in general.[2]

The complexity of suicidal behavior and suicide seem little reflected in their prima facie assignment to the domain of medicine—at least in our times.[3] Most suicide attempts result in some somatic trauma, and medical practitioners and institutions are the natural or typical recipients of such cases. Furthermore, certain identifiable physical and mental diseases rou-

131

tinely treated by medical practioners and institutions figure prominently among the "determinants" of suicidal behavior. And further still, suicidal behavior is frequently defined per se as a disease entity, a pathological syndrome, and employed in practice as one of the standard diagnoses for the purposes of hospitalization and treatment of persons as patients. Where suicidal acts do result in death, physicians may be called upon to perform the medical, legal, and ritual task of "pronouncing," that is, officially ascertaining that the victim is dead.

The premise that the relationship of suicide and the health system does not constitute an invariably perfect fit in practice will be examined. First, let us note some of the concepts that will be used in our investigation of the social systems within which the aforementioned interactions take place:

Each social system will be defined as a sum of the processes of interaction among the participants or actors, but it is the participation itself, namely, participation of an actor in a patterned interactive relationship, that can be seen as the most basic unit of analysis of social systems. This participation, in turn, has two principal aspects:[4]

1. Positional—the location of the participant-actor in the structure of the given system vis-à-vis the other participant-actors and the system as a whole. This is referred to as the actor's *status.*
2. Processual—what the actor actually does, or is expected to do, in his relations to the other participants in the system and in the functional context of the system. This is called the actor's *role.* In analyses of actual empirical systems where these two aspects of an actor's participation are not the specific subject in itself, it is useful to view the two as a "bundle," as two sides of the same heuristic coin: status-role.[5] "There are no roles without statuses or statuses without roles."[6]

In the social systems such as hospitals, clinics, and other health service institutions, certain categories of status-roles are typically indigenous and have particular structural and functional significance: The interaction studied and analyzed for repetitive, system-producing patterns is typically interaction among actors occupying such varied statuses and performing such roles as patient, doctor, nurse, health worker, professional, layman, resident, chief of service, family member, malingerer, crock. Each of these status-roles, of course, not only is quite complex in itself but also coexists in the concrete persons with numerous other status-roles

(father, voter, athlete, office clown, indigent, politician) which—while out of the immediate focus of the investigator, make up the extremely complex phenomenon known as "membership" in the given inclusive society.

For our specific subject—the place of suicide in the health system—the most central patterns of interaction and the most fundamental relationships involve mainly two sets of status-roles: (1) the patient status-role to the extent that it is assumed by, or assigned to, the suicide attempter or victim; and (2) the generalized status-role of the professional health worker with its specific subcategories of doctor, nurse, and others.

As described in the now classic statements by Parsons, and by Parsons and Fox,[7] the patient-physician relationship, like other types of culturally highly patterned relationships, is typically predicated upon meeting certain reciprocal expectations between the two roles that make up this particular, usually dyadic, subsystem. In order for this relationship to arise in the first place, the sick person must first recognize himself as being sick, that is, in terms of sociological analysis, he must enter a broader, more general sick role[8] which confers upon him certain "credits" and "debits."

On the credit side, the entrance into the sick role does two things, above all, for the sick subject: (1) it grants him certain *exemptions* from various demands of his social context (e.g., it may temporarily cancel his work responsibilities and help him to avoid certain burdens of formal social intercourse), and (2) it bestows upon him certain additional *rights* (e.g., the right to greater attention from his family and others, the right to be taken care of). By the same token, the sick role confers upon the affected person certain *obligations,* the most important being the following two: (1) to recognize and treat his sick state as inherently undesirable and to want to get well as soon as possible, and (2) if warranted by the apparent severity of the illness, to "contract technically competent help with whom he agrees to cooperate in a concerted effort to get well."[9] It is particularly this last expectation which, when met, makes the sick-role occupant into a *patient-role* occupant.

Reneging on any of the fundamental obligations by either the patient or the physician tends to terminate the reciprocal obligations of the other and thus to weaken or terminate the relationship.

In the case of suicide—or, more frequently, in the case of suicide attempt—certain features are typically present which tend to make suicidal behavior incongruent with some of the essential expectations of patient role, and thus with continuing occupation of patient status. While the in-

congruence may not always be such as to terminate automatically any type of patient-physician relationship between a suicidal patient and a physician or a medical institution, it can be posited that (1) it endows such relationships with a high amount of tension and instability, and (2) it impedes, retards, and at times prevents the initiation and development of such relationship, making suicide attempters and suicide victims into a special category of "patients" or "deaths" respectively, differentially perceived and acted toward by the members of the health system.

Suicide and the patient role: goodness of fit

What are the main characteristics of suicidal behavior that appear to be incongruous with the basic expectations of the general "sick role" or its more specialized version, the "patient role?" It may be useful to answer that question by applying, in an extremely simplified, schematic way, the four main aspects of the patient role, derived earlier from Parsons, to two contrasting types of situations: where the patient is a "regular" case of somatic disease or injury, or perhaps a case of a standard neurological or mental disorder; and then where the patient will be mainly an attempted suicide but can also be a completed suicide under some circumstances. This will be done here in the form of forcing the respective role expectations into juxtaposed cells of a table. The debit and credit aspects of the role are presumed to be intricately intertwined in most actual cases and no clear sequential or causal order is implied here (see Table 1).

The following patterns can be discerned in the table:

1. With regard to the debit or *obligations* aspects of the patient role, the suicide case typically shows a considerable incongruence. By virtue of certain basic characteristics of suicidal behavior, the crucial expectations of the role are not met. (Disregarding for the moment all exceptions as well as all possibilities of "deeper reinterpretation.")
2. With regard to the credit side, the *exemptions and rights* claimed, the suicide case appears to be more congruent with the sick role-patient role expectations. His claims, implied or explicit, at least appear to point in the same general direction as those of the regular, nonsuicide case. The discordant feature here seems to be mainly quantitative, namely the very "size" of the suicide's claims which overflow or even

Table 1. Basic attributes of patient role as applied to non-suicidal and suicidal type-cases in the health system.

Institutionalized expectations of the *sick* or *patient* status-role	Non-suicidal case ("Regular" somatic or mental disease or injury).	Suicidal case (Injury or illness resulting from suicidal attempt. Completed suicides in some regards.)
Obligation to define illness or condition as undesirable and wish to get well as soon as possible.	*Yes.* Illness or injury originating outside the subject's own volition.	*No.* Injury, illness, or condition resulting from a "willed" act of the subject.
Obligation to seek competent help and to cooperate fully in the process of care toward speedy recovery.	*Yes.* Subject came as patient, on his own, or brought in with his explicit or clearly implicit consent.	*No.* Subject typically brought in by others, often "caught" by others. Implied consent may or may not be legitimized *ex post* by subject, after entry into health system. *Yes.* Self-injury was explicitly instrumental act, manipulative, aimed toward secondary gain. Or: suicide attempt "serious" but means proved sublethal; subject wishes to have this particular injury repaired.
Exemption from social duties and responsibilities.	*Yes.* Claim usually limited in scope and time: temporary relief from job demands, child care, social intercourse.	*Yes, but:* claim typically very extensive; permanent relief from the stress of feeling of "total" failure at work, in marriage, in love; escape from stress of overwhelming guilt or shame, unbearable pain, hopeless illness. Claim can be total, all-inclusive: "Call off the whole thing"; "Stop the world" with which subject cannot cope.
Right to attention from and extraordinary action by others: Condition is beyond self-help and "must be taken care of."	*Yes.* Claim usually limited in scope and time: temporary "take-over" by significant others—family, colleagues, superiors or subordinates; by health system helpers *re* illness.	*Yes, but:* claim typically very extensive, strong, radical; often specifically addressed and aggressive: "I'll show them . . ."; often desire to haunt: "She will not get me off her mind as long as she lives. . . ." Or: claim to grandeur-in-sacrifice; martyrdom for higher goals or for loved persons. Claim "to be taken care of" *can* be total, summarily addressed to all would-be helpers: "Either let me get off and out, *or* take over completely and recondition my existence *in toto.*"

Note: The first two rows are grouped under the margin label "Debit"; the last two rows under the margin label "Credit".

categorically transcend the expectations customary in the existing health system.

In what follows, we wish to examine more closely the patient role (obligations, exemptions, and rights) and the helper role (obligation).

Patient role: obligations

To repeat, the institutionalized role expectations oblige a full-fledged candidate for the patient status to perceive and define his condition of illness or injury as undesirable, and to wish to terminate it by getting well again as soon as possible. They also demand that he take certain positive actions to combat the condition, typically, that he seek a competent helper, such as a physician, and cooperate with him fully. Above all, he is obliged to do nothing deliberate—or to *have done* nothing deliberate in the first place—to bring about the condition or to protract it.

In contrast to the regular patient, the suicide case typically does not, as indicated, meet these expectations. Or, in exceptional cases, he meets them in a highly problematical, questionable way which requires additional probing, adjustment of criteria, and substantial reinterpretation of the prima facie evidence. The somatic injury (cut wrists, gunshot wound, poison in the system)—that is, the immediate reason for the suicidal person's entry into the health institution—cannot be seen as something of which the person is an innocent, straightforward, obvious *victim*. On the contrary, the injury had been "desired" by him, albeit in a very complex volition process. The work, the stress, and the trouble that the health institution and its members now have to undergo on his behalf were *made,* quite tangibly and immediately, by him.

Thus, in departure from the classical tripartite situation composed of (1) the patient (*victim*), (2) the exogenous *cause* (disease, accident, attacker), and (3) the *helper* (physician, nurse, clinic, hospital), a suicide case presents a situation which, eventual ultimate higher-level analyses notwithstanding, tends to be perceived as only bipartite: The cause is, in a sense, endogenous; the attacker tends to coalesce with the victim who thus becomes a kind of quasi victim at best and, in terms of the prevailing health system culture, also a quasi patient. The "common enemy" (the disease, and so forth), which, as such, is shared in the normal, bona fide victim situations by the patient and the helper, and which is normally

"out there," in the sphere has, in the case of suicide, at least partly moved "in here," into the patient-helper dyad, and brought with it a piece of the Hippocratic fence ("the good of the patient . . ."). This now tends to blur and confuse the relationship between the helper on the one hand, and on the other the somewhat two-faced or ambivalent combination, the victim-*cum*-cause.

Then there is the patient's obligation to seek appropriate help and co-operate fully until the termination of the conditions for patient status is achieved. As a rule, suicide attempters[10] or dying suicide victims rarely meet this obligation to "seek and cooperate." In suicide cases, the competent helper, that is, the physician or occasionally other health worker, usually enters the situation on the initiative of someone other than the suicidal person. He is sought and summoned by such third parties as the police, family members, or other finders, and his entry may or may not even subsequently be legitimized by the suicidal person's request or consent, and by the crucial acts of cooperation in getting well. The patient may continue to wish that he had been "successful" in his attempt and had died; his loss of the will to live may have been permanent and his co-operation in recovering from the somatic injury may therefore be either absent or very limited. He may also perhaps genuinely wish to recover quickly, but only in order to be able to carry out his suicide plan at the next opportunity and by use of more reliable means. Finally, he may be highly ambivalent in his attitude and ambiguous in his cooperative response, creating an alternating or blurred situation for those who are to help him.

As far as the *obligations* part of the patient role is concerned, then, the generalized, ideal-type suicide case seems to present an ill fit. In a relationship that is defined as essentially reciprocal, as requiring a symmetrical, synchronical approach by both parties performing their roles and meeting their obligations in a complementary fashion, it must be assumed that deficient role performance by one party cannot remain without consequences for the performance of the corresponding or reciprocal role by the other.

Patient role: exemptions and rights

It has been noted earlier that on the credit side of the patient role, more congruence can be found between the attributes of the regular, somatic

case and those of the suicide case than on the debit or obligation side; that is, both the regular somatic and the suicidal cases meet the patient-role expectations by presenting their environment, including their health-system helpers, with claims to (1) exemptions from the pressures and demands of their given social situations, and (2) rights to being paid greater attention, to being temporarily heeded by significant others, and to being taken care of by them. Yet, the congruence seems to be in direction and quality, but not in extent.

In the regular somatic or standard mental case the extent of the claim, even though wide, is clearly limited. As to the sick-role exemptions, they reach from a headache relieving one from an unwelcome social engagement, at the one end to a chronic illness making one retire permanently from the burden of an incompatible job, at the other. In the area of rights to attention and to be taken care of, the range can perhaps be exemplified by—at one extreme—the hope of being more noticed when absent for a few days from one's desk, and, at the other, by the expectation that "mother's illness will 'naturally' override daughter's career or matrimonial plans." These exemptions and rights are, as a rule, recognized by the respective environments and either granted outright or at least considered to be within the realm of the possible. The significant others of a patient perceive meeting such expectations as being still in agreement with their own roles in the given social situation.

In contrast, the suicide type-case, when occupying the patient role, presents a far more radical set of claims, be they expressed or implied. The *exemption* that the suicide patient hopes to obtain is an exemption from everything, from all the obligations, stresses, and burdens, at once and permanently. The inability to cope with them is complete; what the patient is trying to cancel is not just one encounter but his total engagement.

The *rights to attention and to-be-taken-care-of* are similarly extensive in the claim presented by the suicide case. Typically, he expects to loom very large indeed, be it by how quietly and selflessly he slipped out of existence and thus ceased to encumber the lives of his significant others, or by making a large dent in the conscience of those he sees as having brought him to his disastrous impasse. To the extent that the patient could possibly be taken care of, and perhaps saved, by helpers in the health system, the implications of such a hope are no less total. Thus, if anyone should presume to be able to offer an alternative cure, his cure

would have to be equal to the patient's own in totality and pervasiveness. The helping intervention, the care offered, would have to remake the basic configuration of forces in the patient's existence. It would have to be able to "take it over from here," from the subject's own point of departure, and supply him with a new set of basic conditions.

Assuming that this is a realistic abstraction or extrapolation of the expectations presented by the suicide type-case as occupant of the patient or sick role, how congruent are such expectations with those of the other party in the relationship, the physician or other helper in the health system?

There are some indications that the congruence is rather low; the physicians and the health systems have a culture of their own, as well as a specialized technology. Exercise of specific skills is the hallmark of both. But what is claimed by the suicide patient is the diagnosis and treatment of a total condition, not only of somatic wounds. Since the action perimeter of health system members remains far short of the totality of demands which the suicide presents as an alternative to his own solution, they find the treatment of such a case frustrating.

Role obligations of the helper

The role obligations of the helper can again be typified by summarizing those attributed to the physician whose "primary responsibility is to do everything possible to forward the complete, early and painless recovery of his patients."[11] The "doing everything possible" and always being on the side of the patient and his health allows the physician to subject his patients to procedures on their bodies and to penetrations of their privacy which, in our culture at least, are clearly inadmissible in any other case. This part of the physician's role, however, is inseparably bound with other basic expectations, most particularly with what Parsons calls the "functional specificity" of the physician's acts with or upon the patient.[12] The physician may perform acts which would be "assault and battery" in any other situation, and indeed occasionally do become just that, legally, in some physician-patient relationships where the physician has failed to protect himself with an adequate form of patient's consent and a dispute arises. He may, however, engage in such acts only if they can be fairly, clearly, and directly construed as being in the interest of forwarding the patient's health or life.

Another role requirement, that of "affective neutrality,"[13] not only imposes a near-taboo on physicians caring regularly and in serious health problems for the members of their own families—or for themselves, for that matter—but also forces the physician to segregate as completely as humanly possible the technical or professional sphere of attitudes and behavior from the sphere of emotional involvement, be it in the realm of "appetites," "guilt reactions," or of the milder feelings of likes or dislikes of the patients as persons.

What we have exemplified above in the physician's case extends to the other personnel in the health system as well, partly as an attribute of their traditional, and in some respects legal, position as assistants to, or extensions of, the physician, and partly as an inherent component of the professional role in general. The demands of "doing everything possible" for the health of the patient, putting the patient's welfare first and maintaining "functional specificity" and "affective neutrality" of attitudes and behavior toward the patient may be somewhat diluted as the health worker's professional status distance from the physician increases. Yet, it seems to be clearly expected by the health system culture that these role requirements will govern to a very large extent the behavior of nurses, medical students, laboratory personnel, orderlies, aides, ambulance drivers and attendants, and all others whose job brings them into a helping situation vis-à-vis the patient.

We must ask which of these role expectations—if any—tend to be relaxed or suspended in response to the "deficiency" of the suicide case in meeting the obligations inherent in his role as a patient? To what extent, under what conditions, and by whom is the suicide victim or suicide attempter perceived as quasi patient in whose case it may be deemed permissible to behave as a quasi helper, retaining some but attenuating others of the behavioral prescriptions characteristic of a full-fledged, "normal," helper-patient relationship?

Research literature thus far has relatively little to report on the actual patterns of differential behavior toward suicide cases in health institutions. Some observations, however, have been recorded that indicate significant differences in perception of, and behavior toward, suicides in comparison with other patients, at least in certain categories of settings. For example, the part of the health services system which is a frequent recipient of both "successful" and "attempted" suicide cases is the emer-

gency room of the general hospital. Large municipal hospitals located in the cores of large cities find themselves in that role particularly often.

When a dead or dying—actually or presumably—person is brought into the emergency room and the suicidal origin of his condition is known or strongly suspected, what tends to happen? How is this kind of death or near-death different from some or all of the other "DOA-s" (dead-on-arrival) or "possibles," particularly in the staff's response, both techno-logical and cultural?[14] One study, by David Sudnow, depicting the "so-cial organization of 'death work' " on the basis of direct and thorough participant-observations, reports how in the emergency unit of the large county hospital under study, differential treatment was observed in cases of different types of "DOA-s" and "possible DOA-s." The controlling variable appeared to be not only the person's age (e.g., more frantic life-saving attempts and less haste to "pronounce" in the cases of children and younger persons, as compared to cases of older persons in similar physio-logical state), but also his staff-perceived status in the "moral social structure." The latter is determined particularly by signs of alcoholism but also by other attributes, suicidal origin of the injury being among them:

In the DOA circumstance, alcoholic patients have been known to be pro-nounced dead on the basis of stethoscopic examination of the heart alone, even though such persons were of such an age that were they not alcoholics they would likely have received much more intensive consideration before being so decided upon. Among other categories of persons whose deaths will be more quickly adjudged, and whose "dying" more readily noticed and used as a rationale for palliative care, are the suicide victim, the dope addict, the known prostitute, the assailant in a crime of violence, the vagrant, the known wife-beater and, generally, those persons whose moral characters are considered reproachable.[15]

Staffs in some hospitals apparently also tend to feel greater freedom from some of the customary restraints and to do certain amounts of ex-perimenting and teaching demonstrations on DOA or nearly-DOA cases if such cases also happen to be persons perceived as being of improper moral character, and particularly suicides. Sudnow illustrates this by the case of a woman brought to the emergency unit of the same hospital, near death after swallowing a lethal dose of Clorox. After she died, physicians on the shift took turns practicing insertions of an endotracheal tube, then

called in a group of interns to observe gastric lavage and examine the effect of the Clorox on the gastric secretions. This was apparently not unusual:

On several similar occasions physicians explained that with these kinds of cases they didn't really feel like they were prying in handling the body, but that they often did in the case of an ordinary death, i.e., a "natural death" of a morally proper person. Suicide victims are frequently the object of curiosity, and while there is a high degree of distaste in working with such patients and their bodies (particularly among the nursing staff; some nurses will not touch a suicide victim's dead body), "practice" by doctors is apparently not as distasteful.[16]

Sudnow further reports on other cases in which life-saving operations on suicide victims (attempters) were supplemented by additional, unnecessary surgical side ventures, either for "practice" purposes or quite admittedly motivated by curiosity. The freedom to take such steps was, apparently at least, derived from the fact that the patient had been a suicide—thus having, presumably, given a special form of "implied consent."

It would seem, then, that suicide as a special kind of death or near-death tends to be fairly clearly differentiated by the institutional staff, both in their perception and in contingent action, even in such relatively simple situations of encounter as when the body of a person who has committed suicide somewhere in the community is brought, dead-on-arrival or dying, to the emergency ward of a hospital for the brief interlude between the ambulance ride and coroner's morgue. It also appears that this differentiation is not entirely unique in the case of suicide deaths, but rather a part of a fairly consistent gradient of what perhaps might be best called "ascribed social worthiness." The assignment to the appropriate place on the gradient is done by the hospital staff, or, in some cases and up to a point, even before that by the ambulance driver who brings the DOA or "possible" case to the emergency entrance and announces him as such.[17]

The "worthiness" scale seems to be topped by children, young persons with "normal" deaths or near-deaths (". . . with so much life yet unspent . . .") and the various VIP's and notables recognized as such by the given community. The very bottom seems shared by alcoholics of the skid row type, and suicides[18]—unless, perhaps, the suicide is at the same time a "notable," such as a movie star or a famous literary figure, who, by some mismatch of circumstances of the moment, happened to reach

the kind of emergency room where DOA's picked up from the community are commonplace rather than exceptions.

While it seems that those at the bottom of the "ascribed worthiness" gradient all tend to receive a differential treatment in their *pre-mors* moments, it would seem important to investigate whether or not there are any patterns of organizational behavior (which permit the helpers to step outside some of the expectations of their professional roles) clearly pertaining to suicides as such, but not to alcoholics, assailants in violent crimes, or known prostitutes. We would hypothesize different freedoms to engage in side ventures in surgery or autopsy on the part of helpers based on their feelings that the suicide victim or suicide attempter in a sense "welched" upon, or at any rate did not meet, certain basic expectations of the patient role.

Summary

One of the central concepts of medical sociology is that of the sick role, or patient role. Most of the discussion in the chapter has focused on that concept and examined its applicability to suicide (attempted or completed) as a generalized type-case distinct from that of the regular somatic or mental disease. The question asked was: to what extent does the suicide case fit the institutionalized expectations of the sick role or patient role?

The examination was carried out with the help of an expanded fourfold table model separating the debit or obligation component of the patient role from the credit or exemptions-and-rights component on the one hand, and the suicide case from the regular disease case on the other.

The resulting distribution of basic attributes shows a distinctly deficient fit of the suicide type-case to the debit expectations of the patient role. The deficiency here is categorical, qualitative: The suicide's injury, resulting from a willed act of the subject, is diametrically opposed to the basic patient-role obligation of the subject to define the given illness or injury as undesirable and to wish to terminate it as soon as possible. The suicide case may typically also fail to meet the concurrent patient-role obligation to "seek competent help" and to cooperate fully with such help to effect a speedy recovery; the suicide case is usually brought to the "competent help" by others, often without even an implied consent on the suicide's part. Those suicide attempters who welcome rescue and co-

operate with the helpers do, of course, meet this particular patient-role obligation, but with a crucial modification: They are believed either to be "manipulating" the situation for secondary gains, or merely to have been technically unsuccessful in their self-destructive attempt, wishing to recover from this particular injury only in order to take more lethal steps next time.

On the credit side of the institutionalized patient-role expectations, those consisting of exemptions and rights, the suicide case presents to the analyst a good *qualitative* fit: the suicide, like the regular patient, does make a definite claim to exemption and release from the pressures and responsibilities of his social context and typically also to a right to exceptional attention from, and action by, significant others. At the same time, however, the goodness of fit to the patient-role expectations tends to be counteracted, or even canceled, on *quantitative* grounds. The suicide's claim is, typically, far too great, far exceeding the maximum encountered in the regular patient cases, but, more important, going well beyond whatever obligations are generally recognized and accepted as fitting, legitimate, and realistic by the patient's role counterpart in the situation—the competent helper in the health system: the physician, the hospital, the system as such. In exchange for abandoning his own radical solution to his problem—final departure (or at least an ostensive offering of final departure)—the suicide patient demands or needs from his helpers a solution which is hardly less radical: to make his continued stay livable in the light of *his* minimal standards, to recondition his life fundamentally.

But the competent helper, the health system, as a system of status-roles pertaining to the existing medical and allied occupations and callings, is far from being ready, able, or willing to present the suicide patient with an alternative and equally far-reaching solution, and confines its operations to its much more limited domain, resisting its redefinition by the claims of the suicide case.

Notes and references

1. Some examples of book form literature on this topic: Barney G. Glaser and Anselm L. Strauss, *Awareness of Dying,* Chicago: Aldine (1965); Idem., *Time for Dying,* Chicago: Aldine (1968); David Sudnow, *Passing-On: The Social Organization of Dying,* Englewood Cliffs, N.J.: Prentice-Hall (1967); Jeanne C. Quint, *The Nurse and the Dying Pa-*

tient, New York: Macmillan (1967); Orville C. Brim, Jr., ed., *The Dying Patient,* New York: Russell Sage Foundation (1970); Glenn M. Vernon, *Sociology of Death: An Analysis of Death Related Behavior,* New York: The Ronald Press (1970). Recent periodical literature on sociological aspects of death and dying is large and rapidly growing, especially in the last five years.

2. Howard E. Freeman, Sol Levine, and Leo G. Reeder, eds., *Handbook of Medical Sociology,* Englewood Cliffs, N.J.: Prentice-Hall (1972), p. 506.

3. The historical sequence of shifts of the concept of suicide closer to or farther away from medicine over the centuries was succinctly outlined by Robert T. Hudson in a paper on "Origins of American Attitudes Toward Suicide" presented at the Fofty-Second Annual Meeting of the American Association of the History of Medicine, May 8, 1969, in Baltimore, Maryland.

4. This outline is derived from Talcott Parsons's discussion of basic concepts and points of reference in structural analysis of social systems. See T. Parsons, *The Social System,* Glencoe, Ill.: The Free Press (1951), p. 25.

5. Ibid., pp. 25-26; also G. Gordon, *Role Theory and Illness: A Sociological Perspective,* New Haven: College and University Press (1966), pp. 22-23.

6. Gordon, *Role Theory,* pp. 113-14, quoting R. Linton, *The Study of Man,* New York: Appleton-Century (1936).

7. Parsons, *The Social System,* pp. 428-79, passim; Talcott Parsons and Renee Fox, "Illness, Therapy, and the Modern Urban American Family," *J. Social Issues,* 8:31-44 (1952).

8. Parsons, *The Social System,* p. 285, passim. The concept of "sick role," introduced by Parsons, has quickly become one of the central concepts in medical sociology. It has been systematically developed further and supported by empirical research data; see Gordon, *Role Theory.*

9. Parsons and Fox, "Illness, Therapy," p. 38.

10. At least in cases that are regarded as "serious," with high lethality, or as "true" and "genuine," that is, as distinguished from instances where the suicide attempter himself actively seeks medical assistance immediately after his presumably or allegedly suicidal act, and thus tends to create doubt whether his self-injury should in fact be classified as a suicidal attempt, or merely as a message worded in suicidal symbols.

11. Parsons, *The Social System,* p. 450.

12. Ibid., p. 456.

13. Ibid., p. 451, passim.

14. For discussion of these two concepts see Sol Levine, N. A. Scotch, and George J. Vlasak, "Unravelling Technology and Culture in Public Health," *Am. J. Public Health,* 59, no. 2:237-44 (February 1969).

15. Sudnow, *Passing-On,* p. 105.

16. Ibid., p. 107.

17. Sudnow, *Passing-On,* pp. 100-104, describes a pre-screening practice by ambulance drivers who by sounding special siren alarms and by certain shorthand remarks as they wheel the stretcher into the emergency entrance indicate their suspicion that the patient may be dead—and thus initiate, in fact, at least the first phase of the decision process as to what action will ensue. Drivers also tend to announce, by using the same means, when for example a younger person is being brought in as a possible DOA. Sudnow concludes: "One can observe a direct relationship between the loudness and length of the siren alarm and the considered social value of the person being transported."

18. See also Avery D. Weisman, "The Psychological Autopsy and the Potential Suicide," *Bulletin of Suicidology,* Washington, D.C.: U.S. Government Printing Office (December 1967), p. 17.

SEYMOUR PERLIN AND CHESTER W. SCHMIDT, JR.

8 PSYCHIATRY

Introduction

A suicidal individual's situation demands of the psychiatrist an understanding of the patient's dominant intrapsychic characteristics and of his mode of response to past and current crisis, the diagnosis of possible mental illness, and an assessment of the risk of suicide. Although theory and practice have been based primarily on experience with patients, additional data are increasingly available from nonpatient populations and from indirect methods of examining the lives of those who have committed suicide. Nevertheless, no single theory encompasses in useful fashion the diversity of suicidal behavior.

Psychiatrists have tended to look at the phenomenon of suicide in the larger context of violence; in their examination of suicidal patients, they seem to have been most impressed by the underlying aggression. As we will see, aggression can be embedded in a clinical picture such as depression and can vary from other-destructive to self-destructive behavior. Although aggression itself or in a disease model such as depression has been considered in reactive as well as endogenous terms, the incentives provided by the psychosocial field to commit the ultimate aggression against oneself have been given insufficient attention by psychiatrists. Still, Weisman[1] can view suicide as "not simply a tragic act committed by one person, but an option whose choice is demanded of a person by forces within his psychosocial environment." It does seem possible "to drive another person to suicide."

147

led data for understanding the motivation to kill oneself and the
quent carrying out of a lethal act are now becoming available
gh prospective and retrospective assessment in the aforementioned
atient populations as well as in different types of patients. But sui-
cide is an infrequent act and its occurrence depends on so many different
situational variables that it is difficult to predict. Thus, clinical and ac-
tuarial formulations must attempt to accord proper weight to situational
factors in order to make better predictions of the risk of suicide. Such
predictions are apt to be best made for specific periods of time in homo-
geneous groups.

In this chapter we will consider suicide from the following viewpoints:
psychodynamic theory, recognition of the suicidal individual, studies of
attempted and completed suicide, and methods of assessing completed
suicide.

Psychodynamic theory

In his review of Freud's thinking on suicide, Litman[2] pointed out the link
between outwardly and inwardly directed aggression as interchangeable
aspects of the death instinct. Among the suicide mechanisms that Freud
viewed as involving the breakdown of ego defenses and the release of in-
creased destructive, instinctual energy were: loss of love objects, aggres-
sion directed toward an introjected love object, narcissistic injury, over-
whelming affect, and a setting of one part of the ego against the rest.

Modifications and extensions of Freud's thesis are less dependent on
the supposition of a death instinct. The failure to alter the environment,
on the one hand, and the apparent inability to conform or adapt, on the
other, may result in a retroflexion of rage in which the object for punish-
ment becomes oneself. Identification with the hated object may still oc-
cur, but the inability to alter the behavior of the "significant other" in the
interpersonal situation may be crucial to the development of a helpless
rage that is coercive in design and fed by failure. Such feelings may as-
sume the proportions of death wishes directed against another and one-
self. Fitting revenge on significant others may be fulfilled symbolically
only by the "success" of suicide and its subsequent impact. The hoped-
for result, such as the instilling of guilt in survivors, is often achieved.

In the depressed individual, the guilt of transgression, real or fantasied,
may be mollified by a suicidal attempt which symbolically serves as a

form of atonement or by suicide itself. Similarly, in the depressed person real or imagined failure may have preceded or have been a response to feelings of shame, inadequacy, worthlessness, and so forth; overwhelmed by helplessness and hopelessness, he may obsessively ruminate on suicide as the only solution. And the isolation common to this state may separate him from the help of others, as well from the hurts they may inflict.

In some depressed patients, perhaps especially in the excessively dependent and aged, the goal of reunion with a loved one may precipitate intense identification with this person and the carrying out of the reunion fantasy. Or reunion by suicide may be conceptualized simply as the means by which a better life is obtained. A special risk of suicide may occur during the period of emergence from depression since the emotional energy to commit suicide then becomes available, and the goals foreseen in the depths of illness may be more readily achieved. The suicide rate for depressed patients frequently increases during the six months following discharge from the mental hospital; however, this increase may reflect recurrence of depression as well as the emergence phenomenon described.

Although suicide is said to be the mortality of depressive illness, many suicidal individuals do not appear to be clinically depressed, and many depressed patients are not suicidal. Recent reports suggest that hopelessness may be a better indicator of intensity of *current* suicidal ideation and the risk implied thereby than depression. As will be seen later in this chapter, the warring nature of the world of the potential suicide, depressed or not, or his withdrawal from it requires our attention. Particularly in the aged, suicide may be seen as a release.

Studies of psychotic (schizophrenic) patients will be discussed in the section on Attempted and Completed Suicides. But akin to the notion of separation from others by psychosis as a symbolic form of withdrawal is that of patients who see themselves as already dead. "Strong feelings of detachment, repressed aggression, and dampened affectivity are perceived by many patients as the equivalent of emotional dying or death. Clinically these patients may appear apathetic rather than depressed . . . and see suicide as a release from or as the carrying out of an event that has already happened."[3]

For some, "Suicide can be a response to excessive preoccupation with the fear of death through the feeling of control over the when and how of dying."[4] And the taking of one's life may provide an illusory feeling of

mastery over a situation through the control of life and death. "For many, perhaps even for most people, the idea of having to die is unbearable. Partly they respond to this necessity as if it made life senseless and meaningless. By committing suicide they believe they have cheated death as the condemned cheats the executioner and the populace when he kills himself . . . for most suicides the act does not mean really dying. Dying for them is something that is suffered and passively submitted to; when actively performed it becomes a triumph, as if the ego has proved itself to be almighty when it is strong enough to cast its own life aside."[5]

Menninger's classic statement embodies the issues we are considering. He regards suicide "as a peculiar kind of death which entails three internal elements: the element of dying, the element of killing, and the element of being killed."[6]

There seems little usefulness (or validity) in considering these elements as the basis of a "disease model." The psychodynamic issues[7] involved are but one part of the psychological inventory, and many other data are required for a composite evaluation of suicide attempters and completers.

Furthermore, the information needed for a psychodynamic understanding of suicide will be influenced by our approach to the suicidal individual. The manner in which we interview him may very well determine his inclination to communicate his thoughts of self-destruction openly rather than to continue them in private obsession. Too often a suicidal person is implicitly asked to justify his status, since harm or potential harm is self-inflicted. Havens[8] has made it clear that such examination demands self-examination; how the subject makes us feel—what personal responses undermine, through contagious sadness or annoyance, the interviewer's attention. If the examiner can have empathy for as well as interest in the suicidal individual's predicament, he will not be so likely to take a "why did you do it?" attitude that may be perceived as an outsider's accusation. In the case of an attempt, the patient may relate to the interviewer as he would to a significant other. The interviewer quickly symbolizes societal response in his interpreted role as prosecutor, defender, helper and may thereby contribute to the dynamics of future attempts. The initial interaction is particularly important if made by the interviewer-therapist.

Whatever the approach to a patient by a therapist, distortion may be present. Self-accusation, self-justification and rationalization may occur

before patient and therapist meet. In other cases, when discharge of aggressive feelings via self-injury or relief of guilt by self-punishment occurs unconsciously, for instance, a lack of intent may be the patient's overt communication. Not to be overlooked in any communication is the "cry for help" which seems to accompany or indeed define the suicide attempt.[9]

Recognition of the suicidal individual

Psychiatrists view the potentially suicidal individual against the backdrop of social and demographic factors that may imply greater vulnerability to self-destructive behavior and the likelihood of events and agents that can catalyze suicidal ideation and intent into action. For example, an elderly male who is losing his health and has already lost his job has a degree of vulnerability not shared by younger, healthy, working males; if this old man is alcoholic and recently widowed, the risk is considerably increased. Evidence of prior responses to stress, such as a suicide attempt, may further raise the risk of suicide.

The histories of suicides do not necessarily show clear evidence of specific psychiatric illness and the degree of suicidal risk. However, the whole gamut of psychiatric illness may be found among suicides, and certain groups are notable risks, for example, manic-depressive patients. Many general correlations apply to nonpatients and patients alike. Increasing age and the rate of suicide are related; males are more likely to commit suicide than females; the single, the divorced, and the widowed have a higher rate of suicide than married individuals.

In an interview, a suicidal individual may describe suicidal obsessions, a threat, a gesture, a detailed plan, or an attempt. The history of attempt alone provides immediately useful information for the assessment of increased risk.[10]

The act of self-poisoning provides a useful paradigm for the recognition and assessment of the suicidal individual. The survivor's knowledge of the toxicity generally can be ascertained; in the recovery period (e.g., the awakening from coma), the patient may be particularly amenable to inquiry; the range of agent toxicity is known; and the probability of death from the ingestion can be rated.

In this context Kessel[11] has proposed an "index of endangering life." The untreated consequence of the amount of substance ingested is one

factor; the other comprises the steps taken by the patient to avoid or, alternatively, to ensure discovery. In Kessel's words, "To take tablets knowing that this will remain undiscovered for many hours is a very different matter from promptly entering the living room and brandishing the offending bottle before the assembled family's startled gaze. The quantity of poison ingested is certainly relevant, though patients often have wildly wrong notions about the effects of what they have done."

Knowledge of an individual's awareness of the probable effects of his act can permit further definition of the seriousness of intent. A child's belief that the aspirin he swallows can cause death may be contrasted with the awareness and intent of a physician who self-administers a drug of low toxicity. The schizophrenic who ingests poison may do so because of hallucinated "commands" or may be driven to the act by feelings of persecution. Knowledge of the suicidal individual's awareness of what he is doing (especially if there is a detailed plan for a quick and private death) and of the toxicity of the poison or the potential toxicity of the combination of such ingested agents as barbiturates and alcohol, permits judicious use of an "index of endangering life." Yet, this index will always be subject to such imponderables as the impulsiveness of many suicidal individuals and the fact that some attempts, as Weiss[12] has pointed out, "have at least in part the character of a gamble with death."

Studies of attempted and completed suicide

Much of the psychiatric literature on suicide has been based on studies of attempted suicides followed up for the purpose of determining risk factors and studies which have compared attempted with completed suicides. In the pursuit of etiological determinants, however, it is desirable to compare other groups with those who attempt and those who commit suicide.

Greer and his colleagues[13] compared on the basis of past and present environment 156 attempted suicides admitted to the hospital with nonsuicidal psychiatric patients and with medical, surgical, and obstetric patients without psychiatric disorder. Compared with the matched control group, the attempted suicides had a greater incidence of childhood parental loss. These losses more commonly involved both parents, they occurred at younger age, and they were more likely to be permanent, that is, due to parental death or divorce. As for the present, a significantly

higher proportion of attempted suicides had experienced recent disruption of a close relationship due to interpersonal conflict.

Of interest in any study of attempted or completed suicide is the history of relatives who have committed suicide, thereby serving as role models of response and "solution" at a time of crisis.

In such comparative studies or in the follow-up of attempters, the usual caution must be taken in the application of findings to the individual case. Insufficient consideration may be given to different responses by others to the "message" of the attempt, to the variations in the attempter's ambivalent attitude toward completing suicide, and to the different phases in the course of a possible underlying illness. The following case illustrates the need for detailed analysis of each suicidal act—for the purposes of research as well as treatment.

A fifty-seven-year-old minister entered a psychiatric hospital after making a suicide attempt. Though the attempt was nearly fatal, the patient responded to questioning about his wish for death by saying, "I don't want to die. I just couldn't stand it any longer, and I didn't know where to turn." What he could not tolerate was obsessive sexual rumination about his adolescent daughter. In order to interrupt this obsession, which was causing him intense anxiety, he saw no other way than "to interrupt his life." The patient's course reflects Stengel's[14] description of the suicide attempt as a behavior pattern that is directed not only toward death, but also toward needed human contact and life.

Among those who had already made an attempt, Dorpat and Ripley[15] found the following factors to be associated with greater likelihood of suicide: age (older more than younger); sex (men more than women); "serious" intent (e.g., suicide as a planned act); multiple prior suicide attempts; unmarried status (divorced, widowed, single); living alone; poor physical health; psychosis; lethal method used in attempted suicide; suicide note; infrequent use of health agencies; unemployed or retired; from a "broken home." In the studies reviewed by Dorpat and Ripley, the incidence of suicide among attempters ranged from 0.03 per cent in one short-term study to 22 per cent in the longest follow-up study. The length of follow-up has an obvious bearing on these percentages. In general, we would expect a rate of 1 to 2 per cent of suicides per year among those who have made a suicide attempt.

Suicide may occur during relapse of the mental illness present at the

time of the original attempt or in association with a new psychiatric disturbance—for example, suicide in the course of a schizophrenic relapse or in association with psychotic depression. "Early" or "late" suicide associated with acute presenting illness, a chronic illness in relapse, or a new illness is likely to produce fluctuating patterns in the suicide rate over time in long-term follow-up.

In addition to following up attempted suicides over time, we can retrospectively examine the histories of completed suicides, that is, the case records of patients who have committed suicide. Flood and Seager have compared completed suicides of psychiatric patients with two control groups. The first was obtained by taking the case admitted previous to the last admission of the patient who had committed suicide; the second was made up of patients matched for sex, age, hospital, and diagnosis admitted during the same period. Among the broad diagnostic categories of psychosis, neurosis, and personality disorder, the only important difference was the predominance of psychotic illness in the patients who subsequently committed suicide. Another notable finding was the "high incidence of previous suicidal attempts in the suicide group compared with the two control groups."[16] The most striking feature distinguishing the suicide group was the high incidence of disturbed relationships with hospital staff leading to premature discharge, often against medical advice; aside from the issue of treatment, the significance of this finding may be in the parallel disruptions with and losses of significant others before and after hospitalization.

Rates of suicide among psychiatric patients are difficult to calculate; diagnostic disagreement, the complexity and costs of following up adequate samples, and the variables involved in the decision to judge and record a death as suicide limit both the number of studies and the reliability of reported data. There is general agreement, however, that psychiatric patients who have been hospitalized commit suicide more often than people outside hospitals—with depressives and psychotics heading the list. The commonest disorder is thought to be psychotic depression. Pokorny[17] investigated the suicide rate among former patients in a psychiatric service of a Texas veterans' hospital over a 15-year-period and calculated the suicide rates on the basis of 100,000 such patients per year as follows: depression, 566; schizophrenia, 167; neurosis, 119; personality disorder, 130; alcoholism, 133; and organic brain syndrome, 78. As a subgroup, manic-depressive patients had the highest rate.

Let us now turn to a study of case records of suicides limited to a single diagnosis, schizophrenia. The present authors and their colleagues[18] had access to the case histories of 361 schizophrenic inpatients who had been followed up for a period of at least five years after the date of the initial hospital admission. There had been 12 suicides in this group. In addition to clinical judgments of suicide risk, the patients' records were analyzed[19] according to social and demographic status, diagnostic subcategory, personality, symptomatology, and a prognostic index (which had been shown to correlate with improvement following hospitalization of schizophrenic patients).

The clinical ratings of suicide potential distinguished the 12 suicide cases which were randomly interspersed with 75 controls drawn from the total sample. (It was found that a significantly higher proportion of the suicides were given the specific diagnosis of reactive psychotic depression.) However, four items were found to make significant independent contributions to the clinical predictions. In order of importance these were: high number of previous suicide attempts, alcohol problem, male sex, and old age. The addition of further items did not result in any significant increase in predictability. As expected, the number of previous suicide attempts was the most important single variable associated with outcome as well as the one that influenced raters' judgments the most. A composite index which weighted each of these items and was then reapplied to the entire series of 361 cases proved disappointing. The patients' records suggest the possibility of including additional ratings of the depressed state, hallucinations that command the patient to injure himself, and persecutory delusions in order to obtain a more effective composite prediction of suicide in schizophrenic patients.

In prospective studies, attention can be better directed to such issues as cognitive and affective style, suicidal ideation, self-rating of mood and response to stress, the psychosocial field, the "meaning" of relatives who are mentally ill or who have committed suicide, and situational variables. The need for knowing the dynamics of such factors is clear. In the psychosocial field, for example, does living alone equal isolation; is the number of visits to a household closely correlated with the number of relationships; is loss of support or lack of communication to be equated with hostile pressure from others? Prospective studies give us greater opportunity to achieve a composite picture and to move toward the development of models that have more predictive value.

The possibilities for weighted indices that include behavior patterns in dynamic terms can be seen in the following findings. Fawcett and Bunney[20] were able to separate high- from low-risk patients on the basis of stated intent to die, communication of this intent only to the significant other, and attempted behavioral change just before attempted suicide. In addition to the specific acute features, *chronic* behavior patterns also distinguished the high-risk patients: interpersonal incapacity, marital isolation, and negation or distorted communication of dependency needs.

In studies by the authors[21] the psychosocial fields of random samples of suicide seemed to have begun to disintegrate;[22] if no actual or only modest loss had occurred, there was, nevertheless, a profound sense of disruption. The whole field did not have to change. This suggests a parallel to the issue of loss of partial identity in an individual (e.g., loss of beauty in an actress) which may be felt as loss of the whole identity. A negative identity stereotype, imposed and accepted, may be felt as a similar loss; in the aged this may occur simply as a function of growing old.[23] Thus, if change is sensed as total loss or negatively judged, the individual's entire psychological space or "world" may be felt as "lost" or hostile. His relationship to significant others may then be crucial in generating or suppressing a suicidal impulse.

Loss or disruption in the psychological field may be viewed in terms of both the passivity and the activity of significant others. The husband or wife, for instance, may feel immobilized and unable to respond in an active, helpful manner to the suicidal person in a high-risk crisis situation; or a progressive indifference and helplessness may gradually replace what once had been a responsive attitude and a capacity for action in the other person.[24] We must then begin to speak of others unconsciously colluding with or indeed consciously driving the person-at-risk to suicide. The pressures brought to bear on an individual by others can go beyond conflicts that may produce depression and an increased risk of suicide. The dynamics may be more akin to the scapegoating of a given family member, earmarking him as "sick"; in some families that the authors have studied, a member seems to have been pushed toward suicide as a means of resolving a familial conflict.[25]

In one case of known suicide that could be rated on a passive-to-active pressure continuum, the history was obtained from a husband who had cared for his chronically bedridden wife for 20 years. Although the wife suffered chronic pain from severe arthritis and was bitter at her circum-

stances, she bore the situation in a tenacious manner. Gradually, the husband began to express his distaste for his own care-giving role, to blame his wife more and more for the constriction imposed on his own activities, and to voice barely disguised antipathy toward her for continuing to live. He verbally projected the picture of what he would be "robbed of" in the future, but at the same time expressed concern for her very real physical pain and continued his nursing activities. As the neighborhood deteriorated over the years, he began to talk of burglaries and purchased a gun which he discharged in a "how to work it" session; he then left the loaded gun within arm's reach of his bedridden wife. After the demonstration and a particularly bitter soliloquy, the husband went to work. The wife killed herself shortly afterwards.

In another case, a forty-year-old man returned from the overnight ward of a general hospital after his third serious suicide attempt, to be greeted by the following comment from his wife in the presence of their children: "Here comes your father; he has never done anything well, even taking his own life." The wife and children went out to shop; on their return he was dead by hanging.

Learning and change in the behavioral patterns of both the suicidal or potentially suicidal person and the significant other can take place after an attempt or gesture. An eighteen-year-old woman decided to kill herself after her husband had deserted her; on awakening from a coma induced by a large amount of barbiturates, she found a guilt-ridden husband who wished for a reconciliation and who pledged fidelity. When his behavior became errant again, she made a knowingly superficial gesture, quite unlike the previous attempt, but again achieving change in his behavior. This pattern was then repeated, but finally without reconciliation. Thereupon the woman killed herself. The first attempt is often the most significant in terms of learning (often by chance) how to manipulate the significant other. But each repetition of threat, gesture, or attempt must be understood as part of a new set of circumstances.

Loss of support from significant others may represent "breakdown," immobilization, a giving up (but not disinterest), manifest disinterest, collusion, an active, if unacknowledged, desire to remove the offending person by making it easier for him to commit suicide by altering situational variables such as the availability of a gun, and finally an intentional act of "driving the other person to suicide." Shifts to lower levels of support, say from disinterest to collusion, are in themselves disruptions which

may be regarded as important factors in the implementation of a suicidal plan.

Finally, others also play a role in situations that emphasize fantasied impact after death. An adolescent's "you'll be sorry when I'm dead," a wife's desire for a revenge that will spoil her unfaithful husband's life, a widow's thoughts of reunion with her dead husband, and the acting out of a suicide "pact" as part of a reunion fantasy with a relative or friend who has committed suicide are recurrent examples of this theme.

Method of assessing completed suicide

The question still remains: how can we assess a dead person's motives, particularly if his mode of death is meant to obscure its true nature?

The chief method for assessing the former psychological status and personality characteristics of the recently deceased is the psychological autopsy, an amalgamation of a wide variety of information. In a monograph dealing with this technique, Weisman and Kastenbaum state that the purpose of the psychological autopsy is "to reconstruct the final days and weeks of life by bringing together available observation, fact and opinion about a recently deceased person in an effort to understand the psychosocial components of death."[26] In a review of the psychological autopsy as reformulated by Shneidman for use with suicides, Allen[27] described it as an inventory of information about the victim (name, age, address, marital status, religious practices, occupation, and so forth); details of the death (including the cause or method and other pertinent details); brief outline of the victim's history (siblings, marriage, medical illnesses, medical treatment, psychotherapy, previous suicide attempts); death history of the victim's family (suicides, cancer, other fatal illnesses, ages at death, and other details); description of the personality and life-style of the victim; his typical patterns of reaction to stress, emotional upsets, and periods of disequilibrium, any upsets, pressures, tensions, or anticipations of trouble within the past year; the role of alcohol and drugs in (1) the victim's overall life-style and (2) his death; the nature of his interpersonal relationships (including physicians); fantasies, dreams thoughts, premonitions, or fears relating to death, accident, or suicide; changes in the victim before death (of habits, hobbies, eating, sexual patterns, and other routine practices); information relating to the "life side"

of the victim (upswings, successes, plans); assessment of intention; rating of lethality of implementation, reactions of informants to the suicide.

Shaffer and his coworkers[28] found the psychological autopsy essential to the full understanding of suicide but limited by variations in the interviewer's approach and his expectations of finding a history that was likely to "explain" the suicide, by the frequent lack of a standardized schedule, by difficulties in quantifying the data and developing valid scales of high reliability, and by an absence of suitable norms with which to compare findings.

Thus, it became apparent that what is needed to enhance the value of the psychological autopsy is a method for assessing personality and behavior that is fairly comprehensive, yields quantitative scores along several dimensions, possesses suitable norms, has some claim to reliability and validity, and can be used in the absence of the subject. The instrument chosen by the authors was the Katz Adjustment Scales (KAS-R Forms) which consist of 205 rating scale items designed to provide measures in the following general areas: symptomatology and social behavior, performance of social activities, expectations regarding social activities, free-time activities, and satisfaction with free-time activities. Eighteen separate scales have been derived and can be compared to normative data from samples of the general population. The forms are designed for use by an informant who is a close friend or relative of the subject and who has had an opportunity to observe him for a given period of time. Following brief, neutral directions by the interviewer, the informant rates the subject in terms of the behavioral items in the scales. In order to minimize the extent to which the informant's involvement would tend to bias his reporting, all items have been worded so as to focus on specific behavior and thereby reduce the necessity for inference or judgment.

When this method was used with the relatives and friends of 16 completed male suicides from a sample of coroner's cases, the suicides received scores that deviated considerably from male norms.[29] On the average, they scored significantly higher ($P < K0.05$) on measures of belligerence, verbal expansiveness, negativism, helplessness, anxiety, psychopathological manifestations, nervousness, bizarreness, and hyperactivity (see Table 1). In addition, they revealed a strong tendency toward suspiciousness and showed less participation in both free-time and obligatory social activities. A depression scale was not available on male

A HANDBOOK FOR THE STUDY OF SUICIDE

Table 1. Mean T-scores of two groups of deceased male subjects on the Katz Adjustment Scales-R Forms.

Scale	Completed suicides (N=16)	Driver fatalities (N=25)
1. Belligerence	65*	58*
2. Verbal expansiveness	63*	54
3. Negativism	67*+	55*
4. Helplessness	69*+	51
5. Suspiciousness	66 +	51
6. Anxiety	99*+	54
7. Withdrawal and retardation	50 +	44*
8. General psychopathology	71*+	55*
9. Nervousness	64*+	53
10. Confusion	47	47
11. Bizarreness	75*+	52
12. Hyperactivity	65*	60*
13. Emotional stability	48	49
14. Performance of socially-expected activities	41*	51
15. Expectation of performance	46	48
16. Dissatisfaction with socially-expected activities	63 +	49
17. Performance of free-time activities	59*	53
18. Dissatisfaction with free-time activities	55 +	48
19. Depression[1]	(27.06)+	(19.69)

* Significantly different from normative mean of 50 at .05 level or beyond.
\+ Significantly higher than mean of other deceased group at .05 level or beyond.
[1] Mean raw score–T-score conversion unavailable.
Source: J. W. Shaffer, S. Perlin, C. W. Schmidt, Jr., and M. Himmelfarb, "Assessment in absentia: New directions in the psychological Autopsy," *Johns Hopkins Med. J.*, 130:308-16 (1972).

norms, but an additional cluster of items thought to reflect depression was developed for comparison with other deceased groups.

This mode of assessment does not escape the problems of rater bias and unreliability, and there is a related question of the suitability, for comparative purposes, of normative data derived from persons still living. Comparisons with deceased groups have already begun. Preliminary data from a sample of 25 male suicides and 16 male driver fatalities indicate greater deviance from norms among the suicides.[30] A comparison of the two groups revealed that the suicides were seen by informants as being significantly more negative, helpless, suspicious, anxious, withdrawn, nervous, bizarre, and depressed than were the driver fatalities (see Table

1). In addition, they exhibited significantly more psychopathological symptoms and created greater dissatisfaction—on the part of informants —with their socially expected as well as their free-time activities. Table 1 also reveals strong tendencies toward greater verbal expansiveness and fewer engagements in socially expected activities as well. Further studies should permit the characterization of subgroups of suicides among the driver fatalities, especially in single-car accidents.[31]

Using a modified Katz Adjustment Scale, an investigator may serve as "respondent" and rate the suicide on the basis of available information about his life. In such a study of suicides among physicians,[32] the characteristics which differentiated the suicides from the controls were negativism, suspiciousness, verbal expansiveness, dependency, and impulsivity. When the Lorr Outpatient Mood Scale[33] was applied in a similar manner, the suicides were rated significantly higher than the controls in the areas of thoughtfulness, anger-hostility, and depression. And on the Minnesota-Hartford Personality Assay[34] the suicides were differentiated from controls by their self-destructive tendency, depression, and guilty self-concept.

Such studies are provocative but far from definitive. Further studies of patient and nonpatient populations are needed. Research into suicidal ideation, suicidal gesture, single and multiple attempts with high and low likelihood of success, and completed suicide within a given time period should include varied populations, a systematic approach to the recognition of the will to live, and the evaluation of the internal and external restraints on suicide of person, family, and culture.

Notes and references

1. Avery D. Weisman et al., "Death and Self-Destructive Behaviors," in *Suicide Prevention in the '70s,* eds. H. L. P. Resnik and Berkeley L. Hathorne, Rockville, Md.: National Institute of Mental Health (1973), pp. 13-22.
2. Robert E. Litman, "Sigmund Freud on Suicide," in *Essays in Self-Destruction,* ed. Edwin S. Shneidman, New York: Science House (1967); see also Robert E. Litman and Norman D. Tabachnick, "Psychoanalytic Theories of Suicide," in H. L. P. Resnik, ed., *Suicidal Behaviors,* Boston: Little, Brown and Company (1968), pp. 73-82.
3. A. M. Freedman, H. I. Kaplan, and B. J. Sadock, eds., *Modern Synopsis of Comprehensive Textbook of Psychiatry,* Baltimore: The Williams and Wilkens Company (1972), p. 494.

4. Herbert Hendin, "The Psychodynamics of Suicide," *J. Nerv. Ment. Dis.,* 136:236 (1963).

5. K. R. Eissler, M.D., *The Psychiatrist and the Dying Patient,* New York: International Universities Press (1955), 2nd Edition (1973), p. 66.

6. Karl A. Menninger, *Man Against Himself,* New York: Harcourt, Brace & Company (1938).

7. Note: Since we view suicide in a multiple-etiology, multiple-determinant framework, elaboration of the constructs presented as well as additional psychodynamic formulations among special groups will be presented throughout this chapter.

8. L. L. Havens, "Recognition of Suicidal Risks Through Psychological Examination," *New Eng. J. Med.,* 276, no. 4:210-15 (January 26, 1967).

9. Erwin Stengel, *Suicide and Attempted Suicide,* London: Penguin Books, (1964); Norman L. Farberow and Edwin S. Shneidman, *The Cry for Help,* New York: McGraw-Hill (1961).

10. Note: Patients who exhibit suicidal ideation without attempt, form a special and separate group for study.

11. N. Kessel, "Self Poisoning. The Milroy Lectures for 1965," *Br. Med. J.,* 2:1265-70 (November 1965), 2:1336-40 (December 1965).

12. James M. A. Weiss, "Gamble with Death in Attempted Suicide," *Psychiatry,* 20:17 (1957).

13. S. Greer, J. C. Gunn, and K. M. Koller, "Aetiological Factors in Attempted Suicide," *Br. Med. J.,* 2:1352-55 (December 1966).

14. Stengel, *Suicide.*

15. T. L. Dorpat and H. S. Ripley, "The Relationship Between Attempted Suicide and Committed Suicide," *Compr. Psychiatry,* 8, no. 2:74-79 (1967).

16. R. A. Flood and C. P. Seager, "A Retrospective Examination of Psychiatric Case Records of Patients Who Subsequently Committed Suicide," *Br. J. Psychiatry,* 114, no. 509:433-50 (1968).

17. Alex D. Pokorny, "Suicide Rates in Various Psychiatric Disorders," *J. Nerv. Ment. Dis.,* 139:499-506 (1964).

18. Seymour Perlin, Chester W. Schmidt, Jr., and J. H. Stephens, "Prediction of Suicide Among Discharged Schizophrenic Inpatients," (Presentation at Meeting of American Psychiatric Association, Dallas, Texas, May 1-5, 1972).

19. Note: The analyses were carried out without access to follow-up information.

20. J. A. Fawcett, M. Leff, and William G. Bunney, Jr., "Suicide: Clues from Interpersonal Communication," *Arch. Gen. Psychiatry,* 21, no. 2:129-37 (1969).

21. Seymour Perlin and Chester W. Schmidt, Jr., "Fellowship Program in Suicidology," in *Organizing the Community to Prevent Suicide,* eds. J. Zusman and D. L. Davidson, Springfield, Ill.: Charles C. Thomas (1971).

22. In a study by Murphy and Robins 32 per cent of alcoholic suicides had had a breach in emotional relationships within six weeks of having committed suicide, though such did not hold true for the affective disorder group. It is suggested that suicide in alcoholics is a result of social disturbances, while in the affective disorder group it is a result of depression. At the time of losing an important emotional relationship, the alcoholic is especially vulnerable to suicidal impulses. George E. Murphy and Eli Robins, "Social factors in suicide," *J.A.M.A.*, 199, no. 5:81-86 (1967).

23. Seymour Perlin and R. N. Butler, "Psychiatric Aspects of Adaptation to the Aging Experience," in *Human Aging: A Biological and Behavioral Study*, Washington, D.C.: National Institute of Mental Health, U.S. Government Printing Office (1963).

24. Robert E. Litman, "Immobilization Response to Suicidal Behavior," *Arch. Gen. Psychiatry*, 2:282-85 (1964).

25. Seymour Perlin and Chester W. Schmidt, Jr., "The Need to Drive the Other Person to Suicide" (Unpublished material).

26. Avery D. Weisman and Robert Kastenbaum, *The Psychological Autopsy: A Study of the Terminal Phase of Life*, New York: Behavioral Publications (1968).

27. Nancy H. Allen, *Suicide in California 1960-1970*, California: Department of Public Health, State of California (1973).

28. J. W. Shaffer, S. Perlin, C. W. Schmidt, Jr., and M. Himmelfarb, "Assessment in Absentia: New Directions in the Psychological Autopsy," *Johns Hopkins Med. J.*, 130, no. 5:308-16 (1972).

29. Ibid.

30. Ibid.

31. C. W. Schmidt, S. Perlin, W. Towns, R. S. Fisher, and J. W. Shaffer, "Characteristics of Drivers Involved in Single-Car Accidents: A Comparative Study," *Arch. Gen. Psychiatry*, 27:800-803 (1972).

32. L. C. Epstein, C. B. Thomas, J. W. Shaffer, and S. Perlin, "Clinical Prediction of Physician Suicide Based on Studies of Medical Student Data," *J. Nerv. Ment. Dis.*, 156, no. 1:19-29 (1973).

33. M. Lorr, P. Daston, and I. R. Smith, "An Analysis of Mood States," *Educ. Psychol. Meas.*, 27:89-96 (1967).

34. B. C. Glueck, Jr., P. E. Meehl, W. Schofield and D. W. Clyde, *Minnesota-Hartford Personality Assay*, The Institute of Living, Hartford, Conn.

PETER SAINSBURY

9 COMMUNITY PSYCHIATRY

Community psychiatry is concerned with the development of an appropriate organization to provide for the early recognition, treatment, aftercare, and wherever possible, prevention of mental illness in the population of an administrative (catchment) area. These purposes are common to all schemes of community psychiatry, though the ways in which the community services are integrated to do this will differ depending on the administrative structure of the health and social services of the locality.

Let us consider the effects on the suicidal patient and on the incidence of suicide of introducing community psychiatric services. In particular, we wish to know whether extramural care increases or lessens the risk of suicide in order to determine what measures are required to foster its potential as a suicide prevention service. To begin to answer these questions, it is first necessary to examine the ways in which suicide relates to the management and care of patients, to the suicides' social and family circumstances, and to mental disorder. Is the risk of suicide, for example, increased when the patient is treated in a closed or an open hospital? How does admission to hospital or community care affect it? Does the risk depend on whether he lives with his family or by himself? Is it greater in the period before referral to the psychiatrist or after discharge from care? And what characteristics of his neighborhood, if he is being treated extramurally, are detrimental?

A common criticism of community care is that the suicidal patient is deprived of the expert surveillance and protection against self-injury that the staff and regimen of a hospital afford. This point of view is regularly invoked whenever liberalizing reforms in the mental hospital are mooted, such as unlocking doors, providing cutlery and other ordinary domestic necessities. Certainly, on the face of it, it seems reasonable to fear that the suicidal patient who is free to wander from the wards into the grounds or into town may make for the nearest tree or river, and that in the modern ward of an open hospital he is at liberty to jump through the unbarred windows or use his dinner utensils as a dagger. But such facts as are available provide little support for these apprehensions. It is, therefore, of interest to see how the growth of community psychiatry and the corresponding changes in the mental hospitals in Britain have affected the incidence of suicide in patients.

Before the Mental Health Act of 1930, the custodial function of the hospital was of first importance. This Act, however, marked the first stirrings of a more tolerant attitude to the mentally ill and the beginning of community psychiatry, for among its provisions were the setting up of psychiatric outpatient departments in the general hospitals and the introduction of voluntary admission to the mental hospital. The integration of the mental hospital with the community and the development of a more liberal administration in it were hastened by the passing of the National Health Service Act in 1946. This measure coincided with a period of rapid increase in psychiatric knowledge and of therapeutic skills; it promoted the recruitment of doctors with new ideas to psychiatry. The fusion of a new administrative era and a new generation of psychiatrists led to many experiments directed both at strengthening the links between the mental hospital and the community and in the removing of barriers such as locked wards and restricted visiting within the hospital. Finally, the Mental Health Act of 1958 accelerated these developments; it removed the last barriers between the hospital and the community, between psychiatrists and their medical colleagues, and the distinction between general medical patients and psychiatric ones; and by making the local authorities responsible for certain extramural facilities, it actively promoted community psychiatric services.

Table 1 shows the mean suicide rates of the resident population of the mental hospitals of England and Wales during three-year periods, progressing from a policy of custodial care to one of open doors and then to

Table 1

Year	Mean annual no. patients in hospitals**	Mean annual no. of suicides	Annual suicide rate/ 100,000	Type of psychiatric care
A* 1920-21	101,438	48.7	48.0	Custodial pre-1930 Act
B* 1945-47	133,428	68.7	51.5	Custodial but post 1930 Act
C 1954-56	146,847	55.0	37.5†	Open-hospitals, more liberal policies
D 1964-66	190,426	76.7	40.3†	Community care, more patients in general hospitals' psychiatric beds

* The 1920-21 and 1945-47 figures are adapted from Erwin Stengel, *Attempted Suicide,* Maudsley Monographs, No. 4, London: Chapman and Hall (1958).

** A, B, and C patients resident in mental hospital, D patients in any psychiatric bed including general hospitals.

† Rates in periods C and D are significantly lower than rates in periods A and B (P < .05).

the beginning of community care. The changes in the suicide rate of in-patients are informative. The latter period, during which wards were opened, was accompanied by a significant decrease in suicide when compared with the custodial era (1945-47); although the rate increases a little with the advent of community care, it still remains significantly less than in the days of rigorous supervision when patients were placed on "suicidal caution." This is more remarkable when the characteristics of the patients selected for admission to hospital following the introduction of a community service are considered. Those admitted are patients in whom the risk of suicide is known to be high: the aged, the lonely, those in conflict with their families, patients whom the psychiatrist rated a suicidal risk, and those who have made previous suicidal attempts.[1]

The increased participation of the patients in their local community and also in the hospital community has been accompanied by striking changes in behavior; patients in the more progressive hospitals show less apathy and withdrawal, and are less violent and aggressive,[2] so the greater tolerance, the more hopeful attitude, and the social rehabilitation, so often features of the open hospitals, may actually protect patients against suicide. Two empirical studies have attempted to depict the ef-

fects of the trend toward community psychiatry on suicide in patients: the first was at Dingleton Hospital in Scotland, one of the earliest hospitals to implement fully a policy of open doors,[3] and the second was in Chichester, England, which pioneered a community psychiatric service in 1958.[4]

Dr. Bell initiated an open door administration at Dingleton between 1945 and 1950. In the ten years preceding this innovation there were 91 suicides in the hospital's catchment area, whereas in the ten years following there were only 53. The corresponding figures for suicide in the rest of Scotland were 3,481 and 3,507 respectively. These comparisons certainly make it probable that the acceptance of, and easier access to, the mental hospital by the local community may have been responsible for this diminished suicide rate by inducing more of the mentally ill to come for treatment. Moreover, when the number of suicides in patients who were, or had been, in contact with Dingleton was estimated for the period 1950-59, three cases were identified (one resident patient, one at home on leave, and one who had been discharged a week before). This number corresponds with the expected rate for a 400-bedded hospital calculated on data available for patient suicides in all Scottish hospitals. So Dingleton's open door administration had also protected its patients at least as effectively as the more restrictive practices then customary in the other Scottish hospitals.

But the effects on suicides, for better or worse, are most likely to become apparent with the introduction of community psychiatric services that actively promote the treatment of patients in their homes, at day hospitals, as outpatients, or in hostels. The Chichester community care service is of this kind.[5] It is located in a rural district of Sussex with a population of 120,000. Its initial aims were typical of many community psychiatric programs: to reduce admissions to the district mental hospital, which had become overcrowded, and particularly to explore alternatives for the care of the aged; to overcome institutionalism by hastening discharge; to select the type of disposition best suited to the needs of the patient and of his family; and to examine the notion that treatment given in the usual family and social setting, other things being equal, is beneficial. The way in which the welfare, medical, and psychiatric facilities of an area may be coordinated to achieve such ends will depend on its demographic and cultural characteristics, and local initiative. The distinguishing features of the Chichester service were that it was organized and

run by the staff of the district mental hospital, Graylingwell; and its initial emphasis was on home and outpatient treatment in close collaboration with the general practitioners, that is to say, on clinical rather than social care. All referrals to the service were first examined at home, at the day center, or in an outpatient clinic before a decision was taken whether to give treatment in hospital or in one of the extramural facilities.

A service of this kind treats patients at home who would otherwise have been admitted. On the one hand, doubts are often expressed as to whether this is wise, as many of the extramural patients will be covertly or overtly suicidal; on the other, it is held that improved services will be prophylactic because more treatment facilities will be available for more patients, though clearly much will depend on the thoroughness and skill with which patients are initially screened and the suicidal recognized, on the standards of the subsequent care of patients recommended extramural treatment, and on the aftercare of those who are discharged following admission to hospital.

The Medical Research Council's Clinical Psychiatry Unit at Graylingwell undertook an evaluation of the Chicester services.[6] During one year social and clinical data on all patients referred to the service were recorded and compared with similar data on all referrals to a more traditional, hospital-based service in Salisbury—the control; in addition, a one-in-three random sample was followed up for two years. The findings gave some support for both views. Even though the patients in the two services were matched on severity of illness, the referral rate was very significantly higher in the community service; in particular, a much greater proportion of the elderly were being seen, and patients were also being seen earlier in their illness. Furthermore, although the community service admitted only 14 per cent of referrals to the mental hospital compared with 52 per cent in the hospital-centered one, it still admitted as high a proportion of patients judged to be suicidal by the psychiatrist as did the control. On the debit side, however, it was apparent that certain clinical and social groups, notably the younger, neurotic patients and their families, were not receiving adequate social support and follow-up in the community service, and these groups were having a much less satisfactory clinical outcome.[7]

Having given this brief outline of the Chichester community service, Dr. Walk's findings on suicide in the area can be better appreciated.[8] He compared the suicide rate of patients within a year of contact with a serv-

ice psychiatrist and also the rate for the population at risk (the catchment area of the service) during the five years preceding the introduction of community care and following it. The annual suicide rate of all patients who had seen a psychiatrist within a year was 240 per 100,000 before and 169 after the start of the service. Although this apparently substantial decrease is not statistically significant, the fall is still probably related to the increase in the number of patients referred to the new services, because when the elderly—patients aged sixty and over—who had had contact with a psychiatrist were separately examined, their suicide rate fell from 4.2 per 100,000 of the area population before the service began to zero afterwards (p <0.02).

If a patient dies by suicide within a year of referral to a psychiatrist, this can be regarded as a failure of the service in suicide prevention. The important conclusions, therefore, that can be drawn from Walk's survey are that extending psychiatric services to the community is likely to be reflected in a trend toward reduced suicides in patients and that suicide can be diminished significantly in a group of patients (the elderly) previously shown to be benefiting most from the community service.

Other evidence from a follow-up study of patients in the Chichester community-based service and those seen in the hospital-based one in Salisbury tended to confirm this view. Thomson[9] recently followed through seven years all referrals who had been diagnosed as having a manic-depressive illness. He found the patient suicide rate to be lower in the community service. Although the decrease was not significant, the trend is consistent with that observed by Walk and again points to the preventative effect of a community psychiatric service.

It may be inferred from the various findings so far that close observation of the suicidal patient in hospital, though frequently an obvious and essential precaution, is not necessarily the only, or even the most important, factor in the management of the suicidal and in the prevention of suicide. Those factors in the community and in the organization of community psychiatry that may contribute to suicide prevention therefore merit further attention.

Of first importance is, perhaps, the ready availability of the psychiatrists and other psychiatric personnel. A feature of the new service was that a psychiatrist was on call at the day hospital throughout the 24 hours so that the general practitioner could refer a patient or obtain a visit to the patient's home at very short notice. It was therefore significant that

the incidence of suicide fell most markedly in the elderly for whom serv-
ices had previously been very inadequate. In the past they had received
short measure because too few hospital beds were available for them; con-
sequently the family doctor, aware of the difficulty of having an aged per-
son admitted, cared for the patient himself as best he could. The evalua-
tive research on the new service showed that the referral rate of old
people increased more than any other age group, particularly among
the poor, lonely, single, and very old.[10] That is to say, those most at risk
for suicide gained most from the service.

Secondly, the policy of home visiting and setting up day hospitals pro-
vided an alternative means of giving clinical, welfare, and nursing support
to the aged and their families. As about 40 per cent of the patients re-
ferred to the service were depressed, early treatment might be expected
to have prevented some deaths. Thus, in a community-care program the
psychiatrist and his supporting team are in a better position to exercise
the knowledge needed to assess the suicidal individual: they are able to
observe those symptoms denoting a high risk, to judge how serious the
suicidal intentions are, to determine whether the social and family cir-
cumstances are such as to predispose to suicide, and to decide not only
the most appropriate treatment but also select the conditions under which
it may best be given, whether in or out of hospital. The psychiatrist's
training in suicide prevention, however, does not at present equip him to
take advantage of what is known; though, of course, there are enormous
deficiencies in our knowledge of many of the aspects of prevention just
enumerated.

Table 2, adapted from Walk's paper,[11] lists the proportion of suicides
that had seen a psychiatrist during varying periods before their deaths.
Those authors who had most closely observed the previous history of the
suicide agree in estimating that at least 20 per cent of suicides had been
in contact in the preceding year. A more recent enquiry by Barraclough
and his colleagues[12] in West Sussex and Hampshire, in which the homes
of consecutive suicides in these counties were visited soon after their
deaths and a full account obtained from the relatives, friends, and family
doctor of the suicide's previous medical and psychiatric history, his man-
agement, his social circumstances, and current problems, provided a
unique opportunity to record more precise data. They found that 25 per
cent were having psychiatric treatment during the year before death and
19 per cent had been seen by a psychiatrist within the last month.[13] What

Table 2. Previous psychiatric contact in suicide.

Author	Area	Period of study	Number studied	Psychiatric contact	Period
Parnell and Skottowe	England	1950's	100	23%	Not stated
Motto and Breene	San Francisco	1956-57	174	9%	Contact within six months
Robins et al.	St. Louis	1956-57	134	20%	Not stated
Capstick	Wales	1951-55	881	14%	Contact ever
Kingsley Jones	East Anglia	1957-63	30	20%	Contact within a year
Seager and Flood	Bristol	1957-61	325	16.0%	Contact within six months
				29.8%	Ever an in-patient
Walk	Chichester	1952-56 and 1959-63	123	23.5%	Contact within one year

Source: Adapted from D. A. Walk, "Suicide and Community Care," *Brit. J. Psychiatry,* 113:1381-91 (1967).

emerges of considerable relevance to community psychiatry and suicide prevention, therefore, is that about a quarter of all suicides are known to a psychiatrist. Why, then, is he failing to prevent more of them? We have a number of important leads, some from epidemiological surveys and others from detailed clinical studies such as those of Barraclough, and notably, of Robins et al., in St. Louis.[14]

Three epidemiological investigations are especially valuable guides to planning psychiatric care and suicide prevention in the community. First, Helgason[15] followed for sixty years Icelanders born between 1895 and 1897. One hundred and three, or nearly 2 per cent of those followed, developed a manic-depressive illness; 34 of them were dead by 1960, 18 from suicide. So more than half of the manic-depressives' deaths were suicides and 17 per cent of all cases of manic-depressive illness committed suicide. This figure agrees with a number of other careful investigations in which patients with affective illness have been followed up.[16] People with this diagnosis contributed a far greater proportion of suicides than did those with other psychiatric disorders. An easily recognized and readily treated mental disorder therefore heads the list of mental illnesses associated with suicide.[17] Secondly, Temoche, Pugh, and MacMahon of

the Department of Epidemiology at Harvard[18] compared suicide rates of discharged patients with those of the general population. The residents of Massachusetts who had been in a mental hospital had a suicide rate many times higher than those who had not; and of all the diagnostic categories, the risk was again greatest among those who had had a depressive psychosis: their rate was thirty-six times that of the general population.

Finally, Pokorny[19] identified all patients discharged from the Veterans' Administration hospitals in the United States who died by suicide between 1949 and 1953. He also found the manic-depressives had by far the highest rate. Moreover, over a quarter of those who committed suicide did so within six months; in the Harvard study a third of the suicides occurred within six months of discharge. These well-planned surveys not only confirm the predominance of manic-depressive illness, but the vital lesson from the viewpoint of community psychiatry is that well-planned after-care visits are an essential requirement of any community program that encourages the early discharge of patients, a matter that will be dealt with again in a later section.

Recently clinical investigators relying on reports by the suicides' relatives, friends, and doctor, rather than the inquest reports of coroners (or officials responsible for ascertaining the cause of death), have supported the belief that a large proportion of suicides are suffering from mental illness. They too find that much the commonest disorder is psychotic depression, approximately 45 per cent in the United States[20] and 75 per cent in England;[21] the next most frequent condition is alcoholism in the United States and Scandinavia, and in England personality disorders. In the elderly, early dementias and confusional states take a prominent place; but physical illnesses and chronic incapacitating disorders often appear to precipitate the suicide act in the elderly.[22] It has therefore become our point of view that suicide falls squarely within the realm of community medicine and psychiatry; and prevention will depend on the capacity of the medical, psychiatric, and welfare personnel, and on the willingness of the public health administrators to organize the social and psychiatric services in the light of the facts now available. The view that healthy people kill themselves, and justifiably so if circumstances are sufficiently adverse, or that the individual should be "free" to decide his own fate is not tenable to us; the protection of the suicidal is as much a medical and community responsibility as is any other cause of death against which prophylactic and therapeutic measures are available.

It has already been pointed out that about one quarter of suicides have had comparatively recent contact with a psychiatrist. But what links have the remaining three-quarters had with medical and welfare agencies, or what warning have they given to others in the community? Those who have looked into these questions have come to some surprising conclusions. In Sussex and Hampshire, for example, about 40 per cent of all suicides have seen their family doctors in the week preceding their death and 60 per cent in the previous month;[23] in Wales about three-quarters of suicides were shown to have been under medical care in the "months" preceding death, and most of them also communicated their intentions to their families or neighbors.[24] In St. Louis the findings were similar, but Robins adds that the suicides' communications were repeated to many people in their social and domestic group and that over half of the important manic-depressive group had received medical or psychiatric care in the weeks preceding their death. It therefore seems that psychiatrists, general practitioners and those laymen to whom the community turns in a crisis should have better been able to evaluate these warnings.

In addition to drawing attention to the possibilities of mobilizing more competent medical and psychiatric help to the individual bent on suicide, the investigation in the two southern counties in England also indicated that there were opportunities for the welfare worker and minister in the locality to intervene. Nearly half of the suicides had seen one or other in the period immediately preceding death, though they had not apparently discussed their intentions with them. So it would appear that the suicidal person does not perceive these members of the community as being able to help or give advice, nor have the minister and social worker, at least in this area of England, generally accepted this responsibility as part of their role. Nevertheless, the church and social and welfare organizations clearly can and do make a valuable contribution to suicide prevention in their neighborhoods. In fact, lay bodies such as the Samaritans in Britain and the Suicide Prevention Centers in the United States[25] and other countries[26] have been more active in promoting and organizing suicide prevention than have the official organs of the medical professions. Moreover, some interesting factual evidence has recently been obtained for supposing that these facilities are effective.[27] Shea and Barraclough are currently assessing the incidence of suicide in the clients who seek help from the Samaritans and have found that they have a very high rate (over 300 per 100,000).[28] So the Samaritans are recruiting clients in whom the

risk of suicide is as high as in patients referred to the psychiatrist, and obviously it will become essential for any community psychiatric service to collaborate closely with the lay suicide prevention organizations. The problem now facing both psychiatric and lay facilities is how to improve their skill in assessing the suicidal risk and so diminish the high rate of suicide in those who seek their advice.

There are many reasons, demographic and clinical, for supposing that those who make a suicide attempt can be differentiated from the successful suicide. On the one hand, attempted suicides are more often women, young, and married; clinically, they are more often suffering from personality disorders; and the attempt is often precipitated by domestic crises and upheavals in their personal relationships. Suicides, on the other hand, are predominantly male, elderly, single or separated, and they suffer from depressive psychoses; and the suicide is precipitated by illness, bereavements, and loneliness. Nevertheless, the two groups clearly overlap, and the risk of an attempted suicide subsequently making a fatal attempt is between 1 per cent and 2 per cent a year. The efficient management of the suicide attempt is therefore a necessary function of a community psychiatric program. It was gratifying to find when comparing the Chichester community service and the hospital-based one that a higher proportion of suicide attempts were referred in the former.[29] Certainly, a community service by having alternative agencies to which the suicidal might turn, and more opportunities for assessing and treating attempted suicides, might be expected to see more of them.

In Britain the obvious person whom the suicidal person, or suspecting relatives, would ask for help and advice is the family doctor, because to all intents and purposes, everyone is registered with a local practitioner. In other countries they might turn to the suicide prevention center staffed by both medical and welfare personnel; and in yet others this role might fall to a minister of religion. Everywhere, however, the person who has already inflicted injury on himself will be referred to the casualty department of the general hospital, or where specific emergency clinics are available, to these. Whichever community focus is the initial source of referral, the problems of subsequent assessment and management will be the same, and their current deficiencies in this respect are all too obvious.

We have already seen that extending facilities increases referral rates and so promotes opportunities for prevention; as far as attempted suicide is concerned, this has been amply demonstrated in Edinburgh, where the

setting up of a special and well-advertised ward in the city infirmary for the evaluation of all suicide attempts has greatly increased the referral of cases;[30] but facilities alone are not enough. The general practitioner, the hospital casualty physician, the clinic welfare worker, and particularly the psychiatrist require sufficient training to allow them to evaluate the risk of suicide, and avenues for further investigation and treatment must also be available to them if suicide prevention is to become a practicable proposition.

These key figures, therefore, need to be able to recognize the individual most at risk: depressives, alcoholics, and the suicide attempters, in particular; to be familiar with the characteristics of these patients that increase the risk—such factors as aging, loneliness, bereavement, family history of suicide or depression, history of previous attempt, a recent onset of a depressive illness, or recent discharge from hospital following treatment for it; and also the symptoms of depression that increase vulnerability (persistent insomnia and ideas of guilt, for example). In addition, they must be able to elicit this information and know how to discuss with the patients their attitudes to death and to suicide. These skills are not at present conspicuous among those who first see the suicidal person; and when acquired, they are of limited value unless the means are provided in the community for continued care. The problem of what each member of the team in a community psychiatric service can contribute to the prevention of suicide, their training, and collaboration in the pursuit of these objectives will be dealt with in the following paragraphs.

Those in the community to whom the suicidal person might be expected to turn and should therefore be in a position to assess their intentions and take appropriate action, fall into four main categories: the psychiatrists; other medical practitioners; ancillary medical personnel such as nurses, social and welfare workers; and certain groups of laymen. Each will have a distinctive part to play in an integrated district service and should be trained to make the best use both of their particular professional skills and of their special roles in the community. The psychiatrist must first be constantly aware of the possible risk of suicide in patients referred to him and who is most likely to be vulnerable—aged depressives, for example, or lonely alcoholics. It has already been argued that improved extramural care increases referrals to the psychiatrist, but if services are extended, barriers have to be overcome: distrust of the psychiatrist and of the mental hospital. I have known of more than one suicide

that was precipitated by the patient being told he was to be admitted. Community psychiatry offers alternative disposals when the patient has fears of this kind, but a really flexible service will also allow patients to be easily moved from one type of care to another, such as from treatment as an inpatient care to the day hospital, depending on his needs and circumstances. The hospital then becomes one of a number of possibilities and is not seen as being particularly threatening. The psychiatric team in a community service can be, and should be, so organized that the same personnel see the patient through each of the different facilities. This will ensure that another essential requirement can be met—the systematic aftercare of the suicidal patient during the dangerous convalescence stage, which follows active treatment of his depression, for instance, when patients often still lack confidence and fear they will never be able to cope with their affairs as they used to.

Secondly, the psychiatrist is the expert to whom patients will be sent for an assessment of the risk of suicide, advice on treatment and subsequent management. He must be known to be available for this purpose by everyone who is likely to encounter the suicidal person. Thus, the family doctor, the psychiatric social worker, other welfare personnel employed by the local health services, and lay organizations, such as the Samaritans, should all have easy access to him at all times.

Further, the community psychiatric service should take a leading part in *organizing* suicide prevention and in *training* all personnel who can contribute to the service. In particular, the psychiatric team should be responsible for educating their medical colleagues, a process that should start in the medical schools—the doctor needs to be made aware of suicide as a preventable cause of death early in his career. Similarly, the psychiatrist, by participating in the postgraduate education of hospital and general practitioners in his locality will ensure that suicide prevention is prominently featured so that his colleagues not only come to accept this as a medical responsibility, but also to become aware of the need to collaborate with the psychiatric services in dealing with the problem.

The doctor in charge of the emergency or casualty service of the area has special responsibility in this respect, as casualties who have resorted to self-injury or self-poisoning will first be seen by him. He must recognize that a psychiatric evaluation is essential in order to assess the risk of suicide and to advise on disposal and aftercare. Nearly one-third of the

suicides in Sussex and Hampshire[31] who had made a previous attempt were not seen by a psychiatrist when they made it, but the subsequent fate of the two-thirds that had been seen emphasizes the difficulties as well as our shortcomings in recognizing those in whom intent is greatest.

It has already been indicated that the general practitioner has a pivotal part to play, as he is the member of the community from whom the suicidal person or his relatives and friends that suspect his self-destructive intentions are most likely to seek advice. At present his training does not equip him to fulfill this function. Although the majority of suicides see their doctors, it has been shown that he often fails to appreciate the danger they are exposed to. Eighty-five per cent of suicides in Sussex and Hampshire had been seen by their GP, and nearly the same proportion had been prescribed psychotropic drugs by him. He was, therefore, recognizing emotional distress in the patient, but not its suicidal implications, because he prescribed hypnotics (mostly barbiturates) to many of them; that is to say, they had been given the means to kill themselves. Moreover, about two-thirds of the suicides who died from soporifics and analgesics were obtaining this type of drug from their doctor. Nor was the nature of their disorder fully appreciated, because only 18 per cent of those who were subsequently diagnosed as suffering from a depressive illness had been given antidepressants.[32] The gist of these observations is that a community psychiatric service ought to ensure not only that psychiatrists, but also the family doctor and hospital physician, are familiar with both the symptoms and treatment of depression and other psychiatric disorders associated with suicide.

The attitudes of general practitioners to mental illness and to suicide will be important in the recognition and management of the suicidal patient and in the development of suicide prevention services. Suicidal persons sometimes turn to others in their immediate neighborhood—relatives, friends, the minister, or social worker. The latter should, therefore, be able to cope with their overtures; in addition, they may incidentally have the opportunity of helping the suicidal person unsolicited should they meet them in the course of visiting for other reasons. About one-third of suicides are known to have spoken to a social worker or minister in the six weeks before their death. The training of the psychiatric social worker and public health workers, such as district nurses, health visitors and so on, should include suicide prevention. A community psychiatric service

needs to enlist their support by providing lectures, case conferences, and pamphlets on the subject.

The psychiatric social worker or mental welfare officer is often the first person to be contacted by a patient or his family, and when a skilled interviewer visits the home, she has a unique opportunity to elicit the anxieties of the patient and of other members of the household, or to probe any apprehensions the family have that the patient may be suicidal.

Next, she is often the most suitable person in the psychiatric team to undertake follow-up visits in order to provide support and help with the practical and social problems that may have precipitated a suicidal act. The aftercare of the patient who has attemtped suicide, of the alcoholic or depressive, all of whom are risks, is an essential part of prevention.

Certain crises are commonly associated with and appear to precipitate a suicide. Bereavement and separation are frequent precursors,[33] so support and advice in dealing with personal losses, particularly in the aged, can be prophylactic. Physical illness is present in a surprising proportion of suicides; consequently, the health visitor and welfare worker can also do a great deal to ameliorate the adverse effects of chronic illness. Among the aged, minor disabilities that limit sight, hearing, and movement may have disproportionate effects by restricting activities and interests, with the result that the old person is confined to his room, becomes increasingly lonely, and worthwhile activities are no longer possible. Under these circumstances life may seem to be without any purpose; but referral to a clinic for remedial treatment effects a remarkable change in outlook in many patients.[34]

Living alone, being widowed, moving to a new district, are socially isolating circumstances found more often among suicides than in the general population.[35] The social worker could often do a lot to remedy the loneliness of suicide-prone people through social clubs, personal introductions, and similar measures. Similarly, help with occupational, financial, legal, and marital difficulties may make all the difference to the discharged patient, for example the alcoholic. Reassurance and explanation about the nature of a patient's illness or the suicide act are important as well. An essential aspect of discharge planning is that the patient should be clear when and to whom he can go for help in the community until the crisis in his affairs is past, or until he has acquired enough insight into his problems to cope with them more realistically. Much of what has been

said about social workers applies also to nurses working in the community, particularly in dealing with some of the patients' medical needs.

Organizations such as the Samaritans have been well in advance of the psychiatric and public health bodies in Britain in setting up a community organization for suicide prevention. In this widely publicized program, initiated by Chad Varah, lonely and suicidally disposed people are invited to contact staff members by telephone. Helpers are recruited so that someone is available to clients throughout the twenty-four hours. The movement has expanded rapidly, and there are now branches in most large towns. As was noted, the Samaritans attract high-risk clients. Although there are grounds for believing that the Samaritans are effective in suicide prevention,[36] the high rate of suicide among their clients implies, as is also the case with psychiatric clinics, that we will have to improve our skill in identifying the potential suicide and increase the efficiency of these community agencies in applying the available knowledge of suicide. The most pressing need is for closer collaboration between the psychiatric, medical, and lay bodies. For example, in the Chichester community service for some years past the psychiatrists have arranged seminars and lectures for the local clergy and theological students, but much more remains to be done at the practical, service level.

In a community service it is both possible and desirable to solicit the cooperation of the relatives and other members of a patient's household. Once a patient is known, for example, to suffer recurrent episodes of depression, in which he has suicidal ideas and inclinations, the family can be warned of the symptoms that are likely to accompany a relapse and be asked to inform the family doctor, mental welfare officer, or psychiatrist, should they recur. In addition, they can be told to watch for the hints and forebodings by which the suicide usually betrays what he has in mind: "It will be better for everyone when I go" or "I cannot bear this any more." If the help of families is regularly sought, then by degrees the community at large will come to appreciate the need to heed warnings and threats of suicide, and to discover from whom they may seek advice without fear of rebuff.

Finally, it is worthwhile considering the special opportunities for research into suicide that community psychiatry offers. As the referral rate to a community service is considerably higher than in a hospital-based one,[37] a larger and more representative sample of the mentally ill in the

population at risk is available for study. Consequently, a truer picture of the suicidal patient and of patients who die by suicide in a defined area can be obtained, and epidemiological investigations into attempted suicide and patients' suicide, such as their incidence and hence the extent of the problem that has to be prevented, become possible. By repeating surveys of this kind over a period of time, inquiries into the consequences of improving community services can be undertaken, and by comparing the rates of suicidal behavior before and after implementing the new measures, the effect of specific suicide prevention methods can be evaluated. In this way the results of an intensive training program for community workers on the recognition of the suicide-prone could be determined, on whether improving the channels for the systematic psychiatric examination of patients can affect the suicide rate and repetition of suicide attempts.

The study of suicides occurring in a defined administrative area, such as a district covered by a community psychiatric service, has two benefits.

First, in a community psychiatric service it is easier to gain access to information about suicides soon after their death. Details of their psychiatric and medical history and of their recent management can be obtained from the doctor who treated them; often their families will be known to the service, or can be approached through their general practitioners, and a full account built up of the clinical condition, social factors, and recent stresses that precipitated the act. The suicides can then be compared with selected samples of patients and with the general population of the area, to test working hypotheses about the causes of suicide.

Second, consecutive cases will naturally provide a statistical sample: many problems of epidemiological research in psychiatry, such as defining the disorder and finding all the cases in the population, that hampers a survey of, for example, schizophrenia or delinquency, are largely overcome when suicide is considered because of the medico-legal procedures for ascertaining unexpected deaths. An area service will consequently facilitate a scientific approach to the clinical study of suicide and to the effectiveness of psychiatric programs designed to reduce the suicide rate.[38]

Notes and references

1. J. C. Grad and Peter Sainsbury, "Evaluating the Community Psychiatric Service In Chichester: Results," *Milbank Mem. Fund Quart.,* 44 (part 2):246-78 (1966).
2. J. K. Wing, "Social Treatment, Rehabilitation and Management," in A. Coppen and A. Walk, eds., *Recent Developments in Schizophrenia,* Ashford, England: Headley Bros. (1967).
3. R. A. W. Ratcliff, "The Open Door: Ten Years Experience in Dingleton," *Lancet,* 1:188-90 (1962).
4. J. D. Morrissey, "The Chichester and District Psychiatric Service," *Milbank Mem. Fund Quart.,* 44, (part 2):28-56 (1966).
5. Ibid.
6. Grad and Sainsbury, "Evaluating . . . Chichester: Results," pp. 246-78; P. Sainsbury and J. C. Grad, "Evaluating the Community Psychiatric Service in Chichester: Aims and Methods of Research," *Milbank Mem. Fund Quart.,* 44, (part 2):231-42 (1966).
7. J. C. Grad and Peter Sainsbury, "The Effects that Patients Have on Their Families in a Community Care and a Control Psychiatric Service: A Two-Year Follow-up," *Br. J. Psychiatry,* 114:265-78 (1968).
8. D. A. Walk, "Suicide and Community Care," *Br. J. Psychiatry,* 113: 1381-91 (1967).
9. I. G. Thomson, "Suicide and Mortality in Depression," read at the 5th International Conference on Suicide Prevention, London, 1969.
10. P. Sainsbury, W. R. Costain, and J. C. Grad, "The Effects of a Community Service on the Referral and Admission Rates of Elderly Psychiatric Patients," in World Psychiatric Association, *Report on Psychiatric Disorders in the Aged,* Manchester: Geigy (1968).
11. Walk, "Suicide and Community Care," pp. 1381-91.
12. B. M. Barraclough, B. Nelson, and P. Sainsbury, "The Diagnostic Classification and Psychiatric Treatment of 25 Suicides: A Pilot Study," *Proceedings of the 4th International Conference for Suicide Prevention,* Los Angeles: International Association for Suicide Prevention and Delmar (1968).
13. B. M. Barraclough, J. Bunch, B. Nelson, and P. Sainsbury, "A Hundred Cases of Suicide: Clinical Aspects," *Br. J. Psychiatry,* 124: [in press] (1974).
14. Eli Robins et al., "Some Clinical Considerations in the Prevention of Suicide Based on a Study of 134 Successful Suicides," *Am. J. Public Health,* 49:888-98 (1959).
15. T. Helgason, "The Epidemiology of Mental Disorder in Iceland," *Acta Psychiat. Scand.,* Suppl. 173 (1964).
16. Robins, "Some Clinical Considerations," pp. 888-98.
17. Peter Sainsbury, "Suicide and Depression," in A. Coppen and A. Walk,

eds., *Recent Developments in Affective Disorders,* London: Royal Medico-Psychiatric Association (1968).

18. A. Temoche, Thomas F. Pugh, and Brian MacMahon, "Suicide Rates Among Current and Former Mental Institution Patients," *J. Nerv. Ment. Dis.,* 138:124-30 (1964).

19. Alex D. Pokorny, "Suicide Rates in Various Psychiatric Disorders," *J. Nerv. Mental. Dis.,* 139:499-506 (1964).

20. Robins, "Some Clinical Considerations," pp. 888-98.

21. Barraclough, Nelson, and Sainsbury, "The Diagnostic Classification"; Barraclough, Bunch, Nelson, and Sainsbury, "A Hundred Cases."

22. Peter Sainsbury, *Suicide in London,* Maudsley Monographs No. 1, London: Chapman and Hall (1955); B. M. Barraclough, "Suicide in Old Age," in D. Kay, ed., *Recent Developments in Psychogeriatrics,* London: Royal Medico-Psychiatric Association (1971).

23. Barraclough, Nelson, and Sainsbury, "The Diagnostic Classification"; Barraclough, Bunch, Nelson, and Sainsbury, "A Hundred Cases."

24. A. Capstick, "Recognition of Emotional Disturbance and the Prevention of Suicide," *Br. Med. J.,* 1:1179-82 (1960).

25. Edwin S. Shneidman and Norman L. Farberow, "The Suicide Prevention Center of Los Angeles." in H. L. P. Resnik, ed., *Suicidal Behaviors,* London: J. and A. Churchill, Ltd.; Boston: Little, Brown and Company (1968), pp. 367-80.

26. E. Ringel, "Suicide Prevention in Vienna," in Resnik, *Suicidal Behaviors,* pp. 381-90; World Health Organization, "Prevention of Suicide," *Public Health Papers,* No. 35, Geneva: World Health Organization (1968).

27. See Mary Monk, "Epidemiology," Ch. 10—ED.

28. M. Shea and B. M. Barraclough, "A Study of Samaritan Clients Who Subsequently Commit Suicide," paper read at the 5th International Conference for Suicide Prevention, London, 1969; B. Barraclough and M. Shea, "Suicide and Samaritan Clients," *Lancet,* 2:868-70 (1970).

29. P. Sainsbury, D. A. Walk, and J. C. Grad, "Evaluating the Community Psychiatric Service in Chichester: Suicide and Community Care," *Milbank Mem. Fund Quart.,* 44 (part 2):231-42 (1966).

30. N. Kessel, "The Respectability of Self-Poisoning and the Fashion of Survival," *J. Psychosomat. Res.,* 10:29-36 (1966).

31. Barraclough, Nelson and Sainsbury, "The Diagnostic Classification."

32. B. M. Barraclough, B. Nelson, J. Bunch, and P. Sainsbury, "Suicide and Barbiturate Prescribing," *J. Royal Coll. Gen. Practit.,* 21:645 (1971).

33. J. Bunch, B. M. Barraclough, B. Nelson, and P. Sainsbury, "Suicide Following Bereavement of Parents," *Social Psychiatry,* 6:193 (1971).

34. Peter Sainsbury, "Suicide, Depression and Old Age," *Proceedings of the International Congress on Mental Health,* London (1968).

35. Sainsbury, *Suicide in London;* P. Sainsbury, "Suicide: Opinions and Facts," *Proceedings of the Royal Society of Medicine,* 66:579 (1973).

36. Shea and Barraclough, "Study of Samaritan Clients."
37. Grad and Sainsbury, "Evaluating . . . Chichester: Results," pp. 246-78.
38. Peter Sainsbury, "Social and Epidemiological Aspects of Suicide with Special Reference to the Aged," in R. H. Williams, ed., *Process of Aging,* New York: Atherton Press (1963), pp. 153-75.

10 EPIDEMIOLOGY

Introduction

Epidemiology is concerned with the investigation of the frequency and distribution of a disease or condition, and of the factors that influence its distribution.[1] The data obtained may be useful in formulating programs of control or prevention; and the efficacy of such programs may be evaluated by epidemiological methods.

While epidemiology originally focused on epidemics of infectious disease, the approach and methods of the science make it valuable in studying both acute and chronic illness, mental as well as physical. The methods used have been applied to the problem of suicide for a long time. In 1897 Durkheim published his classic work, *Suicide,*[2] in which he employed one of the primary tools of epidemiology, that of calculating the frequency of suicide among different groups of people and changes in these frequencies over time. Durkheim's analysis and interpretation of these rates were sociological in nature. For example, in commenting on the seasonal changes in suicide rates, he stated, "Finally, if suicide increases from January to June but then decreases, it is because social activity shows similar seasonal fluctuations."[3] In 1895 a physician commented on epidemics of suicide; his interpretation of the increase in suicides in hot weather was that "heat is favorable to the operation of a certain poison in the blood that produces, when in excess, . . . headache, depression and irritability of temper," which, he believed, are

185

compatible with the idea of self-destruction.[4] The interpretation of epidemiological data is thus related to the training and persuasion of the interpreter.

Methods used in epidemiology

The study of the distribution of suicide in a population enables one to establish general associations between suicide and the personal characteristics of individuals who kill themselves—their age, sex, religious or marital status—between suicide and temporal or seasonal events and between suicide and geographic location. Mortality statistics for a city, state, or country, for example, are used to determine whether older rather than younger people are more likely to commit suicide, whether more suicides occur in the spring than in the fall, or whether urban rather than rural inhabitants are more likely to be suicides.

Proceeding from these general associations and from clues gained by clinicians through their experience, the epidemiologist may then test specific hypotheses concerning causes. That is, have persons who commit suicide had a particular kind of childhood experience, a particular work experience, or marital history that differentiates them from nonsuicides? A group of suicides is compared with a group of nonsuicides, and an attempt is made to equate all the factors except the specific one being tested in order to find out whether that factor does differ between the groups. Or, a group of individuals with and a group without the suspected factor are selected and followed over a period of time in order to determine whether the former group yields more suicides than the latter group.

Very often the goal in public health is to prevent or control a disease or event, such as suicide. Programs, possibly based on findings from epidemiological studies, are organized to prevent or reduce suicides and the epidemiologist evaluates their efficacy, not only to determine whether the program is worthwhile but also to ascertain whether the findings from other epidemiological studies can be validated.

In epidemiology the first problem is to define the condition under study. For purposes of this chapter the major subject of discussion will be "reported suicide," that is, suicide officially reported as a cause of death. In some instances "suicide" as determined by review of hospital records or coroner's reports or by interviews with associates of a dead person will also be considered. Although attempted suicides, suicide

threats or thoughts, and suicidal behavior may well represent a continuum of "the suicidal condition," such studies will be considered here only briefly. The problems of obtaining valid data on complete suicide are great enough and will be the major topic discussed.

Frequency and distribution of suicide—
personal characteristics of suicides

In an epidemiological approach, the distribution and frequency of an event in the population are usually studied first. The usual way to compare the frequencies of a disease among groups of people is by the use of rates. Rates of suicide are calculated by dividing the number of persons in a group committing suicide by the total number of persons in that group. In a publication from the National Center for Health Statistics suicide rates for the United States for the years 1950-64 are presented.[5] In the United States in 1964, 20,588 suicides were reported for the total population over five years of age, which was estimated at 190,630,000 on July 1, 1964; the suicide rate was thus .000108 or 10.8 for each 100,000 persons. Separate rates for men and women were calculated by dividing the suicides for men or women by the total number of men or women in the population. In 1964 the rate for men was 16.1 per 100,000 and for women 5.6.

For each age group beginning with ages five to fourteen, suicide rates were also obtained; for men the rates increased with age—9.2 per 100,000 men aged fifteen to twenty-four, to 59.3 for men aged eighty-five and over. For women rates increased from 2.8, for ages fifteen to twenty-four, to 11.6 for ages forty-five to fifty-four, and then decreased to 4.1 for women eighty-five years and older. Rates were also calculated separately for whites, 11.6 per 100,000, and nonwhites, 4.6. Separate rates for persons married, single, divorced, and widowed were presented in two forms. One was the rate based on all suicides for persons in a particular marital status group divided by the total number of persons in that group (the crude rate); the other was the rate for persons in a particular marital group, adjusted for the age distribution of that group. An age-adjusted rate is commonly used in the presentation of mortality statistics because such a rate allows a comparison between groups that may have widely different age compositions, as is true of the several marital status groups. For example, in Table 1 the crude rates for white males

Table 1. Total and age-adjusted suicide rates for white males, 15 years and older, U.S. 1959-61 (3-year average) by marital status.

Marital status	Total (crude) rate per 100,000	Age-adjusted rate*
Single	19.2	35.2
Married	22.2	18.7
Widowed	82.4	90.6
Divorced	96.2	75.7

* Age-adjusted to total population enumerated in 1940.
Source: *Suicide in the United States, 1950-1964.*

show that the highest risk of suicide is among divorced and the lowest among single men. It is obvious, however, that single men are likely to be younger than any other group and divorced and widowed men the oldest. Since suicide rates increase with age, the crude rate does not show whether the single state or the young age of single men accounts for the low rate among single males. Accordingly, it is important to separate age from marital status in calculating these rates.

One way to do this is to examine separately for each age the rates for the several marital groups. In Figure 1 this is done graphically. From this graph it is apparent that married men have the lowest suicide rates for nearly all age groups and widowed or divorced always the highest. To compare suicide rates in this way becomes difficult, however, when many different groups, such as various religious or nationality groups, are being considered. A statistical procedure, age-adjustment, allows one to calculate for each group a summary rate that equalizes the age compositions of the different groups. Several procedures for age-adjustment are described in Lilienfeld et al.[6] Age-adjusted rates for white males of different marital statuses are shown in Table 1. These rates reveal that when the age distributions in the groups are made the same, married men have the lowest and widowed the highest rates. One could, of course, adjust for differences in sex, occupation, or any other characteristic between groups that are being compared. The adjustment of rates to take into account age differences is the most common one, however, because in most illnesses the increase in frequency as age increases is known and one would like to compare the two sexes or the different occupational groups as though they were of similar ages.

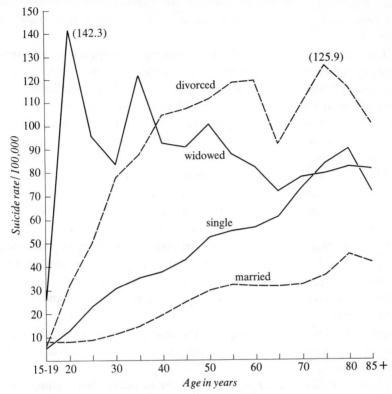

Source: *Suicide in the United States, 1950-1964,* Public Health Service Publication No. 1000, Series 20, No. 5, Washington, D.C.: U.S. Department of Health, Education, and Welfare (1967).

Figure 1. Suicide rates per 100,000 for single, married, widowed and divorced white males, by age: U.S., 1959-61 (3-year average)

There are two important factors to note in dealing with age-adjusted rates. First, the rate itself no longer represents the number of suicides divided by the number of people in the population and cannot be compared with crude rates elsewhere. Age-adjusted rates can only be compared with other rates adjusted in the same way. Thus, in Table 1 the crude rates for single males could be compared directly with rates for single males in some other country. The age-adjusted rate for single males has meaning only in comparison with the other rates in the right-hand column—the single rate is nearly twice that of married men and less

than half that of divorced. If rates for other countries were adjusted in the same way, they could then be compared directly with those in Table 1.

The second factor to consider in examining age-adjusted rates is that they are summary rates and important age differences may be concealed. For example, the graph (with age-specific rates) shows that before age forty widowed men have higher rates than divorced men, and after forty rates for divorced men are higher than for widowed. The age-adjusted rate cannot reflect this shift, which could be important in the interpretation of the rates.

That the age composition and the marital status of a group can be important in explaining suicide rates was discussed in an article about suicide in San Francisco.[7] In San Francisco the crude suicide rate was 29.6 per 100,000 persons in 1960; in the U.S. the rate was 10.4. The author felt that the higher median age and the higher proportion of unmarried people in San Francisco than in the United States might account in part for the much higher rate in the city. Unfortunately, age-specific rates and separate rates for the married and single were not presented and adjustment procedures for age or marital status were not carried out. Consequently, it is impossible to tell from the report whether and to what extent age and marital status help to account for the higher suicide rate in San Francisco.

Comparison of rates of suicide for different occupational groups and social classes is also useful. In the U.S., mortality from suicide is highest among laborers,[8] while in Great Britain both the professional and laborer groups have higher rates than other occupational groups.[9] In assessing rates for occupational groups, however, one must consider the difficulty in obtaining accurate information about the occupation of deceased persons. In addition, occupation may be an important factor not only because of the work involved but also because of the way of life outside of work followed by persons in particular occupations. Reid has suggested one way of determining which of these factors may account for occupational differences in suicide rates. He examined the rates for wives of employed men and found that the wives of professional men as well as their husbands had high suicide rates, implying that social background was probably a factor. On the other hand, wives of laborers did not have particularly high rates, while men employed as laborers did; here the occupation itself was more important than the social background.[10]

Religious affiliation also affects the risk of suicide. Rates are usually reported to be higher for Protestants than for Catholics, and rates for Jews are the lowest. A study of suicide among white adults of the three major religions in New York City showed that Catholics had the lowest rates, 10.9 per 100,000, and Protestants the highest, 31.5 per 100,000; the rate for Jews was 15.5. The religion of the decedent was determined by the affiliation of the cemetery of burial, which in the case of a suicidal death might be inaccurate. The number of persons in each religion was based on sample surveys.[11] However, the U.S. rates for religious groups are difficult to obtain because accurate estimates of the populations in these groups are not easily obtained and because religion is not recorded on death certificates.[12]

Frequency of suicide—temporal factors

In addition to a comparison of rates for groups with different personal characteristics, comparisons of rates over time are helpful in gaining knowledge about suicide. In the U.S. there was little change in rates from 1950 to 1964.[13] The crude rate in 1964, in fact, is roughly similar to that in 1900, although there have been changes over time in sex and age differentials. For example, young women had higher suicide rates than young men until the 1920's when the female rate dropped below the male and has continued to decline.

Dublin has presented a valuable summary of suicide rates in which he shows the wide variation in rates during the period 1900 to 1960. He points out the inverse association between economic prosperity and suicide and the positive association between depression and suicide.[14] In an attempt to determine more clearly how economic cycles are related to suicide, Henry and Short[15] have analyzed the trend in rates for suicide separately for whites and nonwhites, males and females, and young and old persons. Their analysis showed that the suicide rate increased more for high status groups (whites, males, and younger individuals) during economic depressions than for low-status groups. They feel that the data show that high status groups are more sensitive to the frustrations produced by business cycles.

Other temporal variations in suicide have been studied. More suicides occur in the late spring than in other months in the U.S. and in some Western European countries.[16] More suicides are reported to occur on

certain days of the week and certain hours of the day; these temporal associations may, however, reflect the timing of the discovery of the dead person rather than the occurrence of suicide.[17] The relation of suicide to climatic conditions such as barometric pressure, humidity, or precipitation can best be described as confused.[18]

Frequency of suicide—geographic factors

Variations in mortality rates according to geographic locations have led to valuable clues in the etiology of disease. It should be noted, however, that geographic variation in rates has also led to incorrect conclusions because some other factor, such as age or sex of the population, rather than the geographic condition accounts for the difference in rates. In addition, practices of defining suicide may vary geographically. In the U.S. at the present time there is little difference in suicide rates between urban and rural areas.[19] Such a difference existed earlier in the century, when urban rates were higher than rural rates, but seems to have disappeared with increasing urbanization.[20] In European countries rural areas still exhibit lower rates than urban regions.[21] Among regions of the U.S. there

Table 2. Annual age-adjusted* suicide rates (1959-61) for males and females, 15 years and older for nine countries.

Country	Male	Female
Hungary	52.2	20.0
Finland	50.6	12.6
Austria	43.8	17.3
Sweden	33.8	10.8
U.S. (white)	26.4	7.2
Canada	19.4	5.0
Norway	14.6	4.1
Italy	12.6	4.6
Ireland	6.3	2.2

* Age-adjusted to Segi's standard population, 15 years and older, in A. M. Lilienfeld, E. Pederson, and J. E. Dowd, *Cancer Epidemiology: Methods of Study,* Baltimore: The Johns Hopkins University Press (1967).

Source: U.S. rates, *Suicide in the U.S., 1950-1964.*

Foreign countries: (a) Number of suicides, WHO Annual Epidemiological and Vital Statistics, 1959, 1960, 1961. (b) Populations, Demographic Yearbook, 1961. United Nations, 1962. WHO Annual Epid. and Vital Statistics, 1962 (Ireland).

are differences; age-adjusted rates are highest in the Western states and lowest in the South, except for Virginia and Florida.[22]

Variations in rates within small geographic areas have also been analyzed. Sainsbury's study of suicide in London,[23] for example, revealed high rates in areas with rooming houses and single-person dwelling units, and in areas with high rates of mobility and other signs of social disorganization.

Suicide rates for many foreign countries are available in annual reports published by the World Health Organization.[24] High rates are reported in Denmark, Sweden, and Austria, lower rates in the U.S., England, and France, and the lowest rates in Ireland, Italy, and Spain. See Table 2 for a comparison of age-adjusted rates in some of these countries. In some of these countries, as in the U.S., there are increases in rates with age and higher rates for men than for women.

Frequency of suicide—means of suicide employed

The usually unexpected aspect of death by suicide has led to consideration of the more immediate circumstances of the death. As in accidents and homicides, the means employed and the surroundings—the particular place, the proximity of other individuals, for example—are of interest. The means employed—firearms, poison, hanging, jumping—have been tabulated for many groups of suicides. Men tend to use more "violent" methods than women; methods change over time; methods vary by country.[25] Tabulations of the circumstances of suicide are less usual; the major interest in this factor has been in comparing completed suicides and suicide attempts.[26] The possibility that there are suicides by methods not usually regarded as such has led to close investigation of deaths in auto accidents and of other sudden or unexpected deaths. Because there are no explicit statements of how it can be determined whether these kinds of deaths are suicide, it is not possible to judge what effect their inclusion as "suicides" might have upon official suicide rates.[27]

Problems of interpreting suicide rates

In studying rates for possible clues to the etiology or prevention of suicide a number of problems must be considered. Some of them have been

mentioned. One set of problems pertains to the definition of suicide and its being reported as a cause of death. Another concerns how information about the characteristics of persons committing suicide is obtained.

When rates of suicide between two groups of people are compared, one assumes that all the suicides in each group are counted or at least that the same proportion of suicides is counted in each group. This raises the question of how a death is recorded as a suicide. Who decides that a person committed suicide? Who reports or records this information? And do the decision and report reach the agency that publishes suicide statistics for the groups being compared? The answers to these questions vary depending upon legal and social customs and beliefs in different communities. Not only may the definition of suicide vary but also the way in which a group views suicide—whether as a "disgrace," as an unfortunate event, or even as an honorable death. If a group feels that suicide is a disgrace and not to be revealed to outsiders, it may underreport its occurrence; the reporting might be affected more for some individuals than for others. For example, when a married man commits suicide at home, his family may be able to cover up the fact of suicide and his death is reported as "accidental." When a single man commits suicide, there may be no one concerned enough to try to influence the reporting of his death, which is recorded as "suicide."

In analyzing the suicide rates one must then consider the way in which suicides are reported and how reports for particular groups may be biased. In accounting for the high suicide rate in San Francisco, for example, some investigators[28] have suggested that the high number of autopsy examinations performed by the Coroner's Officer there and the large number of toxicological studies may be important. Not only may more suicides be determined and reported than in other cities but also more suicides among certain groups, for example, women, who are likely to use poisons, may be reported. No detailed comparison of rates between San Francisco and other cities with different autopsy rates has been made, but such study might reveal to some extent the effect of such factors on suicide rates.

In a study of suicides in Dublin, McCarthy and Walsh[29] investigated all cases of death coming to the coroner's office of the city and county. On the basis of their examination of the records, they concluded that twice as many suicides occurred in Dublin in a ten-year period as were reported officially. Unfortunately the authors did not contrast the two

rates for separate groups in the city; it would have been of interest to know whether they found the higher rates equally for men and women or for women more than men. Ireland still has a low suicide rate in comparison with other countries, even if the "true" rate is twice the official one. One would like to consider how studies such as this one in other countries might affect reported international differences. One of the difficulties, of course, in such studies is that different investigators use widely different methods and have varied notions of what a "suicide" is.

Another way in which official rates of suicide may be biased is by having an incorrect count of the number of persons comprising the group for which a rate is calculated. For example, the suicide rate for divorced persons may be high because the total number of divorced persons is underestimated. The high rates found in central areas of a city may also result from an undercounting of the population. People move in and out of these areas, and it may be difficult to determine accurately how many persons live there. In areas of high mobility the characteristics of the population may also vary greatly over time, so that it is impossible to calculate accurate rates for different subgroups.

Still another source of error in suicide statistics is the difficulty in obtaining correct information about the dead person. If a person is found dead of suicide in an isolated place or a strange community, there may be no one who knows accurately his age, marital status, or religion; his characteristics may be incorrectly classified and rates for single people with no religious affiliation may thus be inflated.

As Reid points out,[30] an even more important source of possible error in using mortality statistics is that the characteristics of an individual at the time of death, even if they are accurately known, may have little relation to his job, marital status, and so forth, during most of his life. If the interest is in determining possible causes of suicide, knowledge of the life of a person over a fairly long period of time may be more important than his status at death.[31]

Uses of suicide rates

In the preceding sections the distributions of suicide rates in relation to the personal characteristics of individuals, to temporal factors, and to geographic location was presented. The value of rates of this sort is: (1) to enable public health and other officials to know the magnitude of

the problem and, if they have the facilities and knowledge, to set up programs of prevention among those groups or in those areas where the problem is most severe; and (2) to suggest possible causal factors and further study, as illustrated by Durkheim's analysis of suicide rates in Europe, especially France, in the nineteenth century.[32] By very ingenious assembling and cross-classification of suicide rates for religious, marital, occupational, and other groups, he was led to hypothesize that suicides were of four different kinds—egoistic, altruistic, anomic and, rarely, fatalistic. He found evidence for his theory that the type of society of which suicides were members and their relationship to that society were the principal determining factors in their deaths. His analyses and theories have led to many studies of suicide, particularly among sociologists.

Gibbs and Martin,[33] for example, have developed a theory, based on Durkheim's work, of status integration and its relation to suicide, and have tested specific hypotheses generated from the theory. They hypothesized that there would be higher suicide rates in societies where people face conflicts because their several social roles are incompatible; social roles are more compatible in societies with high "status integration." By utilizing data about demographic and social characteristics of a population, such as age, sex, and occupation, they developed measures of status integration that were found to be correlated inversely with suicide rates.

Other studies, such as Sainsbury's in London,[34] have found a relationship between suicide rates and social disorganization, which concurs with Durkheim's theory. Henry and Short's study[35] of the relation between suicide, homicide, and business cycles was also influenced by Durkheim's work. Most of these studies have not considered in any detail the effect of poor reporting of suicide on their analyses and interpretations. It is likely that very large differences in rates between groups would not be affected by differential reporting but small differences may be.

Variations in rates for different countries have led to many interesting speculations about causes of suicide. Durkheim, for example, finding higher rates for Protestant than for Catholic countries, felt that the force of tradition and authority in the Catholic religion was a deterrent to suicide. Since England has rates as low as some Catholic countries, he posited the tradition and hierarchy of the Anglican church and of English society as deterrents also. On the basis of high rates in Sweden and Denmark but low rates in Norway, Hendin[36] investigated and found different personality structures in persons in the three Scandinavian countries.

While there undoubtedly are true variations in suicide among countries, the problems in comparing rates in places that may have very different methods of defining and reporting suicide have been pointed out.[37]

The effect of migration upon mortality has been of considerable interest in relation to a number of conditions, including suicide. Some studies have reported that foreign-born persons in the U.S. have higher rates of suicide than the native-born, leading to the conclusion that migration itself is a factor in suicide or that individuals likely to commit suicide are also likely to migrate.[38]

The present author carried out an analysis[39] for deaths by suicide from 1959 to 1961 comparing: (1) persons in eight foreign countries (see Table 2), (2) immigrants from those countries to the U.S., and (3) U.S.-born white persons. Two "Standarized Mortality Ratios" (SMR's)[40] were calculated for each group of immigrants. These ratios adjust for age differences among the groups. The first SMR compares the immigrants' suicide rate with the rate of U.S.-born whites; in Figure 2 the immigrants' rate is shown as either more or less than the U.S. rate, which is set at 100, the standard rate. The second SMR compares the immigrants' rate with the rate of persons in their country of birth who did not migrate; in Figure 3 the immigrants' rate is shown as either more or less than that in their country of origin, which is set at 100 as the standard rate.

Based on the hypothesis that some early experience or exposure may have had an effect on a condition causing death much later in life, it was expected that those countries with suicide rates higher than the U.S.—Austria, Finland, Hungary, and Sweden—would produce immigrants with lower rates than nonmigrants but higher rates than U.S.-born persons. Figures 2 and 3 show this to be the case except for Finnish immigrants who have a higher rate than both Finnish nonmigrants and U.S.-born persons. Swedish immigrants have rates about the same as Swedes who did not migrate. As expected, immigrants from countries with rates lower than the U.S.—Canada, Norway, Italy, and Ireland—had lower rates than the U.S. natives but higher rates than persons in their birthplace—except for Canadian immigrants.

These data may indicate merely that reporting of suicide is more uniform within the United States than it is between the different foreign countries, and thus rates for the foreign-born tend toward the U.S. mean. If, however, the reporting of suicide and selection of migrants do not wholly account for these findings, the results suggest that factors, which

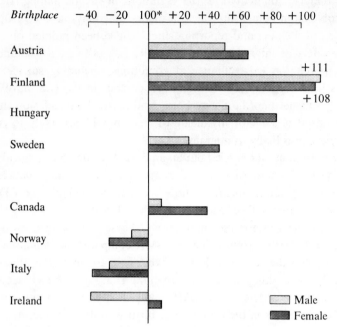

Figure 2. Standardized mortality ratios for suicide, by birthplace for foreign-born immigrants to the United States, males and females 15 years and older, 1959-61

may be both genetic and social, operating early in life have an effect on suicide, an effect that is modified by later experience. In addition, these early influences may still be present in communities of foreign-born in the U.S., but not to the extent they would be in the migrant's country of birth.

These conclusions apply only to the group studied here, persons who may have migrated 30 to 40 years ago, and are about sixty years of age. Similar analyses of suicide rates for migrants to other countries might help in interpreting these findings.[41] Retrospective studies of migrants and nonmigrants might also yield information about the factors that influence suicide.

Migration within a country may be of a very different nature in rela-

tion to suicide than international migration, but no rates for migrants
and nonmigrants within the U.S. are generally available.[42]

Retrospective and prospective studies

The comparison of rates of suicide among different groups is limited by
the availability of such information for some groups (e.g., migrants
within the U.S.) and by the fact that groups may differ in so many
respects that a comparison of rates does not reveal which factors are
significant in explaining the difference in suicide rates. In order to deter-
mine more accurately which factors differentiate suicides from nonsui-
cides other kinds of studies are undertaken. Two types, commonly re-

Figure 3. Standard mortality rates for suicide, by birthplace for emigrants
from eight foreign countries, males and females 15 years and older, 1959-61

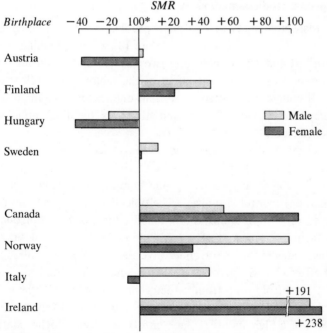

*100 = Country of origin as the standard rate

Statistical Sources: See Sources for Table 2 and Figure 2.

ferred to as retrospective and prospective, will be considered here. These terms refer to the time at which the study is begun in relation to the event of interest. That is, retrospective studies of suicide start with a group of suicides and a comparison group and look at their previous histories to determine what may differentiate the two groups. Prospective studies begin with a group of persons (or two or more groups) and follow them over a period of time to see whether persons with a particular characteristic commit suicide more often than persons without it. Neither method affords complete control over all factors that may affect the individual's suicide, but through careful observation and collection of information on many factors some valid conclusions can be drawn. The design of studies to test hypotheses about suicide is complex and only a few examples can be given here. The reader is referred to Lilienfeld[43] for more detailed discussion of such study designs.

Retrospective studies—methods used

In a retrospective study of two main problems in testing an hypothesis concerning a factor related to suicide are (1) clearly defining the factor to be studied and (2) establishing two groups, one of suicides and the other nonsuicides, so that the effect of the factor can be clearly determined. Of course, very often more than one factor is of interest or the study may be one to look for any and all factors that differentiate suicides from nonsuicides.

The selection of the nonsuicide group, called here the "control" or often more accurately the "comparison" group for the reasons noted, is difficult. Seldom is any control group completely adequate; sometimes more than one control is utilized. The objective in selecting an adequate control group is to minimize the possibility that some extraneous or unknown factor may account for any differences found between suicides and nonsuicides in the factor under investigation. For example, in studying the effect of early parental death on suicide, it would be important to select a control group from a socioeconomic status similar to that of the suicides since people of a low status are in general likely to die earlier than those of a high status. If the controls are from a higher status than the suicides, differences in early parental death may be expected because of the status difference. The relationship between parental death and suicide could not be established by the use of such a control group. Control

of extraneous factors by statistical analysis can also be utilized when the groups being studied are large enough.

In a retrospective study it is very difficult to obtain reliable information about previous events in the life of the dead person or about his psychological status and feelings. The information given by friends or relatives of a deceased person may be biased by the way he died. For example, relatives of persons who died by accident or from an infection may consider questions about the dead person's psychological state as quite irrelevant and not answer them carefully. Certainly associates of suicides are much more likely to recall previous suicide threats or attempts than are associates of persons dying from other causes. The same bias may enter into reports of previous signs or symptoms that could be interpreted as psychological disorder, or reports of psychiatric treatment or hospitalization.

One way of guarding against bias is to validate, through some outside source (hospital or doctors' records), the data obtained by interview. Unfortunately valuable information about an individual's psychological status is not usually recorded in anyone's notes before the individual dies. Even though no means of validation are available, information obtained from associates of a suicide should be compared with information obtained in the same way from associates of a nonsuicide in the control group.

Many studies reporting that suicides have a much higher prevalence of psychiatric disorder than nonsuicides base their conclusion upon questioning associates of suicides and then assuming that nonsuicides have a low prevalence of such disorders. While it is likely that suicides do have more psychiatric illness (see below under Prospective Studies), a careful definition of "psychiatric disorder" and how its presence is determined are necessary in order to interpret its relative importance in suicides and nonsuicides.

Just as reports of the psychological state of suicides may be biased, so may those of events in early life or events just prior to the suicide. In addition, control groups are needed to interpret the reports about suicides' lives. Schmale,[44] for example, conducted interviews with patients hospitalized for a variety of medical conditions; the patients' answers revealed that most of them had recently sustained a loss of some kind (personal or otherwise) and had feelings of hopelessness or helplessness. Many reports about persons who committed or attempted suicide do not

differ greatly from these interviews with individuals who were hospital-
ized for nonsuicidal conditions.

Retrospective studies—findings

Breed[45] has reported a study in which early and possible precipitating
events in the lives of suicides were compared with those of a group of
nonsuicides. In New Orleans he interviewed relatives and associates of
white male suicides and then on the same block where the suicide had
lived he interviewed two other persons about a male each one knew. He
found that the suicides had had a poorer work history, were more likely
to be unemployed, and had not progressed as far in their jobs as the con-
trols. The objection can be raised that the controls, who were selected by
an unknown person in a haphazard way, were chosen because they were
more successful than the average. Breed found, however, that compared
with the total New Orleans population the suicides were in less skilled
kinds of jobs.

Sainsbury's study in London[46] also demonstrated that suicides were
more likely to be unemployed than the rest of the population in the areas
he studied. When the total population is used as a comparison group it
is not always possible, of course, to be sure that such factors as age or
marital status do not account for the difference between suicides and the
population.

MacMahon and Pugh[47] have investigated suicide among widowed per-
sons and used a comparison group in order to throw some light on the
relation between suicide and widowhood. Widowed persons who had
committed suicide were compared with those who died from other causes;
after tracing the death certificate of the spouses of these groups the in-
vestigators found that suicide by widowed persons was concentrated in
the first four years (particularly the first year) after the death of the
spouse. The concentration was more marked for males than females.
Such a study can equate age and sex between the groups and does not
rely upon biased information. However, it is limited by the kind of data
available on official records.

Well-designed investigations of attempted suicide have been reported.
In a study of persons hospitalized after attempted suicide, Greer et al.
selected two comparison groups. One was composed of patients in the
same hospital with a psychiatric diagnosis; the other was a group of pa-

tients with no psychiatric history. Both groups were matched with the attempted suicides for age, sex, social class, country of origin, and diagnosis, in the case of psychiatric patients. They found that the attempted suicides differed from both control groups in having a higher frequency of early parental loss and "recent disruption of a close relationship due to interpersonal conflict."[48] One can, of course, argue that persons who have attempted suicide will remember and interpret events in a different way than nonattempters of suicide. Nonetheless, well-controlled studies can be designed and efforts made to eliminate biases in reporting. Flood and Seager[49] compared psychiatric records of patients who later committed suicide with records of two control groups from the same hospital.[50]

Prospective studies—methods

Because retrospective studies usually depend upon a reconstruction of previous events which may be biased in a number of ways, prospective studies are often considered superior. Defects in memory and missing records are eliminated by starting the study with people who are alive, by obtaining current information about them and then, after suicides have occurred, by comparing the data from suicides and nonsuicides. The difference between the two types of studies is not always clear-cut (Paffenbarger et al.'s study[51] has been referred to as "retrospective–prospective"), but in general the prospective study is less subject to bias. The prospective approach also requires control groups, however, and may present the investigator with other difficulties. In some studies there may be a long wait between the time the research begins and its end point, when there are enough suicides to allow an analysis of data. For this reason some studies use a group from the past—all employees of a plant 15 to 20 years ago or all patients of a hospital during a given time— and find out what has been the experience of these cohorts from that time to the present.

Prospective studies—findings

Most studies that have attempted to study the effect of previous psychiatric illness or status upon suicide have utilized the prospective approach. That is, starting with a group of persons diagnosed as manic-depressive

or schizophrenic or who attempt or threaten suicide, the investigator compares their suicide rate with the rate in groups of similar age, sex, race, marital status, who do not have previous psychiatric illness. This does eliminate the bias of reporting after death about earlier psychological states.

In a study of patients and ex-patients of the psychiatric service of a Veterans' Administration hospital, Pokorny[52] found higher rates of suicide than for the U.S. population as a whole; depressive patients had the highest rate. In a very well-designed study Temoche et al.[53] report a similar finding in Massachusetts, and Malzberg (as reported in Dublin) has found this for New York State Hospital patients.

Just as informants may be more likely to report previous psychological disorder after a person commits suicide, however, there may be more likelihood of reporting suicide as a cause of death for persons who have been in mental hospitals. Such biases are not likely to account for all of the much higher suicide rates for former mental hospital patients.

Wilkins[54] has written a detailed review of studies of the risk of suicide among persons who had attempted suicide. Most of the work reviewed showed much higher rates of completed suicide than expected among persons exhibiting such suicidal behavior. Farberow and Shneidman[55] have compared a number of characteristics between the two groups and Stengel[56] has made some comparisons in relation to the circumstances of the act. In addition, interviews with associates of persons attempting suicide and with associates of a comparable group of persons completing suicide might be helpful. One great lack in knowledge about attempted suicide, of course, is any reasonably accurate count of its occurrence. Rates are difficult to obtain except within small groups, such as previously hospitalized persons, although there have recently been community studies of attempted suicide.[57]

Another useful approach to studying suicide is illustrated by Paffenbarger's follow-up[58] of students examined during their college years at two Eastern men's schools; they were given psychological tests and a medical examination and answered questions about their habits and family background. Fifteen to forty years after their graduation they were traced and all who had committed suicide were compared with a group of men still alive. The data revealed that some factors differentiated the suicides from the other men. The fathers of students who later committed suicide were more likely to have had college training, to be in profes-

sional jobs, or to have died. Subsequent suicides were somewhat less healthy than their colleagues and assessed themselves as suffering from a "complex of anxiety-depression." In this kind of study, of course, nothing is known about factors intervening between college and death, but the data are relatively unbiased by the circumstances of death.

In interpreting the results of these studies the findings from mortality statistics about higher rates in males, nonmarried and older persons, for example, must be taken into account. It seems likely that factors such as decrease in job status, disruption in personal ties, and social disorganization may increase with age and with nonmarried status just as suicide rates increase, and Durkheim believes that these factors affect men more than women. A clear relation between the results of small studies and mortality statistics does not always exist, however. Consequently, it is important that studies applying the case-control method be conducted on many different kinds of groups and be guided when possible by already existing knowledge and theory.

Evaluation of programs

The classic method used to evaluate program services is the experiment in which two comparable groups are established and one receives the services of the program while the other does not. At some point after receipt of service, the effect of the program is measured. Most of the suicide prevention programs are established with the hope that such help will reduce the possibility of suicide.

In using the experimental method to evaluate suicide prevention programs three difficulties arise: (1) how to select comparable groups in an unbiased way; (2) how to justify withholding services from one group; (3) how to measure the effect. The first two problems—unbiased selection of two groups and justification for withholding services—are interrelated. Perhaps ideal for selection is to accept for treatment every second person who requests or is referred for it. No bias arises and with large enough numbers, the two groups are likely to be comparable.

Is it ethical, though, to deny services to someone in need? In order to overcome such an objection, one could provide a minimal service to every applicant and evaluate the more extensive or intensive treatment of a randomly selected group. It is also likely that a program does not have the facilities to care for all persons requesting service, so that limit-

ing the services on a random basis does not change its operation or violate its mission. Herzog[59] discusses the problems of using an "untreated" control group in evaluating psychotherapy and social case work, where the dilemma of not treating a person is similar to that in suicide prevention programs.

Problem 3—the program's effect—does not seem difficult to solve; the treated group should have a lower suicide rate than the untreated. Litman, in suggesting that suicide prevention centers are engaged in intervention rather than prevention, in the "public health epidemiological sense," concludes that one might not expect enough lives to be saved to affect overall suicide rates. Even so, one assumes that intervention would accomplish something, perhaps postpone suicide rather than prevent it; postponement, of course, could be measured.[60] Probably one would want to determine suicide rates at various points after the treatment had begun in order to determine how long or for what periods the services had been effective.

Yet, the rate of suicide even among "suicide-prone" individuals is likely to be small, and very large numbers of people may be required to measure the program's effect. Also, continued observation over a period of time of both groups, especially those not receiving services, might prove to be very expensive in effort as well as time. For these reasons, some investigators may prefer to use measures other than life or death to determine the program's effect. Litman has also suggested that change in the "lethality" rating of a suicidal client at a suicide prevention center be used as a method of evaluation. The problem is to attain a reliable, agreed-upon rating of "lethality."[61] A change in psychological status, and so forth, may be used to indicate success or failure of a program. The choice of measures to use and the way in which information is obtained from persons in both treated and untreated groups are subject to bias, however; in addition, there is no conclusive evidence that better psychological status decreases the risk of suicide. Nonetheless, such measures may yield some evaluation of a program.

There have not, to my knowledge, been experimental attempts to evaluate suicide prevention programs, but there have been at least two studies in which the suicide rates in communities with and without such programs were compared. In California, Weiner[62] found that the suicide rate in Los Angeles increased after inception of a prevention program while the rate in San Bernardino (without a program) decreased slightly,

but not significantly, over a similar period of time. Bagley,[63] on the other hand, found that communities in Great Britain that had Samaritan suicide prevention services were more likely than communities without such services to have decreased suicide rates after initiation of the programs. In Bagley's study, the communities with and without services were matched on a variety of economic, social, and demographic factors. Weiner does not explain on what grounds San Bernardino was selected as a control for Los Angeles.

Kramer[64] discusses the use of observations over time of matched communities, one of which has a new program of services, and the use of trend data in evaluating mental health services. Problems arise with both of these methods. First, to compare suicide rates in a community before and after a preventive program has begun assumes that no important factors other than the program have been operating to affect suicides. Because in any given community the suicide rate is fairly small, significant changes might not be detectable until the program had been in operation for some time and therefore other factors may well have had an effect. There is also the problem that the program itself may affect the reporting of suicides, irrespective of changes in the "true" rate. The use of matched communities assumes that no factor except the program differentiates the two communities; such sites are difficult to find and the differential reporting of suicide could again become a problem.

Consequently, it is not surprising that results of the two studies mentioned before were contradictory. More controlled and careful studies are needed in order to determine fully the effect of suicide prevention services.

Notes and references

1. John M. Cassel, "Potentialities and Limitations of Epidemiology," in A. H. Katz and J. S. Felton, eds., *Health and the Community,* New York: Macmillan, The Free Press of Glencoe (1965); A. M. Lilienfeld, E. Pederson, and J. E. Dowd, *Cancer Epidemiology: Methods of Study,* Baltimore: The Johns Hopkins University Press (1967).
2. Durkheim, Émile, *Suicide,* J. A. Spaulding and G. Simpson, trans., Glencoe, Ill.: The Free Press (1951).
3. Ibid., p. 299.
4. Letter to the Editor, Sept. 2, 1893, in *J.A.M.A.,* 205, no. 10:17 (1968).
5. *Suicide in the United States 1950-1964,* Public Health Service Publica-

tion No. 1000, Series 20, No. 5, Washington: U.S. Department of Health, Education, and Welfare (1967); see also Morton Kramer, Earl S. Pollack, Richard Redick and Ben Z. Locke, *Mental Disorders/Suicide,* Cambridge, Mass.: Harvard University Press (1972) for a thorough, comprehensive presentation and analysis of suicide rates for the United States, particularly for the period 1959 to 1961.

6. Lilienfeld et al., *Cancer Epidemiology.*

7. Richard H. Seiden, "Suicide Capital? A Study of the San Francisco Suicide Rate," *Bulletin of Suicidology,* pp. 1-10 (December 1967).

8. Louis I. Dublin, *Suicide: A Sociological and Statistical Study,* New York: The Ronald Press (1963); Sidney Norton and M. Bright, "Suicides in Baltimore City: 1950-1963," *Baltimore Health News,* 42:117-24 (November 1965).

9. Dublin, *Suicide.*

10. D. D. Reid, *Epidemiological Methods in the Study of Mental Disorders,* Geneva: World Health Organization (1960).

11. M. E. W. Goss and J. I. Reed, "Suicide and Religion: A Study of White Adults in New York City, 1963-67," *J. Life-Threatening Behavior,* 1: 163-77 (Fall 1971).

12. Dublin, *Suicide.*

13. *Suicide in the U.S. 1950-64.*

14. Dublin, *Suicide,* p. 23.

15. Andrew F. Henry and James F. Short, Jr., *Suicide and Homicide,* New York: Macmillan, The Free Press of Glencoe (1954).

16. Dublin, *Suicide.*

17. Norton and Bright, "Suicides in Baltimore City," pp. 117-24.

18. Edward Digon and H. B. Bock, "Suicides and Climatology," *Arch. Environ. Health,* 12:279-86 (1966); Alex D. Pokorny, "Suicide and Weather," *Arch. Environ. Health,* 13:255-66 (1966).

19. *Suicide in the U.S. 1950-1964.*

20. Dublin, *Suicide.*

21. Hans Hartelius, "A Study of Suicides in Sweden 1951-1963, Including a Comparison with 1925-1950," *Acta. Psychiat. Scand.,* 43, no. 2:121-43 (1967).

22. *Suicide in the U.S. 1950-1964.*

23. Peter Sainsbury, *Suicide in London,* Maudsley Monograph No. 1, London: Chapman and Hall (1955).

24. Annual Epidemiological and Vital Statistics, 1959, 1960, 1961, Geneva: World Health Organization (1962), (1963), (1964).

25. Dublin, *Suicide;* Hans Hartelius, "Suicide in Sweden 1925-1950: A Statistical Analysis and Psychodynamic Interpretation," *Acta. Psychiat. et Neurol. Scand.,* Copenhagen, 32:141-81 (1957); Hartelius "Suicides 1951-1963," pp. 121-43.

26. Edwin S. Shneidman and Norman L. Farberow, "Statistical Comparisons between Attempted and Committed Suicides," in Farberow and Shneid-

man, eds., *The Cry for Help,* New York: McGraw-Hill (1961), pp. 19-47; Erwin Stengel, *Suicide and Attempted Suicide,* Baltimore: Penguin Books (1964).

27. Theodore J. Curphey, "The Role of the Social Scientist in the Medico-Legal Certification of Death from Suicide," in Farberow and Shneidman, eds., *The Cry for Help,* pp. 110-17.

28. Earl Cohen, "Suicide in San Francisco: Reported and Unreported," *Calif. Med.,* 102:426-30 (1965); Seiden, "Suicide Capital?" pp. 1-10.

29. P. D. McCarthy and Dermot Walsh, "Suicide in Dublin," *Br. Med. J.,* 1:1393-96 (1966).

30. Reid, *Epidemiological Methods.*

31. Maris considers this of great importance in urging the study of the suicidal career rather than of the characteristics of a person at death; see Ronald W. Maris, *Social Forces in Urban Suicide,* Homewood, Ill.: The Dorsey Press (1969).

32. Durkheim, *Suicide.*

33. Jack Gibbs and Walter T. Martin, *Status Integration and Suicide,* Eugene, Ore.: University of Oregon Press (1964).

34. Sainsbury, *Suicide in London.*

35. Henry and Short, *Suicide and Homicide.*

36. Herbert Hendin, *Suicide and Scandinavia,* New York: Grune and Stratton (1964).

37. There are differences between England and Scotland in both suicide and undetermined death rates. Barraclough has discussed differences between the two countries in procedures for investigating and classifying unnatural deaths and suggests how they may account for part of the reported differences in the suicide rates. See B. M. Barraclough, "Are the Scottish and English Suicide Rates Really Different?", *Brit. J. Psychiatry,* 120: 267-73 (March 1972).

38. Dublin, *Suicide.*

39. The plan for this analysis was suggested by Wm. Haenszel, "Cancer Mortality among the Foreign-born in the United States," *J. Nat'l. Cancer Inst.,* 26:37-132 (1961).

40. A Standardized Mortality Ratio is defined as: the number of deaths occurring in a given group expressed as a percentage of the number of deaths that would be expected if the rates of death of a standard population had obtained. Lilienfeld et al., *Cancer Epidemiology.*

41. Whitlock made comparisons for immigrants to Australia similar to those shown here for American immigrants. His method of analysis differed from this one; the immigrants to Australia were younger than those to the United States at the time the comparisons were made and had probably lived a shorter time in Australia; and he used somewhat different groups of foreign-born persons than in this analysis.

Nonetheless, he found that "Apart from the English-speaking settlers, suicide rates are closer to home-based rates than they are to Australian

rates. This finding suggests that attitudes to suicide are part of a nation's culture and that the stronger its influence is, the more likely immigrant suicide rates will remain relatively unchanged in Australia." F. A. Whitlock, "Migration and Suicide," *Med. J. of Australia*, 2:840-48 (1971).

42. Kramer et al., using previously unpublished data, found that in the United States persons born in one state and dying in another had somewhat higher rates of suicide than those who were born and died in the same state. As the authors comment, however, this is a crude measure of migration and furnishes no information about time of moving, number of times moved, and so forth; see Kramer et al., *Mental Disorders*.

43. Lilienfeld, et al., *Cancer Epidemiology*.

44. Arthur H. Schmale, Jr., "Relationship of Separation and Depression to Disease: I. Report on a Hospitalized Medical Population," *Psychosomat. Med.*, 20, no. 4:259-77 (1958).

45. Warren Breed, "Occupational Mobility and Suicide among White Males," *Am. Sociological Rev.*, 28, no. 2:179-88 (1963).

46. Sainsbury, *Suicide in London*.

47. Brian MacMahon and Thomas F. Pugh, "Suicide in the Widowed," *Am. J. Epidem.*, 81, no. 1:23-31 (1965).

48. S. Greer, J. C. Gunn, and K. M. Koller, "Aetiological Factors in Attempted Suicide," *Br. Med. J.*, 2:1352-55 (1966).

49. R. A. Flood and C. P. Seager, "A Retrospective Examination of Psychiatric Case Records of Patients Who Subsequently Committed Suicide," *Br. J. Psychiatry*, 114:443-50 (1968).

50. See Seymour Perlin, "Psychiatry" Ch. 8—ED.

51. Ralph S. Paffenbarger and D. P. Asnes, "Chronic Diseases in Former College Students: III. Precursors of Suicide in Early and Middle Life," *Am. J. Public Health*, 56:1026-36 (1966).

52. Alex D. Pokorny, "Suicide Rates in Various Psychiatric Disorders," *J. Nerv. Ment. Dis.*, 139, no. 6:499-506 (1964).

53. A. Temoche, Thomas F. Pugh, and Brian MacMahon, "Suicide Rates Among Current and Former Mental Institution Patients," *J. Nerv. Ment. Dis.*, 138, no. 2:124-30 (1964).

54. James Wilkins, "Suicidal Behavior," *Am. Sociological Rev.*, 32, no. 2: 286-98 (1967).

55. Shneidman and Farberow, "Statistical Comparisons," pp. 19-47.

56. Stengel, *Suicide*.

57. In Edinburgh in 1967, a rate of about 160 attempts per 100,000 persons was reported; in New Haven in 1970, the crude rate was estimated to be 183 per 100,000; and in London, Ontario in 1970, a rate of 730 was found. Such wide variation undoubtedly reflects differences in the methods used to determine suicide attempts rather than in actual suicidal behavior in the areas. See R. C. B. Aitken, Dorothy Buglass, and Norman Kreitman, "The Changing Pattern of Attempted Suicide in Edinburgh: 1962-67," *Br. J. Prev. Soc. Med.*, 23:111-15 (1969); M. Weissman et al.,

"Suicide Attempts in an Urban Community, 1955 and 1970," *Social Psychiatry*, 8:82-91 (1973); P. C. Whitehead, F. G. Johnson and R. Ferrence, "Measuring the Incidence of Self-Injury: Some Methodological and Design Considerations," *Am. J. Orthopsychiatry*, 43:142-48 (1973).

58. Paffenbarger, et al., "Chronic Diseases," pp. 1026-36.
59. Elizabeth Herzog, *Some Guidelines for Evaluative Research*, Washington, D.C.: U.S. Department of Health, Education, and Welfare (1959).
60. Robert E. Litman, "Suicide Prevention: Evaluating Effectiveness," *J. Life-Threatening Behavior*, 1:155-62 (Fall 1971).
61. Ibid.
62. I. William Weiner, "The Effectiveness of a Suicide Prevention Program," *Ment. Hyg.*, 53, no. 3:357-63 (1969).
63. Christopher Bagley, "The Evaluation of a Suicide Prevention Scheme by an Ecological Method," *Soc. Sci. and Med.*, 2:1-14 (1968).
64. Morton Kramer, "Epidemiology, Biostatistics and Mental Health Planning," in R. Monroe, G. Klee, and E. Brody, eds., *Psychiatric Epidemiology and Mental Health Planning*, Washington, D.C.: American Psychiatric Association (1967), pp. 1-63.

11 **CASE REGISTERS**

Suicide is suspected of being grossly understated in the statistics based on cause-of-death certification. Various estimates have been made of the actual occurrence of suicide, some indicating that it is as much as twice the reported figure.[1] Dublin suggests that the recorded suicide figures are understated by as much as one-fourth to one-third.[2] Douglas lists five major forms of unreliability in the official statistics on suicide: "(1) unreliability resulting from the choice of the official statistics to be used in making the tests of the sociological theories; (2) unreliability resulting from subcultural differences in the attempts to hide suicide; (3) unreliability resulting from the effects of different degrees of social integration on the official statistics keeping; (4) unreliability resulting from significant variations in the social imputations of motives; (5) unreliability resulting from the more extensive and professionalized collection of statistics among certain populations."[3]

Virtually all countries and their major political subdivisions routinely release annual data on suicides, in many cases subdivided by such factors as age, race, sex, education, religion, type of employment, and marital status. A number have records predating the nineteenth century. Because of the unknown extent of underenumeration, these statistics are at best of dubious value. Researchers, in general, appear to be cognizant of this problem and usually preface their analysis of findings with a statement

regarding underreporting. However, their stated estimates as to the extent of this gap often differ considerably. They commonly proceed from this to a discussion of the data under study without any further consideration of variations in the magnitude of underreporting over time, between geographic areas, and between population cohorts with defined characteristics. Monk has enumerated and discussed these issues.[4] While some investigators have sought to overcome this patent limitation by stating that differences noted are large and could not have resulted from under-enumeration alone, most have not.[5] It is, therefore, not surprising that suicide statistics are often quoted without any recognition of the spuriousness of such data.

Douglas has provided one of the most extensive descriptions of the deficiencies and limitations in employing such data. He showed, for example, that some geographic areas have noted sizable variations in the number of reported suicides in consecutive time periods which resulted primarily from changes in collection procedures or legal requirements. He postulated from this that all suicide theory dependent on official suicide statistics must therefore per se be suspect.[6]

Let us consider as one remedial procedure the development of data banks on suicides and suicidal attempts and the means of linking this information with other related systematic data collection systems. Data banks have been employed in a large number of areas for a variety of purposes. The terms can therefore be defined in different ways. Here it is used interchangeably with case registers and refers to a record-keeping system in which certain information is submitted routinely to a central agency on each individual coming to the attention of a specified set of facilities, agencies, and professional personnel because of a defined illness, disability, or action. Data on each reported episode of these individuals are linked longitudinally within this agency to form a cumulative record of their careers in this field.

Case registers have served as an important resource for some types of statistical analysis not available with traditional data collection procedures. Only registers contain duplicated and unduplicated counts on specified population cohorts and provide data on the sequence of, and time gap between, services. Since registers are a ready source for following groups of individuals over time, they can be used to study the relationship between treatment modality and ultimate illness or disability

outcome. They can also provide a sample frame for surveys and other more intensive follow-up studies.

Data banks were originally established in the late nineteenth and early twentieth centuries as management tools in various communicable disease control programs. Many states and cities continue to maintain tuberculosis and venereal disease registers for this purpose. Other health-related data banks, in such fields as blindness, cancer, rheumatic fever, and stroke are of more recent origin and function primarily for research purposes in a limited number of geographic areas. Several drug abuse registers have now been established.

A large number of epidemiological investigations of the incidence and prevalence of mental illnesses have been conducted in several countries during the past fifty years.[7] While the concept of psychiatric case registers for this purpose has been discussed for some time, only a few are presently in existence. One of the earliest was maintained by a psychiatrist who was the only physician in a small, isolated fishing village on the west coast of northern Norway for several years during the Second World War.[8] Several small registers now exist in England and Scotland while a more extensive program covers the Republic of Croatia (Yugoslavia). In the United States, the first psychiatric case register was established in Monroe County (Rochester), New York, in 1960. It was followed in 1961 by a register encompassing the entire state of Maryland.

The Maryland registry is based on routine, uniform reporting from more than 150 private and public, inpatient, and outpatient facilities in the state and in the adjacent District of Columbia.[9] These facilities provide treatment for more than 98 per cent of all individuals admitted to such care. It does not include data on patients seen by psychiatrists in private practice. A majority of participating facilities report on a voluntary, noncompulsory basis. The confidentiality of all information submitted is protected against improper use (including immunity from court subpoena) by a state statute, applicable to all health-related research, enacted in 1963. The Register, which had been administered by the Maryland Department of Mental Hygiene in cooperation with the National Institute of Mental Health, has been under the sole control of the recently organized Maryland Department of Health and Mental Hygiene since the merger of the two agencies in 1970. A number of papers reporting Register findings are in the literature.[10]

In the years 1961-70, the Maryland Register has identified more than 110,000 individuals (or 3 per cent of the state's population) as being under care in participating facilities. The number of persons reported for the first time to the Register is currently approximately 10,000 per year. Register procedures for routine, annual matching with all death records for Maryland residents provide information on the mortality experience of those who are, or have been, under defined psychiatric care. In addition, questions related to suicidal attempts or gestures have been included in the termination form since 1964.

A brief, preliminary study showed that 15 per cent of the 299 Maryland suicides reported in 1964 were known to have been under psychiatric care.[11] This would indicate a rate more than seven times as large as the comparable figure for the general population. However, this varied by type of suicide. While only 20 of the 191 who died from self-inflicted gunshot wounds were known to the Register, 6 of the 9 who jumped from high places were. A more detailed study, based on data from the Monroe County Register, found that the individuals admitted to this data bank in 1960 had a subsequent known suicide rate 15 times as great as the 9.7 (per 100,000 estimated population) noted for the entire county.[12] For those whose diagnosis was depression, either psychotic or neurotic, the rate was 230. For those reported to have attempted suicide, the average annual rate was 905 during the next two-and-one-half year follow-up period.

These relatively large rates are not unexpected, since the high incidence of mental illnesses among persons committing suicide has been pointed out by a number of investigators. Kraepelin, for example, expressed the belief that mental disturbances were a direct factor in at least one-third of all suicides.[13] Dublin, however, in discussing the concept enunciated by some psychiatrists that all suicides are per se psychotic, stressed that the extent of this relationship should be considered cautiously because of the problems in defining mental health or mental illness.[14] This comment would appear to be justified in view of recent findings that a majority of residents studied in one geographic area (midtown Manhattan) had some mental disturbances.[15] While this figure is considerably higher than comparable data reported by other investigators, rates of serious mental disturbances in excess of 10 per cent are quite standard.

Despite this stated correlation, the number of suicides among persons

hospitalized for mental illnesses remains relatively quite small. Our data for Maryland's state-operated mental hospitals show an average of less than 5 suicides per year in a patient population of about 7,500. New York State has had between 30 and 40 suicides annually among 90,000 resident patients.[16] A perusal of comparable statistics reported by other states indicates somewhat similar ratios. Although national figures are not available, these proportions would be equal to about 250 suicides in all mental hospitals per year. The resultant rate is approximately midway between national figures and the Monroe County and Maryland Register findings noted earlier. However, comparisons of this type are invalid since the opportunity for committing suicide successfully within the confines of a state mental hospital is severely restricted.

Douglas expressed the belief that deficiencies in suicide statistics result, in part, from inconsistencies and variations in the definition of this term. If this is correct, as generally believed, then the problem is compounded in efforts to determine the number attempting suicide. Published data on the number of such attempts are not available since, to my knowledge, reporting of cases is not legally required by any state. Only a few studies on specified cohorts have been reported.[17] One national figure cited, between 175,000 and 200,000 per year, would reflect a rate of approximately 100 per 100,000 population.[18] The accuracy of this figure is admittedly questionable and it may quite possibly be considerably higher. A very rough estimate which can be derived from this is that, during a one year period, one in ten persons seeking to commit suicide succeeds in this endeavor. Whether or not this relationship has varied over time or between geographic areas is, of course, not known. However, since known suicides are concentrated among males in the older age groups while suicidal attempts are believed to be more common among younger females, this ratio is probably considerably higher among the former and lower among the latter.

Since many individuals make repeated attempts, the number who have ever tried to commit suicide cannot be estimated with any assurance of accuracy. My personal belief, based on the above, is that it is probably between three and five million. If the correct figure is within these limits, then somewhere between one in five and one in eight who seeks to commit suicide either succeeds in killing himself in the first attempt or dies from a subsequent endeavor. This is admittedly a very rough estimate and the numeric relationship of suicidal attempt to subsequent suicide

for various population groups cannot be determined. It does compare closely with Stengel's reported findings that about 10 per cent of those who had made an unsuccessful suicide attempt died from self-inflicted causes within an 18-year follow-up period.[19] While some researchers have shown that a high proportion of those who killed themselves had attempted suicide earlier one or more times, such retrospective findings fail to consider the unknown number of persons who do not progress from unsuccessful to successful suicide.

Must we be content with dubious suicide statistics and with even more questionable data on suicidal attempts? I believe that a completely correct count of suicides is not attainable since some cases will not be recognized or will be deliberately hidden from central authorities. However, the level of present knowledge could be markedly improved and expanded by the maintenance of systematic data banks on suicides and suicidal attempts. Such case registers could provide data such as the number of persons attempting suicide in various population subgroups during specified time periods, the probability and frequency of reoccurrence, and the proportion of suicide attempters who ultimately succeed in this endeavor. Linkage with comparable data from psychiatric case registers would provide continuing statistics on the numeric and sequential relationships between treated mental illnesses, attempted and completed suicides.[20] The following is one suggested method for establishing such a system.

Because of my knowledge of Maryland's Register since its inception in 1961, this discussion will focus primarily on the steps required for developing such a program. In this I shall concern myself solely with methodology, omitting consideration of the related need for general agreement on definition of terms and standard, systematic procedures for investigating through psychological as well as standard autopsies all deaths believed to be due to violent causes. Both of these requirements have been widely recognized for some time and a number of cities and states have instituted the latter program.

Maryland is commonly divided into Baltimore City (population 900,000), seven suburban counties (population 2,500,000) and 16 nonmetropolitan counties (population 600,000). The state's recent population increase of approximately 60,000 per year has been mainly concentrated in the suburban counties. Baltimore City, like most metropolitan centers, has had an exodus of white middle-class residents to surrounding

areas and a concomitant rise in the number and proportion of black inhabitants. More than one-fourth of the white population living in the city in 1960 had migrated to nearby counties by 1970, with a resultant net decrease in this group exceeding 100,000. Its population increasingly is old, sick, and community-dependent. Baltimore now has an estimated 19.1 residents sixty-five years of age or older for every 100 between eighteen and sixty-four; this is nearly twice the comparable figure of 9.9 for the suburban counties.[21] There, residents are mainly white, young, and relatively affluent. The number of inhabitants in many of the 16 nonmetropolitan counties has remained fairly constant, primarily due to the continuing out-migration of younger residents. These counties, like Baltimore City, face many of the health problems related to a population with a proportionally large concentration of aged inhabitants.

Approximately 350 Maryland residents are known to commit suicide each year. The resultant rate compares closely with national figures. Health and mental hygiene officials estimate that at least 3,500 others annually make an unsuccessful attempt and between 50,000 and 75,000 have tried one or more times to kill themselves. As with national data, correct figures are probably not lower but may quite conceivably be considerably higher. If, as available statistics indicate,[22] suicide occurs most frequently among those living alone, then cases will become more concentrated in metropolitan centers such as Baltimore. The large cities should therefore be the focus of prevention services.

Whether these figures are accurate or too low, they indicate that in Maryland, as elsewhere, suicide is a major health problem. The number of suicides reported to the Statistics Division is increasing and reached a record 398 in 1969; the estimated number who have attempted suicide exceeds comparable figures for most major disease or disability categories. Despite this, the state has never had any agency or program to develop, direct, and coordinate activities in this field and none is projected at the present time. Local suicide prevention centers are, to my knowledge, nonexistent. Efforts to establish this service for Baltimore City residents in recent years have been unsuccessful because of the inability to obtain the required financial support.

This absence of a centralized suicide prevention bureau is undoubtedly related to the prevailing lack of knowledge regarding the magnitude and impact of this problem. The absence of reliable data is a key factor in this gap. Establishment of such a program, either as an independent

agency or preferably as a unit within the existing Department of Health and Mental Hygiene, would undoubtedly greatly simplify recommended research procedures. They, in turn, would, I believe, be an essential ingredient of such a program.

Registers in health fields have been established and maintained for one of two reasons—as a treatment tool in case management or for research purposes. The Maryland Psychiatric Case Register's attainment of originally stated objectives has in part resulted from its rigid restriction to the latter function. Suicide registers, similarly, must be dependent on accurate and complete reporting from a large number of sources. Whether submission of data is voluntary or required by law, this is possible only if assurance can be provided that individual information submitted will remain confidential. A suicide register, restricted to research, could provide this guarantee since it would come under the provisions of the 1963 Health Research Act.

The suggested sequential steps in setting up a suicide register would be as follows:

1. Administrative decision to develop a suicide register: I believe that the decision to maintain a Suicide Register must either be preceded by the establishment of, or be part of the development of, a suicide prevention program. This relationship would appear to be essential since one of the prime justifications for the continuing existence of such a register would be the value of its data output in the planning and administrative decision-making processes.

A number of questions should be recognized and resolved before a decision is reached on whether or not to proceed with this project. What data are, or have been, available on suicide and suicidal attempts? What are the advantages of suicide registers as compared with traditional data collection systems? What are the anticipated uses of the statistics that will be emanating from this register? Will it receive full and continuing support from administrative and program staff? What is the expected cost of operations over time and is there reasonable expectation that funding will be provided? What will be the number and type of personnel required? Are these available? How should this register be administered and how should it relate to existing statistical and research programs and staff?

The above are examples of issues that readily come to mind. The de-

cision-making process should most appropriately be initiated by the statistical staff who should provide documentation regarding the purpose, value of, and need for, this project. If a suicide prevention bureau is in existence, its staff should participate in the drafting of this proposal. Aside from evaluation, this plan should fit into the total program concept of service, research, and evaluation.

For example, the research value of a Suicide Register would be greatly expanded by the linkage of information on individuals with comparable data from a psychiatric case register. This joining together would provide important knowledge regarding the previous and subsequent psychiatric history of those known to have made suicidal attempts. Conversely, it would also provide data on suicidal attempts among groups of individuals treated for specified mental illnesses. It could be readily achieved with a minimum of effort, particularly if similar report forms, report items, and definitions are employed, and should be initiated at the onset of the suicide register's operation.

Basic computer procedures have been developed for matching the psychiatric register data bank with other record systems. It can be employed for a number of special studies and projects and made available for use by other agencies. The linkage of the two registers could therefore be established as a routine, repetitive operation. The Register staff, in consultation with their advisory groups, should develop annual tabulations and suggested research studies from the combined data. A periodic review of desired output would appear to be warranted.

2. Key questions and decisions: Should reporting of suicidal attempts be voluntary or legally required? This is the key question that would have to be resolved prior to the onset of operations. A system dependent solely on voluntary reporting of cases offers distinct advantages. A program requiring reporting of suicidal attempts would be difficult to enforce and would undoubtedly engender extensive hostility and anxiety. Underreporting, particularly of cases not seen in hospitals or noted by the police, would surely be considerable and selective. A voluntary reporting system, on the other hand, would encounter fewer difficulties. It could achieve a high level of completeness if adequate assurances could be provided that data on individuals would remain confidential and would be used only for research purposes. This assurance can be provided where legislation has been enacted. In addition, reporting might be enhanced by the pay-

ment of a token sum for every report completed and submitted. Our experience with the Psychiatric Case Register is that a research program based on voluntary reporting can achieve and maintain a high level of participation if close, constant attention is paid by the staff to all necessary details.

Should the Suicide Register encompass the entire state or should it be limited initially to certain specified geographic areas? A program that, from the onset, seeks to cover the whole state would be difficult and costly since there are a large number and variety of potential contacts. Establishing working relationships with all of these would be very time consuming and would require a large staff. My preference would therefore be to test the concept in a limited number of defined areas and, if successful, to expand this gradually. One possibility would be to begin with a suburban county, a nonmetropolitan county with a medium-sized city and substantial rural segments, and census tracts which have been defined as catchment zones for one or more comprehensive community mental health centers within a major city. One such catchment might be oriented to a lower-income group in which health services are provided mainly either by hospitals within the area or in its vicinity or by other public health units. The number of physicians in private practice serving these residents is likely to be minimal.

3. *Contact of all possible respondents:* Possible respondents can be divided into three categories—hospitals, police, and physicians in private practice. A directory of all doctors should be compiled initially, based on membership in the local medical societies and on listings in the classified sections of telephone books. They, as well as hospital administrators and police chiefs, should receive a personal letter from the administrative head of the department outlining this proposed program, requesting their support and participation and asking for the opportunity to have Register staff discuss it with them in detail. If there are local medical societies that hold regular meetings, efforts should be made through them to have an opportunity to describe this project to the collective membership. Particular effort should be made to involve the society leadership and county health officers at the earliest opportunity.

In all direct contact with possible respondents, the research potential of this project should be stressed. The fact that data from the Suicide Register will not be used for case investigation or management should

be emphasized. A copy of the state legislation on the confidentiality of health research should be provided to all contacts. They should be informed of the proposed starting date and of the general form contents. Efforts should be made to obtain, at a minimum, conditional agreement to participate. They should be told that necessary forms with appropriate instructions will be sent to them in advance. In all contact with hospitals and police, the records they keep on suicidal attempts should be studied for possible adjustments to meet the Register needs.

Wherever possible, members of advisory groups should include recognized leaders in the three major categories of projected respondents—hospitals, police, and physicians in private practice. This should be preceded by community discussions and investigations to determine such key individuals.

4. Determination of questionnaire form: With relatively minor adjustments reporting forms of psychiatric case registers would be quite suitable for a Suicide Register. Upon completion, the carbon copy of such a form remains with the reporting facility. A duplicate of the statistics supplied is therefore available to the respondent to be used in any manner deemed appropriate.

The Maryland Psychiatric Case Register questionnaire provides an example of the data sought. Identifying information is essential for matching or linkage procedures. This includes name, address, social security number, place of birth, and mother's maiden name. Date of birth, age, race, and sex are used dually for matching purposes as well as for demographic statistics. Also in this latter category are questions on education, religion, marital status, occupation and employment status. Additional questions relating to household composition and mobility (length of continuous residence at current address, in county and state) have produced unsatisfactory results since answers could not be provided in many instances. Unless specific efforts can be made to obtain this information accurately in a much higher proportion of cases, they cannot be included in any analysis of data and should therefore be omitted from this type of form. Completion time can be minimized by setting up questions on a check-off basis and eliminating virtually all requirements for writing in information.

A separate section can deal with the suicidal attempt. Here also, a check-off procedure could be employed with few exceptions. Among the

questions that might be included are date, time, site, and type of current attempt, extent of resultant injuries, number of known previous attempts, and date, time, site, and type of last known previous attempt, and so forth. If the individual died from these self-inflicted wounds, this should be indicated. The reporting source should, of course, also be identified.

5. *Development and maintenance of storage retrieval procedures:* As indicated, approximately 3,500 Maryland residents are believed to have attempted suicide each year in addition to the 350 who make a successful effort. On the basis of these figures, the three areas suggested for initial inclusion should have about 50 suicides and 500 attempts annually. Even if this program is maintained permanently and expanded gradually to include other areas, the number of cases reported would, for some time, not be sufficient to warrant computer procedures or other sophisticated data processing.

Rather, a system based on a manually maintained record file and standard I.B.M. punch card equipment such as a sorter should be sufficient for all maintenance and data output needs. These cards should be stored by year of occurrence and can be used for all required tabulations. Manual unduplication is a relatively simple process and merely requires that cards first be sorted alphabetically in name order. Our experience with the Psychiatric Register has been that a trained, medium-level clerk can link events for a given individual with a high level of accuracy at a rapid rate (approximately 2,500 cards in a seven-hour day). The number of cases where linkage could not be determined in this manner because of variations in the spelling of the patient's name or changes in reported address, age, and social security number has consistently been considerably less than 1 per cent. In these instances, inquiry of reported sources usually resolved differences and produced a definite decision as to whether or not a match did exist.

In addition to separate sets of cards for each year, a cumulative set should be maintained similarly and updated at periodic intervals. Tabulations can be prepared from this in a standard manner or by conversion of cards to tape for computer use. Ultimately, this file may become too large for efficient card management and therefore may have to be maintained on tape. However, experience indicates that this should not be necessary until the reported number of cases reaches at least 15,000.

Routine procedures have been developed for matching files annually

with death records for all residents in a given area in order to determine the subsequent mortality experience of individuals known to have been under psychiatric care. A similar program should be instituted for the "Suicide Register." Life expectancy data and cause of death distributions could be derived from this and compared with matched population cohorts.

6. Maintenance of continuing operations and goals: The continuing existence of the Register is dependent on the full cooperation of all respondents. Our experience has been that this can be achieved and maintained through continuing personal contact, frequent transmittal of meaningful routine and special reports and assistance wherever possible in special studies or other data needs. An advisory board can be an important resource in maintaining appropriate relations with possible respondents.

As indicated, the Suicide Register should serve as an important research resource and as an important tool for program planning, administration, and evaluation.

Notes and references

1. National Center for Health Statistics, U.S. Department of Health, Education, and Welfare, *Suicide in the United States, 1950-1964,* Public Health Service Publication No. 1000, Series 20:1.
2. Louis I. Dublin, *Suicide: A Sociological and Statistical Study,* New York: The Ronald Press (1963), p. 3.
3. Jack D. Douglas, *The Social Meanings of Suicide,* Princeton, N.J.: Princeton University Press (1967), p. 203.
4. See M. Monk, "Epidemiology," Ch. 10–ED.
5. Brian MacMahon, Samuel Johnson, and Thomas F. Pugh, "Relation of Suicide Rates to Social Conditions," *Public Health Reports,* 78, no. 4:286 (April 1963).
6. Douglas, *Social Meanings,* pp. 163-231.
7. Tsung-Yi Lin and C. C. Stanley, "The Scope of Epidemiology in Psychiatry," *World Health Organization Public Health Papers,* No. 16.
8. Johan Bremer, "Social Psychiatric Investigation of a Small Community in Northern Norway," *Acta Psychiat. Neurol.,* Suppl. 62 (1951).
9. Maryland Department of Mental Hygiene and National Institute of Mental Health, "Maryland Psychiatric Case Register-Description—History, Current Status and Future Uses," (mimeographed).
10. Gerald D. Klee, Evelyn Spiro, Anita K. Bahn and Kurt Gorwitz, *An Ecological Analysis of Diagnosed Mental Illness in Maryland,* Psychiatric

Research Report 22 of the American Psychiatric Association, Washington, D.C. (April 1967) pp. 107-48; Kurt Gorwitz, Anita K. Bahn, Myles Cooper, Frances Jean Warthen, "Some Epidemiological Data on Alcoholism in Maryland," *Quart. J. Studies Alcohol* (June 1970); Kurt Gorwitz, Frances Jean Warthen, "Effects of Desegregation of a State Mental Hospital System on Rates of Treated Mental Illnesses," *HSMHA Health Reports* (January 1971); Frederick N. Brandand, Kurt Gorwitz, "Relationship of Cerebrovascular Disease to Senile, Presenile and Cerebral Arteriosclerotic Dementia," *J. Chron. Dis.,* (1971) pp. 569-83.

11. Maryland Department of Health and Mental Hygiene, "Mental Health and Mental Illness in Maryland," p. 27 (mimeographed).

12. Elmer A. Gardner, Anita K. Bahn, and Marjorie Mack, "Suicide and Psychiatric Care in the Aging," *Arch. Gen. Psychiatry,* 10:547-53 (June 1964).

13. Emil Kraepelin, *Lectures on Clinical Psychiatry,* second German edition, rev. and ed. Thomas Johnstone, 3rd English edition, New York: Wood (1917).

14. Louis I. Dublin, *The Facts of Life From Birth to Death,* New York: Macmillan (1951), p. 263.

15. L. Srole, J. Langner, S. Michael, M. Opler, and J. Rennie, *Mental Health in the Metropolis:* New York: McGraw-Hill (1962).

16. New York State Department of Mental Hygiene, *Annual Report,* Albany, N.Y. (1960).

17. Erwin Stengel, "Recent Research Into Suicide and Attempted Suicide," *Am. J. Psychiatry,* 118, no. 8:725-27 (February 1962).

18. Norman L. Farberow and Edwin S. Shneidman, eds., *The Cry for Help,* New York: McGraw-Hill (1961).

19. Stengel, "Recent Research," pp. 725-27.

20. "In the Missouri Division of Mental Health statewide automated Standard System of Psychiatry, 151 patients who had attempted suicide were compared with 424 who had not and with 97 who had committed suicide. Much of the data was provided from relatives using an automated history. Compared with non-attemptors, attemptors were young and more often female, depressed, assaultive, and had a family history of suicide. Actual suicides were more often male, better educated, and in general more resembled the attemptors than non-attemptors." I. W. Sletten, R. C. Evenson, and H. L. Brown, "Some Results from an Automated Statewide Comparison among Attempted, Committed, and Nonsuicidal Patients," *J. Life-Threatening Behavior,* 3, no. 3:191-97 (Fall 1973)—ED.

21. Kurt Gorwitz, "Maryland Faces the 1970's—An Analysis of Population Trends in Relation to Health Needs and Services," *Md. St. Med. J.,* 20: 64-68 (February 1971).

22. National Office of Vital Statistics, unpublished data.

INDEX

Absalom, 4
acedia, 12-13
acetylcholine, 116, 118
acute suicide, 108
Adonais, 32-33
Aelius Verus, 12
affective neutrality, 140
Africa: studies of suicide in, 79-88; and
 suicide prevention in, 89
African Homicide and Suicide, 80, 84-
 86, 88
age, 153, 176, 187-90. *See also* elderly
age-adjusted suicide rates, 189-90
Age of Reason, 40
aggression, 102-4, 147-48, 151
Ahitophel, 4
Airs, Waters, Places, 20
Albert, 37
alcoholics: and anhedonia, 115; as po-
 tential suicides, 151, 155, 176, 179;
 treatment of, in emergency rooms,
 141, 143; and suicide rate, 25, 94,
 108, 154-55, 73
aldolase, 114
alienation, 33, 45-46
Allen, Nancy H., 158
Alpha-methyl-DOPA, 127
altruistic suicides, 75n. 2, 78-79, 96, 196
Alur, the, 85-86, 88
ambulance drivers, 134n. 17
Ammianus Marcellinus, 7
amphetamine, 122, 126
Anatomy of Melancholy, 17

anger, 63, 68
Anglicans, 196
anhedonia, 115
animals and brain self-stimulation, 121-
 22; criticism of studies using, 127; ef-
 fects of reserpine on, 125; studies us-
 ing, and serotin, 117-18; use of, in
 studies of pleasure, 114-15
anomic suicides, 79, 104-5, 196
anomie, 94-96, 98, 100, 105
anticipatory guilt feelings, 68
antidepressant drugs, 115, 125-26
antiheroism, 45
Antonius Pius, Emperor, 7
Aquinas, Saint Thomas, 64, 66-67
Arbuthnot, John, 20
Arendt, Hannah, 51
Aretaeus, 11
Aristotle, 67
Artaud, Antonin, 42-43
Asclepius, 9
attempted suicides: characteristics of,
 175-76; childhood of, 152; and ex-
 tremist art, 53; and psychiatric social
 workers, 179; relatives of, 153; re-
 porting of, 221-22; and the signifi-
 cant other, 148-49; studies of, 202-3;
 and suicide rate, 151, 154-55, 161,
 204, 216-18; and use of question-
 naire, 223-24
Auenbrugger, Leopold, 24
Augustine, Saint, 65
Aulus Gellius, 7

filmed 1930, New York, with music by
Hanns Hasting; approximately 3 minutes;
excerpt of *Mary Wigman, Dancer* by Lutz
Becker, 1974

204 **C. Williams**
The Supernatural Visitor, 1840
book frontispiece, 19 x 9.25 cm
University of London Library, Harry Price
Library

205 **Anna Zemankova** (1908–1926)
Untitled
mixed media, 62.5 x 45 cm
The Outsider Collection

LIST OF ILLUSTRATIONS

LENDERS LIST

185 **John Michael Rysbrack** (1694–1770)
The Magician
pen, red and brown ink, grey/brown wash
heightened with white, 37.6 x 22.8 cm
The Syndics of the Fitzwilliam Museum,
Cambridge

186 **Martin Schongauer** (c.1430–91)
The Temptation of St Anthony
engraving, 30.2 x 22.5 cm
Trustees of the British Museum, London

187 **Eva and Jan Švankmajer** (b.1940 and b.1934)
Devil Head from the film *Faust*, 1994
papier mâché and mixed media,
approximately 100 x 120 x 150 cm
Collection of the artists

188 **Mark Symons** (1886–1935)
Ave Maria, c.1928
oil on canvas, 123 x 66 cm
Reading Museum Service (Reading Borough
Council)

189 **Dorothea Tanning** (b.1910)
Cat, 1986
collage and gouache, 39.4 x 49.5 cm
Private collection, courtesy of Michael Hue-
Williams Fine Art Ltd

190 **Tarot cards, anon.**
Schreiber Flemish 6, C18
I *Le Bateleur*, VI *L'Amour*, VII *Le Chariot*,
X *La Roue de la Fortune*, XII *Le Pendu*,
XIII *La Mort*, XV *Le Diable*, XVI *La Foudre*,
XVIII *La Lune*, XIX *Le Soleil*,
XX *Le Jugement*, XXI *Le Monde*, XXII *Le Fol*
printed cards, each 11.9 x 7 cm
Trustees of the British Museum, London

191 **Tarot cards, anon.**
Schreiber French 20, C19
4 *Dépouillement/Air*, 5 *Voyage/Terre*,
8 *Etteilla/Questionnaire*, 25 *Etranger/Nouvelle*,
26 *Obstacle/Trahison*, 34 *Chagrin/Surprise*,
48 *Amour/Désir*, 68 *Lotene/La Maison*,
76 *Lettre/Ambarras*
printed cards, each 11.6 x 6.5 cm
Trustees of the British Museum, London

192 **Howard Thurston**
Dreams come true!
book
University of London Library, Harry Price
Library

193 **Shafique Uddin** (b.1962)
Untitled
acrylic, 68.5 x 48.5 cm
The Outsider Collection

194 **After Vasari** (?)
St Peter in Prison, with the Angel
pen and brown ink, 21 x 13.2 cm
The Governing Body, Christ Church, Oxford

195 **Venetic, anon.**
The Martyrdom of St Agnes, early C17
pen and light-brown wash over red chalk,
heightened with with bodycolour on buff
paper, 41.7 x 27.5 cm
The Governing Body, Christ Church, Oxford

196 **Agostino Veneziano** (worked 1509–36)
The Carcass (Lo Stregozzo)
engraving, 30.8 x 63.8 cm
Trustees of the British Museum, London

197 **Pascal Verbena** (b.1941)
Waterdiviner
wood, 52 x 33.4 x 65.2 cm
The Outsider Collection

198 **Western India, anon.**
Horoscope roll drawn up for George Giberne
(1797–1876), civil servant for the East India
Company, 1821
linen-backed paper, 3322 x 18 cm
Collection of Paul Sieveking, London

199 **Anthonie Wierix** (1552–1624)
Christ listening at the door of the heart
engraving, 9.1 x 5.6 cm
Wellcome Institute Library, London

200 **Anthonie Wierix** (1552–1624)
Christ shooting flaming arrows into the heart
engraving, 9.1 x 5.6 cm
Wellcome Institute Library, London

201 **Anthonie Wierix** (1552–1624)
Christ cleaning sins out of the heart
engraving, 9.1 x 5.6 cm
Wellcome Institute Library, London

202 **Anthonie Wierix** (1552–1624)
Christ inspecting sins in the heart
engraving, 9.1 x 5.6 cm
Wellcome Institute Library, London

203 **Mary Wigman**
Hexentanz (Witches' Dance)
film of solo dance by Mary Wigman; first
performed on 1 October 1926, Dresden;

168 **Persia, anon.**
A man watching a Kylin being devoured by a
dragon, mid-C17
pen and wash, 19.7 x 11.6 cm
The Syndics of the Fitzwilliam Museum,
Cambridge

169 **Valerie A. Potter** (b.1954)
I am afraid that you are right, she said..., 18.5.91
embroidery on cotton duck, 50.5 x 60.2 cm
The Outsider Collection

170 **Attributed to Giulio Cesare Procaccini**
(c.1570–1625)
The Annunciation
pen and brown ink on carta azzurra,
37.7 x 25.9 cm
The Syndics of the Fitzwilliam Museum,
Cambridge

171 **Quay Brothers** (b.1947)
Portion of décor from puppet animation
film *This Unnameable Little Broom* (being a
largely disguised version of Tableau II from
the *Epic of Gilgamesh*), 1985
wood, wire, feathers and mixed media,
69 x 69 x 92 cm
Collection of Quay Brothers

172 **Quay Brothers** (b.1947)
Hoof-wand from *Institute Benjamenta*, a
feature film directed by Quay Brothers, 1995
mixed media, length 77 cm
Collection of Quay Brothers

173 **Marcantonio Raimondi** (c.1480 –1527/34)
Raphael's Dream, c.1508
engraving, 23.8 x 33.5 cm
The Syndics of the Fitzwilliam Museum,
Cambridge

174 **Odilon Redon** (1840–1916)
*The Temptation of St Anthony. It is a Skull
Wreathed in Roses*, 1888
plate VI, lithograph on chine appliqué,
29.7 x 21.7 cm
National Gallery of Scotland, Edinburgh

175 **Odilon Redon** (1840–1916)
*The Temptation of St Anthony. Everywhere
Eyeballs are Aflame*, 1888
plate IX, lithograph on chine appliqué,
20.5 x 15.9 cm
National Gallery of Scotland, Edinburgh

176 **Rembrandt Harmensz van Rijn** (1606–69)
*The Angel Preventing Abraham from
Sacrificing his Son, Isaac*, c.1634–35
red chalk over black chalk, with grey wash,
19.5 x 14.7 cm
Trustees of the British Museum, London

177 **Studio of Guido Reni** (1575–1642)
The Archangel Michael Subduing the Devil
pen and brown ink, 41.8 x 27.5 cm
The Governing Body, Christ Church, Oxford

178 **George Romney** (1734–1802)
Meeting of the Three Witches and Hecate
pen, ink and watercolour wash over pencil,
39.2 x 51.6 cm
The Syndics of the Fitzwilliam Museum,
Cambridge

179 **Cristoforo Roncalli** (1552–1626)
An Angel seated on Clouds
red chalk, 31.3 x 23.7 cm
National Gallery of Scotland, Edinburgh

180 **Dante Gabriel Rossetti** (1828–82)
Study for *The Return of Tibullus to Delia*
pencil, 22.2 x 19.6 cm
The Syndics of the Fitzwilliam Museum,
Cambridge

181 **Thomas Rowlandson** (1756–1827)
The Fortune Teller, 1815
coloured aquatint, 13.6 x 22.6 cm
University of London Library, Harry Price
Library

182 **Thomas Rowlandson** (1756–1827)
*The Dance of Death: Death rocks the cradle:
Life is o'er: The infant sleeps, to wake no more*
hand-coloured aquatint with etching,
12 x 24 cm
Wellcome Institute Library, London

183 **Thomas Rowlandson** (1756–1827)
*The Dance of Death: Fungus, at length,
contrives to get Death's Dart into his cabinet*
hand-coloured aquatint with etching,
12 x 24 cm
Wellcome Institute Library, London

184 **Thomas Rowlandson** (1756–1827)
*The Dance of Death: The Careful and the
Careless led to join the living and the dead*
hand-coloured aquatint with etching,
12 x 24 cm
Wellcome Institute Library, London

148 **John Martin** (1789–1854)
The Egyptians drowning in the Red Sea, c.1832
watercolour, 20.6 x 15.5 cm
The Board of Trustees of the Victoria & Albert
Museum, London

149 **John Martin** (1789–1854)
Rebellion of Korah, 1833
watercolour and wash, 8.5 x 14 cm
The Board of Trustees of the Victoria & Albert
Museum, London

150 **John Martin** (1789–1854)
The Face of God upon the waters
mezzotint, 19 x 29 cm
Trustees of the British Museum, London

151 **Matta**
Untitled, 1996
pencil and crayon on photocopy, 42 x 29.7 cm
Private collection, Paris

152 **Mexico, State of Guererro, Nahua, anon.**
Bat mask, c.1950
mixed media, 68 x 52 x 20 cm
Collection of Anthony Shelton

153 **Henri Michaux** (1899–1984)
Tusch Mescalin, 1957
ink, 24 x 32 cm
Private collection
© ADAGP, Paris and DACS, London 1996

154 **Follower of Michelangelo**
A dragon fighting a serpent
pen and brown ink, 17.4 x 20 cm
The Governing Body, Christ Church, Oxford

155 **Minetta**
What the cards tell, 1896
book
University of London Library, Harry Price
Library

156 **Ulrich Molitor**
De laniis et phitonicis mulieribus, c.1489
book
University of London Library, Harry Price
Library

157 **Gustave Moreau** (1826–98)
Sappho, c.1884
watercolour, 18.4 x 12.4 cm
The Board of Trustees of the Victoria & Albert
Museum, London

158 **George Moss**
Harry Price and 'spirit', c.1922
photograph, 14.5 x 9.6 cm
University of London Library, Harry Price
Library
Photograph: B. & N. Microfilm

159 **J.B. Murry** (1907–89)
Spirit writings, 1988
biro and blue chalk, 35.5 x 27 cm
The Outsider Collection

160 **Narwhal tusk**
ivory/dentine, 233.7 cm
Booth Museum of Natural History, Brighton

161 **Michel Nedjar** (b.1947)
Triple Head
died cloth, 60 x 22 x 33 cm
The Outsider Collection

162 **New Guinea, Sepik River, anon.**
Head rest, C19
wood and bamboo, 18 x 10 x 51 cm
The Freud Museum, London

163 **Jacopo Palma (Il Giovane)** (1544–1628)
St Francis in Ecstasy
pen, brown ink and wash over black chalk
on brown paper, 38 x 23.9 cm
National Gallery of Scotland, Edinburgh

164 **Samuel Palmer** (1805–81)
Figures in a Garden
body colour and wash, 13.5 x 9.4 cm
The Board of Trustees of the Victoria & Albert
Museum, London

165 **Parmigianino (?) after Raphael** (1503–40)
*Study of a left foot, propped upon a piece
of knotted cloth*
red chalk, 11.1 x 11.3 cm
The Governing Body, Christ Church, Oxford

166 **William Partridge**
The book of fate: the universal fortune-teller,
c.1766
book
University of London Library, Harry Price
Library

167 **Giovanni Battista Passeri** (1610–79)
Two Angels with Arms Raised
pen and grey wash, 27.7 x 21 cm
The Governing Body, Christ Church, Oxford

129 **Max Klinger** (1857–1920)
On the Finding of a Glove: Action, 1881
etching, 40 x 50 cm
Scottish National Gallery of Modern Art,
Edinburgh

130 **Max Klinger** (1857–1920)
On the Finding of a Glove: Homage, 1881
etching, 40 x 50 cm
Scottish National Gallery of Modern Art,
Edinburgh

131 **Max Klinger** (1857–1920)
On the Finding of a Glove: Repose, 1881
etching, 40 x 50 cm
Scottish National Gallery of Modern Art,
Edinburgh

132 **Max Klinger** (1857–1920)
On the Finding of a Glove: Abduction, 1881
etching, 40 x 50 cm
Scottish National Gallery of Modern Art,
Edinburgh

133 **Max Klinger** (1857–1920)
On the Finding of a Glove: Anxieties, 1881
etching, 40 x 50 cm
Scottish National Gallery of Modern Art,
Edinburgh

134 **Alfred Kubin** (1877–1959)
Adoration, *c.*1900
pen and Spritztechnik on Katasterpapier,
23.5 x 23.5 cm
Piccadilly Gallery, London

135 **Alfred Kubin** (1877–1959)
Reclining on a Divan, *c.*1900
pen and Spritztechnik on Katasterpapier,
22.8 x 12.7 cm
Piccadilly Gallery, London

136 **Alfred Kubin** (1877–1959)
The Suicide, 1922
lithograph, 28.5 x 34 cm
The Board of Trustees of the Victoria & Albert
Museum, London

137 **Hans von Kulmbach** (*c.*1480–1522)
*St Christopher with Sea Monsters in the
Background*
pen and brown ink, with traces of black
chalk, 23.7 x 19.8 cm
The Governing Body, Christ Church, Oxford

138 **C.W. Leadbeater**
Man Visible and Invisible, 1902
book
University of London Library, Harry Price
Library

139 **Frederick George Lee**
Glimpses of the supernatural, vol. II, 1875
book
University of London Library, Harry Price
Library

140 **Giovanni Battista Lenardi** (1656–1704)
The Martyrdom of the Quattro Coronati
pen and brown wash over red and black
chalk, heightened with white bodycolour
on brown-toned paper, 47.7 x 35.6 cm
The Governing Body, Christ Church, Oxford

141 **Leonardo da Vinci** (1452–1519)
Allegory of the Political State of Milan
pen and brown ink, 20.6 x 28.3 cm
The Governing Body, Christ Church, Oxford

142 **Glenn Ligon** (b.1960)
No. 762 Man, 1990
oil, 76.2 x 56.5 cm
Collection Emily Fisher Landau, New York

143 **John Linnell, after Blake** (1792–1882)
*The Portrait of a Man who instructed Mr Blake
in painting in his dreams*, *c.*1819
pencil, 27 x 21.5 cm
The Syndics of the Fitzwilliam Museum,
Cambridge

144 **Lambert Lombard** (1505–66)
A Cherub Flying, Carrying part of a Column
pen and brush and brown wash, 12.6 x 10.3 cm
The Governing Body, Christ Church, Oxford

145 **Lambert Lombard** (1505–66)
*The Virgin and Child in the clouds, with two
young monastic saints and angels*
pen and brown ink, 31.8 x 24.4 cm
The Governing Body, Christ Church, Oxford

146 **Raphael Lonné** (1910 –89)
Untitled, 1977
coloured ink, 26.8 x 39.5 cm
The Outsider Collection

147 **Marlet**
Le Sorcier de Tivoli, *c.*1820
coloured lithograph, 19 x 27.5 cm
University of London Library, Harry Price
Library

111 **Shirazeh Houshiary** (b.1955)
Study for *The Earth is an Angel*, 1987
ink wash, metallic paint and pencil,
50.9 x 63.4 cm
Tate Gallery (presented by the Weltkunst
Foundation, 1987)

112 **Italy, Milan, anon.**
The Sacred Heart of Jesus
colour process print, 10.5 x 6 cm
Wellcome Institute Library, London

113 **Italy, Naples, anon.**
The Lord appearing to Moses on Mount Sinai,
with a vision of the Tabernacle above, c.1700
pen and brown wash, 42 x 25.6 cm
The Governing Body, Christ Church, Oxford

114 **Italy, Rome, anon.**
Agata Paladino in a street accident,
27 May 1843
oil on tin, 25 x 35.7 cm
Wellcome Institute Library, London

115 **Italy, Rome, anon.**
A builder falling from a platform in an apse,
St Bruno interceding before the Virgin
oil on canvas laid on cardboard, 55.3 x 40.9 cm
Wellcome Institute Library, London

116 **Italy, Rome, anon.**
Man stabbing a woman with a stiletto, late C19
oil on canvas, 30.1 x 39.6 cm
Wellcome Institute Library, London

117 **Italy, Rome, anon.**
Two men and a woman praying to a
monastic saint and the Virgin of Sorrows
for the health of a child, c.1890
oil on canvas, 28.2 x 38.5 cm
Wellcome Institute Library, London

118 **Italy, Rome, anon.**
A woman being rescued after falling down
a well, c.1850
watercolour and engraving, 18.5 x 25.5 cm
Wellcome Institute Library, London

119 **Italy, Tuscany, anon.**
The Vision of St Thomas Aquinas:
'Bene Scripsisti de me, Thoma', c.1600
pen and brown ink and blue wash on blue
paper, 26.5 x 20 cm
The Governing Body, Christ Church, Oxford

120 **Megan Jenkinson** (b.1958)
Comprehensio reaches for the foundation
of certainty in the elusive world of virtual
reality, 1996
from the 'Virtues' series, cibachrome
collage, 55 x 60 cm and 22 x 20 cm
Collection the artist

121 **David Jones** (1895–1974)
Illustration to the Arthurian Legend
The Four Queens find Lancelot sleeping, 1941
watercolour and pen, 62.9 x 49.5 cm
Tate Gallery (purchased, 1941)

122 **Wassily Kandinsky** (1866–1944)
Abstrakte Komposition K22, 1922
pen and ink, 25.5 x 29.2 cm
Fridart Foundation
© ADAGP, Paris and DACS, London 1996

123 **H. Kirchenhoffer**
The Book of Fate formerly in the possession
of Napoleon, 1833
printed chart
University of London Library, Harry Price
Library

124 **Paul Klee** (1879–1940)
Ghost of a Genius, 1922
oil transfer and watercolour, 50 x 35.4 cm
Scottish National Gallery of Modern Art,
Edinburgh
© DACS 1996

125 **Paul Klee** (1879–1940)
More Here than There, 1922
coloured pencil, 23 x 28.5 cm
Piccadilly Gallery, London

126 **Max Klinger** (1857–1920)
Rescues of Ovidian Victims, 1879
First Intermezzo, etching and aquatint,
27.5 x 18.9 cm
Trustees of the British Museum, London

127 **Max Klinger** (1857–1920)
The Bear and the Elf, 1881
(plate 1, Opus IV) Intermezzi, etching
and aquatint, 41.4 x 29 cm
Collection of Lutz Becker

128 **Max Klinger** (1857–1920)
Amor, Death and the Other Side, 1881
(plate 12, Opus IV) Intermezzi, etching
and aquatint, 20.3 x 42 cm
Collection of Lutz Becker

96 **Lady Clementina Hawarden** (1822–65)
Girl Asleep, c.1863–64
photograph, 23.6 x 27.9 cm
The Board of Trustees of the Victoria & Albert
Museum, London

97 **Lady Clementina Hawarden** (1822–65)
Study from Life, c.1863–64
photograph, 23.8 x 28.1 cm
The Board of Trustees of the Victoria & Albert
Museum, London

98 **Tim Head** (b.1946)
The Mind's Eye, 1975
plastic and mirror, 21 x 11 x 9 cm
Collection of Michael Craig-Martin, London

99 **Attributed to Joseph Heintz the Elder**
(1564–1609)
*The Dead Christ Lamented by five Angels
with Calvary in the Background*, 1589
pen and brown wash, 38.4 x 30.8 cm
The Governing Body, Christ Church, Oxford

100 **Gertrude Hermes** (1901–83)
Fathomless Sounding
wood engraving on buff wove paper,
38 x 25.3 cm
The Visitors of the Ashmolean Museum,
Oxford

101 **After Hieronymus Hess** (1799–1850)
Death beating the shoemaker
lithograph printed by G. Danzer, 17.1 x 13.1 cm
Wellcome Institute Library, London

102 **After Hieronymus Hess** (1799–1850)
Death leading off the Queen
lithograph printed by G. Danzer, 17.1 x 13 cm
Wellcome Institute Library, London

103 **After Hieronymus Hess** (1799–1850)
Deaths drumming and piping
lithograph printed by G. Danzer, 16.8 x 13.5 cm
Wellcome Institute Library, London

104 **Susan Hiller** (b.1942)
Virgula Divina/water-witching, 1991
from a large vitrine installation,
'From the Freud Museum', 1991 ongoing
photocopy of artist's notes on dowsing
methods; artist's hand-made divining rods;
two pendulae, one hand-made, in customized
cardboard box, 33.5 x 25.5 x 6.3 cm
Private collection

105 **Susan Hiller** (b.1942)
Sophia/wisdom, 1993
from a large vitrine installation,
'From the Freud Museum', 1991 ongoing
artist's typology of religious practioners;
waters collected at four sacred sites, in
antique bottles, corked and sealed; tags with
site names, etc., in customised cardboard
box, 25.5 x 33.5 x 6.3 cm
Private collection
© the artist 1996

106 **Susan Hiller** (b.1942)
/power, 1995
from a large vitrine installation,
'From the Freud Museum', 1991 ongoing
colour photocopy of postcard reproduction
of painting entitled *La mano poderosa*; hand
talismans, tagged, from Egypt, North Africa,
Mexico, etc., in customised cardboard box,
33.5 x 25.5 x 6.3 cm
Private collection

107 **William Hope**
Harry Price and 'spirit', c.1922
photograph, 14.5 x 9.5 cm
University of London Library, Harry Price
Library

108 **William Hope**
Spirit photograph of Sir Arthur Conan Doyle
(sitter: Mrs Harold Lock), 29 September 1930
photograph, 12.2 x 8.4 cm
University of London Library, Harry Price
Library

109 **Georgiana Houghton**
*Chronicles of the photographs of spiritual
beings*, 1882
book
University of London Library, Harry Price
Library
Photograph: B. & N. Microfilm

110 **Georgiana Houghton**
The Unclad Spirit from *Chronicles of the
photographs of spiritual beings*, 1882
photograph of plate 5
University of London Library, Harry Price
Library
Photograph: B. & N. Microfilm

77 **John Anster Fitzgerald** (1832–1906/9)
Death of Cock Robin
watercolour on card, 23.5 x 17.8 cm
The Board of Trustees of the Victoria & Albert
Museum, London

78 **P.R.S. Foli**
Pearson's fortune teller, 1924
book
University of London Library, Harry Price
Library

79 **France, Paris, anon.**
Harpie, c.1773/97
hand-coloured engraving, 24 x 38.5 cm
Wellcome Institute Library, London

80 **France, Paris, anon.**
Notre Dame de bonne Déliverance:
the Virgin with votive offerings
hand-coloured etching, 35 x 23.5 cm
Wellcome Institute Library, London

81 **Henry Fuseli** (1741–1825)
Two Figures
pen, ink and pencil, 30.8 x 25 cm
The Board of Trustees of the Victoria & Albert
Museum, London

82 **Henry Fuseli** (1741–1825)
The Witch and the Mandrake
pencil over indications in red chalk on fine
waxed paper, 42.8 x 54.5 cm
The Visitors of the Ashmolean Museum,
Oxford

83 **After Fuseli**
Head of a Damned Soul, c.1788–90
line engraving and etching in black ink,
35 x 26.5 cm
The Syndics of the Fitzwilliam Museum,
Cambridge

84 **Adam Fuss** (b.1961)
Untitled, 1994
unique cibachrome photogram,
101.6 x 76.2 cm
Courtesy Robert Miller Gallery, New York

85 **Giovanni Battista Gaulli (Baciccio)**
(1639–1709)
Cherubs, c.1675
pen, ink and wash, 22.2 x 38.1 cm
The Board of Trustees of the Victoria & Albert
Museum, London

86 **Jacques de Gheyn II** (1565–1629)
A Witches' Sabbath, c.1583–84
pen and brown ink, 37.7 x 51.9 cm
The Governing Body, Christ Church, Oxford

87 **Giorgio Ghisi** (1520–82)
Allegory of Life ('Raphael's Dream'), 1561
engraving, 37.7 x 53.8 cm
Trustees of the British Museum, London

88 **Francisco José Goya y Lucientes** (1746–1828)
The Chinchillas
from 'Los Caprichos' series, etching
and aquatint, 17.4 x 12.3 cm
Trustees of the British Museum, London

89 **Francisco José Goya y Lucientes** (1746–1828)
Hobgoblins
from 'Los Caprichos' series, etching
and aquatint, 18.6 x 13 cm
Trustees of the British Museum, London

90 **Francisco José Goya y Lucientes** (1746–1828)
They Spruce Themselves Up
from 'Los Caprichos' series, etching
and aquatint, 18 x 12.7 cm
Trustees of the British Museum, London

91 **Francisco José Goya y Lucientes** (1746–1828)
Way of Flying
from 'Los Proverbios' series, etching
and aquatint, 21.4 x 32.5 cm
Trustees of the British Museum, London

92 **Greece, anon.**
Eros, Hellenistic period, 3rd–2nd century BC
terracotta, height 10 cm
The Freud Museum, London

93 **Greece, Myrina, anon.**
Eros, Hellenistic period, 3rd–2nd century BC
terracotta, height 16 cm
The Freud Museum, London

94 **Greece, Myrina, anon.**
Eros, Hellenistic period, c.150–100BC
terracotta, height 38 cm
The Freud Museum, London

95 **Guercino (Giovanni-Francesco Barbieri)**
(1591–1666)
Angel
pen, ink and wash, 25.4 x 18.7 cm
The Board of Trustees of the Victoria & Albert
Museum, London

61 **George Dance** (1695–1768)
Man pursued by Monsters
pen, grey wash and watercolour, 21 x 16.4 cm
The Syndics of the Fitzwilliam Museum,
Cambridge

62 **George Dance** (1695–1768)
Whence and What Art Thou?
pencil, pen and grey ink, 13 x 8 cm
The Syndics of the Fitzwilliam Museum,
Cambridge

63 **Ferdinand-Victor-Eugène Delacroix**
(1798–1863)
Study for *Tam O'Shanter*, 1849
graphite, 17.4 x 22.3 cm
The Syndics of the Fitzwilliam Museum,
Cambridge

64 **Louis Jean Desprez** (1743–1804)
The Chimaera
etching, 30.4 x 37.5 cm
Trustees of the British Museum, London

65 **Gustave Doré** (1832–83)
Illustration to *London*, 1872
pen, ink and wash, 36.2 x 26 cm
The Board of Trustees of the Victoria & Albert
Museum, London

66 **Richard Doyle** (1824–83)
*A rider thrown from his horse before a wood,
in which sits one of the Jöten, a Scandinavian
race of giants*
watercolour, pen and ink, 11 x 17.8 cm
The Board of Trustees of the Victoria & Albert
Museum, London

67 **Jean Duvet** (c.1485–1561)
*Apocalypse: Jean Duvet as St John
the Evangelist*, 1555
engraving, 30.1 x 22.6 cm
The Syndics of the Fitzwilliam Museum,
Cambridge (Marlay Fund, 1916)

68 **Jean Duvet** (c.1485–1561)
*Apocalypse: The Angel gives St John the book
to eat, c.*1555
engraving, 30.4 x 21.5 cm
The Syndics of the Fitzwilliam Museum,
Cambridge (Marlay Fund, 1916)

69 **Jean Duvet** (c.1485–1561)
*Apocalypse: The Whore of Babylon seated
on the seven-headed beast, c.*1555
engraving, 30.3 x 21.9 cm
The Syndics of the Fitzwilliam Museum,
Cambridge (Marlay Fund, 1916)

70 **Jean Duvet** (c.1485–1561)
*Apocalypse: The Fall of Babylon, c.*1555
engraving, 30 x 21.1 cm
The Syndics of the Fitzwilliam Museum,
Cambridge (Marlay Fund, 1916)

71 **Jean Duvet** (c.1485–1561)
*Apocalypse: Satan bound for 1000 years, c.*1555
engraving, 30.2 x 22 cm
The Syndics of the Fitzwilliam Museum,
Cambridge (Marlay Fund, 1916)

72 **Jean Duvet** (c.1485–1561)
*The Unicorn purifies the water with its horn, c.*1555
engraving, 22.6 x 39.5 cm
The Syndics of the Fitzwilliam Museum,
Cambridge

73 **Egypt, anon.**
Udjat eye amulets representing
the Eye of Horus
glazed pottery, lengths varying between
1.3-3.3 cm
The Royal Pavilion Art Gallery and Museums,
Brighton

74 **Max Ernst** (1891–1976)
The Evader, 1926
plate 30 from 'Histoire Naturelle' series,
lithograph, 27 x 45 cm
Arts Council Collection

75 **Max Ernst** (1891–1976)
Eve the Only One to Remain Ours, 1926
plate 34 from 'Histoire Naturelle' series,
lithograph, 43 x 26.2 cm
Arts Council Collection

76 **Garry Fabian Miller** (b.1957)
April 7 1993, 1993
light, oil, cibachrome print, 84 x 84 x 4 cm
Collection the artist, courtesy of Michael
Hue-Williams Fine Art Ltd
© the artist 1996

44 **Thomas Burke, after Fuseli** (1749–1815)
The Nightmare, 1783
stipple etching, 30.4 x 37.5 cm
Trustees of the British Museum, London

45 **Luca Cambiaso** (1527–85)
The Assumption of Mary Magdalene
pen and brown ink and red chalk over black
chalk, 27.6 x 18.4 cm
The Syndics of the Fitzwilliam Museum,
Cambridge

46 **Luca Cambiaso** (1527–85)
The Rape of Deianira or Hippodameia
pen and ink, 28.3 x 27.6 cm
The Board of Trustees of the Victoria & Albert
Museum, London

47 **Julia Margaret Cameron** (1815–79)
First Ideas, Portrait of Freddy Gould, c.1864–65
photograph, albumen print from collodion
glass negative, 25.4 x 20 cm
The Board of Trustees of the Victoria & Albert
Museum, London

48 **Julia Margaret Cameron** (1815–79)
My Grandchild, aged 2 years and 3 months,
c.1864–65
photograph, albumen print from collodion
glass negative
The Board of Trustees of the Victoria & Albert
Museum, London

49 **Julia Margaret Cameron** (1815–79)
Portrait of Mary Hillier (1847–1936), c.1867
photograph, carbon print from copy
negative, 35 x 26.7 cm
The Board of Trustees of the Victoria & Albert
Museum, London

50 **Julia Margaret Cameron** (1815–79)
An Angel at the Tomb, Freshwater, 1869
photograph, callotype, 30.3 x 20.8 cm
The Board of Trustees of the Victoria & Albert
Museum, London

51 **Domenico Maria Canuti** (1620–84)
The Martyrdom of St Catherine
red chalk and brown wash, 38.7 x 27.2 cm
The Governing Body, Christ Church, Oxford

52 **Hendrik de Clerck** (1570–1629)
The Adoration of the Shepherds
pen and brown wash, 21.5 x 19.6 cm
The Governing Body, Christ Church, Oxford

53 **Mat Collishaw** (b.1966)
Catching Fairies, 1994
4 hand-tinted black and white photographs,
from a series of 12, 20.3 x 25.4 cm
Private collection

54 **Mat Collishaw** (b.1966)
Ultra-violet Angels, 1996
ultra-violet sensitive ink, paper, steel,
light and fittings, each 35.5 x 25 x 5 cm
Collection the artist
© the artist 1996

55 **Sir Arthur Conan Doyle**
The Coming of the Fairies, 1922
book
University of London Library, Harry Price
Library

56 **Sir Arthur Conan Doyle**
The Fairies and their sun-bath from
The Coming of the Fairies, 1922
photograph of plate E
University of London Library, Harry Price
Library

57 **Studio of Pollard Crowther**
Kuda Bux reading a newspaper blindfolded,
c.1936
photograph, 21 x 15.7 cm
University of London Library, Harry Price
Library
Photograph: B. & N. Microfilm

58 **Richard Dadd** (1817–c.1886)
Christ rescuing St Peter from the waves, 1852
watercolour, 25.4 x 34.9 cm
The Board of Trustees of the Victoria & Albert
Museum, London

59 **Richard Dadd** (1817–c.1886)
Songe de la Fantaisie, 1864
pen, ink, brush and watercolour on card,
38.3 x 31.4 cm
The Syndics of the Fitzwilliam Museum,
Cambridge

60 **Richard Dadd** (1817–c.1886)
Dancing Jester and Imp
pencil and pen, 17.7 x 12.8 cm
National Gallery of Scotland, Edinburgh

28 **William Blake** (1757–1827)
*The Angel of Divine Presence Clothing Adam
and Eve with coats of Skins*, 1803
pencil, grey wash and watercolour,
39.3 x 28.7 cm
The Syndics of the Fitzwilliam Museum,
Cambridge

29 **William Blake** (1757–1827)
Illustrations to *Paradise Regained: Christ
Placed by Satan on the Pinnacle of the Temple*,
c.1816–18
pen, indian ink, grey wash and watercolour,
16.6 x 13.3 cm
The Syndics of the Fitzwilliam Museum,
Cambridge

30 **William Blake** (1757–1827)
Illustrations to *Paradise Regained: Christ
Refusing the Banquet Offered by Satan*,
c.1816–18
pen, indian ink, grey wash and watercolour,
17 x 13.5 cm
The Syndics of the Fitzwilliam Museum,
Cambridge

31 **William Blake** (1757–1827)
Job: Behemoth and Leviathan, 1825
engraving, watercolour and grey wash,
22 x 17 cm
The Syndics of the Fitzwilliam Museum,
Cambridge

32 **William Blake** (1757–1827)
Job's Evil Dreams, 1825
engraving, watercolour and grey wash,
22 x 17 cm
The Syndics of the Fitzwilliam Museum,
Cambridge

33 **William Blake** (1757–1827)
America, A Prophecy
relief etching, pen and watercolour,
heightened with gold, 30.4 x 23.6 cm
The Syndics of the Fitzwilliam Museum,
Cambridge

34 **William Blake** (1757–1827)
Morning Chasing Away the Phantoms
pen, indian ink, grey wash and watercolour,
16.5 x 13 cm
The Syndics of the Fitzwilliam Museum,
Cambridge

35 **William Blake** (1757–1827)
Satan Addressing his Potentates
pen, indian ink, grey wash and watercolour,
17.3 x 13.3 cm
The Syndics of the Fitzwilliam Museum,
Cambridge

36 **Gekkotei Bokusen** (1736–1824)
Immortal Having his Ears Cleaned, c.1815
woodcut printed in colours, 18 x 13.6 cm
The Syndics of the Fitzwilliam Museum,
Cambridge

37 **Gekkotei Bokusen** (1736–1824)
Long-nosed Conjurors with Elephant, c.1815
woodcut printed in colours, 18 x 13.6 cm
The Syndics of the Fitzwilliam Museum,
Cambridge

38 **Boulonnois**
Le Médecin guérissant fantasie (A surgery
where all fantasy and follies are purged
and good qualities are prescribed), 1650/75
engraving, 37.9 x 51.6 cm
Wellcome Institute Library, London

39 **Emmy Bridgewater** (b.1906)
Untitled, 1941
ink, 17.7 x 25.1 cm
Blond Fine Art, London

40 **Pieter Bruegel** (c.1525–69)
The Temptation of St Anthony
pen and indian ink, 21.6 x 32.6 cm
The Visitors of the Ashmolean Museum,
Oxford

41 **After Bruegel**
The Peasant Women Attacking Monsters
pen, brown ink and black chalk, 15.4 x 20.1 cm
The Visitors of the Ashmolean Museum,
Oxford

42 **Christopher Bucklow** (b.1957)
Guest – 3 pm, 22nd September 1995, 1995
from 'Guest' series, 25,000 solar images,
unique cibachrome photograph, 101.6 x 76.2
cm
Private collection
© the artist 1996

43 **Christopher Bucklow** (b.1957)
Sol Invictus, 3.41 pm, 22nd December 1994, 1994
1,000 solar images, unique cibachrome
photograph, 27.2 x 27.6 cm
Private collection

12 **Anon.**
Giusta misura dei Piedi (Foot measurement of the Virgin, taken from her shoe said to be preserved in a convent in Spain)
woodcut with letterpress, 6.4 x 18.6 cm
Wellcome Institute Library, London

13 **Anon.**
Jesus inside heart
cut-out on pink paper, 11 x 8.6 cm
Wellcome Institute Library, London

14 **Anon.**
Nuestra Señora de los Desamparados (The Virgin interceding for those in despair), C20
chromolithograph, 26.2 x 19.2 cm
Wellcome Institute Library, London

15 **Anon.**
Rapping hand, *c.*1880–1900
life-size wooden model of female hand with velvet cuff
University of London Library, Harry Price Library
Photograph: B. & N. Microfilm

16 **Anon.**
Speaking trumpet, through which spirits could communicate, *c.*1920s
metal, height 37 cm
University of London Library, Harry Price Library

17 **Anon.**
Witch with magical signs on skirt
woodcut, 8.4 x 6.2 cm
Dancing in a fairy ring
woodcut, 6.6 x 8.4 cm
Wizard with monster birds
woodcut, 7.7 x 7.1 cm
Wellcome Institute Library, London

18 **Anon.**
Wizard with devil
woodcut, 7 x 7.2 cm
The devil reaping
woodcut, 7.2 x 12.6 cm
Time is, Time was, Time past
woodcut, 6.5 x 5.5 cm
Wellcome Institute Library, London

19 **Hans Baldung Grien** (1484/5–1545)
Witches' Sabbath
chiaroscuro woodcut, 37.4 x 25.4 cm
Trustees of the British Museum, London

20 **Monika Beisner** (b.1942)
Inferno, canto XVII. Geryon, the usurers, 1992
egg tempera, 10 x 15 cm
Collection the artist

21 **Monika Beisner** (b.1942)
Inferno, canto XI. The structure of Hell explained, 1993
egg tempera, 10 x 15 cm
Collection the artist

22 **Monika Beisner** (b.1942)
Inferno, canto XXXIII. Ugolino, the traitors, 1994
egg tempera, 10 x 15 cm
Collection the artist

23 **Monika Beisner** (b.1942)
Purgatorio, canto II. The angel pilot, 1995
egg tempera, 10 x 15 cm
Collection the artist
© the artist 1996

24 **Attributed to Jacques de Bellange**
(active 1600–17)
Madonna and Child, with St James the Great, Quenching the Fires of Hell, *c.*1600–10
pen and brown ink with brown, yellow and mauve washes on blue paper, 55.1 x 41.6 cm
National Gallery of Scotland, Edinburgh

25 **Jacopo Zanguidi, called Bertoia** (?) (1544–74)
The Rape of Proserpine, with Ceres Seeking her in her Chariot Drawn by two Dragons, Carrying Torches lit in the Flames of Mount Etna
pen and grey wash over black chalk, heightened with white bodycolour on blue paper, 19.2 x 40.1 cm
The Governing Body, Christ Church, Oxford

26 **Catherine Blake** (1762–1831)
Portrait of the Young William Blake in a Dream, *c.*1827–31
pencil, 15.5 x 10.4 cm
The Syndics of the Fitzwilliam Museum, Cambridge

27 **William Blake** (1757–1827)
Europe, A Prophecy, 1794
relief etching, pen and watercolour, heightened with gold, 30.4 x 23.6 cm
The Syndics of the Fitzwilliam Museum, Cambridge

LIST OF WORKS

Works are on paper, unless stated otherwise

1 **Denise Allison** or **Clifford Scullion**
Satanic cloud above the Statue of Liberty, 1989
photograph, 10 x 15.2 cm
Private collection

2 **Anon.**
*Abomination des sorciers, c.*1613
Harry Price's bookplate based on Jasper
Isac, engraving
University of London Library, Harry Price
Library

3 **Anon.**
*L'Archidoxe magique de Paracelse, divisée
en sept livres,* third section, Paris, 1733
modern half-calf binding, illustrated with
coloured pen-drawn magical figures,
23.5 x 17.5 x 1.2 cm
Wellcome Institute Library, London

4 **Anon.**
*La Clavicule de Salomon Roy des Hébreux
traduite de L'Hébreux en Italien par Abraham
Colorno par ordre de S.A.S. de Mantoue, mise
nouvellement en françois,* mid-C18
original calf binding, illustrated with
coloured pen-drawn figures of pentacles,
sigils, etc., 23.5 x 18 x 3.5 cm
Wellcome Institute Library, London

5 **Anon.**
*Magia de profundis seu Clavicule Salomonis
regis Lib. IV (The key of Solomon the King, or,
a complete system of profound magical
science), c.*1835
half-vellum binding, 24 x 19 x 1.2 cm
Wellcome Institute Library, London

6 **Anon.**
Cold Water Trick!!, 1843
theatre bill, Royal Liver Theatre, Liverpool,
56.9 x 22.3 cm
University of London Library, Harry Price
Library

7 **Anon.**
'Margery' Crandon producing teleplasmic
mass from her nostrils, *c.*1925
three black and white stereoscopic prints,
11.7 x 16 cm, 11.8 x 8 cm, 11.7 x 8 cm
University of London Library, Harry Price
Library
Photograph: B. & N. Microfilm

8 **Anon.**
'Margery' Crandon with trumpet, described
on verso as 'Walter's independent voice
apparatus', *c.*1925
stereoscopic print, 7.8 x 15.3 cm
University of London Library, Harry Price
Library

9 **Anon.**
Helen Duncan with 'Peggy', *c.*1931
photograph, 21.5 x 16.8 cm
University of London Library, Harry Price
Library

10 **Anon.**
'Teleplasm' from Helen Duncan, showing at
a magnification of x 70
A: the paper 'teleplasm' secured from Helen
Duncan on 4 June 1931
B: control mixture of 60% chemical and 40%
mechanical wood pulp. A sample of
'teleplasm' is attached to the bottom
of the card
photomicrographs, 14.4 x 21.8 cm
University of London Library, Harry Price
Library

11 **Anon.**
Farewell Tour!, 23 February 1879
theatre bill for performance of Ira E.
Davenport, one of the Davenport brothers,
conjurers and mediums, 58.3 x 23.6 cm
University of London Library, Harry Price
Library

Ringbom, Sixten, 'The Sounding Cosmos:
A Study in the Spiritualism of Kandinsky
and the Genesis of Abstract Painting', *Acta
Academiae Abiensis*, series A, vol. 38, no. 2,
Åbo, 1970

Roberts, Gareth, *The Mirror of Alchemy:
Alchemical Ideas and Images in Manuscripts
and Books from Antiquity to the Seventeenth
Century*, London, 1994

Ruskin, John, *Modern Painters*, III, London,
1898

– *The Stones of Venice*, III, London, 1851–53

Sass, Louis, *Madness and Modernism: Insanity in
the Light of Modern Art, Literature and Thought*,
Cambridge, Mass., 1992

Serres, Michel, La Légende des anges, Paris, 1993

Sheldrake, Rupert, *Seven Experiments That
Could Change the World: A Do-It-Yourself Guide
to Revolutionary Science*, London, 1994

Signs and Wonders, ed. Bice Curiger, Zurich
and Santiago, 1995

Silouan, Staretz: Gillian Rose, *Love's Work*,
London, 1995

The Spiritual in Art: Abstract Painting 1890–1985,
Los Angeles Museum of Art, 1986

Stafford, Barbara Maria, *Body Criticism: Imaging
the Unseen in Enlightenment Art and Medicine*,
Cambridge, Mass., 1993

Steiner, Rudolf, *The Anthroposophic Movement*,
trans. Christian von Arnim, Bristol, 1993

Stevens, Anthony, *Private Myths: Dreams and
Dreaming*, London, 1995

Stevens, Wallace, *Opus Posthumous*, ed. S.F.
Morse, New York, 1957

Stoichita, Victor I., *Visionary Experience in the
Golden Age of Spanish Art*, London, 1995

Stoker, Bram, *Dracula*, London, 1897

Stonor Saunders, Frances, *Hidden Hands: A
Different History of Modernism*, London, 1995

Teresa of Avila: *The Life of Teresa of Avila*, trans.
J.M. Cohen, London, 1957

Thompson, E.P., *Witness against the Beast:
William Blake and the Moral Law*, New York,
1993

Tuchman, Maurice, and Eliel, Carol S., eds.,
*Parallel Visions: Modern Artists and Outsider
Art*, Princeton, 1992

Vitebsky, Piers, *The Shaman Voyages of the Soul:
Trance, Ecstasy and Healing from Siberia to the
Amazon*, London, 1995

Walker, Barbara G., *The Woman's Encyclopaedia
of Myths and Secrets*, London, 1983

Warner, Marina, *Monuments & Maidens: The
Allegory of the Female Form*, London, 1985

– *From the Beast to the Blonde: On Fairytales and
Their Tellers*, London, 1994

Washington, Peter, *Madame Blavatsky's Baboon:
A History of the Mystics, Mediums and Misfits
who Brought Spritualism to America*, New York,
1995

Yeats, W.B., 'Swedenborg: Mediums and the
Desolate Places', in *Visions and Beliefs in the
West of Ireland*, ed. Lady Gregory (1920),
London, 1970

Zegher, Catherine De, *Inside the Visible: An
Elliptical Traverse of 20th-Century Art: in, of,
and from the feminine*, Cambridge, Mass., 1996

Douglas, Alfred, *The Tarot: The Origins, Meaning and Uses of the Cards*, Harmondsworth, 1972

Duchet-Suchaux, G. and Pastoureau, Michel, *The Bible and the Saints*, trans. David Radzinovicz Howell, Paris, 1994

Duffy, Maureen, *The Erotic World of Faery*, London, 1989

Dürer, Albrecht: Ernst Gombrich, *The Sense of Order*, London, 1979

Eliade, Mircea, *Images and Symbols: Studies in Religious Symbolism*, trans. Philippe Mairet, New York, 1969

Enright, D.J., ed., *The Oxford Book of the Supernatural*, Oxford, 1995

Ernst, Max, *Au-delà de la peinture* (1925), Paris, 1937, quoted Patrick Waldberg, *Surrealism*, London, 1965

Faraday, Michael: Lawrence Weschler, *Mr Wilson's Cabinet of Wonders*, New York, 1995

Feynman, Richard: Andrew Robinson, 'Science's Inner Frontier', *Times Higher Education Supplement*, 5 April 1995

Friedrich: John Leighton and Colin J. Bailey, *Caspar David Friedrich: Winter Landscape*, London, 1990

Godwin, Joscelyn, *Athanasius Kircher: A Renaissance Man and the Quest for Lost Knowledge*, London, 1979

Goya, Francisco José de, *Truth and Fantasy: The Small Paintings*, London, 1994

Gregory, Richard L., ed., *The Oxford Companion to the Mind*, Oxford, 1988

Hart, Clive, *Images of Flight*, Berkeley, 1988

Henkel, Kathryn, *The Apocalypse*, Baltimore, 1973

Hildegard of Bingen: Peter Dronke, *Women Writers of the Middle Ages*, Cambridge, 1984; *Poetic Individuality in the Middle Ages: New Departures in Poetry 1000–1150*, London, 1986

Hiller, Susan and Coxhead, David, *Dreams: Visions of the Night*, London, 1976

Holmes, Richard, *Coleridge: Early Visions*, London, 1989

Homer, *The Odyssey*, Book XII, trans. E.V. Rieu, Harmondsworth, 1946

Hume, David, 'On Miracles', in *An Enquiry Concerning Human Understanding*, London, 1758

Identity and Alterity: Figures of the Body 1895–96, Venice, 1995

Kandinsky, Vladimir, *Concerning the Spiritual in Art* (1914), trans. M.T.H. Sadler, New York, 1977

Keats, John, 'Otho the Great', in *Keats: The Poetical Works*, ed. H.W. Garrod, Oxford, 1966

Kenton, Warren, *Astrology: The Celestial Mirror*, London, 1974

Kirk, Robert, *The Secret Commonwealth*, ed. Stewart Sanderson, Cambridge, 1976

Klee, Paul, *Notebooks*: I, *The Thinking Eye*, trans. Ralph Manheim, London, 1961; II, *The Nature of Nature*, trans. Heinz Nordern, London, 1973
– *On Modern Art* (1924), London, 1989

Lawlor, Robert, *Sacred Geometry: Philosophy and Practice*, London, 1990

Leadbeater, C.W., *Man Visible and Invisible: Examples of Different Types of Men as Seen by Means of Trained Clairvoyance*, Wheaton, Illinois, 1987

Lewis, I.M., *Ecstatic Religion: An Anthropological Study of Spirit Possession and Shamanism*, Harmondsworth, 1971

Link, Luther, *The Devil: A Mask without a Face*, London, 1995

Merleau-Ponty, Maurice, 'Notes de travail', in *Le Visible et l'invisible*, Paris, 1964; *The Visible and the Invisible, Followed by Working Notes*, trans. Alphonso Lingis, Evanston, 1968

Montgomerie, Robert, 'Montgomeries Answer to Polwart', in *Longer Scottish Poems*, I, 1375–1650, eds. Priscilla Bawcutt and Felicity Riddy, Edinburgh, 1987. Jacqueline Simpson brought this splendid, diabolical invective to my attention, and I thank her

Newman, William R., *Gehennical Fire: The Lives of George Starkey, an American Alchemist in the Scientific Revolution*, Cambridge, Mass., 1995

Opie, Iona and Peter, eds., *The Oxford Book of Nursery Rhymes*, Oxford, 1977

Packer, Alison, Beddoe, Stella, and Jarrett, Lianne, *Fairies in Legend*, London, 1980

Paley, Morton, *The Apocalyptic Sublime*, New Haven, 1986

Redon: *Odilon Redon 1840–1916*, London, 1995

Rilke, Rainer Maria, Letter to Witold von Hulewicz, *Selected Letters 1902–26*, trans. R.F.C. Hull, London, 1988

SELECT BIBLIOGRAPHY

Ackroyd, Peter, *William Blake*, London, 1995

Allderidge, Patricia, *The Late Richard Dadd 1817–86*, London, 1974–75

L'Âme au Corps: Arts et sciences 1793–1993, ed. Jean Clair, Paris, 1993

Aristotle, *Metaphysics*, I, trans. Hugh Tredennick, London, 1933

Barlow, Fred, *A Collection of Psychic Photos*, ed. E.J. Dingwall, *c*. 1930. The British Library has stored these on CD ROM as a pioneer PIX project

Barrow, Logie, *Independent Spirits: Spiritualism and English Plebeians 1850–1910*, London, 1986

Benjamin, Walter, 'Theses on the Philosophy of History', in *Illuminations: Essays and Reflections*, trans. Harry Zohn, New York, 1969

Bergson, Henri, *Dreams*, trans. Edwin E. Slosson, London, 1914

Berlin, Isaiah, *Against the Current: Essays in the History of Ideas*, ed. Henry Hardie, Oxford, 1979

Beuys, Joseph: Caroline Tisdall, 'Of Fat, Honey and the Rest' (1974), in Caroline Tisdall, *Grist to the Mill: Selected Writing 1970–1995*, London, 1996

Binski, Paul, *Medieval Death: Ritual and Representation*, London, 1996

Blake, William, *The Poetry and Prose of William Blake*, ed. David Erdman, New York, 1965

– *The Marriage of Heaven and Hell*, Oxford, 1975

Bompiani, Ginevra, 'The Chimera Herself', in *Fragments for a History of the Human Body*, I, eds. Michel Feher, Ramona Nadaff and Nadia Tazi, New York, 1989

Borges, Jorge Luis, with Marguerita Guerrero, *The Book of Imaginary Beings*, ed. Norman Thomas di Giovanni, Harmondsworth, 1980

Brandon, Ruth, *The Spiritualists: The Passion for the Occult in the Nineteenth and Twentieth Centuries*, New York, 1983

Bull, Malcolm, ed., *Apocalypse Theory and the Ends of the World*, Oxford, 1995

Burke, William, *A Philosophical Enquiry into the Origin of Our Ideas of the Sublime and the Beautiful*, ed. Adam Phillips, Oxford, 1990

Calvino, Italo, *Invisible Cities*, trans. William Weaver, London, 1974

Cameron, Julia Margaret, *Annals of My Glass House*, London, 1874

Carroll, Lewis, *Sylvie and Bruno*, London, 1893

Carter, Angela, 'Come unto these Yellow Sands', in *The Curious Room*, London, 1996

Certeau, Michel de, *The Mystic Fable*, I, trans. Michael B. Smith, Chicago, 1992

Christian, William, Jr, *Visionaries*, New York, 1996

Coleridge: *Miscellanies, Aesthetic and Literary, of Samuel Taylor Coleridge*, ed. G. Ashe, London, 1885

– *The Complete Poetical Works of Samuel Taylor Coleridge*, ed. E.H. Coleridge, 2 vols, Oxford, 1912

– *Collected Letters of S.T. Coleridge*, I, ed. E.L. Griggs, Oxford, 1956–71

– *Biographia Literaria*, ed. J. Shawcross, 2 vols, Oxford, 1970

Collins, Marcia, *The Dance of Death in Book Illustration*, Columbia, Missouri, 1978

Corlett, Alf, *Art of the Invisible*, Bede Gallery, Jarrow, 1977

Dante Alighieri, *Convivio*, trans. Richard H. Lansing, London, 1990

– *The Divine Comedy*, 3 vols, trans. John D. Sinclair, London, 1958

Debroise, Olivier, Sussman, Elisabeth, and Teitelbaum, Matthew, *El Corazón Sangrante/The Bleeding Heart*, Boston, 1991

Descartes, René, *La Dioptrique*, in *Oeuvres philosophiques*, I, ed. F. Alquié, Paris, 1963

A Circle for raising the Spirit Oberion

the Holy Shroud, or Sudarium (Veronica's name means 'vera icon', true image).

vision Sight of something not of this world: a spectacle that is not of the body though it appears to the visionary as vividly as if it were embodied; often very bright and blissful: 'Truly I saw the visions I saw'; 'Watchful I received them, looking around with a pure mind and the eyes and ears of the inner person ...' wrote Hildegard of Bingen. 'The brightness and the light that appear before the gaze are so different from those of earth that the sun's rays seem quite dim in comparison ... It is as if we were to look at a very clear stream running over a crystal bed, in which the sun was reflected, and then to turn to a very muddy brook, with an earthy bottom running beneath a clouded sky' (Teresa of Avila).
FUSS; GHISI; HERMES; NEAPOLITAN, ANON.

wand Wizard's and enchantress's equipment; Circe uses an early example to turn the companions of Odysseus into swine.
QUAY BROTHERS

wings Most familiar signifier for immateriality, for bodies that are not subject to the laws of the here and now, but which can communicate between worlds. Heavenly creatures tend to birds' wings (Caravaggio seems to have studied a pigeon for his musical angel in *Rest on the Flight into Egypt*); fairies often wear butterfly or dragonfly wings; devils fly on the leathery webbed pinions of bats, as do dragons. See bat, feather, angel.
REMBRANDT; PALMA (IL GIOVANE)

witch One of the many things witches do is steal men's penises, and hide them in a nest up a tree and hand them back only in return for favours (Robert Montgomerie, C17); they also fly to sabbaths where they worship the Devil. Walpurgisnacht, formerly the eve of May Day, was the witches' special night out in German folklore. Current covens practise theurgy.
ANON., *Abomination des Sorciers*; BALDUNG GRIEN; FUSELI; LEONARDO; MOLITOR; ROMNEY; VENEZIANO

wonder 'The lover of myth is in a sense a lover of Wisdom, for myth is composed of wonders' (Aristotle); 'Nothing is too wonderful to be true' (Michael Faraday).

Zodiac From Greek for 'animal circle': in astronomy, since Babylonian times denotes the band of the sky in which, from the vantage point of the earth, the planets, sun and moon seem to move; also the twelve constellations of the sun's yearly cycle; in astrology, the heavenly system governing destiny.

113 **Italy, Naples, anon.**
*The Lord appearing to Moses on Mount Sinai, c.*1700

udjat eye or wedjat eye Amulet from ancient Egypt; the emblematised eye of the cobra goddess.

unconscious, the In Freud's geography of the psyche, the deep foundation of the person, the place from which dreams issue, the well-spring of desires, the raw material of artistic expression, the source of slips and other self-revealing behaviours, the part of the mind that forms perceptions and conduct in an undisclosed, invisible fashion, which vary from individual to individual and are formed in early infancy. This theory has been largely set aside in recent thinking about the mind's 'unconscious' processing of experience, i.e. when it is not aware that it is doing this, either in sleep or waking.

visualisations of states of mind revealed by clairvoyance; highly influential on development of abstraction.
LEADBEATER

theurgy White magic; like goety, a useful, neglected word.

trance An other state of mind; many kinds and degrees are known, from the lover's enthralment to narcolepsy; congruous with a bewildering range of activities – sleep-walking, convulsions, mystical visions – and induced in a variety of ways: by the beauty of the beloved, drugs, drumming, dancing, a soothing voicer repeating a phrase, the swinging of a pendulum.
ROSSETTI

triton Merman, fish-tailed dweller of the deep; sportive with mermaids.
KULMBACH; REDON

troll Giant from Scandinavia, shares numskull character of his southern cousin, the ogre; often hairy, sometimes has two or three heads; more lately (C19) shrunk to imp and goblin dimensions.
DOYLE

unicorn Creature can only be caught by a virgin, who lures him by her fragrance to put his head in her lap; this method of capture became a medieval allegory for the Church's seduction of the redeemer; horn has power to purify foul water and detect poisons and, some say, to arouse love.
DUVET; *Narwhal tusk*

vernicle Cloth which miraculously received the imprint of Jesus's face in blood, sweat and tears after Veronica used it to relieve his sufferings on the road to Calvary; an early photograph of a sort, just predating

57 Studio of Pollard Crowther
Kuda Bux reading a newspaper blindfolded, *c.*1936

sublime, the Spectacles and experiences that excite terror and power: 'No passion so effectually robs the mind of all its powers of acting and reasoning as fear. For fear being an apprehension of pain or death, it operates in a manner that resembles actual pain. Whatever therefore is terrible, with regard to sight, is sublime, too ... ' (William Burke).

sulphur Brimstone; characteristic bad smell of hell; gives off yellow smoke.

Swedenborg, Emmanuel (1688–1772) Philosopher, mystic, born in Sweden, died in London. Blake, Baudelaire, Rimbaud, Yeats were among the many imaginations lit up by his cloudy vision of the mysterious, hidden universal order, though Blake subsequently rebelled furiously. 'It was indeed Swedenborg who affirmed for the modern world, as against the abstract reasoning of the learned, the doctrine and practice of the desolate places ... and discovered a world of sprits where there was a scenery like that of the earth, human forms, grotesque or beautiful, senses that knew pleasure and pain, marriage and war, all that could be painted upon canvas, or put into stories to make one's hair stand up' (Yeats, 1914).

synaesthesia 'The sound of colours is so definite that it would be hard to find anyone who would try to express bright yellow in the bass notes, or dark lake in the treble ... Generally speaking, colour is a power which directly influences the soul. Colour is the keyboard, the eyes are the hammers, the soul is the piano with many strings ... The artist is the hand which plays, touching one key or another, to cause vibrations in the soul' (Kandinsky, 1914).

tail Catch a glimpse of one swishing under the hem of a skirt, or a jacket: Old Nick is about.
SCHONGAUER

Tam O'Shanter Hero of Robert Burns's poem (1791), stumbles on a wild party of witches and warlocks; they spot him, he flees, but one young witch catches hold of his mare Meg; Tam escapes, leaving his mare's tail in the witch's clutches.
DELACROIX

Tarot Origin and meaning of word unknown; *tarocchi* cards for games appeared in Italy C14; twenty-two major arcana or trumps used for fortune-telling in C18; then plundered for imagery and literary form (T.S. Eliot, *The Waste Land*; Calvino, *The Castle of Crossed Destinies*).
MINETTA, *What the cards tell*

tele- Prefix from Greek for 'afar', much used for neologisms in occult studies, as in 'tele-kinesis', moving objects by mental projection, and 'tele-pathy', mind-reading and mind-projection; conjurors and thought-readers working as entertainers have many very clever, ancient trade secrets. Scientific attempts to analyse how messages might be communicated 'ethereally', continue with sometimes startling results.

Theosophy Founded by Madame Blavatsky (1831–91), author of the massive *The Secret Doctrine* (1888), which was an important force in the diffusion of Indian mysticism. Among later adepts, Annie Besant (1847–1933) and C.W. Leadbeater (1854–1934) strongly influenced Kandinsky, Klee, and Mondrian with

relic Bodily remains of holy person, or almost any stuff which belonged to or once had contact with the saint; principally used by Catholics, and often mocked, on account of there being, for example two heads of John the Baptist on earth, one from when he was young, the other from his death. But the practice meets the human need for contact with lost loved ones and 'the very special dead' through mementoes, keepsakes.

Road to Damascus, the Scene of Saul's vision (Acts 9:3–9); his conversion from a hammer of Christians into Saint Paul, the Apostle of the Gentiles; hence proverbial phrase for seeing the light.

-scopy Suffix signifying 'looking into', as in metoposcopy, fortune-telling by reading lines on face and forehead.

Scot, Reginald A good man, and a merciful one; was not listened to enough when he spoke up against the persecution of innocent old women (and others) in his book, *The Discoverie of Witchcraft* (1584).

shaman Word imported from Siberia, adopted to describe magicians who work as priests and healers, with spirit helpers in animal form; they undergo terrifying ordeals perceived as out-of-the body experiences and states of possession; found today practising alongside the major religions rather than within them, as in Haiti or parts of Latin America; many recent artists of Utopian inspiration and anthropologist leanings, like Joseph Beuys, have reinterpreted the function of contemporary art in the light of the shamanistic enterprise.

shoe Intimate trace of the wearer; ambidextrous sexual symbol; also symbolic of pilgrimage.

'signs and wonders' Recurring phrase, used by classical authors as well as in the Bible, for a show of divine anger – or providence; e.g. 'The sun shall be turned into darkness/ and the moon into blood (Acts 2:20). Two prime difficulties about them persist: a) ascertaining that the devil isn't up to his tricks; b) interpreting what they mean.

Solomon Wisest of kings, his name was routinely invoked to validate a series of grimoires and cabbala, as in *The Keys of Solomon*, from the Middle Ages through to the present.

-sophy Suffix, from the Greek *sophia*, 'wisdom', used to coin scientific compounds for mystical and metaphysical systems, as in Theosophy.

spiritualism Mid-C19 term, coined in the interests of achieving respectability for the ancient necromantic practice of raising the spirits of the dead in order to speak to them – as Odysseus did with Circe's help when he descended into Hades and consulted Tiresias about his future (*Odyssey*, Book XI).

spirit photograph Image produced by chance or magic – or miracle: Jesus's face in the snow, the Virgin Mary's in the sky; 'extras' or visitors from the other side, obtained by mediums.
CONAN DOYLE, *Coming of the Fairies*, *Fairies' Sun Bath*; ALLISON, *Satanic cloud*

stigmata Marks of Christ's wounds appeared on the body of Saint Francis of Assisi (1181– 1226) as he prayed; many men and women have since claimed similar proof of their intense, mystical sympathy with the Passion.
PALMA (IL GIOVANE)

parousia The final fulfilment, the Second Coming, as promised by the visions of Saint John.
DUVET

pentacle Five-pointed star, can be drawn in a continuous line; used for spells and as an amulet

phantasy From Greek for 'making visible'; spelt with 'ph', mere 'fantasy' turns into a yet more powerful faculty; for Plato a source of illusion, for the Romantics the seat of empathy and creativity.

pleroma Bliss of fullness at the end of time (if one has been sorted to the side of the lambs in the Christian Judgement Day).

prayer Combining repetition, incantation, meditation, in practices like the rosary and the Stations of the Cross; well-tried method of passing through to the inner world, 'on a wing and a prayer'.

Price, Harry (1881–1948) Conjuror, psychic, ghost-buster, charlatan, self-publicist, creator of the National Laboratory of Psychical Research in 1922 and bibliophile; his remarkable library of the occult now kept in Senate House, University of London.

psyche 'Soul' in Greek, now naturalised as secular substitute by the English translations of Freud; idea of an irreducible self, conscious and unconscious, whose point of view informs the subject's thought and perception even when s/he is unconscious. Many experiments called 'psychic' challenge this position, contest the boundaries of the individual and attempt to widen his/her mental powers.

Quattro Coronati Saints Severus, Severianus, Carpophorus, Vittorinus, C3, martyred after they refused to worship the Roman God of Health, Aesculapius.

Queen Mab 'She is the fairies' midwife ... she gallops night by night/Through lovers' brains, and then they dream of love' (*Romeo and Juliet*).

rapping Signal spirits give in seances to show that they have come, as bidden. Fame of the 'Rochester Rappings' and the Fox sisters, New York State, 1844–55 spread quickly and widely; European spiritualist enthusiasm lasted well into this century.

rapture From Latin for 'seize', same root as in rape or ravishment; the state of being completely carried away, by intense prayer, vision or other miracle (see also ecstasy).

Redon, Odilon (1840–1916) Painter, printmaker, important force in Symbolism; through dream imagery fashioned personal and religious language of symbols: 'All my originality consists ... of making improbable beings come to life humanly according to the laws of the probable, putting, as far as possible, the logic of the visible at the service of the invisible.'
Temptation of Saint Antony

15 **Anon.**
Rapping hand, *c.*1880–1900

Outsider Art English gloss on 'Art Brut', the name given by Jean Dubuffet in the late 1940s to the 'raw' work of self-taught artists who do not belong to the official art world; who might also be excluded from society at a larger level, through a history of mental disturbance or eccentric obsessiveness.
LONNÉ; MURRY; NEDJAR; POTTER; UDDIN; VERBENA; ZEMANKOVA

Ovid (43BC–AD17) Poet; few books have been as influential as on visual poetics as his *Metamorphoses*.
CAMBIASO, *Rape*; KLINGER, *Rescues*

Palmer, Samuel (1805–81) Mystical painter; transfigured ordinary English countryside by intensity of his vision.
Figures in a Garden

paradise From the Arabic word for a walled garden; sometimes 'the Earthly Paradise'. Placed by Dante at the summit of the Mountain of Purgatory.
FUSELI, *Two Figures*; PALMER

vii **Samuel Palmer**
Harvest Moon

[70]

millenarianism Collective feeling, recurring
in popular movements, that something
important (the Coming of Christ's
Kingdom) must be going to occur at the
close of a century or a thousand year cycle;
that mass destruction will be followed by
regeneration and salvation for the happy
few who understood the hidden signific-
ance in time. It's perhaps worth noting
that according to the Islamic calendar,
dated from the Hegira (AD622), the year
2000 will be, less dramatically, 1378.
BLAKE, *Europe*, *America*; DUVET; MARTIN

miracle 'It is belief in miracles that is the
miracle' (David Hume, 1758).
DADD

mirror, magic Used in prophecy, divination
(catopromancy), and conjuring; in medieval
mysticism, the radiance of the face of
God is so intense it can only be received in
the burnished glass of the soul.
LEONARDO

monster Perhaps more various than angels;
the Unicorn in *Through the Looking Glass*
comments: 'I always thought [children]
were fabulous monsters!'; Alice is highly
indignant to hear this from a unicorn.
Eventually, they call a truce: 'Well, now
that we *have* seen each other,' said the
Unicorn, 'if you'll believe in me, I'll
believe in you.'
AFTER BRUEGEL; BRUEGEL; BURKE; DANCE,
Man Pursued; DESPREZ; DOYLE; DUVET;
DE GHEYN II; GHISI; GOYA, *Hobgoblins*;
KUBIN, *Suicide*

mouth Gaping, fanged orifices, in places
other than the face, signal danger: from
Hellsmouth, for example (see Leviathan),
and the tempter.

New Age After the Age of Servitude which
ended with the birth of Christ, and the
Age of Faith and Filial Obedience
(when the New Testament and apostolic
succession ruled), the New Age would
come, of Spiritual Liberty for the Children
of God: so prophesied Joachim of Fiore,
a C13 visionary monk much taken up in
the C17 and C18.

nightmare Ephialtes and Incubus were
gods of the nightmare, who sat on your
chest as you slept and squeezed the breath
out of you; Christian demonology
associated this activity with witches,
especially female ones.
FUSELI

occult Latin for hidden; used of beliefs,
epistemologies, systems that are premised
on the existence of an invisible reality
that obeys its own rules and exercises
significant power over apprehensible and
material phenomena.

Ouija board From the French *oui* and
German *ja*, a talking board or planchette
on which spirits spell out messages in
seances.

Ourobouros The serpent that eats its own
tail; hence a circle with no beginning and
no end, a symbol of eternity.

61 **George Dance**
Man pursued by Monsters

-mancy Suffix which denotes divination, as in bibliomancy (consulting pages of a book at random); catopromancy (scrying a mirror); chiromancy (palm-reading); coracamancy (decoding the cawing of ravens and crows); geomancy (decipherment of the landscape, intimacy with *feng shui*, or spirits of land and water); metopomancy (reading lines of face and forehead); oneiromancy (interpretation of dreams); etc. From the sorceress Manto, daughter of the prophet Tiresias. Fortune-telling can be (and has been) done with many other arrangements, such as raw egg whirled in water; coffee grounds or tea leaves at the bottom of a cup.
LEONARDO; MARLET; '*Le Sorcier de Tivoli*'; ROWLANDSON; THURSTON; *Dreams come True!*; WILLIAMS

mandrake The plant mandragora, with a bifurcated root resembling man; very tough to pick; said to shriek when pulled out of the ground; used in magic rites and narcotic potions. 'Go and catch a falling star/Get with child a mandrake root/Tell me where all past years are/Or who cleft the devil's foot' (John Donne).

Martin, John (1789–1854) Apocalyptic painter and engraver of themes from the Bible and myth; spectacular chiaroscuro effects for the vertiginous void and divine thunderbolts.
Egyptians Drowning, Face of God, Rebellion of Korah

mermaids and **mermen** Fish-tailed ocean-dwellers, identified with sirens since C15; lure humans by song, sometimes living with them for a while, often abandoning them heartlessly. Homer's had 'foreknowledge of all that is to come' (*Odyssey*, Book XII).
KULMBACH

Mesmer, Franz (1734–1815) Advocate of 'animal magnetism', the theory that invisible fluids transmitted messages between bodies, so regulating their mutual balance could cure certain disorders; 'mesmerism' caught on, inspiring mass trances (especially among women) in the best drawing-rooms; a commission of inquiry in 1784 found against the existence of animal magnetism, but admitted therapeutic benefits had occurred.

metamorphosis Shape-shifting; a characteristic of dwellers in fantasy worlds, and an effect of magic, sometimes dire, sometimes benign; witches like Circe have the 'baneful' wisdom to change men's shapes; thus, in Christian imagery, often a sign of diabolical or heathen activity: hell's punishments metamorphose sinners' bodies through the devils' food chain, whereas in heaven, the elect will be reunited with their unique, entire, unchanged individual body.

milk 'There I'll kiss/The bowl of bliss,/And drink my eternal fill/On every milken hill' (Walter Raleigh); heaven is a land flowing with milk and honey, as Coleridge also said of Xanadu ('For he on honey dew hath fed/And drunk the milk of paradise'); the Virgin squeezed three drops from her breasts on to Saint Bernard's lips in a vision; conversely, Ganesha, the elephant-headed god of good fortune, became an insatiable milk-drinker all over the world in 1995.

86 **Jacques de Gheyn II**
A Witches' Sabbath, c.1583–84

42 **Christopher Bucklow**
Guest – 3 pm, 22nd September 1995, 1995

116 **Italy, Rome, anon.**
Man stabbing a woman with a stiletto, late C19
118 **Italy, Rome, anon.**
Woman being rescued, *c.*1850

176 **Rembrandt**
The Angel Preventing Abraham from
*Sacrificing his Son, Isaac, c.*1634–35

40 **Pieter Bruegel**
The Temptation of St Anthony

Can any understnd the spreadings of the Clouds
the noise of his Tabernacle

15

Also by watering he wearieth the thick cloud by his counsels
He scattereth the bright cloud also it is turned about

Of Behemoth he saith. He is the chief of the ways of God
Of Leviathan he saith. He is King over all the Children of Pride

Behold now Behemoth, which I made with thee

W Blake invenit & sculpsit

London Published as the Act directs March 8. 1825 by Will Blake N.3 Fountain Court Strand

Proof

19 **Hans Baldung Grien**
Witches' Sabbath

168 **Persia, anon**.
A Kylin being devoured by a dragon, mid-C17

36 Gekkotei Bokusen
Immortal Having his Ears Cleaned, c.1815

59 **Richard Dadd**
Songe de la Fantaisie, 1864

153 **Henri Michaux**
Tusch Mescalin, 1957

49 **Julia Margaret Cameron**
Portrait of Mary Hillier (1847–1936), c.1867

76 **Garry Fabian Miller**
April 7 1993, 1993

190 **Anon.**
Le Diable tarot card, C18

105 **Susan Hiller**
Sophia/wisdom, 1993

23 **Monika Beisner**
Purgatorio, canto II. The angel pilot, 1995

gives birth to a system of symbols, harmonious in themselves and consubstantial with the truths of which they are the conductors' (Coleridge); 'The imagination wishes to be indulged' (Wallace Stevens).

invisible, the Beyond the sight of the body, the realm of unseen phenomena: 'We are bees of the invisible. We madly gather the honey of the visible to store it in the great golden hive of the invisible' (Rilke); 'The invisible is what is not actually visible, but could be ... ' (Merleau-Ponty, 1964).

Kandinsky, Wassily (1866–1944) Russian artist, innovatory thinker and pioneer of symbolic abstraction; developed Swedenborgian ideas about the hidden internal relationships between the senses into a full visual theory (synaesthesia).
Abstrakte Komposition K22; LEADBEATER

Klee, Paul (1879–1940) Wrote manifesto for the art of the inner eye, in his 1924 lecture 'On Modern Art': 'Chosen are those artists who penetrate to the region of that secret place where primeval power nurtures all evolution ... who is the artist who would not dwell there?/ In the womb of nature, at the source of creation, where the secret key to all lies guarded./But not all can enter. Each should follow where the pulse of his own heart leads ... /What springs from this source, whatever it may be called – dream, idea, or phantasy – must be taken seriously only if it unites with the proper creative means to form a work

of art./Then those curiosities become realities – realities of art which help to lift life out of its mediocrity./For not only do they, to some extent, add more spirit to the seen, but they also make secret visions visible.'
More Here than There, Ghost of a Genius; LEADBEATER

Klinger, Max (1857–1920) German artist, print-maker; only twenty-one when he published his disturbing sequence of prints, *On the Finding of a Glove*; morbid, melancholy, furious imagination; friend of Paul Klee.
See LIST OF WORKS

Kubin, Alfred (1877–1959) German artist, print-maker, portraying nightmares, the uncanny and the macabre.
Adoration, Reclining on a Divan, Suicide

Leviathan 'Who can open the doors of his face? his teeth are terrible round about' (Job 41:14); huge sea-monster, synonymous with hell, and hence of its lord, Satan; Thomas Hobbes's image for society.

levitation Saint Joseph of Copertina (1603–63) is its patron saint, as he often rose in the air, once carrying someone with him and absent-mindedly letting go, something Saint Teresa of Ávila (1515–82), was careful to avoid. She did, however, express regret in her autobiography at her tendency to leave the ground.

129, 133 **Max Klinger**
On the Finding of a Glove, 1881

horoscope Chart giving configuration of the stars and planets at the exact moment of someone's birth; hence predictions about the character and destiny of the subject; widespread Caesareans and induced births have no effect on popularity of belief today.

hypnagogic vision Occurs between states of waking and full sleep; produces intense and vivid dream images, cultivated first by Romantics and later by Surrealists: 'when I close/These lids, I see far fiercer brilliances, – /Skies full of splendid moons and shooting stars,/And sparkling exhalations, diamond fires,/And panting fountains quivering with deep glows' (Keats, 1818).

hypnosis Differs from sleep and from other kinds of trance; hypnotised subject's hands can hold objects, unlike sleeper's; susceptibility to pain diminishes, and may even vanish. Saint Bernadette during her visions of the Virgin Mary at Lourdes did not feel pain when her finger was held in a candle flame.

Hildegard of Bingen (1098–1178) 'The Sibyl of the Rhine', poet, composer of songs and musical dramas, polymath scientist extending the borders of biology, astronomy and physics of her times; abbess and saint; communicated visions she began to receive aged five in 'cascades of images' (Peter Dronke). She directed artists to illuminate them: manuscripts contain uniquely powerful cosmic envisionings.

hocus pocus Possible corruption of *hoc est corpus*: the words of the priest at the moment he turns the bread into the body of Christ; used derisively of magic and magicians since early C17.

horn Diabolical signifier, often; Sir Hans Sloane collected human examples for his cabinet of curiosities, a founding collection of the British Museum.
SCHONGAUER

icon Sacred image, sometimes produced miraculously (in a tree, from the sea, without hands), partaking in the divine power of its subject; can ooze blood, manna, sweat; often wonder-working.

imagination 'What is now proved was once only imagin'd' (Blake, 'Proverbs of Hell'); 'That reconciling and mediatory power, which incorporating the reason in images of the sense, and organising (as it were) the flux of the senses by the permanent and self-circling energies of the reason,

hallucination Distinguished from 'illusion', in that its subjects, while materially absent, are true cognitive experiences, overpowering the capacity to discriminate between reality and fantasy.

halo Radiance, often solar, emanating from someone very holy; either body-length (a 'mandorla'), or a golden disc around or above the head, often seen in perspective by Renaissance artists, signifying the person's numen, or sacred inner power. See also aura.

harpy She-monster, winged, with raptor's claws, filthy and greedy; Ariel metamorphoses into a harpy in order to do mischief on Prospero's behalf in *The Tempest*; last spotted in Peru in C17.

hasard objectif 'Objective chance', principle of synchronicity/serendipity that the Surrealists lived by, letting their 'sixth sense' or other unknown factors lead events; exemplified in André Breton's novel *Nadja* (1928).

heart Jesus appeared to many mystics, from C13 on, and made them a gift of his bleeding heart; after Saint Margaret Mary Alacoque's experiences in C16, the cult of the Sacred Heart took off; approved by the Pope in 1856; cult of the Immaculate Heart of Mary followed, after the Virgin appeared in turn to Saint Catherine Labouré and showed her her wounded heart, in Paris, 1830.
WIERIX

hell From Old Norse *hel*, meaning death or 'burial ground', the afterlife down below, a place of shadows in Homer, the valley of tears, the pit of fire, a diabolical kitchen where devils feast on sinners. Dante imagined the 'groaning city' of 'eternal pain' with lasting effect on the imagination, in private and in public. In *Invisible Cities*, Italo Calvino reminds us: 'The inferno of the living is not something that will be; if there is one, it is what is already here, the inferno where we live every day, that we form by being together. There are two ways of escaping suffering it. The first is easy for many: accept the inferno and become such a part of it that you can no longer see it. The second is risky and demands constant vigilance and apprehension: seek and learn to recognise who and what, in the midst of the inferno, are not inferno, then make them endure, give them space' (1972).
BELLANGE (ATTRIB.); BLAKE; DUVET; AFTER FUSELI

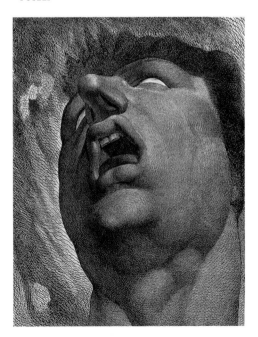

83 **After Fuseli**
Head of a Damned Soul, c.1788–90

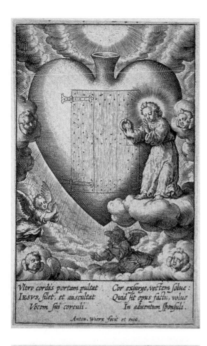

Vltro cordis portam pultat
IESV, silet, et auscultat
Vocem sui coreuli.

Cor essurge, veccem solue:
Quid sit opus sactu, volue
In aduentum sponsule.

Anton. Wierx fecit et excud.

mortis sedent. Luc. I

Sat est, IESV, vulnerasti,
Sat est, totum penetrasti
Sagittis ardentibus.

Procul, procul hinc libido:
Nam cælestis hic Cupido
Vincet ignes ignibus.

Anton. Wierx fecit et exc.

Dum scrutaris in lucernis
Et vestigas cum laternis
Cor peccatis obsitum;

O quot monstra deprehendis!
IESV, scopas ni præbendis,
Manet culpis perditum.

Anton. Wierx fecit et excud.

O beatam cordis ædem!
Te cui cælum dedit sedem
Purgat suis manibus.

Animose puer verre,
Monstra tuo vultu terre,
Tere tuis pedibus.

Anton. Wierx fecit et excud.

199–202 **Anthonie Wierix**
Christ with the heart

ghost Madame du Deffand (1697–1780) was asked if she believed in ghosts; she answered, 'Non, mais j'en ai peur.' (No, but I am scared of them.) The same root gives 'ghastly' and 'aghast', cognate states with the sublime.
DANCE, *Whence*

giant Often in myth giants belonged to the world between gods and humans before the present era, and were overthrown; they resent their fall, and so are vengeful, greedy (cannibals, even) and often stupid. Saint Christopher, who carried wayfarers across a river, is a kind-hearted exception, and therefore patron saint of travellers.
BOKUSEN, *Immortal*; DOYLE; KULMBACH

Gilgamesh, Epic of Oldest extant poem, Sumerian, 3000BC; includes story of the Flood; hero loses his friend Enkidu, the wild man, and so comes to understand love and death.
QUAY BROTHERS, *This Unnameable Little Broom*

glove Female symbol, connected with chivalry; knights wore a lady's glove in their helmet as a sign of favour; Klinger recast this relation in an unsettling erotic dream sequence.
KLINGER, *On the Finding of a Glove*

goat The Devil is an ass, but also at times a goat, inheriting features from Pan, pagan embodiment of nature, fertility, appetite and unruliness.

goety Necromancy or black magic, useful C16 term; needs reviving.

Goya, Francisco (1746–1828) Spanish painter and engraver, most trenchant portraitist, most eloquent pastoralist, most bitter chronicler of inhumanity (*Disasters of War*); darkest fantasist (*Proverbios*; *Caprichos*, and last paintings). Protested, 'I'll have you know I'm not afraid of witches, spirits, phantoms, boastful giants, rogues, knaves, etc., nor do I fear any other kind of beings except human ones' (1825).
See LIST OF WORKS

griffin Beast with head and wings of an eagle, body and paws of a lion; some are true griffins, some false, as John Ruskin pointed out: 'Imagination's power' to see to the heart has produced 'griffinism, and grace, and usefulness, all at once ...' (1898).

Grimalkin Common pet name for a witch's cat.

grimoire Spellbook, used for magic by an enchantress, magus or witch. The angel makes John eat such a book (Rev. 10:9–11); Prospero drowns his in *The Tempest*; Umberto Eco has a fine collection.
AFTER BRUEGEL; FUSELI; ROMNEY; RYSBRACK

grotesque Fantastic combinations producing hybrid creatures and ornamentation, ranging from medieval gargoyles, ornamental scrolls in Renaissance arcades, to ugly inventions intended to shock: 'Whoever wants to do dreamwork, must mix all things together' (Dürer). Can inspire horror and fear as well: 'There are few grotesques so utterly playful as to be overcast with no shade of fearfulness, and few so fearful as absolutely to exclude all ideas of jest' (Ruskin, 1851–53).
BOKUSEN, *Long-nosed Conjurors*

guardian angel Counter-Reformation belief that every soul is given a special protector at birth; children, worried that s/he will not have room, have often slept on the side of their beds, or made way by moving to the floor.

Se repulen.

90 **Francisco Goya**
They Spruce Themselves Up

F

fairy The British Isles alone contain such a
varied population of fairies, goblins, imps
and sprites that it would take a much longer
dictionary than this to name them all.
'Fairy' is related to *fatum*, or Fate; fairyland
is 'the perilous realm'; fairy wives bring
dangers as well as bliss, and fairy
godmothers boons. Fairies 'are said to be
of a middle nature betwixt man and Angel
... intelligent Studious Spirits, and light
changeable bodies (like those called Astral)
somewhat of the nature of a condens'd
cloud, and best seen in twilight' (Robert
Kirk, C17). Small in the Celtic tradition
('the little people'), but human-size
in European fairy-tales and *The Arabian
Nights*. Fairies did not die out with the
Middle Ages: Lewis Carroll owned a
photograph; Conan Doyle, master of
deduction from first principles, supremo
of detective fiction, remained convinced by
the Cottingley fairy photographs till he died.
CONAN DOYLE; DADD, *Songe, Dancing Jester*;
DOYLE; GOYA, *Hobgoblins*; KLINGER, *Bear*

fantasy 'The power by which the intellect
represents what it sees' (Dante, *Convivio*).

Faust, Dr or Faustus The most famous of
recent magi; hero of seekers of knowledge;
seduced by Mephistopheles into trading his
soul for more; Goethe's long, quasi-sacred
dramatic treatment was a huge influence
on C19 wisdom-seekers, including Rudolf
Steiner and Anthroposophy.

feather 'It pleased the king to raise a little
feather from the ground, and he com-
manded it to fly. And it did as the king
wished. The feather did not fly because of

anything in itself, but because the air lifted
it. Thus am I' (Hildegard, C12). On the rela-
tion of the soul to God, see wings, angel.

Fort, Charles (1874–1932) American philo-
sopher of science, autodidact, collector
of aberrations and 'strange phenomena';
iconoclast profoundly sceptical about all
claims to knowledge; emphasised that
belief is such a serious act of allegiance it
should not be squandered; warned, 'One
measures a circle beginning anywhere.'
Fortean Times, the monthly *Journal of
Strange Phenomena*, is named after him.

Freud, Sigmund (1856–1939) Interpreter
of dreams, story-teller, fantasist, hypnotist,
mythographer, collector; reinvented the
soul for C20 (see psyche).
GREECE, ANON.; HILLER; NEW GUINEA,
ANON., *Head rest*

Friedrich, Caspar David (1774–1840)
German Romantic painter of solitary
wanderers in desolate landscapes; revo-
lutionised the artist's relation to nature:
'It is not the faithful representation of air,
water, rocks and trees, which is the task
of the artist, but the reflection of his soul
and emotion in these objects ... The artist
should not only paint what he sees before
him, but also what he sees within him.
If, however, he sees nothing within him,
then he should desist from painting what
he sees before him' (Friedrich, c. 1830).

Fuseli, John Henry (1741–1825) Born Swiss,
moved to London in 1779; close friend
of Blake; inspired by Shakespeare, Milton,
his contemporary Romantics, and the
American and French Revolutions to
create frenzied images of inner fantasy
and supernatural enchantments,
malignant as well as benign.
The Witch and the Mandrake, Two Figures;
BURKE, *The Nightmare*; AFTER FUSELI,
Damned Soul

E

ecstasy State of being 'out of oneself', of losing individual boundaries and floating into a common ocean of being; experienced by mystics, visionaries and some hedonists. BELLANGE (ATTRIB.)

ectoplasm Material manifestation of spirit, viscous, white, firming up into faces, figures, and 'pseudopods', copiously produced in seances around 1890–1930; coincides with the first enthusiasm for photography, hence often captured by the camera. Also called 'teleplasm' for its mobile character. ANON., *'Margery' Crandon;* ANON., *Helen Duncan*

Ernst, Max (1891–1976) Surrealist artist; explored the images in random marks, collage, and frottage, rubbings from diverse materials and surfaces like floorboards, 'to assist my contemplative and hallucinatory faculties ... I was surprised at the sudden intensification of my visionary capacities ... He [Botticelli] is right: one is bound to see bizarre inventions in such a smudge; I mean that he who will gaze attentively at that spot will see in it human heads, various animals, a battle, rocks, the sea, clouds, thickets, and still more: It is like the tinkling of a bell which makes one hear what one imagines.' *The Evader, Eve the Only One to Remain Ours*

Eros Psyche breaks the prohibition and looks at her lover, who is none other than the god of love; she sees 'his golden hair, washed in nectar and still scented with it, thick curls straying over white neck and flushed cheeks and falling prettily entangled on either side of his head ... At his shoulders grew soft wings of the purest white ... The rest of his body was so smooth and beautiful that Venus could never have been ashamed to acknowledge him as her son' (Apuleius, *The Golden Ass*). Freud collected images of the god, who sometimes teasingly lifts his tunic to show his genitals. GREECE, ANON.

ether Greek for the upper air beyond the moon, used until the 1920s for the subtle, rarefied substance through which light, radio waves, etc., were transmitted; a powerful metaphor for invisible matter.

Etteilla Anagram of Alliette, name of late-C18 French wig-maker and barber, who popularised through his practice and writings the art of cartomancy, with Tarot packs and other cards he designed himself. *Tarot cards*, ANON.

ex voto Ancient form of thanksgiving for a granted prayer; image of the danger passed, the accident averted, the illness overcome; often home-made, painted, mixed media or cast in wax or tin, hung up at a shrine; mainly found in Catholic cult.

eye, evil Known as *fascinum* in Latin, hence 'fascinate': the gaze that binds, stops movement, arrests life, curdles milk; can be averted by apotropaic eyes, small personal amulets or huge oracular eyes painted on the prows of ships.

eye, third Pineal gland (*conarion*): pine-cone shaped single gland, involved in periodicity and circadian rhythms, long thought to be site of consciousness in the brain ('the seat of the imagination, and of common sense'; the unifying point of soul and body, according to Descartes); identified in recent occultism with the inner eye of enlightenment emblazoned on the Buddha's forehead. REDON

il sole e l'altre stelle.' (Power failed me before this high fantasy; but already my desire and my will, like a wheel that rolls evenly, were being revolved by the love that moves the sun and the other stars.)

Descartes, René (1596–1650) Father of dualism, and much reviled for it; however, his method of inquiry led him to observe: 'it is the soul that sees, not the eye ... This is why maniacs and men asleep often see, or think they see, objects that are not before their eyes ... '

Devil a.k.a. Lucifer, Satan, Beelzebub, Old Nick; as Mephistopheles, tempts **Faust** with knowledge in return for damnation; radically revisioned by Milton, **Blake**, Baudelaire, as protest against God, as radiant pattern of human striving and existential failure; belief in his activities often provides pretext for intolerance, paranoia and sectarian violence.
BLAKE, *Paradise Regained, Satan*; BRUEGEL

Doré, Gustave (1832–83) French illustrator, print-maker; menacing chiaroscuro renderings of the Bible, Dante, Milton, Bunyan.
Illustration to London

dowsing Water-divining for hidden aquifers, with hazel twig or other forked implement.
HILLER; VERBENA

dragon Rain-bearing principle of fertility in some religions; heraldic emblem of Wales; guardian of treasure, secrets and power in Celtic myth; prime symbol of powerful evil in Judaeo-Christian tradition: 'And the great dragon was cast out, that old serpent, called the Devil, and Satan, which deceiveth the whole world: he was cast out into the earth, and his angels were cast out with him' (Rev. 12:9).
BERTOIA; DUVET; PERSIA, ANON.

dream Common process of thinking; some of the earliest writings in existence (cuneiform on tablets) may be interpretations of dreams; long interpreted as premonition and prophecy; later vehicle of divine revelations (Bunyan, Blake); Thomas De Quincey (1785–1859) developed, before Freud, a theory of personal childhood experience crystallising in dream symbols and continuing to affect the adult.
CATHERINE BLAKE; W. BLAKE, *Evil Dreams*; BURKE; CAMERON; GHISI; HAWARDEN; JONES; LINNELL, AFTER BLAKE; MOREAU; NEW GUINEA, ANON., *Head Rest*

Duncan, Helen Scottish medium; last person to be charged and found guilty under an old witchcraft statute in 1933; sentenced to nine months' imprisonment.

Dunglas Home, Daniel (1833–86) The most celebrated 'physical' medium of the Victorian age – often seen to float through the air, horizontally, sometimes out of one window and in at another. Turned tables; conjured invisible music-makers.

Duvet, Jean (c. 1485–1561) Sometimes called Master of the Unicorn; print-maker influenced by Dürer in theme and medium, but his temperament was more turbulent, his vision even more fierce and urgent.
Apocalypse, Unicorn

7 **Anon.**
Crandon producing teleplasmic mass, c.1925

[38]

96 **Lady Clementina Hawarden**
Girl Asleep, c.1863–64

173 **Marcantonio Raimondi**
Raphael's Dream, c.1508

THE
DREAMER'S COMPANION;
OR,
UNIVERSAL INTERPRETER OF DREAMS.
TO WHICH IS ADDED,
The Secret of the Dumb Cake;
With the Method of ascertaining Future Events by Means of
PALMISTRY,
OR THE LINES OF THE HAND.

PART THE FIRST.

LONDON: ORLANDO HODGSON, 10, CLOTH FAIR.
Price One Penny.—Coloured Plates.

(Richard Feynman, C20 physicist). When I sleep, what is doing the dreaming for me? Is it different to be conscious as me, and conscious as you? Is there an abstract, immaterial principle that governs the individuality of consciousness? Is there a mind distinct from the soft grey matter of the physical brain? These are a few of the hard questions that have burned fiercely since the earliest thinkers passed on their thoughts about thinking; the struggle goes on ...
KLEE; KUBIN, *Reclining on a Divan*

Counter-Enlightenment Term coined by Isaiah Berlin, adopted by E.P. Thompson and others, to characterise heterogeneous intellectual opposition from mid-C17 to the cult of reason; embracing various romantic, vitalist, psychic and spiritual approaches to knowledge, and ranging from Gianbattista Vico's study of myths, Blake's private mythologies, to today's New Age.

crystal Translucent and radiant, mediates between visible and invisible; symbolises clarity and purity; the building material of the heavenly city.

crystals Gems used in divination and spiritual strengthening: the most rapidly expanding area of contemporary occult interest and allegiance. What the I Ching was to the 1970s, crystals are to the 1990s.

Dadd, Richard (1819–77) Painter of fairy microcosms and states of mind; spent nine years in Bedlam after killing his father; transferred to Broadmoor. 'Our laws of space do not apply to this picture; nor do our laws of being ... If each ear of corn, each spiked chestnut husk, is rendered with a naturalist's delight, so are the spread, fluttering wings and brilliant garb of the crowd, some of whom are so small they are scarcely visible to the naked eye as they glide behind a clod of earth, secrete themselves beneath a blade of grass ... And their eyes are full of indifference; a cruel, fierce regard, a fixed grin on all their tiny faces' (Angela Carter). *Songe, Dancing Jester; Christ rescuing St Peter*

Dance of Death Danse macabre. Possibly influenced by early Buddhist funerary rituals, Death appeared piping and drumming, on the walls of medieval churches and cemeteries, in pages of manuals for dying well; carried off emperor and slave, monk and nun, old bawd and infant, levelling all.
AFTER HIERONYMUS HESS; KLINGER, *Amor*; ROWLANDSON

Dante Alighieri (1265–1321) Closes his transcendental vision of hell, purgatory and heaven with the admission that even his inner eye cannot encompass this highest mystery, but that simultaneously he was enraptured by knowledge of it: 'All'alta fantasia qui mancò possa;/ma già volgeva il mio disio e'l velle/sí come rota ch'igualmente è mossa,/l'amor che move

cabbala (also kabbalah) Meaning in Hebrew 'receiving': the arcane interpretation and use of the Torah, or Jewish law, based on the Pentateuch, the first five books of the Bible; some of it is rabbinical tradition, handed down orally since C13; some of it is intense subjective fantasy, popular in late C19 France and Germany. 'Keep your mind on hell and despair not' (Staretz Silouan).

Cameron, Julia Margaret (1815–79) Photographer; using her family friends and servants as models, created fantasies, dreams and allegories, with an uncompromising, unvarnished immediacy: 'The photograph thus taken has been almost the embodiment of a prayer.' *Angel; First Ideas; Grandchild; Portait of Mary Hillier*

Carroll, Lewis (Rev. Charles Dodgson) (1832–98) Creator of the *Alice* books and exhilarating nonsense verse; inventor of the Nyctograph, a tool for writing in bed in the dark; defined three states of the psyche: a) 'ordinary', when there is no consciousness of the presence of fairies; b) 'eerie', when the subject, while being conscious, is also aware of them; and c) 'a form of trance', during which the sleeper's 'immaterial essence migrates to other scenes, in the actual world, or in Fairyland ... ' Wonderland was not a fantasy, not exactly, for him.

Catherine, Saint Martyred in Alexandria C4 after disputing with pagan philosophers and defeating them in debate. Doctor of the Church (one of the few women); identified by the wheel studded with knives which burned up in divine flames, necessitating her beheading.

centaur Pliny reports seeing one in Rome; it had been brought from Egypt embalmed in honey; symbol of animal passions.

CAMBIASO, *Rape*

Chimaera Fire-breathing monster with the heads of a lion, goat, and dragon, killed by the hero Bellerophon; since C17 signifies illusion itself, the impossible and delusory figment of the imagination: 'a creature of language, the metaphor of metaphor' (Ginevra Bompiani); Borges quotes Rabelais: 'Can a chimera, swinging in a void, swallow second intentions?'

clairvoyance Second sight; the gift of seeing the future.

STUDIO OF POLLARD CROWTHER

Cock Robin Subject of *Mother Goose* nursery rhyme, written down C18, burlesquing life, death and funeral rites.

FITZGERALD

Coleridge, Samuel Taylor (1772–1834) Poet, letter-writer, dazzling theorist of mind and imagination, walker in these islands, in Germany and in Xanadu: 'To make the external internal, the internal external, to make nature thought, and thought nature, – this is the mystery of genius in the Fine Arts. Dare I add that the genius must act on the feeling, that body is but a striving to become mind, – that it is mind in its essence!' ('On Poesy or Art', 1818).

conjuring Used both for devilry and natural magic; witnesses and participants play a crucial part in establishing the shifting boundary between the entertainers' sleight of hand and the paranormal, between the normal and paranormal.

consciousness 'I wonder why. I wonder why./I wonder why I wonder./I wonder *why* I wonder why/I wonder why I wonder!'

belly. He moveth his tail like a cedar: the sinews of his stones are wrapped together. His bones are as strong as pieces of brass; his bones are like bars of iron. He is the chief of the ways of God: he that made him can make his sword to approach unto him' (Job 40:16–19). But this wonder – and favourite of Blake's – fell into disgrace, and was exiled, and now lurks in swampland, like a sort of hippopotamus.
BLAKE, *Job*

Beuys, Joseph (1921–86) Sculptor, performer, teacher, Utopian; born and brought up in Cleves, German Lowlands, so felt spiritually connected to Bosch and Bruegel; worked with myths and symbols, borrowed from far-flung cultures as well as home-grown (fat, honey, felt, horses, hares, coyotes); strong defender of irrationality as a way of producing new meanings: 'My intention is obviously not to return to [such] earlier cultures but to stress the idea of transformation and substance. That is precisely what the shaman does in order to bring about change and development: his nature is therapeutic' (1974).

Blake, William (1757–1827) Artist and poet; Londoner; visionary, revolutionary, forged a unique personal philosophy and metaphysics, populated with his own pantheon of divinities and devils; brought out a sequence of illustrated books, including *Songs of Innocence*, to little interest or acclaim; prophet of the Counter-Enlightenment and champion of the imagination: 'How do you know but ev'ry Bird that cuts the airy way,/Is an immense world of delight clos'd by your senses five?'; 'Thought alone can make monsters, but the affections cannot.' (*The Marriage of Heaven and Hell*).

blindness To distinguish the envisioning capacity of the mind's eye from the eyes of the body, Descartes invited us to consider the case of a blind person: 'It is not necessary to assume the transmission of something material from the object to our eyes in order that we may see colours and light, nor even the occurrence in the object of anything resembling our ideas or sensations of it. For in just the same way, when a blind man is feeling bodies, nothing has to issue from them and be transmitted along his stick to his hand; and the resistance or movement of the bodies, which is the sole cause of his sensations of them, is nothing like the ideas he forms of them ... '
See LIST OF WORKS

Bosch, Hieronymus (1453?–1516) In his polymorphously perverse make-believe pictures 'the criterion of the beautiful replaces that of the true ... It is by this metamorphosis that a chart of knowledge is transformed into a garden of delights' (Michel de Certeau).

Brocken Highest peak of the Harz range in Germany; famous for hauntings and witches' gatherings, especially on Walpurgisnacht; Coleridge walked there, hoping for sightings, but was content instead with: 'the sight of a Wild Boar with an immense Cluster of Glow-worms round his Tail & Rump' (1799).

Bruegel, Pieter (*c.* 1525–69) Flemish painter; specialised in scenes of daily life and activity, including children's; influenced by Bosch, also created terrifying, but somehow absurdist phantasmagoria. *Temptation of Saint Antony*; AFTER BRUEGEL, *Peasant Women*

astrology Ancient method of deciphering the language and influence of the planets, once practised in Babylon, India, China, now also in daily newspapers everywhere; sustains complex macro/microcosmic philosophy; inspirer of elaborate and occasionally sumptuous calendars, charts and manuals. See -mancy.

aura The light emanating from a person, according to theosophical ideas, influenced by Hindu beliefs; visible only to some; sometimes called 'photisms'. See halo.

Babylon Ancient Chaldaean city; synonym for wickedness: Saint John sees it embodied in the great Whore who triumphs against the true Church – but only for a time.
DUVET

Baldung Grien, Hans (1484/5–1545) German artist; inspired by most macabre and ferocious fantasies of contemporary witch-hunters.
Witches' Sabbath

bat Sorcerer's and witch's familiar, on account of nocturnal habits; C19 Irish fantasist Bram Stoker first connected vampire of the species to the undead who suck the blood of the living: 'I saw ... the whole man emerge, and begin to crawl down the castle wall, over that dreadful abyss, face down, with his cloak spread out around him like great wings ... ' (*Dracula*, 1897).
BALDUNG GRIEN; FUSELI, *Witch*; GOYA, *They Spruce Themselves Up, Way of Flying*

the Spirit of life in Christ Jesus hath made me free from the law of sin and death' (Rom. 8:2). Connected, in C18 London artisan circles, with radical Calvinism and political dissent of various stripes. See Blake.

Antony, Saint C3 hermit in the Egyptian desert, terribly afflicted with demons, who appeared to him sometimes in the shape of lovely young girls (half) dressed to kill; a favourite subject of painters.
BRUEGEL; SCHONGAUER

Apocalypse, The Greek for 'revelation', as granted to Saint John in the concluding, convulsively violent book of the New Testament, the source of many later images of Doomsday.
DUVET

Behemoth 'Lo now, his strength is in his loins, and his force is in the navel of his

99 **Attributed to Joseph Heintz the Elder**
The Dead Christ Lamented by five Angels, 1589

54 **Mat Collishaw**
Ultra-violet Angels, 1996

177 **Studio of Guido Reni**
The Archangel Michael Subduing the Devil

A

abracadabra Nonsense rhyming magic, possibly cabbalistic in origin, based on a nearly palindromic triangle; used to protect, open doors, cast spells and turn one thing into another; still conjuring's most reliable formula.
ROMNEY, RYSBRACK

Agnes, Saint Martyred in Rome C4, aged around thirteen, after being thrown into a brothel because she refused an arranged marriage, where her hair grew miraculously long to cover her nakedness. Her emblem: a fleecy lamb (a Latin pun on her name); patron saint of young girls.
VENETIC

alchemy Magic chemistry; earliest documents C2, Egyptian; widely practised in medieval and Renaissance Europe; attempted at a vulgar level to turn base metals into gold; in mystical thought and art searched for a universal panacea, 'the philosophers' stone'; inspired a complex, finely tuned system of allegorical correspondences between the properties of inert and animate matter, and between microcosm and macrocosm, represented in some of the most exquisite manuscripts ever made.

amulet An ornament made in a symbolic form with power to keep the wearer from harm: from the udjat eye to the currently popular fundamentalist Christian fish logo on cars.

angel As various as roses, far too many to name; include cherubim (a.k.a. erotes, putti), seraphim, powers, thrones, dominations; elves, fairies, imps, brownies, peris; genii, nymphs, sylphs. Also the Angel of History: 'The angel would like to stay, awaken the dead, and make whole what has been smashed. But a storm is blowing from Paradise; it has got caught in his wings with such violence that the angel can no longer close them. ... This storm is what we call progress' (Walter Benjamin, on Klee's *Angelus Novus*).
W. BLAKE, *Angel*; CAMBIASO, *Assumption*; CAMERON; DE CLERCK; GAULLI; GREECE, ANON.; GUERCINO; HEINTZ THE ELDER (ATTRIB.); LOMBARD, *Cherub*; NEAPOLITAN, ANON.; PARMIGIANINO; PASSERI; PROCACCINI; REMBRANDT; STUDIO OF GUIDO RENI; RONCALLI; AFTER VASARI

antinomianism Doctrine that to the holy all is holy, and that rules (moral or other) need not apply to them; Gospels invoked in support, for example: 'For the law of

185 **John Michael Rysbrack**
The Magician

A SHORT DICTIONARY OF THE INNER WORLD

ARTISTS' NAMES and *titles* refer to the works in the exhibition, which are listed on pp. 83–95

87 Giorgio Ghisi
Allegory of Life ('Raphael's Dream'), 1561 (detail)

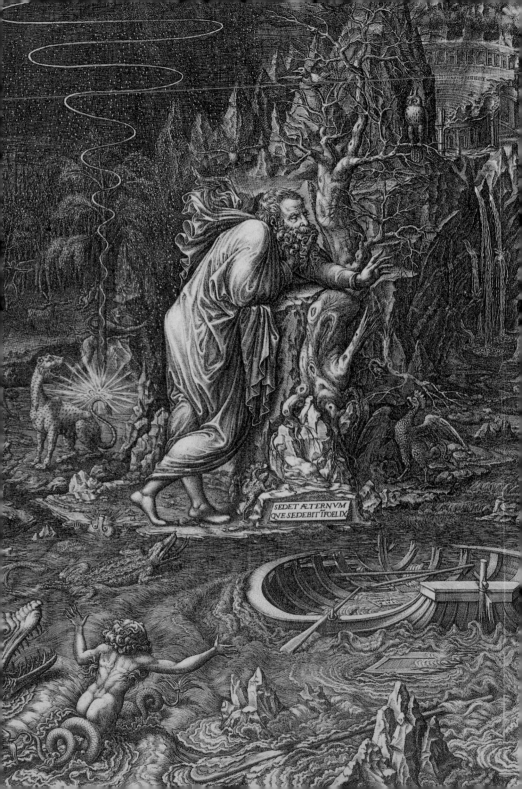

SEDET AETERNVM
QVE SEDEBIT ĪPOELIX

Christian saints: prodigious, but not fantastic through and through like the chimaera or the griffin.

The heterogeneity of the works of art and objects in *The Inner Eye* threatened to defeat any attempt at synthesis or overview, so instead of a catalogue essay, I've written a short, open-ended dictionary, with entries arising from motifs, subjects and artists in the show, hence selective, provisional, fragmentary. So, alert all readers: add headings and definitions and glosses as you like.

The inner world is common ground, a lingua franca intelligible across the borders of personal fantasy, with its own complex history and conventions, even when the imaginings are acute and disordered and painful, like Richard Dadd's. This common ground is not sequestered from change; it's sown and grown from the subjective findings, inventions, choices and discoveries of artists, *flâneurs*, dreamers: all of you looking, passing here.

Marina Warner
Kentish Town, 1996

NOTES

1. Emily Dickinson, from *The Complete Poems of Emily Dickinson*, ed. Thomas H. Johnson, Poem no. 451, © 1929 by Martha Dickinson Bianchi; © renewed 1957 by Mary L. Hampson. By permission of Little, Brown and Company
2. Immanuel Kant, *Critique of Pure Reason*, trans. Norman Kemp Smith, New York, 1965
3. Jean-François Lyotard, 'Answering the Question: What is Postmodernism?' (1983), in *Postmodernism: A Reader*, ed. Thomas Docherty, New York, 1993
4. Ibid.
5. Ibid.
6. Gianbattista Vico, *The New Science* (1725); see Isaiah Berlin, 'Vico's Concept of Knowledge', and 'Vico and the Ideal of the Enlightenment', in *Against the Current Essays in the History of Ideas*, ed. Henry Hardie, Oxford, 1979
7. Robert Kirk, *The Secret Commonwealth*, ed. Stewart Sanderson, Cambridge, 1976
8. In conversation, May 1995
9. *Collected Letters of S.T. Coleridge*, ed. E.L. Griggs, Oxford, 1956–71; quoted Richard Holmes, *Coleridge: Early Visions*, London, 1989
10. Paul Klee, *On Modern Art* (1924), London, 1989
11. John Ruskin, *Modern Painters*, London, 1898, III

122 **Wassily Kandinsky**
Abstrakte Komposition K22, 1922

124 **Paul Klee**
Ghost of a Genius, 1922

emerged: though at first I expected to include African and Indian materials (after all astrology came, like the Wise Men, from the East; much of the magical tradition has roots in Egypt, in Africa), *The Inner Eye* concentrates principally on Western Europe, with the exception of some items that reveal how arbitrary and clumsy this distinction is: the dragon from Persia, so like the home-grown variety, and a New Guinean head rest from Freud's collection, which

he saw as a 'dream stool'. On the whole, allegories are excluded, because they tend to be intellectual constructs assembled by cerebral bricolage rather than inward visions. Here, John Ruskin's famous definition of True and False Griffins becomes relevant: citing the mythical beast, and contrasting a medieval, Lombard variant with a classical example, Ruskin argued that such a creature can be represented truthfully or fallaciously. '"Well, but," the reader says, "what do you mean by calling either of them true? There never were such beasts in the world ... "' But, Ruskin rejoins, 'The difference is, that the Lombard workman did really see a griffin in his imagination, and carved it from the life, meaning to declare to all ages that he had verily seen with his immortal eyes such a griffin as that; but the classical workman never saw a griffin at all, nor anything else; but put the whole thing together by line and rule.'[11]

Together with Renaissance allegories and their close cousins, emblems, I also set aside illustrations of myths, but not because they are kit-assembled 'by line and rule'. The gods and goddesses of the Greek pantheon are ambiguously embodied when they come down to earth (their flesh may be ivory and their blood ichor), but they behave like human beings – notoriously so; while they clearly need to metamorphose into animals and other shapes in order to communicate with (and rape) their chosen favourites, they do not exist beyond the visible. In some ways, I took them to resemble

to their original owners' descendants from the ethnographic collections of museums; they contain scraps of possessions, rags, objects, nothing of intrinsic value, but they are thought to be imbued with the identity of the family to whom they belong, and, as recovered family totems, they are received and unwrapped in great solemnity during the ritual. I do not believe in the gods invoked in the ceremony; I do not even believe that the bundles have necessarily been correctly identified; their contents are worthless. But I would never treat such a bundle as if it had no value. It has been saturated with power by its celebrators' feelings, and consequently transformed.

Of course belief is a highly complex philosophical issue, not to be glibly disentangled here. But *The Inner Eye* can be approached in the same spirit as an outsider approaches a bundle ceremony: with curiosity, with respect, and with the strength that comes when these convictions do not have to draw you in as a consenting participant (a believer). Its exhibits can be contemplated without exacting allegiance: it is possible to thrill to the face of God moving on the waters in John Martin's deep, sable velvet vision without subscribing to the Creationist reading of Genesis.

The idea for *The Inner Eye* was inspired by a famous passage from one of Paul Klee's lectures, where he advocates an art that passes beyond manifest appearances, and reaches in to what he calls 'the womb of nature, at the source of creation, where the secret key to all lies guarded'.[10] This kind of thinking owes a lot to Theosophy and its pantheistic variant, the Anthroposophy of Rudolf Steiner, which influenced Klee as well as many other artists at the Bauhaus to attempt a taxonomy of forms and colours and assign them spiritual significance – Klee's notebooks return obsessively to this task. But in that lecture of 1924 (quoted in full later in the Short Dictionary), he concluded that the happy few who could enter and grasp the secret key needed to learn the language of art to shape the fantasies stirred up. 'Then,' he wrote, 'those curiosities become realities – realities of art which help to lift life out of its mediocrity. For not only do they, to some extent, *add more spirit to the seen, but they also make secret visions visible.*' (Emphasis added.)

When I began selecting such secret visions for *The Inner Eye*, I defined my criteria as I proceeded, and gradually certain boundaries

shop will raise a powerful thirst (in myself, at least) for a dash of
Voltairean irony; this reaction admittedly arises mainly from the
poverty of inspiration of the mimsy sub-Art Nouveau-cum-*Book of
Kells* graphic style favoured by New Age packaging. *The Inner Eye*
tries to encompass the invigorating variety of means that people
have devised over time, in all their fantastic ingenuity, to penetrate
the great mysteries; and I wanted it to range from the mystical to
the absurd, from the excited, heavenly tumult of a Renaissance saint
in trance to the sample of ectoplasm 'captured' from the medium
Mrs Helen Duncan at a seance in the 1920s.

When faced with the supernatural, the question of belief
appears to present itself with great urgency: the Enlightenment
tradition insists that if something is not true, it should not be
believed; for example, since it is improbable that star signs govern
individual destiny, it is foolish and credulous to give astrology
serious attention. However, this axiom does not hold when a
Western observer attends a sacred ritual of another society. Imagine
a bundle ceremony among one of the indigenous tribes in Canada –
Cree or Blackfoot. Some of these bundles have recently been restored

30 **William Blake**
*Christ Refusing the Banquet, c.*1816–18

archive for the Society of Psychical Research, to read excited letters written in the 1920s by established scientists like Sir Oliver Lodge and William Crookes about 'spirit photographs' and their authentic capture of invisible auras and ghosts and presences.

The symbolic languages developed by such disciplines as alchemy, astrology, angelology wrought systems of thinking about phenomena which may not reveal directly what the future holds in store for your daughter, but have incidentally deepened our understanding of the movement of the galaxies, the structure of crystals and so forth, and often through works – in word and images – of incomparable richness. The American writer Edmund White has commented that just as anthropologists can judge a culture by the variety and number and nature of its tools, so multiple systems of inquiry into meaning, many-faceted analyses and representations of the mysteries of consciousness and creation, including their perceived spiritual and supernatural aspects, add instruments to the tool-box, enrich the languages by which we know ourselves and the world, expand syntax and give us more mulch to grow in – a broader vocabulary, a deeper reservoir of symbols, a richer store of motifs and concepts.[8] Coleridge, for example, commented with some excitement in the course of drawing a self-portrait in a letter: '[I] have read almost everything – a library-cormorant – I am *deep* in all out of the way books ... Metaphysics, & Poetry, & "Facts of mind" – (i.e. Accounts of all the strange phantasms that ever possessed your philosophy-dreamers from Thoth, the Egyptian to Taylor, the English Pagan) are my darling Studies ... '[9]

Some of the artists in *The Inner Eye*, like Blake or Kandinsky, are distinguished by the energy with which they too followed many of Coleridge's 'darling Studies' and tried out every sort of available tool – Blake in eighteenth-century London, Kandinsky in nineteenth- and twentieth-century Moscow, Munich, Berlin and Paris. They built for themselves individual systems of thought in the chambers and corridors of their imaginations, incidentally inventing material forms as they did so, as with Blake's hand-coloured visual printed poetry, or Coleridge's unfolding autobiography in letters, philosophy on the wing.

Of course there are glaring problems with any endorsement of the visionary tendency: a visit to the crystals counter of a New Age

Vico's mythic historiography,[6] or Robert Kirk's anthropology of fairies,[7] Blake's private mythologies, Henry Fuseli's and Richard Dadd's images. In the eighteenth and nineteenth centuries, the 'propensity towards the marvellous', as the sceptical David Hume called it, was intertwined with progressive, even radical thought, in politics and the arts: from the millenarian emancipation and labour movements of urban tradesmen and women, as discussed by

E.P. Thompson in *Against the Beast* and Logie Barrow in *Independent Spirits*, to the search for a revolutionary language of expression in the first abstract experiments of Kandinsky and Klee.

That propensity towards the marvellous 'can never be thoroughly extirpated from human nature', Hume acknowledged, with some regret, and it is necessary also to own that allegiance to irrationality and the occult lies at the basis of some of the most alarming developments of the twentieth century: Fascism on the one hand, and fundamentalism on the other.

However, the dangerous developments of some strands in Counter-Enlightenment thought have not supplied the principal motives for the contempt and/or disregard in which it has generally been held; that response has arisen, rather, from a continuing, deep and unexamined commitment to an idea of reason as distinct from imagination, which may set up in itself a false opposition between the methods the mind uses to gain and apply knowledge. It is worth remembering that cracks on oracle bones, produced by priests applying a hot instrument, may constitute the first written script, and that reading may have begun with the need to decipher these enigmas; also, that some of the earliest texts concentrate on interpreting dreams. The 'Counter'-Enlightenment may not be such an enemy of knowledge, after all (and, let's not forget, knowledge is the royal road to truth), while the Enlightenment tradition itself may not be built simply of purely rational materials. It's startling, for example, looking at the

109 **Georgiana Houghton**
Photographs of spiritual beings, 1882

works for *The Inner Eye*, I had many motives, but four are salient. I wanted to shift the emphasis from explorations of the visible to the riches of the invisible envisioned, to those unpresentable allusions to the conceivable. I also wanted to refresh interest in artistic acts of the imagination, on the faculty of creative image-making, and at the same time to point to some continuities within the ruptures of this last half-century; to ravel up the past and the present and reveal that Romantic and later, modernist struggles to express concealed inwardness and subjectivity necessarily draw on the visual linguistics of earlier mystical imagery (this is the point about inherited parts of image-speech), even when they originate fresh metaphors or reinvigorate old ones. It seems to me vital, too, to own up to irrationality within the Western tradition, and not only pre- or post-Enlightenment, but enmeshed with the very Enlightenment itself; the degree of this interwovenness has been denied, and uses of magic and fantasy have often been ascribed to the Other, to the Stranger, who is consequently characterised as primitive, barbaric, even inhuman. But the drawings of nightmares, demons, witches and other phantasmagoria, the instruments of prophecy, divination and spells in *The Inner Eye* will at least reveal that European culture and beliefs have not been securely placed in this epistemological hierarchy, and that we had, and have, our own brands of voodoo, for good or ill. It is a question of admitting, as Prospero does at the end of *The Tempest*, 'This thing of darkness I acknowledge mine'. (But not exclusively, of course.)

The term 'Counter-Enlightenment', coined by Isaiah Berlin and since used by E.P. Thompson and others, characterises the attack on the cult of reason made, from the mid-seventeenth century onwards, by a variety of fine minds, from a wide variety of standpoints, and in a number of places, ranging from Italy to Scotland. The rebellion against lucidity and rationality pursued metaphysical, Romantic, vitalist, psychic and spiritual knowledge, but it was not a coherent or united movement; rather the term can be used to lasso thinkers and historians, poets and artists of very different persuasions, who nevertheless lay common stress on the valuable function of fantasy and imagination in the analysis of reality and in the truthful description of human experience and human beings' place in the world. It is represented at its most fascinating by such works as Gianbattista

the wall the image of a soul burning in the fires of purgatory.
The most exciting new optical instrument of the day was immediately
used to make visible something that of its very nature cannot be
seen and does not exist in visible form.

But, the objection leaps up, the soul in the flames is visible,
even before it is captured in the image – in the mind's eye. For, as
I write this introduction and you read it, we are both conjuring up
pictures inside our heads; Robert Fludd, in his Neoplatonist study of
consciousness and the universe, *Utriusque Cosmi* (1629), called this
faculty the 'oculus imaginationis', and he illustrated it with a
diagram that makes consciousness look a little like Kircher's magic
lantern, a prophecy of the cinema, with a back projection of thoughts
on a screen beyond the skull. You can stand in a supermarket queue,
looking at the items in the trolley, reading the cover stories on
Family Circle and glancing at the other people waiting near you;
and at the same time, your head can be filled with pictures, some
of which are memories, but many of which are fantasies, hopes,
speculations, daydreams and parts of night dreams, none of which
has been seen with the eyes of the body and maybe never will be.
Consciousness is a picture palace, among other things; and one that
is filled with phantasms.

The Inner Eye attempts to stage a picture palace, too, filled with
such figures from the world beyond the visible. Jean-François
Lyotard actually locates the dynamic of what he calls the 'modern'
in this struggle to present the unpresentable: 'I shall call modern
the art which ... present[s] the fact that the unpresentable exists.
To make visible that there is something which can be conceived and
which can neither be seen nor made visible: this is what is at stake
in modern painting ... '[3] Lyotard connects this desire, naturally
enough, with the experiments of the Russian Constructivists and
other 'avant gardes in painting [which] devote themselves to making
an allusion to the unpresentable by means of visible presentations',[4]
but his argument can be applied to other inventions (and traditions)
of form and medium which enter into that baffling and pleasure-
giving gap between perception and representation: 'It is our business',
he concludes, 'not to supply reality but to invent allusions to the
conceivable which cannot be presented.'[5]

When I was choosing the drawings, prints, objects and other

he included a diagram. The concept of an angelic messenger could only become so literal and pseudo-scientific because of the depth and fixity of the tradition of the winged figure in art, which has made a phantasm into an apparently natural, familiar being whom everyone – almost everyone – recognises. Yet an angel, like a demon, is pure image, a sign without a material referent – even if you believe in their existence. For if you do, then you do not believe they are creatures on the same sensory plane as humans; theologically, spirits do not have apprehensible bodies at either end of the supernatural ladder of being: the image of an angel is a way of communicating angelic nature, not a likeness taken from life, as in a portrait photograph.

But the desire to make unperceived objects of fear and fantasy stand before one's eyes as if they were real – the drive to incorporate them into the gaze – has inspired so much art that *The Inner Eye,* with over a hundred works, offers only a tiny hole wiped in a fogged-up window pane. It's significant, for example, that the earliest magic lantern, illustrated in the 1671 edition of *Ars Magna Lucis* (The Great Art of Light, 1646) by the magus Athanasius Kircher, projects on to

The apprehension of mysteries, within the natural and outside
it, is as rooted in the empirical acquisition of data as the mastery
of a new skill. Immanuel Kant's view of vision's social and cultural
contingency enters here: 'Our representation of things, as they are
given, does not conform to these things as they are in themselves,
but [that] these objects as appearances conform to our mode of
representation.'[2] Among these 'objects as appearances', crucial yet
oddly overlooked, are images of the inner world, of the unseen; these
unseen phenomena, ranging from harpies and midnight hags to
seraphs, paradise's 'milken hills', and the sensations of anguish or
bliss or ecstasy, have been visualised by artists and communicated so
effectively that the conventions they use and adapt have themselves
become invisible: nobody, except perhaps a child seeing a baroque
angel for the first time, finds it strange that a naked boy could hurl
himself *sotto-in-sù* from heaven's ceiling on swansdown wings.

In America, where the cult of angels has become a new popular
frenzy, one writer seriously calculated that the dimensions commonly
represented were inaccurate, and that in order to fly, a grown angel,
even a slender one, would need at least a fourteen-foot wing-span;

MAKING SECRET VISIONS VISIBLE

The Outer – from the Inner
Derives its Magnitude ...
The Inner – paints the Outer –
The Brush without the Hand –
Its Picture publishes – precise –
As is the inner Brand ...
The Star's Whole Secret – in the Lake –
Eyes were not meant to know.

Emily Dickinson, c.1862[1]

The flow of images these days, swollen by new technologies,
brings us a flood of messages about material phenomena, from the
structure of a strand of DNA to the beautiful, blowing plumes of
uncreated stars caught by the Hubble telescope. Optics have never
had a longer, deeper reach; optical innovations profoundly influence
art and representation, as they have done since the earliest camera
obscura or magic lantern. But the ways such images are structured,
in form, colour and composition, as well as the ways they are
received and understood – as sublime, as pathetic, as rich, as
meaningless, as inspirational or ironic – reveal deep connections
to iconologies that precede the disclosures and revelations of these
scientific breakthroughs. The language of vision has a syntax,
grammar, vocabulary, a history and a changing development over
time; its intelligibility depends partly on handed down expressions,
on habitual ways of envisioning, on codes known, assembled and
disassembled in cognitive patterns that have been learned and
passed on; but in its frequent unintelligibility, also in its approxi-
mations, blur and fumbling, it still grasps at known characters
and figures as it strives to communicate.

175 **Odilon Redon**
The Temptation of St Anthony, 1888

AUTHOR'S ACKNOWLEDGEMENTS

For help with the catalogue, I would like to thank many friends
and colleagues who made invaluable comments and suggestions:
Lutz Becker, Roy Foster, Alison Samuel, Bice Curiger, Jacqueline
Burckhardt, John Docherty, Alexandra Bradley, Mariët Westermann
and Marcia Reed. I'm especially grateful to Nick Groom for his
careful reading of the Dictionary and his contributions in criticisms
and quotations; at the South Bank Centre, Ann Jones helped with
patient energy in the early stages, Julia Risness was the Empress of
the pack throughout; *The Inner Eye* could not have happened without
Roger Malbert's enthusiasm, interest and discernment from start
to finish: much gratitude to them all for their support.

Marina Warner

encountered only in passing, briefly exposed in exhibitions or books and then returned to darkness, there is a genuine sense of discovery in exploring their mysteries.

We thank Marina Warner for her inspiration and passionate commitment to this project. Our thanks are due too to those who have generously lent to the exhibition, enabling us to include so many works of outstanding quality. We are especially grateful as well to the following people: Dawn Ades, Ken Arnold, Lutz Becker, David Bindman, René Block, Eugen Blume, Malcolm Bull, Richard Calvocoressi, Mungo Campbell, Frances Carey, Timothy Clifford, Nicola Coleby, Charlotte Cotton, Erica Davies, Tobias Döring, Joanna Drew, Antony Griffiths, Robin Hamlyn, Keith Hartley, Mark Haworth-Booth, Monika Kinley, Susan Lambert, Alison Lloyd, Norbert Lynton, Andrew Motion, Jane Munroe, Richard Morphet, Sheila O'Connell, Michela Parkin, Janice Reading, David Scrase, Paul Sieveking, Janet Skidmore, Howard Smith, Natalie Tobert, Peter Underwood, Julia Walworth, Alan Wesencraft, Lucy Whitaker and Christopher White.

Susan Ferleger Brades
Director, Hayward Gallery

Roger Malbert
Head of National Touring Exhibitions

'Dreaming – Either one does not dream
at all, or one dreams in an interesting
manner. One must learn to be awake in
the same fashion – either not at all,
or in an interesting manner.'

Nietzsche, *Joyful Wisdom*

The Inner Eye belongs to a series of National Touring Exhibitions
curated by artists and creative writers on themes of their choice.
Our invitation to Marina Warner, writer of fiction, art criticism and
cultural history, to devise an exhibition was guaranteed, above all,
to result in something interesting, but exactly how extraordinary an
array of images she would assemble, from Renaissance drawings
to nineteenth-century popular ephemera, was impossible to foresee.
Her combination of erudition, critical alertness and imaginative
freedom has given us here a new perspective on the familiar
territory of Western European art. Resonances between images
across centuries, and of beliefs from neo-Platonic to supernatural,
are demonstrated in an exhibition that roams easily between 'high'
and 'low' art, as well as across time.

In keeping with the heterogeneity and unorthodox nature of
much of this material, Marina Warner has followed her introductory
essay with a short Dictionary in which are explained some of the
principal manifestations and exponents of the 'inner world' that is
her subject.

The selection of works focuses principally on drawings and prints,
most of which belong to this country's major public collections.
Their great wealth of material permits an exceptional breadth of
reference and, since so many of these images, if known at all, are

A National Touring Exhibition
organised by the Hayward Gallery,
London

EXHIBITION TOUR

City Art Galleries, Manchester
14 September – 3 November 1996

Museum and Art Gallery, Brighton
23 November 1996 – 5 January 1997

Glynn Vivian Art Gallery, Swansea
18 January – 9 March

Dulwich Picture Gallery, London
10 April – 1 June

Exhibition devised and selected by Marina Warner
Exhibition organised by Roger Malbert, Ann Jones
and Julia Risness

Catalogue designed by Martin Farran-Lee
and Henrik Bodilsen
Printed by The Beacon Press, UK
Copy-edited by Daphne Tagg

© The South Bank Centre 1996
© Texts, Marina Warner 1996

The right of Marina Warner to be identified as the author
of the work has been asserted by her in accordance with
the Copyright, Designs and Patents Act 1988

ISBN 1 85332 155 9

National Touring Exhibitions, Hayward Gallery and
Arts Council Collection publications are distributed
by Cornerhouse Publications, 70 Oxford Street,
Manchester M1 5NH
(tel. 0161 237 9662; fax. 0161 237 9664)

The Inner Eye

Art Beyond the Visible
Marina Warner

National Touring Exhibitions

In Memoriam Helen Chadwick, artist, 1953–1996

Donated
To The Library by

RICHARD FRAGOMENI

June, 1998

The Inner Eye

Art Beyond the Visible